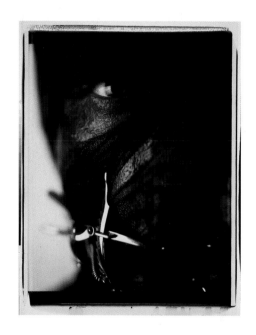

Esse is **percipi**.

GEORGE BERKELEY, *Principles of Human Knowledge*, 1710

"To be is to be perceived."

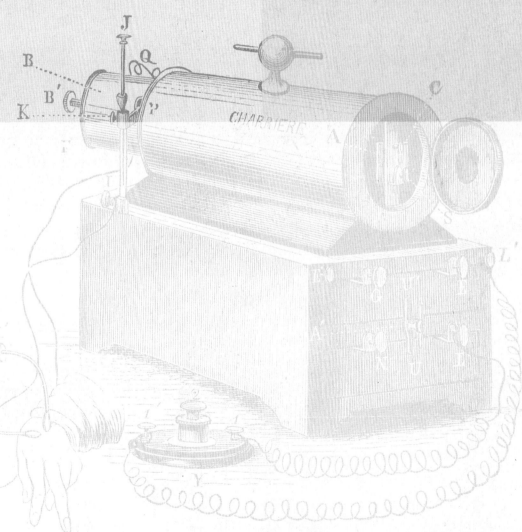

Robert A. Sobieszek

Ghost in the Shell

Photography

and the Human Soul,

1850–2000

778·92 SOB

Essays on

Camera

Portraiture

Los Angeles County Museum of Art

+

MIT Press

Cambridge, Massachusetts | London, England

Table of Contents

Published by the Los Angeles County Museum of Art, 5905 Wilshire Boulevard, Los Angeles, California 90036, and MIT Press, Cambridge, Massachusetts 02142.

Published in conjunction with the exhibition *Ghost in the Shell* held at the Los Angeles County Museum of Art, October 16, 1999 – January 17, 2000.

10 9 8 7 6 5 4 3 2 1
1999 2000 2001 2002 2003

Printed in Italy.

cover: Unidentified photographer, *X-Ray of Human Skull* (anterior view) (detail), c. 1920, cat. no. 129.
back cover: Unidentified photographer, *X-Ray of Human Skull* (posterior view), c. 1920, gelatin-silver print, collection Thomas Walther, photograph by D. James Dee.
endsheets: (left) Suzanne Lafont, *Grimaces 28* (detail by permission), 1992, cat. no. 63. (right) Greg Gorman, *Djimon Screaming* (detail by permission), 1991, cat. no. 51.
front flyleaf: Gottfried Helnwein, *Self-Portrait*, 1987, cat. no. 54.
frontispiece: Eikoh Hosoe, *Ordeal by Roses #32* (detail by permission), 1962, cat. no. 58.
back flyleaf: Lucas Samaras, *Photo-Transformation, 11/1/73*, 1973, cat. no. 105.

Library of Congress Cataloging-in-Publication Data

Sobieszek, Robert A., 1943–
 Ghost in the Shell: photography and the human soul, 1850–2000/Robert A. Sobieszek.
 p. m.
 Includes bibliographical references.
 ISBN 0-262-19425-2 (hardcover : alk. paper). —
 ISBN 0-262-69228-7 (pbk. : alk. paper)
 1. Portrait photography—History—20th century Exhibitions. 2. Portrait photography—History—20th century Exhibitions. I. Title.
TR680.S62 1999
779′ .2—dc21
 99-25393
 CIP

I

"Gymnastics of the Soul"

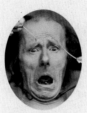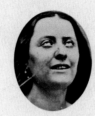

THE CLINICAL AESTHETICS OF
Duchenne de Boulogne

32

II

"Tolerances of the Human Face"

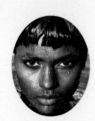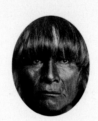

THE AFFECTLESS SURFACES OF
Andy Warhol

80

III

"Abstract Machines of Faciality"

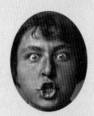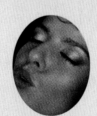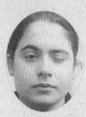

THE DRAMATURGICAL IDENTITIES OF
Cindy Sherman

170

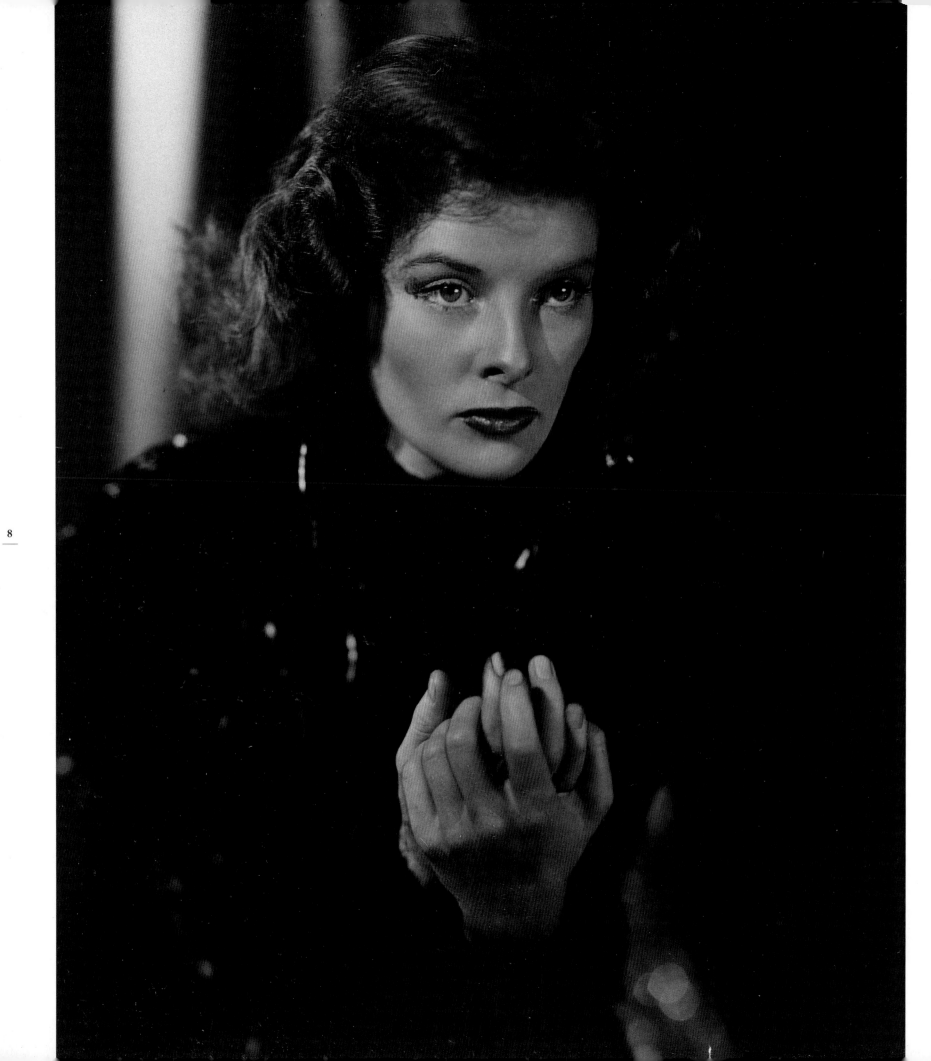

DIRECTOR'S FOREWORD

Graham W. J. Beal

Director

LOS ANGELES COUNTY MUSEUM OF ART

The belief that the human face expresses and reveals human character has underpinned the art of portraiture in Western art for many centuries. When photography was invented in the middle of the nineteenth century, the medium was eagerly embraced for its potential to depict—in clear and loving detail—people and things with complete objectivity. But despite its apparent bias toward the factual, the camera also provided artists with a new and very versatile set of tools for wide-ranging aesthetic experiments. Like a portrait made by a painter, a photograph of an individual does more than reveal the appearance of a sitter at a particular moment in life; it also says a great deal about the photographer, the technology, and the tastes of the time.

With this premise in mind, "GHOST IN THE SHELL": PHOTOGRAPHY AND THE HUMAN SOUL, 1850–2000 traces the entire history of photographic portraiture—from early likenesses on silver plates to recent video installations—in light of how the art has influenced and been influenced by the medical and social sciences as well as popular culture. Organized by Robert A. Sobieszek, curatorial co-chair and curator of photography, the exhibition is the first of its kind to combine traditional, modernist, and postmodernist works that demonstrate the startling convergences, echoes, and departures among a century and a half of photographed faces.

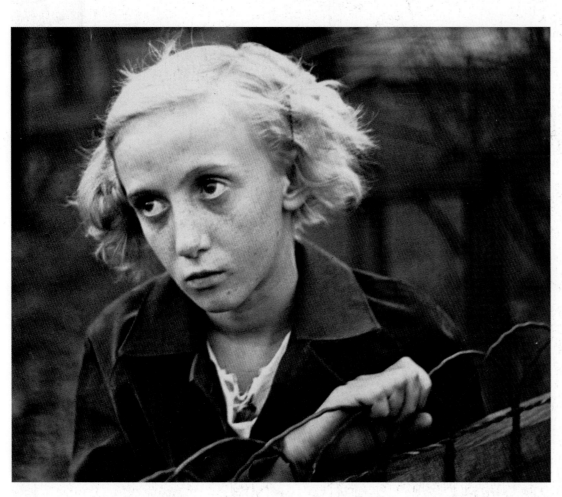

The Los Angeles County Museum of Art is proud to continue its long tradition of presenting provocative and innovative exhibitions of art. On behalf of the museum's trustees and the executive staff, I would like to thank all those whose dedication and commitment brought this project to completion, and all the lenders to the exhibition, whose generosity in agreeing to part with treasured works from their collections for the duration of the show enables us to offer our audiences this rare experience.

ACKNOWLEDGMENTS

Robert A. Sobieszek
Curatorial Co-Chair and
Curator of Photography
LOS ANGELES COUNTY MUSEUM OF ART

This project is the culmination of more than three decades of investigation, deliberation, and discovery, not to mention a certain degree of procrastination. Of course, over the years, many individuals have offered advice, constructive criticism, and suggestions of paths to follow. I will most likely have forgotten any number of the fruitful asides and casual remarks made to me during this protracted sojourn, but to those who made them, I extend my appreciation for your insights and apologies for my forgetfulness. Many others, however, I do recall and wish to name, and to them I would like to formally express my appreciation for their help and assistance along the way. In the summer of 1966, Nathan Lyons suggested I look into the work of Oscar Gustave Rejlander, and while examining this Victorian photographer's illustrations in Charles Darwin's *The Expression of the Emotions in Man and Animals,* I encountered the photographs of Duchenne de Boulogne, whose early electroshock experiments in facial expressions were the immediate cause of my interest in the subject of this exhibition. After a few early lectures, I received encouragement from Alice Andrews, Janet Borden, Robert Fichter, Nicholas Graver, Harold Jones, Grant Romer, and Jacqueline Thurston. Richard Yanul very generously shared his bibliographic findings with me; Elizabeth Anne McCauley conveyed information about Duchenne and progress reports on her own work on A.-A.-E. Disdéri; Philip J. Wiemerskirch placed the holdings of the University of Rochester's School of Medicine and Dentistry library completely at my disposal; and the bibliophile Harrison Horblit allowed me the privilege of examining his first editions of Duchenne's *Mécanisme de la physionomie humaine* at my leisure.

The idea of assembling an exhibition around the theme of what I had been studying occurred to me periodically since the 1970s, but other projects, various demands, and certain conceptual obstacles conspired to deflect its realization. In 1996 Harrison's widow, Jean, donated the Harrison D. Horblit Collection of Early Photography to the Houghton Library at Harvard University. A symposium and accompanying anthology of essays were then planned for early 1999, and I was privileged to be among a group of distinguished photographic historians invited to contribute a

paper on any topic represented in the collection. Choosing Duchenne's masterpiece for my essay, therefore, became the immediate catalyst for the completion, at least tentatively, of this study. I would like to thank the Houghton's librarian Richard Wendorf as well as his colleagues Anne Anninger and Julie Melby, and my editor for that version of the Duchenne essay, Dorothy Straight. Thomas F. Barrow of the University of New Mexico was customarily astute in his reading and critique of chapter one; my colleague Timothy Benson, curator of the Robert Gore Rifkind Center for German Expressionist Studies here at LACMA, gave me wise counsel about early twentieth-century theories and steered me to the drawings of Oskar Schlemmer, which assisted in framing the argument in chapter two; Rick McKee Hock of the George Eastman House was consistently patient in listening to my long-distance readings of various drafts of the final chapters and equally unselfish in sharing the results of his own investigations into similarly arcane areas; and Catherine Mathon of the Ecole nationale supérieure des beaux-arts was wonderfully generous in sharing her research findings on Duchenne. I also wish to thank Alan Trachtenberg for sharing with me his discovery of the daguerreotypist Montgomery P. Simons of Richmond, Virginia, who, in 1853, seems to have been the earliest photographer to systematically depict the expressions of human passions with a camera.

Graham W. J. Beal, director of LACMA, has been supportive of this project from the moment I mentioned it to him, and over the course of more than three years, he and others at LACMA have been especially generous in their time and suggestions, including Carol Eliel, Howard Fox, Thomas Frick, Paul Holdengräber, Amy Kesselhaut, John Listopad, Anne Oshetsky, Garrett White, Keith Wilson, Penny Wynn, and Lynn Zelevansky. I must also extend my most heartfelt appreciation to my department cohorts Eve Schillo and Tim B. Wride, and to our interns Sharyn Church, Wendy McNaughton, Susan Ogle, and Karen Roswell for their continued support and sustained good spirits while putting up with my peculiar obsession with the project. I owe much to the editor of this catalogue, Margaret Gray, its designer, Amy McFarland, and its photographer, Barbara Lyter, who were a joy to work with, as were Jennifer Wachli, Tim Anderson, and the other members of the museum's professional staff who so generously contributed to various aspects of the project.

In 1998 I presented the topic of *Ghost in the Shell* to two seminars, one undergraduate and one graduate level, at the Department of Art History at USC. I was also invited to conduct a half-day session outlining the project to the assembled Getty Scholars at the Getty Research Institute for the History of Art and the Humanities, whose collective theme that year was "Representing the Passions." I would like to thank all these students and scholars for their feedback and criticism. I would also like to acknowledge Gordon Baldwin of the J. Paul Getty Museum, Charlotte B. Brown of UCLA's Special Collections, Norman Bryson, Susan Cahan of the Peter and Eileen Norton Family Foundation, Robin Chandler of UCSF's Special Collections, Katharine E. S. Donahue and Theresa Johnson of the Louise M. Darling Biomedical Library at UCLA, Régis Durand of the Centre national de la photographie, Dr. Elizabeth Giese, Sander Gilman of the University of Chicago, Cheryl Haines, Maria Morris Hambourg of the Metropolitan Museum of Art, Margaret Harker, Juliana L. Hanner and Joanne Heyler of the Eli Broad Family Foundation, Françoise Heilbrun of the Musée d'Orsay, William Hunt, Terry Landau, Theresa Luisotti, Juliet Myers of Bruce Nauman's Studio, Mary Panzer of the National Portrait Gallery, Sarah Roberts of the California Institute of the Arts, Michael Roth and Charles Merewether of the Getty Research Institute for the History of Art and the Humanities and Beth Guynn and Mark Henderson of the Institute's Special Collections, Howard and Barbara Rootenberg, Debora L. Silverman of UCLA, Victoria Steele of Special Collections at USC, David Wooters and Rachel Stuhlman of the George Eastman House, and John Szarkowski, once again, for his sage and timely advice. Lastly, I would like to dedicate this study to my wife, Hyesook Choi, without whose presence before me, grace in suffering my absences while I was in front of the computer screen, and constant attempts to ground me in the realities of the readers' needs, it would not have been as easy or as fulfilling.

This exhibition would not have been possible without the various private and public lenders who so willingly and kindly made the works in their custody available; these lenders are listed separately.

"Ghost in the Shell"

Where does consciousness begin, and where end?
Who can draw the line? Is not everything interwoven with everything?
Is not machinery linked with animal life in an infinite
variety of ways? The shell of a hen's egg
is made up of a delicate white ware and is a machine
as much as an egg-cup. SAMUEL BUTLER, *Erewhon* (Harmondsworth: Penguin Classics, 1985), 199; quoted in Keith Ansell Pearson, "Viroid Life: On Machines, Technics and Evolution," in Pearson, ed., *Deleuze and Philosophy: The Difference Engineer* (London and New York: Routledge, 1997), 197.

RIGHT
J. J. Butler, *Names of the Phrenological Organs* (detail), from George Combe, *A System of Phrenology* (1844), engraving, private collection, Los Angeles.

Ghost in the Shell is a survey of the different ways the photographic arts have investigated, interpreted, represented, and subverted the human face and consequently the human spirit, psyche, soul, and character over the course of the last 150 years. The three principal essays, arranged more or less chronologically, address traditional, modernist, and postmodernist views of the face, although, as the photographs collected here will make obvious, the primary approach of one period often reappears in another. Each essay is triggered (only somewhat arbitrarily) by the work of a single artist, but each also discusses the context and traditions in which this work developed and its influences on what evolved later. Although the book is not a technical history of photography, I try to suggest certain shifts in photographic practice that affected the changing perceptions traced by the medium. The first essay, "'Gymnastics of the Soul': The Clinical Aesthetics of Duchenne de Boulogne," examines the book of remarkable albumen-print photographs published by the French physiologist Duchenne de Boulogne in 1862 in the context of the nineteenth-century fascination with physiognomy, and shows how these images set the stage for photographic explorations of human identity that followed. The second essay, "'Tolerances of the Human Face': The Affectless Surfaces of Andy Warhol,"

discusses Warhol's early photo-silkscreened portraits of Marilyn Monroe and other celebrities in light of social and anthropological identities, the iconicity of fame, and the modernist shift in the concept of subjectivity. The final essay, "'Abstract Machines of Faciality': The Dramaturgical Identities of Cindy Sherman," explores the conceptual continuum that links Sherman's fictive tableaux in large-scale color prints to the "theater of the passions" staged by the nineteenth-century French neurologist Jean-Martin Charcot, Surrealist masks, and performance art, and concludes with a discussion of schizophrenia and multiple selves as metaphors for the postmodern human condition.[1]

In considering the subject of this exhibition, I relied on the image of the darkened glass, or *cristal oscuro,* which may be transparent or reflective depending on the viewer's position.[2] Hold up a dark glass with a light behind it, and you will see whatever is on the other side, if only dimly or partially, as in St. Paul's *speculum obscurum*.[3] If the light is in front of the glass, nothing behind it will be visible, but your reflection will be discernible on its surface, as in a polished mirror. Shatter the glass, and each broken shard will be transparent or reflective, depending on its position. The human face acts like a dark glass that is alternately transparent, reflective, and fractured. At times we are privy to the illuminations of interior states of emotions or feelings, at others we see only what we consciously or unconsciously project, and at still other times we are witness to arrangements of expressions suggestive of multiple meanings, interpretations, and subjectivities. But what lies behind the face, within the person being observed or depicted and beyond any grasp of objectivity, requires a different metaphor, one that alludes to the ineffable nature of whatever

it is that makes us human (or even, for that matter, transhuman or posthuman). In order, then, to differentiate between the container and the contained, let us consider the human machine, or more particularly its face, as something of a malleable shell that encompasses and reveals the unnameable ghost(s) residing within each of us.

Ghost in the Shell is the title of a Japanese graphic novel *(manga)* and the animated film *(anime)* based on it.[4] Both include a discussion of just how many prostheses or synthetic components may be added to a human and how much intelligence or emotion may be programmed into a cyborg before any real distinctions between the two cease to exist.[5] The same question motivates the essays here, which explore how defining the human has become an increasingly elusive undertaking, complicated by the very machines we have used to document our efforts. The phrase "ghost in the shell" also evokes Leo Marx's *The Machine in the Garden,* which treats technology's assault on the pastoral ideal, a cultural symbol or "image that conveys a special meaning (thought and feeling) to a large number of those who share the culture."[6] My concern is instead with a "human ideal" and how what has been thought essentially or contingently human about us has been represented by the camera. Finally, "ghost in the shell" echoes an important essay by John Welchman:

For the 20th century the photographic became the crucial domain of conflict between the real and the reproduced. It put on a series of masks ranging from the supposedly pure social presence of the documentary to the pure abstract materialism of formal experiment. . . . But both extremes of the photographic stage their signification through an implicit notion of the absolute: thus photography becomes the ghost in the machine of rational and universalist knowledge, the very flicker of the God-form.[7]

13

[1] A note on the use of the term "faciality": Gilles Deleuze and Félix Guattari used the French neologism *visagéité* in *Mille plateaux: capitalisme et schizophrénie* (Paris: Les Editions de Minuit, 1980), and Brian Massumi translated it as "faciality" in *A Thousand Plateaus: Capitalism and Schizophrenia* (Minneapolis: University of Minnesota Press, 1987), 168. In 1988 Jean-Jacques Courtine and Claudine Haroche used the French *facialité* in their *Histoire du visage: Exprimer et taire ses émotions (XVIe–début XIXe siècle)* (Paris: Editions Rivages, 1988; reprinted, Paris: Editions Payot & Rivages, 1994), 124. The same year, John Welchman's essay "Face(t)s: Notes on Faciality" appeared in *Artforum* 27, no. 3 (November 1988). It would seem that this term aptly conveys the quality or condition of having facial expression or the instance of a face that signifies.

[2] I owe the metaphor of the dark glass to the Spanish artist Valentín Vallhonrat, from both conversations and his *Cristal oscuro,* exh. cat. (Madrid: Centro nacional de exposiciones y promoción artística and Olivares & Nusser, 1996).

[3] 1 Cor. 13:11.

[4] MASAMUNE SHIROW, *Ghost in the Shell,* trans. Frederik Schoot and Toren Smith (Milwaukie, Oreg.: Dark Horse Comics, 1995); MAMORU OSHII, dir., *Ghost in the Shell,* prod. Kodansha (Bandai Visual and Manga Entertainment, 1995).

[5] This discussion is not the idle fantasy of speculative fiction but an ongoing debate in contemporary philosophy; see, e.g., DAVID CHALMERS and JOHN SEARLE, "'Consciousness and the Philosophers': An Exchange," *The New York Review of Books,* 15 May 1997, 60–62.

[6] LEO MARX, *The Machine in the Garden: Technology and the Pastoral Ideal in America* (London: Oxford University Press, 1976), 4.

[7] JOHN WELCHMAN, "Face(t)s: Notes on Faciality," 134–5. Since the late 1980s "ghost in the machine" has been the title of an album by the Police (1987), a motion picture from Twentieth Century Fox (1993), an exhibition of contemporary photography at MIT's List Visual Arts Center (1994), a telecast episode of an Inspector Morse mystery (1994), a play by David Gilman (1996), a Web page on Christian evolutionism by Arthur Custance (rev. 1997), and an *X-Files* novelization (1997).

In feminist writer Donna J. Haraway's incisive metaphor of the cyborg, "the machine is us," and in the novels of Rudy Rucker, a human is only a "meat machine" or hardware in which "the soul *is* the software, you know."[8] Whatever it may be called—personality, individuality, self, soul, character, "invariant of consciousness,"[9] or software—what persists of being human continues to be found embedded within, lurking behind, projected upon, or subsiding beneath the human face, and the photographic representation of the face remains the principal tool of our time for delineating the ghost in the shell.

Ghosts, dead relatives, spiritual apparitions, auras, and energy fields have been photographed with varying degrees of believability and conviction; so have fairies, poltergeists, and UFOs. The history of photography is filled with such examples, from William Mumler's spirit photographs of the 1860s to Duane Michals's seraphic narratives of the 1960s, from Elsie Wright and Frances Cottingley's snapshots of pixies in the 1920s to Francesca Woodman's astral manifestations of the 1970s, and from the luminous vibrations of the soul that Hippolyte Baraduc photographed through a "psycho-odo-fluidique" current in the 1890s to the ecstatic ectoplasms extruding from artist Mike Kelley's nostrils in an image from the 1990s.[10] As fascinating as these are, they are not the ghosts and goblins that haunt this study. I am concerned instead with the very real corporeality and materiality of the human face, the mechanics by which our countenances articulate the inexpressible nature of the human spirit, and how this spirit has been and continues to be visually expressed through or represented by the camera arts.

OPPOSITE
Akira Sato,
Sweetheart, 1962,
cat. no. 108.

ABOVE
Diane Arbus, *Puerto Rican Woman with Beauty Mark, N.Y.C.,* 1965/printed later, © 1999 Estate of Diane Arbus, cat. no. 3.

8 DONNA J. HARAWAY, "A Cyborg Manifesto: Science, Technology, and Socialist-Feminism in the Late Twentieth Century," in *Simians, Cyborgs, and Women: The Reinvention of Nature* (New York: Routledge, 1991), 180; RUDY RUCKER, *Software,* in *Live Robots* (New York: Avon Books, 1994), 66.

9 "An objective measure of exactly what it was that stayed the same between successive mental states, allowing an ever-changing mind to feel like a single, cohesive entity." GREG EGAN, *Diaspora* (New York: Harper & Row, 1998), 77.

10 For a good survey of these subjects, see ANDREAS FISCHER and VEIT LOERS, eds., *Im Reich der Phantome: Fotografie des Unsichtbaren,* exh. cat. (Ostfildern-Ruit: Cantz Verlag, 1997).

"Photography and the Expressive Face"

I had seen faces in photographs I might have found beautiful had I known even vaguely in what beauty was supposed to consist. And my father's face, on his death-bolster, had seemed to hint at some form of aesthetics relevant to man. But the faces of the living, all grimace and flush, can they be described as objects? SAMUEL BECKETT, "First Love" (1946), in *The Complete Short Prose: 1929–1989* (New York: Grove Press, 1996), 38.

16

RIGHT
J. Holloway,
Attention (after
Charles Le Brun),
from Johann Kaspar
Lavater, *Essays
on Physiognomy*
(1789–98),
engraving,
private collection,
Los Angeles.

OPPOSITE
Unidentified artist,
*The Four
Temperaments*, from
Johann Kaspar
Lavater, *Essays
on Physiognomy*
(1789–98),
engraving,
private collection,
Los Angeles.

Reading the expressive language of human faces (and to some degree those of animals) is thoroughly embedded in Western culture and to varying degrees in every culture. Writers from ancient to modern times have commented on the inordinate power of the face to communicate at least various aspects, if not the entire truth, of the human soul. Pliny the Elder wrote that "the face of man is the index to joy and mirth, to severity and sadness." St. Jerome held that "the face is the mirror of the mind, and eyes without speaking confess the secrets of the heart." Shakespeare's Duncan asserts, "There's no art to find the mind's construction in the face," Diderot described expression as "the image of a sentiment," and George Crabbe echoed Pliny the Elder's metaphor: "The face [is] the index of a feeling mind." Darwin contended that "the movements of expression give vividness and energy to our spoken words. . . . [and] reveal the thoughts and intentions of others more truly than do words, which may be falsified." Even T. S. Eliot's ambivalent Prufrock says, "There will be time to prepare a face to meet the faces that you meet." More recently, the contemporary Japanese novelist Kōbō Abe has written, "The face, in the final analysis, is the expression. The expression—how shall I put it?—well, the expression is something like

an equation by which we show our relationship with others. It's a roadway between oneself and others."[1]

Faces can be misread and they can dissemble, however, and these problems have troubled even the most optimistic attempts to decode their gestures. As Nathaniel Hawthorne observed, "No man, for any considerable period, can wear one face to himself, and another to the multitude, without finally getting bewildered as to which may be the true." And when Antonin Artaud exclaimed, "The human face is an empty force, a field of death," he may have been alluding to the ultimate futility of reading physiognomies.[2] Nevertheless, the human face continues to be the site of social communication in life and emotional representation in the arts. And nowhere in the arts since the middle of the last century has the face been more visible than in photography and its allied practices (film, video, holography, etc.). From tiny, cased daguerreotypes to gigantic close-ups at the cineplex; from portraits of those we cherish in our homes to images of those we admire or idolize in magazines; from the most expressive, dramatic facial studies to the most clinical renditions of emotionless countenances, we are consistently and addictively bent on studying facial representations and trying to discern what lies behind them.

Photography, invented in Europe in the 1830s at the height of what has been called a "physiognomic culture," was hugely responsible for sustaining public and scientific fascination with the pseudoscience of physiognomy and its allied disciplines, phrenology and pathognomy, for most of the last century.[3] Dominating this culture was the belief that a person's character, subjectivity, or even soul could be read in the features of the face (physiognomy), the shape of the skull (phrenology), or the expressions of the emotions (pathognomy). In short, the outward signs of a person's face signified the inner character of that person. Ushered in by the

1. *Sanguine*. 2. *Phlegmatick*. 3. *Cholerick*. 4. *Melancholy*.

[1] PLINY THE ELDER, *Historia Naturalis* 7; ST. JEROME, *Letters* 54; *Macbeth*, 1.4.12–13; DENIS DIDEROT, *Essais sur la peinture,* in *Oeuvres esthétiques* (Paris: Editions Garnier frères, 1965), 696; GEORGE CRABBE, "Lady Barbara; or, The Ghost," in *Tales of the Hall,* vol. 2 (London: John Murray, 1819), 145; CHARLES DARWIN, *The Origin of the Emotions in Man and Animals,* 3rd and definitive ed. (New York and Oxford: Oxford University Press, 1998), 359; T. S. ELIOT, "The Love Song of J. Alfred Prufrock" (1915), in *The Complete Poems and Plays, 1909–1950* (New York: Harcourt, Brace, and World, 1962), 4; KŌBŌ ABE, *The Face of Another,* trans. E. Dale Saunders (Tokyo: Charles E. Tuttle, 1967), 27.

[2] NATHANIEL HAWTHORNE, *The Scarlet Letter,* The Library of America edition (New York:

Vintage Books, 1990), 190; ANTONIN ARTAUD, preface to exhibition of his portraits at Galerie Pierre, Paris, in Margit Rowell, ed., *Antonin Artaud: Works on Paper,* exh. cat. (New York: Museum of Modern Art, 1996), 94.

[3] GRAEME TYTLER, *Physiognomy in the European Novel: Faces and Fortunes* (Princeton: Princeton University Press, 1982), 78.

[4] For a discussion of Daumier's caricatures, see JUDITH WECHSLER, *A Human Comedy: Physiognomy and Caricature in 19th Century Paris* (Chicago: University of Chicago Press, 1982), esp. 139–40; for Balzac et al., see TYTLER, *Physiognomy in the European Novel.* Although physiognomy and caricature are closely linked, as Wechsler admirably demonstrates, the present study will not focus on the latter, since its impact on photography is rather tangential.

Swiss clergyman Johann Kaspar Lavater's *Physiognomische Fragmente zur Beförderung der Menschenkenntniss und Menschenliebe* (Essays on physiognomy, designed to promote the knowledge and the love of mankind), published in 1775–78, this culture reached an apogee of sorts by the 1840s, following the translations and vulgarizations of Lavater's magnum opus into English and French, the publication of Honoré Daumier's popular caricature series, such as *Physiognomic Gallery* and *Sketches of Expressions,* and Balzac's and Dickens's immensely successful character-scrutinizing novels.[4] Even before the invention of photography, there was an immense public appetite for pictures of personalities, characters, and their expressions. Lavater's *Essays on Physiognomy,* in nearly all its editions, was notable for its hundreds of engraved portraits, heads, silhouettes, and comparative facial features; the fashionable *Physiologies* of Parisian types and behaviors were customarily illustrated; and journals such as *Le Charivari* and *La Caricature* depended on lithography to depict their various subjects and

human types. When photographic portraiture appeared, with its claims of detailed rendition and objectivity, it was quickly and enthusiastically conscripted into physiognomic practice. According to an article in the British *Cornhill Magazine* in 1861,

Such portraits and engravings of portraits as we have had, it has been utterly impossible to get beyond the nebulous science of a Lavater. We required the photograph.... Nothing short of the photograph can correct this uncertainty, and make the physiognomist feel that he is on sure ground.[5]

This culture and its artists, well-armed with Lavater's directions for reading character from faces and having a developed taste for it, wedded photography to physiognomics from the very start. The invention of the first photographic process, the daguerreotype, was announced in August 1839. Three months later, the French daguerreotypist Frédéric Goupil-Fesquet, a traveling companion of the painter Horace Vernet, made what might be the earliest photographic portrait described in print, of Mehemet Ali, prefect of Alexandria. "Mehemet's physiognomy is full of interest," wrote Goupil-Fesquet.[6] Photography was an immediate popular success. Within a year, photographic portrait studios began to open throughout Europe, and by 1851 professional, camera-made portraits from various capitals were exhibited to wide acclaim at London's Great Exhibition. In the same year, French critic Francis Wey published the first art theory of photographic portraiture, in part to counter the onrush of banal likenesses he encountered.[7] Describing resemblance in portraiture as a matter of artistic interpretation coupled with historic fashion, Wey explained that the funda-

mental problem for the "heliographer" (an early term for photographer) was "how to unite the charms of ideal resemblance to sober reality" given that there were three classes of models: "One impresses us by purity and nobleness of outline; the other by physiognomy, by color, and by animated expression. . . . whilst the third class comprises a very large number of faces, neither beautiful nor ugly, and offers nothing worthy of our choice."[8] For Wey, producing an "aesthetical daguerreotype" meant eschewing mere mechanical reproduction and making certain "sacrifices" of strict accuracy in the interest of beauty: careful lighting that focused on the face and subdued other "vulgar" details, a harmonious distribution of lights and darks, and a "misty or atmospheric" background. Only by moderating the camera's obdurate specificity could the daguerreotypist avoid creating portraits that looked like "fried fish stuck fast to a silver plate" and, instead, introduce "the life and expression of physiognomy" into the likenesses of sitters and thereby impart the "satisfaction which belongs to works of art."[9]

While the art of portraiture was developing, largely based on theories such as Wey's, many early photographs seem to have been motivated by the opposite impulse: a quest for direct, exact, and unmediated likenesses. The same year Wey published his theory, the German philosopher Arthur Schopenhauer wrote,

That the outer man is a picture of the inner, and the face an expression and revelation of the whole character, is a presumption likely enough in itself, and therefore a safe one to go by; borne out as it is by the fact that people are always anxious to see anyone

5 "The First Principle of Physiognomy," *Cornhill Magazine* 4 (1861): 570.

6 [Frédéric] Goupil-Fesquet, *Voyage d'Horace Vernet en Orient* (Brussels: Société Typographique Belge, 1844), 1, 59. Another edition, *Voyage en Orient fait avec Horace Vernet en 1839 et 1840* (Paris: Challamel, n.d.), was in the libraries of Yale University but has been lost.

7 Francis Wey, "Théorie du Portrait," parts 1 and 2, *La Lumière* 1, no. 12 (27 April 1851): 46–47; no. 13 (4 May 1851): 50–51. This article is available in English as "Theory of Portraiture," trans. Ambrose Andrews, *The Photographic Art Journal* 5, no. 1 (January 1853): 33–36; no. 2 (February 1853): 104–9.

8 Wey, "Theory of Portraiture," *The Photographic Art Journal* 5, no. 2 (February 1853): 105.

9 Ibid., 107.

who has made himself famous by good or evil. . . . photography, on that very account of such high value, affords the most complete satisfaction of our curiosity.[10]

Portraits of the famous had long been regarded in Europe as models of greatness to be admired and as sources of instruction and inspiration. The romantic critic Théophile Thoré wrote that Jean-Antoine Houdon's bust of Molière on display at the Comédie Français represented the most beautiful and ideal modern (male) head, and counseled that if mothers adorned niches in their children's rooms with reproductions of it, "future generations would doubtlessly profit from it in physical and moral beauty."[11]

By the early 1860s, largely due to advances in paper printing, photography studios had cultivated an unprecedented public demand for portraits of the famous. André-Adolphe-Eugène Disdéri made a fortune by inventing and mass-marketing *cartes-de-visite,* or visiting-card portraits, small, uniformly sized photographs of royalty, politicians, and celebrities. Although his work was for the most part prosaic and formulaic, he insisted in his published manuals that "one must be able to deduce who the subject is, to deduce spontaneously his character, his intimate life, his habits"; the photographer must capture the "language of the physiognomy, the expression of the look" and "must do more than photograph, he must '*biographe.*'"[12]

Trust in the camera's capacity to render inner character dominated portrait photography from its earliest years. The camera was even popularly believed capable of eliciting or extracting the hidden soul of its subject. The protagonist of Nathaniel Hawthorne's novel *The House of the Seven Gables* (1851), Holgrave, a daguerreotypist, discusses the penetrating insights provided by the daguerreian portrait: "While we give it credit only for depicting the merest surface, it actually brings out the secret character with a truth that no painter would ever venture upon, even could he detect it."[13] Of course there were also those who doubted that early photographic portraits, especially quotidian daguerreotypes, did much more than reduce the subject to a type. The eponymous character of Herman Melville's *Pierre; or, The Ambiguities* (1852) considered

with what infinite readiness now, the most faithful portrait of any one could be taken by the Daguerreotype, whereas in former times a faithful portrait was only within the power of the moneyed, or mental aristocrats of the earth. How natural then the inference, that instead of, as in old time, immortalizing a genius, a portrait now only *dayalized* a dunce. Besides, when every body has his portrait published, true distinction lies in not having yours published at all. For if you are published along with Tom, Dick, and Harry, and wear a coat of their cut, how then are you distinct from Tom, Dick, and Harry?[14]

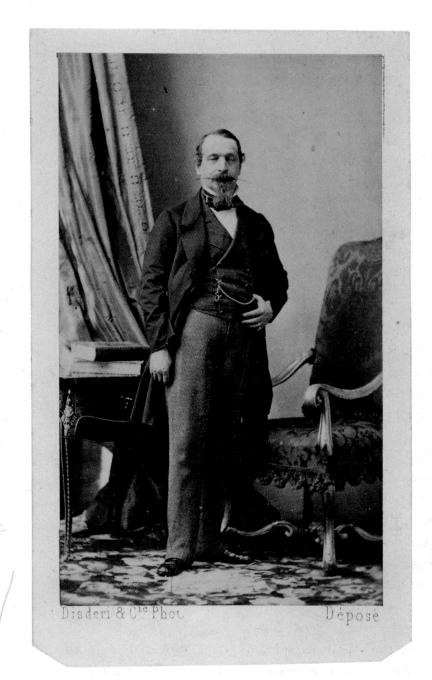

[10] ARTHUR SCHOPENHAUER, "Physiognomy," in *Religion: A Dialogue and Other Essays,* trans. T. Bailey Saunders (London: George Allen & Unwin, 1915), 75.

[11] THÉOPHILE THORÉ, *Salons de T. Thoré* (Paris, J. Renouard, 1868), 402–3; quoted in Pontus Grate, *Deux Critiques d'art de l'époque romantique: Gustave Planche et Théophile Thoré* (Stockholm: Almqvist and Wiksell, 1959), 170.

[12] A.-A.-E. DISDÉRI, *Renseignements photographiques indispensable à tous* (Paris: chez l'auteur, 1855), 13; quoted in Elizabeth Anne McCauley, *A. A. E. Disdéri and the Carte de Visite Portrait Photograph* (New Haven: Yale University Press, 1985), 41.

[13] NATHANIEL HAWTHORNE, *The House of the Seven Gables* (Boston: Houghton Mifflin, 1964), 81.

[14] HERMAN MELVILLE, *Pierre; or, The Ambiguities* (Evanston and Chicago: Northwestern University Press and the Newberry Library, 1971), 254.

Thus, as these two literary sources suggest, there were two attitudes toward camera portraiture from the very first decades of the medium: one that searched for meaning in the face, and one that simply saw nondescript mugs. The two camps developed into two distinct styles of photography, which flourished alongside each other and would in turn foster differing styles throughout the modern period.

But most early photographers, especially those who aspired to artistic status, insisted on the camera's ability to reveal its subjects' inner nature. In 1864 Philadelphia photographer Marcus Aurelius Root, since renowned for his daguerreian portrait of Edgar Allan Poe (page 176), published the first American history and art theory of photography, *The Camera and the Pencil*. Basing his ideas as much on the mystic writings of Emanuel Swedenborg as on Charles Bell's anatomical studies of emotional expression, Root argued that "expression is a *sine qua non* towards what a man really is, whether in an original or a portrait."[15] Moreover, "a portrait, so styled, however splendidly colored, and however skillfully finished its manifold accessories, is worse than worthless if the pictured face does not show the *soul* of the original,—that *individuality* or *selfhood*, which differences *him* from all beings, past, present, or future."[16] In 1871 the Boston daguerreotypist Albert Sands Southworth expanded on this notion of interpretive portraiture:

The whole character of the sitter is to be read at first sight; the whole likeness, as it shall appear when finished, is to be seen at first, in each and all its details, and in their unity and combination. . . . it is required of and should be the aim of the artist-photographer to produce in the likeness the best possible character and finest

ABOVE
Marcus A. Root,
Self-Portrait, 1855,
courtesy George
Eastman House,
cat. no. 102.

RIGHT
Albert Sands
Southworth and
Josiah Johnson
Hawes,
Lemuel Shaw,
c. 1860,
cat. no. 118.

expression of which that particular face or figure could ever have been capable. But in the result there is to be no departure from truth in the delineation and representation of beauty, and expression, and character.[17]

Predominantly an Emersonian transcendentalist, Southworth proposed that all things in nature had a language and a soul, and that the role of the artist was to contemplate and portray this inner character, particularly of the human subject.[18]

This artistic concept of the goals of photographic portraiture predominated in the nineteenth century and extended well into the twentieth. British photography critic A. J. Anderson wrote in 1910, "The gift of character reading is essential in the portrait photographer; and once the sitter's character is discovered, it is no bad plan to try and photograph

some predominant quality in the abstract."[19] In 1913, before he had become a modernist and while he was still very much a romantic pictorialist, the German portrait photographer Helmar Lerski wrote, "Every passion, every soul-stirring incident in life, leaves a certain visible trace in the face of man. To truly represent a highly emotional character in a picture it is necessary to bring out these traces. The true photographer must understand to engrave them into his negative." The aim of most portrait photographers at the time, he observed, was merely to render a "beautiful flesh tone, without any regard whatsoever for the character of the person to be represented." Nevertheless, with thoughtful and judicious use of lighting a photographer could instill almost any desired character in the subject and make of the model "a God or a Devil (there being at least a trace of each in every human being)."[20] In 1922 the American photographer Paul Strand observed that when the moment was right "the whole concept of a portrait takes on a new meaning, that of a record of innumerable elusive and

[15] MARCUS AURELIUS ROOT, *The Camera and the Pencil* (Philadelphia: M. A. Root, 1864), 161.

[16] Ibid., 143.

[17] ALBERT SANDS SOUTHWORTH, "An Address to the National Photographic Association of the United States," *The Philadelphia Photographer* 8, no. 94 (October 1871): 320–1.

[18] See ibid., 322; see also RALPH WALDO EMERSON, *Nature* (1836), in *The Selected Writings of Ralph Waldo Emerson*, ed. Brooks Atkinson (New York: Modern Library, 1968), 15.

[19] A. J. ANDERSON, *The Artistic Side of Photography in Theory and Practice* (London: Stanley Paul & Co., 1910), 319.

[20] HELMAR LERSKI, "Aphorisms on Photography and Art," trans. E. F. R., *The American Annual of Photography: 1914* 28 (1913): 268–9.

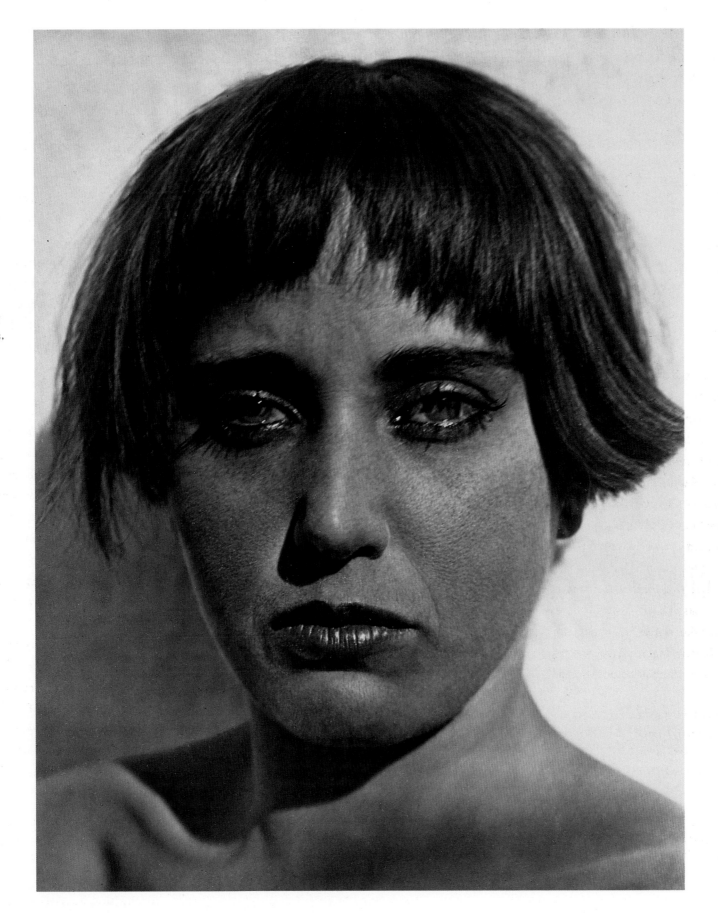

Edward Weston,
Nahui Olin, 1923,
© 1981 Center
for Creative
Photography,
Arizona Board
of Rights,
cat. no. 145.

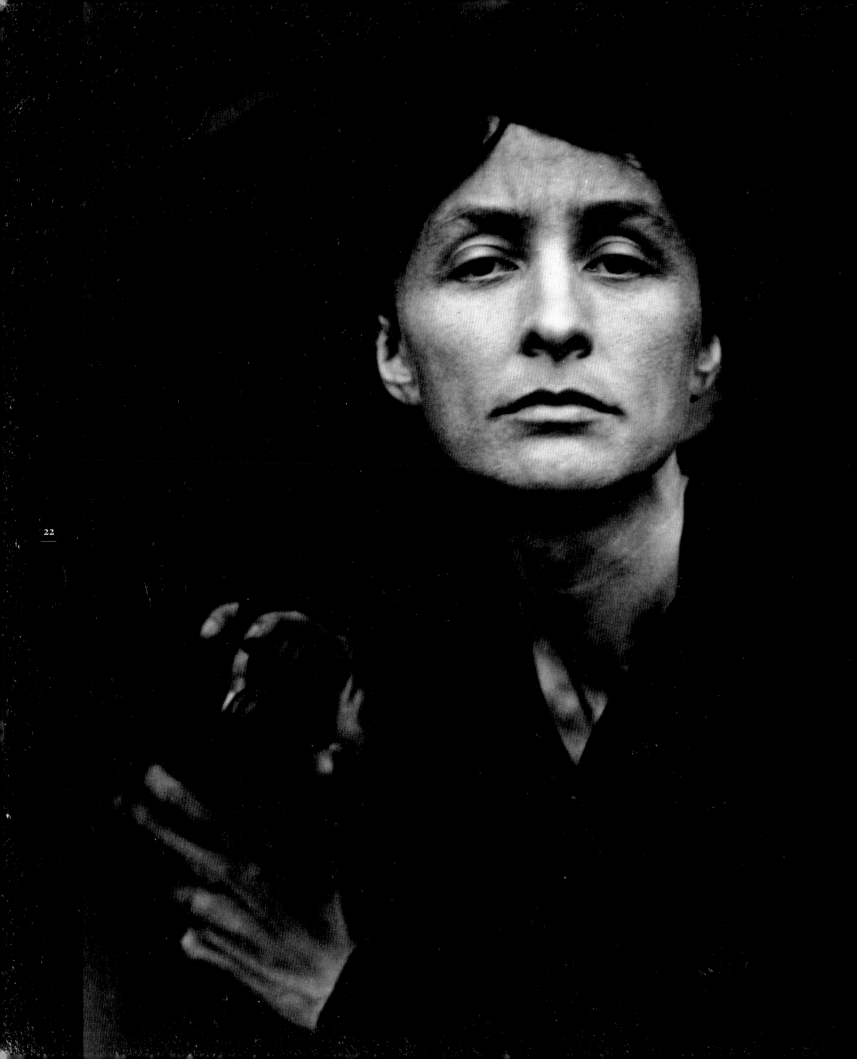

constantly changing states of being, manifested physically."[21] And the American modernist Edward Weston asserted even as late as 1939 that the photographer had to "penetrate below the surface of his subject" and "recognize the rare moment when the face is unmasked to reveal the inner self."[22] Traces of this belief even persist today in popular manuals and guides to "reading faces," in the emotional exaggerations in motion pictures, television soap operas, and advertising, and in the marketing language of commercial portrait studios. Echoing both Southworth and Weston, California studio portraitist Phillip Stewart Charis wrote in 1995, "The photographer must now seek out what lies beneath the surface of the face; for the personality of the sitter is revealed by what lies beneath a veil which subtly alters that surface. Piercing that veil to reveal the subject's character is something that . . . can only be recognized and captured in a fraction of a second."[23]

For the most part, however, discussion of physiognomic expression in portraiture seems to have died in the early twentieth century, along with serious scientific consideration of physiognomy, phrenology, and pathognomy. These essentialist systems, which formulated distinct and immutable codes for reading character and emotional states, were either progressively viewed with mistrust and abandoned or else enlisted in the cause of social or racial control. Psychoanalysis, literature, and modern urban life had proven the human soul far more elusive, human emotions far more complex, and human misdirection far more subtle than could be mediated or accounted for by simple facial gestures and signs.

In the middle of the last century, Charles Baudelaire defined the modern as "the transitory, the momentary, and the contingent" and suggested that unrelenting change characterized modern life.[24] In this context the modern subject's inner self, or "inscape," to use Gerard Manley Hopkins's word, seemed too complex, too transitory, and much too fluid to be delineated in any single depiction. Photographer Arnold Newman wrote, "It seems to me that no one picture can ever be a final summation of a personality. There are so many facets in every human being that it is impossible to present them all in one photograph."[25] For resolute essentialists, though, photographers could still capture something of the multiple aspects of the inner person. Artist Alexander Rodchenko argued that a file of snapshots of Lenin was worth immeasurably more than a single "synthetic" portrait.[26] Similarly, Paul Strand suggested that individual photographs taken over a course of years, such as Alfred Stieglitz's serial portrait of his wife, Georgia O'Keeffe, could come closer than a single exposure to capturing a subject's essence:

With the eye of the machine, Stieglitz has recorded just that, has shown that the portrait of an individual is really the sum of a hundred or so photographs. He has looked with three eyes and has been able to hold, by purely photographic means, space-filling, tonality and tactility, line and form, that moment when the forces at work in a human being become most intensely physical and objective. In thus revealing the spirit of the individual he has documented the world of that individual, which is today.[27]

In this regard, one might recall Harry Callahan's lengthy documentation of his wife, Richard Avedon's multipart portrait of his dying father, or Emmet Gowin's annual portraits of his wife and her sisters.

Modernist photography came gradually to renounce any concern for probing the human psyche and developed new goals, and most modern portraitists have come to doubt the camera's ability to explore inner character and emotional states; the only penetrative vision was hinted at by László Moholy-Nagy's suggestion that the modern artist make use of radiography or X-ray photography.[28] William Mortensen, the American pictorialist whose photography had been derided as nonmodernist by the likes of Weston, wrote in 1948, "Thoughts and emotions cannot be photographed, despite the protestations of some mystically minded portraitists. . . .

21 PAUL STRAND, "Photography and the New God," *Broom* 3, no. 4 (1922), in Alan Trachtenberg, ed., *Classic Essays on Photography* (New Haven: Leete's Island Books, 1980), 149.

22 EDWARD WESTON, "Thirty-Five Years of Portraiture," part 2, in *Edward Weston on Photography,* ed. Peter C. Bunnell (Salt Lake City: Peregrine Smith Books, 1983), 110.

23 PHILLIP STEWART CHARIS, artist's statement in Robert A. Sobieszek, ed., *A Lasting Tradition: The Studio Portraiture of Phillip Stewart Charis* (San Juan Capistrano: Forster Publications, 1995), 9.

24 CHARLES BAUDELAIRE, *The Painter of Modern Life and Other Essays,* trans. and ed. Jonathan Mayne (London: Phaidon Press, 1964), 3.

25 ARNOLD NEWMAN, quoted in Robert Sobieszek, introduction to *One Mind's Eye,* by Newman (Boston: David R. Godine, 1974), viii.

26 ALEXANDER RODCHENKO, "Against the Synthetic Portrait, For the Snapshot," *Novyi lef* 4 (1928), in Christopher Phillips, ed., *Photography in the Modern Era: European Documents and Critical Writings, 1913–1940* (New York: Metropolitan Museum of Art and Aperture, 1989), 240–1.

27 STRAND, "Photography and the New God," 149–50.

28 "Penetration of the body with light is one of the greatest visual experiences." LÁSZLÓ MOHOLY-NAGY, *Painting, Photography, Film,* trans. Janet Seligman (Cambridge: MIT Press, 1969), 69.

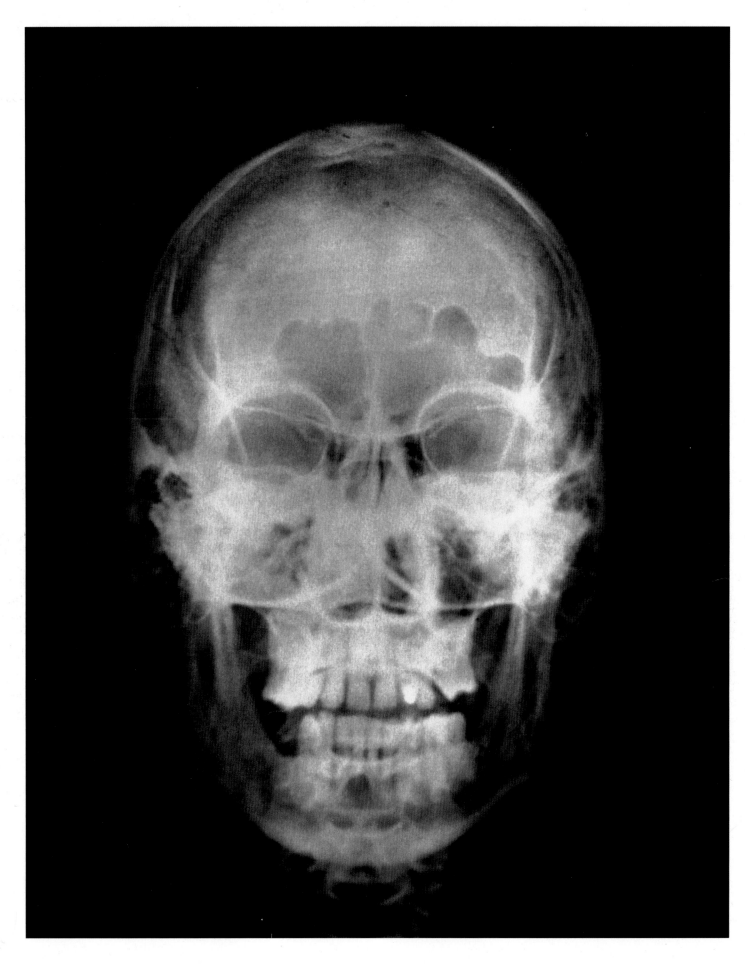

OPPOSITE
Unidentified pho-
tographer, *X-Ray
of Human Skull*
(anterior view),
c. 1920,
cat. no. 129.

BELOW
William Mortensen,
Suspicion, c. 1935,
cat. no. 79.

Physical fact is ultimately the sole pictorial material."[29] Mortensen, who had photographed character heads and the faces of madness in the mid-thirties, also contended that "emotion may be expressed, or the utter lack of it may be expressed, but the only important fact is that of *expression*"—meaning the expression of the artist.[30] Artaud said it best: "The subject is not of importance, nor the object. What matters is the expression, not the expression of the object, but of a certain ideal of the artist."[31]

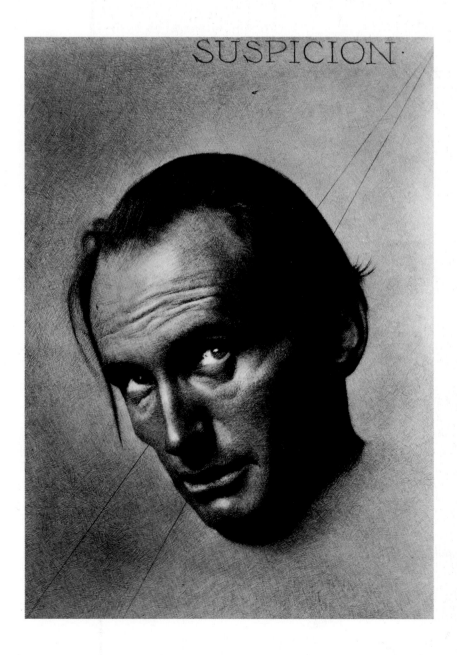

In the wake of Cubist abstraction, nonobjective art, and the New Objectivity of the twenties, the elements of physical fact, surface, and light became the tools and primary concern of the modern photographer. "In photography of this kind," wrote critic Curt Glaser in 1931, "the model is only raw material, to be shaped by the artist's creative will."[32] Even August Sander's comment, "Every person's story is written plainly on his face," had more to do with social class and the physical effects of certain occupations than with emotional character.[33] In the sixties, fashion and portrait photographer Richard Avedon assumed an extreme, reductivist position: "You can't get at the thing itself, the real nature of the sitter, by stripping away the surface. The surface is all you've got."[34] Modernist faces became abstracted surfaces, isolated from their interiority and blankly clinical. As Minor White suggested in 1963, if any subjectivity or "state of feeling" were mirrored in the face, it was that of the photographer or the viewer.[35]

This reversal of subjectivity is precisely what distinguishes the neutral expressions in certain modern portrait photography from those in traditional portraits vested with physiognomic significance. Instead of trying to reveal the inner personality, character, and subjectivity of the sitter, modernist photographers turned the camera onto themselves, as it were, and sought to express their own artistic agendas through the vacant faces of others. But no matter how blankly, clinically, and soullessly the modernist

[29] WILLIAM MORTENSEN, *The Model: A Book on the Problems of Posing* (San Francisco: Camera Craft Publishing, 1948), 173.

[30] Ibid., 172. For a discussion of Mortensen's character heads, such as *Suspicion* (c. 1935) and *Johan the Mad* (c. 1931), see DIANE DILLON, "William Mortensen and George Dunham: Photography as Collaboration," in Michael Dawson, Dillon, and A. D. Coleman, eds., *William Mortensen: A Revival* (Tucson: Center for Creative Photography, University of Arizona, 1998), 47–54.

[31] ANTONIN ARTAUD, *Oeuvres complètes,* vol. 2 (Paris: Gallimard, 1956), 220; quoted in Jacques Derrida, "to Unsense the subjectile," in Derrida and Paule Thévenin, *The Secret Art of Antonin Artaud,* trans. Mary Ann Caws (Cambridge: MIT Press, 1998), 103.

[32] CURT GLASER, introduction to *Köpfe des Alltags* (1931), by Helmar Lerski, in David Mellor, ed., *Germany: The New Photography, 1927–33* (London: Arts Council of Great Britain, 1978), 63.

[33] AUGUST SANDER, "Photography as a Universal Language," trans. Anne Halley, *Massachusetts Review* 19, no. 4 (winter 1978): 675. Cf. SABINE HAKE, "The Faces of Weimar Germany," in *The Image in Dispute: Art and Cinema in the Age of Photography,* ed. Dudley Andrew (Austin: University of Texas Press, 1997), 124.

[34] RICHARD AVEDON, "Borrowed Dogs," in Ben Sonnenberg, ed., *Performance and Reality: Essays from Grand Street* (New Brunswick and London: Rutgers University Press, 1989), 17.

[35] MINOR WHITE, "Equivalence: The Perennial Trend," *PSA Journal* 29, no. 7 (1963), in Nathan Lyons, ed., *Photographers on Photography* (Englewood Cliffs, N.J.: Prentice-Hall, 1966), 174.

portrait is rendered, we are still tempted to read its physiognomy. Discussing his social and generational portrait of the German people, Sander admitted, "The field in which photography has so great a power of expression that language can never approach it, is physiognomy."[36]

Throughout modernism, photographers have provided us with countless faces onto which we can project myriad subjectivities, and as critic John Welchman points out, "The fact is that the photographic has momentarily subsumed physiognomy and caricature under *its* probe."[37] Even the most affectless and mute faces portrayed by Sander, Avedon, Chuck Close, or Thomas Ruff contain at least the suggestion of some subjectivity behind them and at the very least present arenas on which we may project our own versions of what went before and came after the instant of the photograph. As cynical as we are about the grand systems of Lavater and others, the human countenance continues to serve as a site for speculation. It does not matter how abstracted the depicted face is, or if it is an icon, symbol, or fiction; what concerns us is that it does still signify an other, another's face: an announcement of communication, the beginning of countless dramatics, a locus of potential passions, an allegory of the human soul, and a potential embodiment of personal ethics.

The blank face of modern times is also only part of the picture. Another site of subjectivity in the representation of faces throughout modernism into the postmodern is make-believe: the actor willfully representing the emotions, enacting the passions, and otherwise role playing or engaging in artifice. If the traditional portrait can trace its ancestry to the expressive features of Lavater's facial types (physiognomy), and the modernist portrait finds an analogy in the static forms of Franz Joseph Gall's cranial structures (phrenology), this third strain might be said to have its roots in the fictively staged emotional outpourings and exaggerated states common to the arts since the theater of Racine, the agitated self-portraits of Gustave Courbet, and the anatomical investigations into emotional expression by Charles Bell and Charles Darwin (pathognomy). This strain can be traced back to nineteenth-century pantomime, to turn-of-the-century theater and dance, to prenarrative cinema, and to certain

[36] SANDER, "Photography as a Universal Language," 675; cf. HAKE, "The Faces of Weimar Germany," 123.

[37] JOHN WELCHMAN, "Face(t)s: Notes on Faciality," *Artforum* 27, no. 3 (November 1988): 136.

OPPOSITE
Chuck Close,
Alex, 1987/
printed 1996,
cat. no. 21.

RIGHT
Cindy Sherman,
*Untitled
(Cosmo Cover Girl),*
1990,
cat. no. 114.

avant-garde movements of the early
twentieth century. A theater of the
emotions is there in the portraits
and self-portraits of the Expression-
ists, in the mugging faces of the
Italian Futurists and the Dadaists,
and in the masks and Freudian enactments of the Surrealists. Human
expression may be incomprehensible, unreadable by any scientific system,
but the artist as actor can still embrace dissimulation and avail her- or him-
self of the language of active emotional expression that has been part of
the theater's repertoire since the seventeenth century. If the face is at most
a signifier of physical identity, or at the least an ontological blank abstrac-
tion, the artist can still use its expressions, trusting public consent about
their meaning or embracing ambiguity for other, at times subversive, ends.

If, moreover, in light of post-Freudian theory, the ego, the core self,
can no longer be confidently viewed as an essential singularity, then there
is no end to the masks, roles, identities, and fictional personas available
to the artist. But as Oscar Wilde once warned, they "who go beneath the
surface . . . who read the symbol, do so at their peril."[38] Performers have
long known a kind of attenuation of self brought about by their craft;
the American entertainer Loie Fuller saw herself in 1913 as two distinct
women, one onstage and another off, "since my personality counts for
nothing" during a performance.[39] Method acting called for actors and
actresses to remove themselves from their own identities and assume the
raw emotions of their characters. New York Happenings and Viennese
Actionist theater sought to express regressive, primal, uncodified emo-
tional states. In 1961 performance artist Hermann Nitsch wrote that in his
theater "deep-seated psychic strata which previously lay without the area
of artistic transmission, are touched upon and begin to have a formal artis-
tic effect. . . . There should be no shrinking away from revealing one's
own psychopathological situation."[40] Since the 1960s, pathognomic exer-
cises of the human soul in art have become increasingly complicated while

[38] OSCAR WILDE, "Preface to *The Picture of
Dorian Gray,*" in *The Artist as Critic: Critical
Writings of Oscar Wilde,* ed. Richard Ellmann
(New York: Vintage Books, 1970), 236;
quoted in Eugenia Parry Janis, "Review Essay:
Portraiture," in Thomas F. Barrow, Shelley
Armitage, and William E. Tydeman, eds.,
*Reading into Photography: Selected Essays,
1959–1980* (Albuquerque: University of New
Mexico Press, 1982), 192.

[39] LOIE FULLER, *Fifteen Years of a Dancer's
Life, with Some Account of Her Distinguished
Friends* (Boston: Small, Maynard & Co., 1913);
quoted in Felicia McCarren, "The 'Sympto-
matic Act' Circa 1900: Hysteria, Hypnosis,
Electricity, Dance," *Critical Inquiry* 21, no. 4
(summer 1995): 755.

[40] HERMANN NITSCH, *Orgies Mysteries Theatre*
(Darmstadt: März Verlag, 1969), 46.

at the same time evolving into a kind of theater of shifting states, most notably in the works of Douglas Gordon and Cindy Sherman. A number of postmodernist theorists have also come to view schizophrenia as a model for contemporary life; according to Jean Baudrillard, the schizophrenic "can no longer produce the limits of his own being, can no longer play nor stage himself, can no longer produce himself as mirror. He is now only a pure screen, a switching center for all the networks of influence."[41] Others offer a paradigm of multiple-personality disorder and suggest that "the self is not only decentered but multiplied without limit," and that the imperative is "not to become a unitary core, it's to have a flexible ability to negotiate the many—cycle through multiple identities."[42] Sherman, who has assumed hundreds of personas in front of her camera, has said, "I divide myself up into many different parts," and "it's much more interesting to show a fake body and a fake face."[43]

Virginia Woolf, whose novels include characters with multiple shifting selves and whose diaries are peppered with comments about the futility of addressing the human soul, wrote that "on or about December, 1910, human character changed" and suggested that the modern movement began at roughly the same time.[44] Historian William R. Everdell locates the birth of the modern period somewhat earlier, in Richard Dedekind's number theory of 1872, which established modernism's fundamental concept: discontinuity. According to Everdell, "Emotions superimpose themselves in the minds of poets and succeed each other in the hearts of readers without predictability, logic or coherence," and they can be probed for only by modernism's principles of ambiguity and irony.[45] In 1971 photographer Diane Arbus, discussing the presentation of the self in everyday life, said, "Something is ironic in the world and it has to do with the fact that what you intend never comes out like you intend it."[46] Earlier, she had described her photographic subjects as "people who appear like metaphors somewhere further out than we do, beckoned, not driven, invented by belief, author and hero of a real dream by which our own courage and cunning are tested and tried; so that we may wonder all over again what is veritable and inevitable and possible and what it is to become whoever we may be."[47]

Postmodernism takes the tactics of ambiguity and irony to new levels, especially in self-portraiture. Critic Scott Bukatman claimed that J. G. Ballard's early novels are dominated by psychological landscapes in which "as in melodrama or surrealism, everything becomes at once objective and subjective."[48] The postmodern human face in art has become a blend of Surrealist masquerade and melodramatic theatrics; reading physiognomic expression in contemporary facial representation (photographic, videographic, or cinematic) has ultimately become an exercise in surfing between the objective and subjective and interpreting the fluid and discontinuous

selves and states of mind that are signified. Of course, distinguishing between the subjective and the objective and interpreting them has always been the physiognomic and pathognomic agenda; it is only the notion of the self that has changed dramatically. But the human faith in vision—to secure meaning from what we encounter on the surfaces we see—has not changed. This faith is apparent both in the eighteenth-century comment (this book's epigraph) that "to be is to be perceived" and in the postmodern contention that "images are immortal, bodies are ephemeral."[49] And for the last century and a half, the photographic arts have contributed enormously to our visual perception of being.

[41] Jean Baudrillard, "The Ecstasy of Communication," trans. John Johnson, in Hal Foster, ed., *The Anti-Aesthetic: Essays on Postmodern Culture* (Port Townsend, Wash.: Bay Press, 1983), 133.

[42] Sherry Turkle, "Sex, Lies, and Avatars," interview by Pamela McCorduck, *Wired* 4, no. 4 (April 1996): 160, 164.

[43] Cindy Sherman, "A Woman of Parts," interview by Noriko Fuku, *Art in America* 85, no. 6 (June 1997): 79, 125.

[44] Virginia Woolf, "Mr. Bennet and Mrs. Brown," in *The Virginia Woolf Reader,* ed. Mitchell A. Leaska (New York: Harcourt Brace, 1984), 194. This essay went through a draft and two revisions between 1923 and 1924; Woolf was commenting on the advent of modernism in English literature—works by E. M. Forster, D. H. Lawrence, Lytton Strachey, James Joyce, and T. S. Eliot— but her choice of date coincides with the Grafton Galleries' exhibition *Manet and the Post-Impressionists,* organized by her friend the art critic Roger Fry.

[45] William R. Everdell, *The First Moderns: Profiles in the Origins of Twentieth-Century Thought* (Chicago: The University of Chicago Press, 1997), 99.

[46] Doon Arbus and Marvin Israel, eds., *Diane Arbus* (New York: Aperture, 1972), 1–2.

[47] Arbus, "The Full Circle," *Infinity* 11, no. 2 (February 1962): 9.

[48] Scott Bukatman, *Terminal Identity: The Virtual Subject in Post-Modern Science Fiction* (Durham and London: Duke University Press, 1993), 41.

[49] "*Esse is percipi.*" George Berkeley, *Principles of Human Knowledge* (1710), in *Principles of Human Knowledge and Three Dialogues between Hylas and Philonous,* ed. Roger Woolhouse (New York: Penguin Books, 1988), 54; Stelarc, "Phantom Body," *Stelarc,* online: http://www.stelarc.va.com.au (15 December 1998). Stelarc, an Australian performance and body artist, goes further: "What it means to be human is no longer the state of being immersed in genetic memory but rather . . . in the realm of the image."

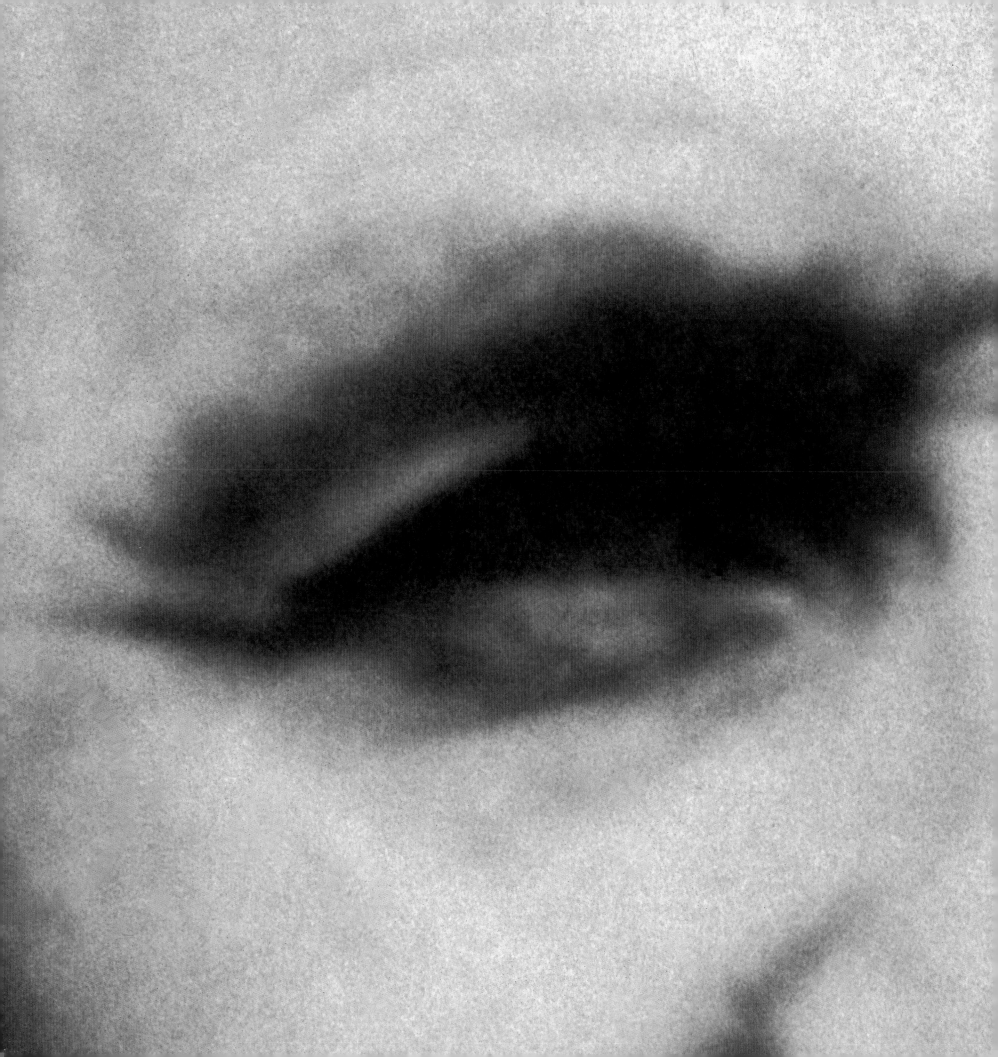

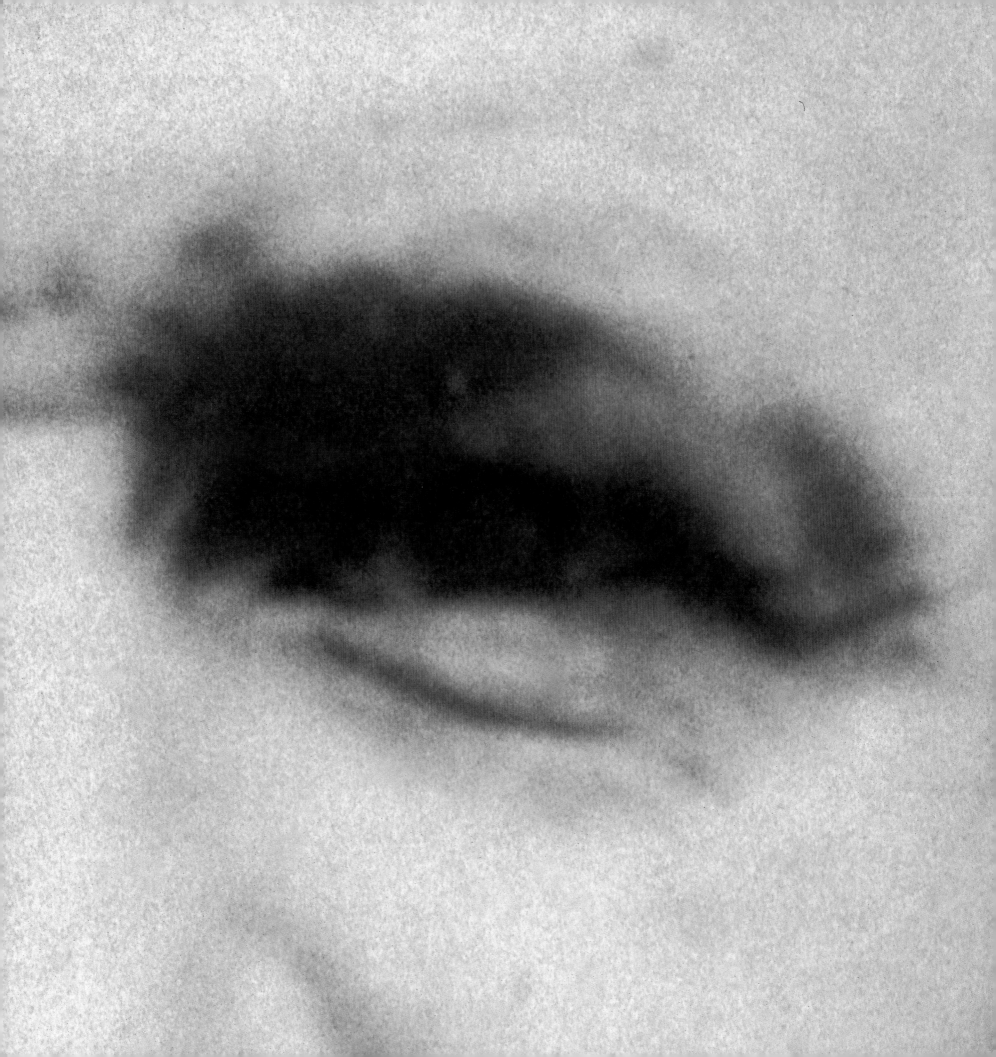

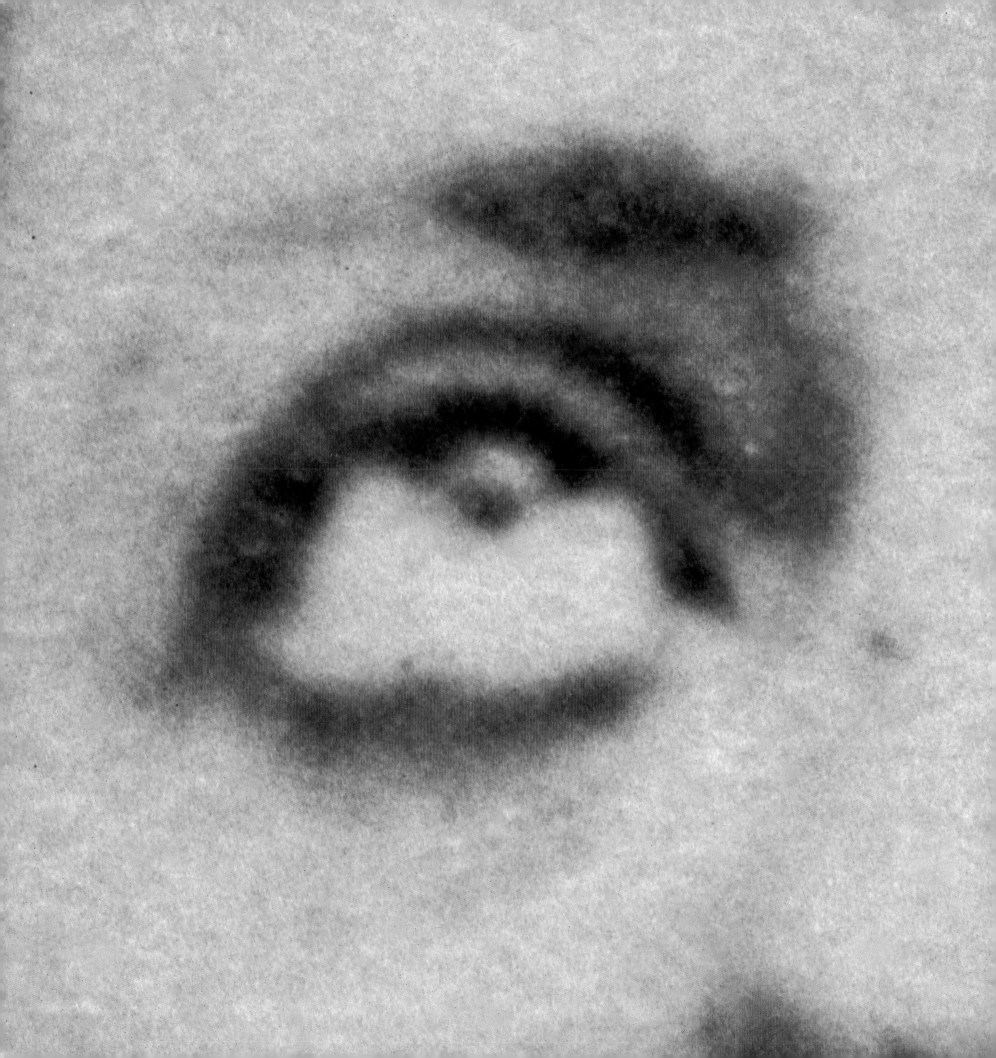

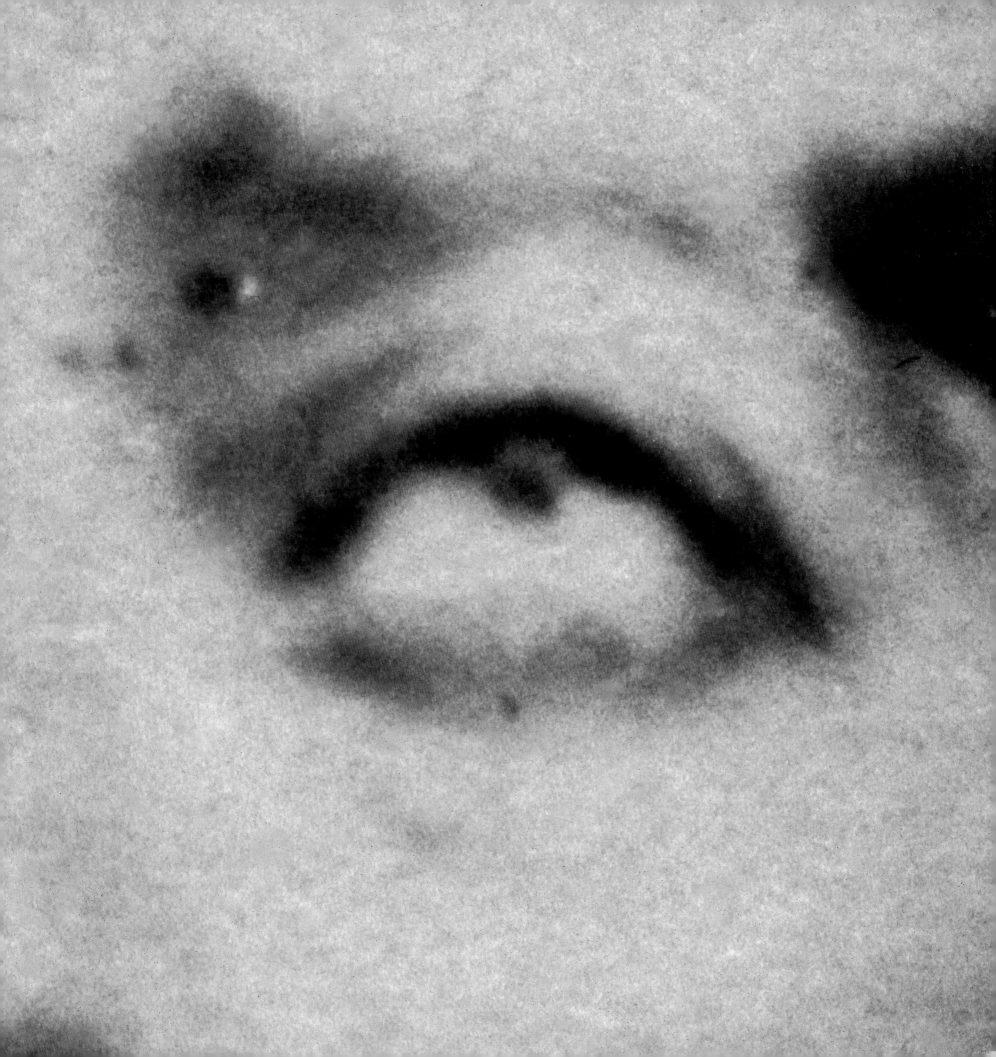

"Gymnastics of the Soul"

THE CLINICAL AESTHETICS OF
Duchenne de Boulogne

To render our most secret emotions and passions
with as much delicacy as vigor,
it is necessary to know what organs nature
employs to express them. "Photography of the Passions," review of a lecture by a Dr. Malley "on an album
of the mechanism of the physiognomy, com-
posed by M. Duchenne" (trans. from *L'Ami
des sciences*), *The Photographic News* 2, no. 43
(1 July 1859): 198. This article is also cited in
La Gavinie, "Chronique," *La Lumière* 9, no. 9
(26 February 1859): 36, where the lecture is
attributed to a Dr. Mallez.

No one even casually paging
through Charles Darwin's *The
Expression of the Emotions in Man
and Animals* (1872) can fail to be
struck by Duchenne de Boulogne's
photography. When I first saw
his images of an old man grimacing
in terror and agony, they seemed like the forgotten records of some sort
of arcane, malevolent experiment—bizarre depictions of the tortured
geometries of the human face that have continued to haunt me for years.
I am reminded of one in particular, an oval collotype showing the old
man being shocked by electrodes into a rictus of abject horror, whenever
I see any film version of *Frankenstein; or, The Modern Prometheus* (1818),
Mary Shelley's classic novel of galvanic reanimation. Darwin's source for
these illustrations was his personal copy of Duchenne's relatively obscure
text, *Mécanisme de la physionomie humaine; ou, Analyse électro-physiologique de
l'expression des passions applicable à la pratique des arts plastiques* (The mecha-
nism of human physiognomy; or, the electro-physiological analysis of the
expression of the passions, applicable to the practice of the plastic arts,

RIGHT
G.-B. Duchenne de
Boulogne, "An
anatomical prepara-
tion of the muscles
of the face," fig. 1
from *Mécanisme de la
physionomie humaine*
(1862), albumen
print, photograph
courtesy the Getty
Research Institute,
Research Library.

OPPOSITE
G.-B. Duchenne de
Boulogne, pl. 7
(detail) from Charles
Darwin, *The Expres-
sion of the Emotions
in Man and Animals*
(1872), collotype
print, private collec-
tion, Los Angeles.

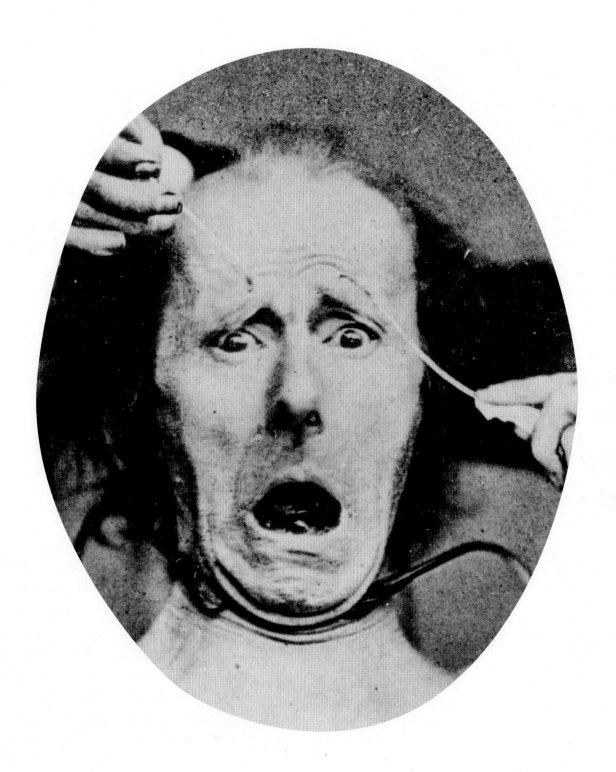

RIGHT
G.-B. Duchenne
de Boulogne,
"Specimen of an
Electrophysiological
Experiment,"
c. 1854–62,
photograph courtesy
George Eastman
House,
cat. no. 42.

OPPOSITE
G.-B. Duchenne
de Boulogne,
"The double
current volta-faradic
apparatus of
Doctor Duchenne
de Boulogne,"
fig. 2B from
*Mécanisme de la
physionomie humaine*
(1862), engraving,
photograph
courtesy the Getty
Research Institute,
Research Library.

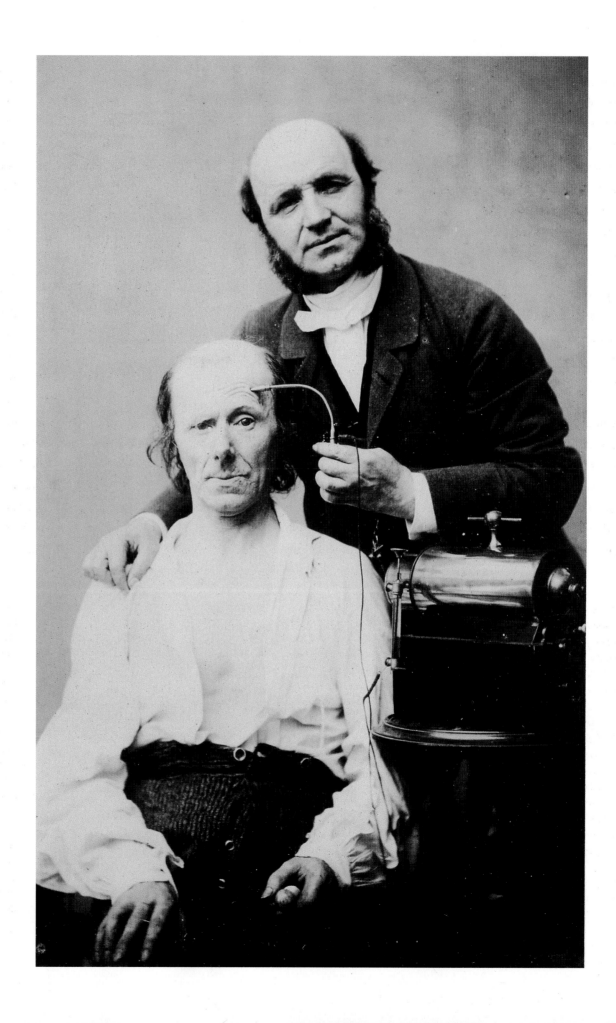

1862), and its portfolio of unforgettable photographs.[1] There, the images of the old man are joined by those of five other human models, whose faces display a wide variety of expressions, many suggesting extreme emotions or passions. The expressions, however, are all synthetic, the results of electroshock administered by all-too-visible probes.

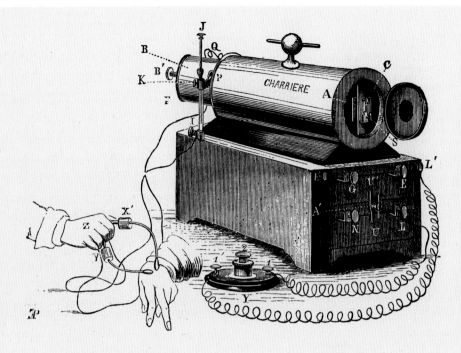

Guillaume-Benjamin Duchenne was born in Boulogne-sur-Mer in 1806. He received a bachelor's degree in letters in Douai, studied medicine and applied electricity at the Académie de médicine in Paris, and opened a practice in his native Boulogne. There, in 1835, he began experimenting with therapeutic "electropuncture," a technique by which electric shock was administered beneath the skin with sharp electrodes to stimulate the muscles.[2] Returning to Paris in 1842—he would live there until his death in 1875— he continued his experiments and developed a noninvasive technique

Nothing in earlier nineteenth-century photography compares to these representations, and only a few scientific engravings of electrical experiments on cadavers from the end of the eighteenth and the early nineteenth centuries even suggest a context in which Duchenne's work may be placed. Its title, however, contains three notions useful in understanding its goals: It is a study of human physiognomy; it includes an analysis of the expression of the emotions; and it was meant to be useful to the visual arts. Duchenne's *Mécanisme,* therefore, serves as an excellent place to begin a discussion of how the camera has been used to probe what lies beneath the human face.

of muscle stimulation that used faradic shock on the surface of the skin, which he called "électrisation localisée."[3] He articulated his theories fully in *De l'électrisation localisée et son application à la pathologique et la thérapeutique* (On localized electrization and its application to pathology and therapy), first published in 1855 and followed by a second edition in 1861 and a third in 1872. A pictorial supplement to the second edition, *Album de*

[1] Dr. G.-B. Duchenne de Boulogne, *Mécanisme de la physionomie humaine; ou, Analyse électro-physiologique de l'expression des passions applicable à la pratique des arts plastiques* (Paris: Vᵉ Jules Renouard, 1862). This work has recently been published in English; see G.-B. Duchenne de Boulogne, *The Mechanism of Human Facial Expression,* ed. and trans. R. Andrew Cuthbertson (Cambridge: Cambridge University Press, 1990). Unless otherwise noted, I will cite both this first French edition (hereafter Duchenne, *Mécanisme*) and Cuthbertson's translation (hereafter Cuthbertson trans.).

The Harrison D. Horblit Collection of Early Photography at the Houghton Library, Harvard University, contains two copies of the first edition: a quarto with eighty-eight plates of albumen prints and a large octavo with ninety-three. Charles Darwin seems to have been mistaken when he wrote that the work appeared in both octavo and folio editions; cf. *The Expression of the Emotions in*

Man and Animals (London: John Murray, 1872), 5. John T. Hueston and Cuthbertson contend that there was a "grande-edition" in-folio edition, but I have never seen an example; cf. "Duchenne de Boulogne and Facial Expression," *Annals of Plastic Surgery* 4, no.1 (July 1978): 420. Duchenne's publisher announced that a "deluxe," "grand-in-quarto," limited edition of the work was available as a boxed set, but Jean-François Debord of the Ecole nationale supérieure des beaux-arts doubts if any were actually made; cf. "The Duchenne de Boulogne Collection in the Department of Morphology, L'Ecole nationale supérieure des beaux-arts," in Cuthbertson trans., 243. Duchenne also assembled two personal albums of untrimmed albumen contact prints; one is now among the Darwin papers at Oxford, the other at the Ecole des beaux-arts in Paris, whose curator of historical photographs, Catherine Mathon, concurs that no folio edition appeared; in conversation, 3 July 1998.

[2] For further details of Duchenne's life, see Emanuel B. Kaplan, "Duchenne of Boulogne and the Physiologie des Mouvements," in Solomon R. Kagan, ed., *Victor Robinson Memorial Volume: Essays on History of Medicine* (New York: Froben Press, 1948), 177–92. (Note: The author of this essay is frequently and erroneously cited in the literature as Emanuel Bikaplan.) See also Nancy Ann Roth, "Electrical Expressions: The Photographs of Duchenne de Boulogne," in Daniel P. Younger, ed., *Multiple Views: Logan Grant Essays on Photography, 1983–89* (Albuquerque: University of New Mexico Press, 1991), 105–37; and Tarah Rider, *Dr. Guillaume-Benjamin-Armand Duchenne,* History of Photography Monograph Series 25 (Tempe: Arizona State University, 1989), unpag. The earliest mention of "electropuncture" seems to appear in J. B. Sarlandières, *Mémoires sur l'électropuncture considerée comme moyen nouveau, de traiter efficacement la quotte, les rhumatismes et les affections nerveuses, et sur*

l'emploi du "Moxa japonaia" en France (Paris: Mlle Delaunay, 1825); see Cuthbertson, "The Highly Original Dr. Duchenne," in Cuthbertson trans., 231 n. 36.

[3] The earliest mention of "localized electrization" appears in a note that Duchenne deposited with the Académie des sciences in 1847; he elaborated on it in two articles in *Archives générales de médicine* in 1850 and 1851; see "Travaux de l'auteur," in Duchenne, *Mécanisme,* 7; and Paul Guilly, *Duchenne de Boulogne* (Paris: J.-B. Baillière et fils, 1936), 45–47. Elsewhere the technique is described as "percutaneous faradic stimulation"; see Hueston and Cuthbertson, "Duchenne de Boulogne and Facial Expression," 411. For a general description of "localized electrization," see Cuthbertson, "The Highly Original Dr. Duchenne," 231.

photographies pathologiques, was published in 1862, only a few months before the appearance of *Mécanisme.* In his research into precisely how certain muscles functioned in complex bodily movements, Duchenne pioneered the fields of kinesiology and neurology, leading to the diagnosis and treatment of physiological disorders such as muscular dystrophy and atrophic paralysis and compelling orthopedic surgeon Emanuel B. Kaplan to rank him as the "father of electrotherapy and electrodiagnosis."[4]

The result of nearly twenty years of study, Duchenne's monumental *Physiologie des mouvements, demontrée à l'aide de l'expérimentation électrique et de l'observation clinique et applicable à l'étude des paralysies et des deformations* (Physiology of movements, demonstrated with the aid of electrical experimentation and clinical observation, and applicable to the study of paralyses and deformations), published in 1867, is unquestionably his most important contribution to medical science. This work, however, and Duchenne himself might very well have been lost among the incunabula of medical history were it not for his earlier and much smaller *Mécanisme de la physionomie humaine,* in which he applied "localized electrization" to the "electrophysiological and aesthetic study of facial expression."[5] This fairly rare and, until recently, seldom-discussed publication has a place at the center of a number of discourses, not least among them the consideration of the nature of the human psyche, how it expresses itself, and how it is represented.

The Mechanism of Human Physiognomy

The publication history of Duchenne's *Mécanisme* is complex and to a degree uncertain. Published in stages over the course of 1862 and possibly into 1863, the completed first edition includes a volume of text divided into three parts—"General Considerations," a "Scientific Section," and an "Aesthetic Section"—and an "atlas" of photographic plates.[6] The goal of the study, however, is clear. In the wake of Auguste Compte's philosophy of positivism, Duchenne sought conclusively and scientifically to chart the "grammar and orthography of human facial expression,"[7] believing that he was investigating a God-given language of facial signs:

In the face our Creator was not concerned with mechanical necessity. He was able in his wisdom or—please pardon this manner of speaking—in pursuing a divine fantasy…to put any particular muscles into action, one alone or several muscles together, when He wished the characteristic signs of the emotions, even the most fleeting, to be written briefly on man's face. Once this language of facial expression was created, it sufficed for Him to give all human beings the instinctive faculty of always expressing their sentiments by contracting the same muscles. This rendered the language universal and immutable.[8]

Like physiognomists and phrenologists before him, Duchenne trusted that the human face was a map whose features could be codified into universal taxonomies of inner states; unlike them, he was skeptical of the face's capacity to express moral character. He therefore focused on isolating the dominant, secondary, and associative muscles of the face and identifying their roles in articulating the various emotions and passions. Like earlier anatomists and physiologists, Duchenne based his myological experiments on precise scientific methods and a thorough knowledge of existing literature; he broke ranks with them, however, by substituting experimentation for pure observation.[9] Finally, like a number of earlier theorists, Duchenne emphasized the usefulness of his findings to the fine arts, but he differed from his predecessors in believing that he required photography to publish and popularize his research. He therefore worked with a talented young photographer, Adrian Tournachon, and even taught

[4] KAPLAN, "Duchenne of Boulogne and the Physiologie des Mouvements," 186.

[5] DUCHENNE, *Mécanisme,* part 3, 141; Cuthbertson trans., 105.

[6] The three fascicles—"Considérations Générales," "Partie Scientifique," and "Partie Esthétic"—did not appear simultaneously but rather months apart, in two installments. The first installment consisted of "General Considerations" and the "Scientific Section" and a separate volume of seventy-two photographic plates, referred to as an "atlas" of plates in some copies and an "album" in others (hereafter the atlas). The second installment consisted of the "Aesthetic Section," not envisioned at the outset, its eleven additional plates, and nine "tableaux synoptiques" (tables of photographs from both sections arranged in grids to help the viewer distinguish the expressions portrayed) at the end. A complete copy of the first edition may exist, therefore, in either a single volume or as many as four. The numbering of text pages and plates is somewhat irregular. Text pages are numbered i–viii and 1–70 in "General Considerations," i–xi and 1–128 in the scientific section, and 129–94 in the aesthetic section. Each of the few complete copies produced had to have an original albumen photograph pasted in as frontispiece and another ninety-two photographs (adding the plates and tables for the aesthetic section to the plates for the scientific section) pasted into the atlas; while the images are known mostly as vignetted, in some editions the negatives were fully printed. (Three text engravings are numbered 1, 2, and 2bis.) I am deeply indebted to Richard Yanul, historian of photographically illustrated books, who years ago supplied me with much of the bibliographic information in this note. Richard Yanul to Robert Sobieszek, als, 29 August 1972. It should be noted that although the bibliography in Guilly does not cite a second edition of *Mécanisme,* one was published by J.-B. Ballière in 1876, containing a frontispiece portrait of Duchenne and his elderly male subject and the nine synoptic plates.

[7] DUCHENNE, *Mécanisme,* part 3, 129; Cuthbertson trans., 101.

[8] DUCHENNE, *Mécanisme,* part 1, 31; Cuthbertson trans., 19.

[9] GUILLY, *Duchenne de Boulogne,* 196.

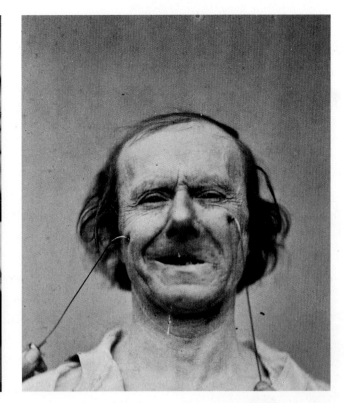

RIGHT

G.-B. Duchenne de Boulogne, "The Muscle of Fright, of Terror," fig. 64 from *Mécanisme de la physionomie humaine* (1862), albumen print, Horblit Collection, The Houghton Library, Harvard University. "By looking at each side of this figure we see a gradation in pain and terror."

FAR RIGHT

G.-B. Duchenne de Boulogne, "The Muscles of Weeping and Whimpering," fig. 48 from *Mécanisme de la physionomie humaine* (1862), albumen print, Horblit Collection, The Houghton Library, Harvard University. "On the left . . . mild weeping; pity. On the right . . . feeble false laughter."

himself the art in order to fully document his pioneering experiments.[10]

After outlining the background of the study and the principles according to which it was conducted, Duchenne defines the fundamental expressive gestures of the human face and links each with a specific facial muscle or muscle group. He identifies thirteen primary emotions whose expression is controlled by one or two muscles: "attention," "reflection," "aggression," "pain," "joy and benevolence," "lasciviousness," "sadness," "weeping and whimpering," "surprise," "fright," and "terror." He also isolates the precise contractions that result in each expression and separates them into two categories: partial and combined. Partial contractions are caused by the movement of a single muscle or muscle group and include those that are 1) completely expressive; 2) incompletely expressive; 3) expressive when complemented by the movement of another muscle or single group; and 4) completely inexpressive. Combined contractions result from the excitation of a number of differing muscles at the same time to produce expressions that are either 1) expressive of complex emotions; 2) simply inexpressive grimaces; or 3) discordantly expressive, as when the muscle of joy is triggered along with that of pain. In short, Duchenne attempted to construct a positivist thesaurus of human facial expressions from a scientific point of view.

From an art-historical point of view, the *Mécanisme de la physionomie humaine* was the first publication on the expression of human emotions to be illustrated with actual photographs: startling and almost surreal images of men, women, and children whose facial features are so artificially distorted into what Duchenne called the "gymnastics of the soul" that they frequently appear to present nothing more than wildly grotesque or utterly inchoate grimaces.[11] Yet behind these apparently insane countenances was a method. In many cases Duchenne had applied faradic shock to one muscle on the right side of the subject's face and to a completely different one on the left, and viewers were instructed to examine each half of the face independently to compare the most subtle of expressions.[12] For instance, figure 48 is captioned, "On the left, electrical stimulation

[10] "M. Adrien Tournachon, a photographer whose ability is known to everyone, has been kind enough to lend me the sum of his talent to execute some of the negatives for this scientific section." DUCHENNE, *Mécanisme*, part 2, vi; Cuthbertson trans., 39. Tournachon took these photographs in 1854. Most of the photographs in the scientific section, however, were taken by Duchenne himself as early as 1852 but mostly in 1856. The eleven plates corresponding to the aesthetic section were taken by Duchenne in late 1862 or even in early 1863; see below, note 77.

[11] DUCHENNE, *Mécanisme*, part 1, 53; Cuthbertson trans., 31.

[12] This tactic seems to have evolved from an approach Duchenne used in many of the plates in the unpublished personal album he dedicated to the Ecole des beaux-arts, in which he stimulated only one side of the face and left the other "en repos" for comparison; see *Mécanisme de la physionomie humaine par le Docteur Duchenne (de Boulogne), Album composé de 74 photographiées*, figs. 11, 17, 19, 21, 28, and 30. But Duchenne was not the first to suggest or depict a separate expression on either side of the face: In 1746, James Parsons, a physician

and friend of Hogarth, delivered two lectures at the Royal Society, London, in which he used drawings of faces showing pairs of expressions such as "fear and terror" and "scorn and derision." See J. PARSONS, "Human Physiognomy Explain'd: in the Brounian Lectures on Muscular Motion for the year MDCCXLVI," in Royal Society (London), *Philosophical Transactions for the Year 1746* 44, no. 1 (supplement); and JENNIFER MONTAGUE, *The Expression of the Passions: The Origin and Influence of Charles Le Brun's "Conférence sur l'expression générale et particulière"* (New Haven: Yale University Press, 1994), 101–2.

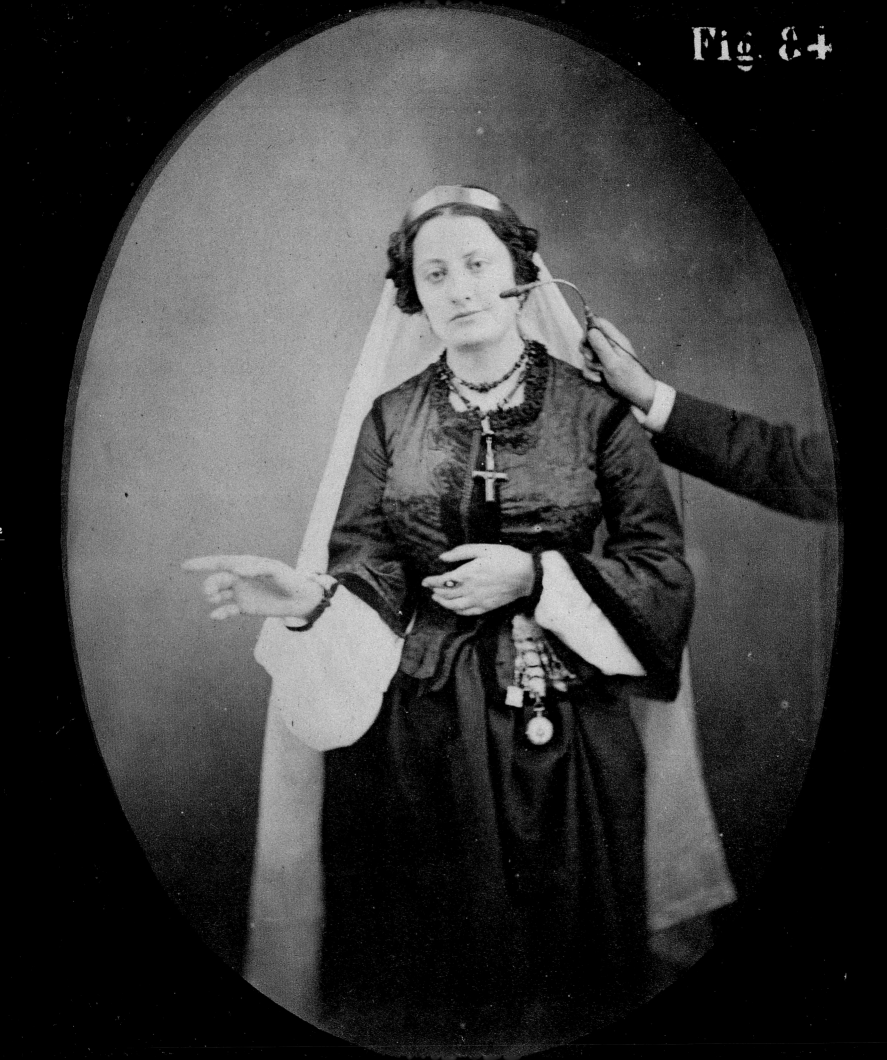

Fig. 84

42

OPPOSITE

G.-B. Duchenne
de Boulogne,
"Lady MacBeth—
Receiving King
Duncan with a
Perfidious Smile,"
fig. 84 *from Mécanisme
de la physionomie
humaine* (1862),
albumen print,
photograph courtesy
the Getty Research
Institute, Research
Library. "False smile
on the left, by cover-
ing the right side
of the mouth; frigid
air of discontent
on the right, by
covering the left
side of the mouth."

RIGHT

G.-B. Duchenne
de Boulogne, synop-
tic plate 4 from
*Mécanisme de la
physionomie humaine*
(1862), albumen
print, photograph
courtesy the Getty
Research Institute,
Research Library.
"I have produced a
different expression
on each side of the
face. . . . The synop-
tic tables facilitate
the study of this
phenomenon that
I call simultaneous
contrasting of the
expressive lines of
the face."

of *m. zygomaticus minor: mild weep-
ing; pity.* On the right, moderate
electrical stimulation of *m. zygo-
maticus major: feeble false laughter.*"[13]

Duchenne used six living mod-
els in the scientific section, all but
one his patients, but the primary
model was the "old toothless man,
with a thin face, whose features,
without being absolutely ugly,
approached ordinary triviality."[14]
Lest the reader conclude that a
degree of torture or at least some
inhumane treatment was inherent
in these experiments, Duchenne
pointed out that the subject had
"reduced sensation. He was suffer-
ing from a complicated anaesthetic
condition of the face. I was able to experiment on his face without caus-
ing him pain, to the extent that I could stimulate his individual muscles
with as much precision and accuracy as if I were working with a still
irritable cadaver."[15] Duchenne took pains to assert that great care was
required in limiting the amount of "electrical excitation" administered to
each of his subjects, as too much of a shock would produce only a "gri-
mace" instead of a real expression; he also insisted that in spite of being
artificially induced, the expressions in his portraits remained "grippingly
true" to life.[16]

Having demonstrated in the scientific section the principal facts of
the grammar and orthography of human facial expression "with the most
complete empiricism," in the aesthetic section, published later, Duchenne

defended his work against its early critics and elaborated on his claim of
having assembled a pictorial thesaurus of beauty. In reply to criticism of
his use of the ugly old man, Duchenne argued that his model was prefer-
able to Adonis for "scientifically" outlining the lines of the face, that by
his example he showed that "every human face could become spiritually
beautiful through the accurate rendering of his or her emotions," and
that the only other alternative open to him—to animate the face of a
corpse, which he had already done—would have presented a far "more
hideous and revolting spectacle."[17] It was in order to "placate those
who possess 'a sense of beauty,'" he explains, that he undertook and pho-
tographed these additional electro-
physiological studies specifically to
illustrate the "set of conditions that
constitute beauty from the aesthetic
point of view."[18] Whereas the sci-
entific section was intended solely
to exhibit the expressive lines of
the face and the "truth of expres-
sion," the aesthetic section would
demonstrate that the "gesture and
the pose together contribute to the
expression; the trunk and the limbs
must be photographed with as
much care as the face so as to form
an harmonious whole."[19] For these
plates Duchenne used a partially
blind young woman who, in his
insensitive words, "had become
accustomed to the unpleasant sen-
sation of this treatment" and was

ÉLECTRO-PHYSIOLOGIE PHOTOGRAPHIQUE.
PL. 4

[13] DUCHENNE, *Mécanisme,* part 2, 82;
Cuthbertson trans., 81.

[14] DUCHENNE, *Mécanisme,* part 2, 6;
Cuthbertson trans., 42. This patient's face
is the one perhaps most associated with
Duchenne. The same frontispiece showing
them in *Mécanisme* also appears as the fron-
tispiece to his later *Album de photographies
pathologiques, complémentaire du livre intitulé
De l'électrisation localisée.* A series of photo-
graphs in the collection of the Kunstforum
Läderbank in Vienna showing a different
male model undergoing similar experiments

in 1856/57 has been credited to Duchenne,
although the images bear little stylistic resem-
blance to his known work; cf. ELISABETH
MADLENER, "Ein Kabbalistischer Schauplatz:
Die physiognomische Seelenerkundung,"
in Jean Clair, Cathrin Pichler, and Wolfgang
Pircher, eds., *Wunderblock: Eine Geschichte
der modernen Seele,* exh. cat. (Vienna: Löcker
Verlag, 1989), 173–4. According to Catherine
Mathon, the photographs could be the work
of German physiologist Robert Remak
(1815–1865), who visited Duchenne in 1852
to learn about his experiments with faradiza-
tion; in conversation, 3 July 1998. Remak was
also in Paris in 1856 to deliver a paper to the

Académie des sciences and may have seen
Duchenne's photography on that trip.
See REMAK, *Galvanotherapie der Nerven- und
Muskelkrankheiten* (Berlin: August Hirschwald,
1858), 244; and JEAN-FRANÇOIS DEBORD, "Le
mécanisme de la physionomie humaine: La
Vie et l'oeuvre de Duchenne de Boulogne,"
in Jean Clair, ed., *L'Ame au corps: Arts et sci-
ences, 1793–1993,* exh. cat. (Paris: Réunion
de musées nationaux and Gallimard/Electa,
1993), 414.

[15] DUCHENNE, *Mécanisme,* part 2, 7;
Cuthbertson trans., 43.

[16] Ibid.; Duchenne's phrase is "saisissantes
de vérité."

[17] DUCHENNE, *Mécanisme,* part 3, 130–2;
Cuthbertson trans., 101–2.

[18] DUCHENNE, *Mécanisme,* part 3, 133;
Cuthbertson trans., 102; Duchenne's phrase
is "au point de vue plastique."

[19] DUCHENNE, *Mécanisme,* part 3, 133–5;
Cuthbertson trans., 102–3.

uncomprehending enough that he was "obliged to position her and dress her as if she were a mannequin."[20]

This model was also faradically stimulated to provoke a different expression on either side of her face. Duchenne advised that looking at both sides of the face simultaneously would reveal only a "mere grimace," and again he urged the reader to examine each side separately and with care.[21] Moving from scientific experiments to artistic practice, he chose to direct a set of complex and often irrational scenes of melodramatic histrionics by contrasting different facial expressions at the same time and in the same model, posed for this purpose in various fictional tableaux. These eleven scenes, which Duchenne boasted of having photographed himself with the aid of a laboratory assistant, form a curious collection of narrative genre scenes, not entirely unlike other genre images produced by amateur and artist photographers of the time but infinitely more unorthodox in what they suggest. It was here, with these eleven photographic plates and their accompanying texts, that Duchenne's *Mécanisme* broke decisively with traditional studies of physiognomy and the expressions of emotions to become a strange, provocative addition to the literature of life and art in the nineteenth century.

Crises of Consciousness

The standard biography of Duchenne, published in 1936, devotes only a very few pages to the *Mécanisme,* whose "very rare" photographs are described as "veritable bibliophilic curiosities" of great "historical and documentary value."[22] The book and its photographs are still rare, but in 1981 the general public was introduced to them in the film version of John Fowles's novel *The French Lieutenant's Woman* (1969).[23] Both versions frame a remarkable convergence of many of the issues brought about by Duchenne's *Mécanisme*. The setting is Lyme Regis along the southwestern coast of England, the year is 1867, and the Victorian era's confidence in what had for centuries been defined as human nature is being shattered. *The Origin of Species,* in which Darwin looked back in time and across the animal kingdom, arguing that humans had evolved from lower animal forms, had been published in 1859. His *Expression of the Emotions in Man and Animals* would appear in 1872, further substantiating the theory of

evolution by looking at the human face as a conduit of animal-like inner passions. In *The French Lieutenant's Woman*, an amateur paleontologist is obsessed by a young woman and visits a specialist in mental disorders, or an alienist, who expounds on the taxonomies of melancholia devised by a "clever German doctor" named Hartmann. The alienist asserts that the arts of psychology and psychiatry have lagged far behind those of the physical sciences: "We know more about the fossils out there on the beach than we do about what takes place in that girl's mind." The film version of the scene shows the paleontologist examining plates from Duchenne's *Mécanisme* during this discussion. The casual references to a doctor Hartmann and the incorporation of Duchenne's photographs act as rather sophisticated, albeit oblique, glosses on two fundamental crises of human consciousness in the nineteenth century: the theory of evolution and that of the unconscious.

In 1917 Sigmund Freud suggested that there had been three "ego-smashing" revolutions in Western thought: Copernicus proved that we were not at the center of the universe, Darwin demonstrated that humanity was not a special creation but descended from the animal world, and Freud himself established that our minds are subject to the unknowable forces of the unconscious.[24] Earlier, in *The Interpretation of Dreams* (1899), Freud had noted the work of Eduard von Hartmann on the unconscious and its role in artistic creation.[25] Possibly the "clever German doctor" mentioned in Fowles, von Hartmann formulated a concept of the unconscious as unrelated to reason and the will, beginning in the early 1860s and primarily in response to Hegel's and Schopenhauer's theories.[26] His massive three-volume *Philosophy of the Unconscious* first appeared in 1869 and had gone through nine editions and revisions by 1884. Von Hartmann's fashionably pessimistic consideration of the unconscious, with its method

[20] DUCHENNE, *Mécanisme,* part 3, 141; Cuthbertson trans., 105.

[21] To help the reader distinguish the emotions, Duchenne appended the atlas of nine synoptic illustrations featuring many of the plates from both sections, photographically reduced (often with pieces of black paper covering individual halves of the faces) and rearranged into grids of sixteen images per plate.

[22] GUILLY, *Duchenne de Boulogne,* 208.

[23] KAREL REISZ, dir., *The French Lieutenant's Woman,* scr. Harold Pinter, prod. Juniper Films (United Artists, 1981). JOHN FOWLES, *The French Lieutenant's Woman* (Boston: Little, Brown and Company, 1969).

[24] "[The ego] is not even master in its own house." SIGMUND FREUD, *Introductory Lectures on Psycho-Analysis,* ed. and trans. James Strachey (New York: W. W. Norton and Co., 1966), 353; discussed in Bruce Mazlish, "The Fourth Discontinuity," in Melvin Kranzberg and William H. Davenport, eds., *Technology and Culture* (New York: New American Library, 1972), 217–8. Mazlish and others, following Gilles Deleuze and Félix Guattari's lead, argue that each of these three revolutions helped eliminate the discontinuity between the human and nature, and that a fourth revolution is eroding the discontinuity between human and machine. See also SCOTT BUKATMAN, *Terminal Identity: The Virtual Subject in Postmodern Science Fiction* (Durham: Duke University Press, 1993), 8–9. For a broader survey of this concept, see KEITH

ANSELL PEARSON, "Viroid Life: On Machines, Technics and Evolution," in Pearson, ed., *Deleuze and Philosophy: The Difference Engineer* (London and New York: Routledge, 1997), 180–210.

[25] FREUD, "The Interpretation of Dreams," *The Basic Writings of Sigmund Freud,* ed. and trans. Dr. A. A. Brill (New York: Random House, 1938), 482 n. 1.

[26] See EDUARD VON HARTMANN, "Preface to the Seventh Edition," in *Philosophy of the Unconscious: Speculative Results According to the Inductive Method of Physical Science,* trans. William Chatterton Coupland (1931; reprinted, London: Routledge & Kegan Paul, 1950), xxii. See also C. K. OGDEN's preface in same.

PUERPERAL MANIA IN FOUR STAGES.

From a Photograph by Dr Diamond

Drawn on Stone by W. Bagg Printed by Hullmandel & Walton.

W. Bagg, *Puerperal Mania in Four Stages* (from a photograph by Dr. Diamond), pl. 7 from John Conolly, "The Physiognomy of Insanity," *The Medical Times and Gazette* (19 June 1858), lithograph, private collection, Los Angeles.

of inductive science and its discussions on the passions and dream imagery, ambitiously probed the unknown and unseen regions of human psychology, just as Duchenne was scientifically examining the inner mechanisms by which the muscles of the human face were employed to express emotions. The philosopher and the physiologist disagreed, however, on whether all muscular activity was voluntary.

Freud later made the notion of an imperial will or consciousness largely suspect; for von Hartmann the will was still omnipotent and the cause of all reflex actions. "Muscular contraction," he contended, "is manifestly by far the most important organic function dependent on conscious volition."[27] But scientists had already begun to discredit this theory. The Scottish anatomist Charles Bell had suggested that some facial and bodily movements were utterly independent of the mind,[28] and in 1852 Duchenne had demonstrated that, as he phrased it, "the movements of facial expression are not controlled by the will, as are those of the limbs or trunk. Only the soul has the faculty of producing them truly."[29] Later even Darwin hesitatingly concluded that most "movements of expression, and all the more important ones . . . cannot be said to depend on the will of the individual."[30] At issue here was the separation of mind and brain, a schism that was vastly widened by medical scientists during the last century and one that would greatly inform the modern era. For if the mind does not control every expressive action, if some are the result of involuntary neurophysiological reflexes generated by the brain, then just what is communicated by a facial expression?

In further contrast to von Hartmann's theory of "conscious volition," there was also the steadily expanding literature on what Michel Foucault has called the "awareness of unreason," which by Duchenne's and Darwin's time had become the "world's *contratempo*."[31] Various forms of insanity had been clinically charted, the multiple faces of madness had been delineated, and the very nature of character and personality had come to be spoken of as inherently destabilized and decentered.[32] John Fowles used this destabilization in *The French Lieutenant's Woman,* in which a young scientist's compulsive quest

[27] VON HARTMANN, *Philosophy of the Unconscious,* vol. 1, 169.

[28] "In the human countenance, under the influence of passion, there are characters expressed, and changes of features produced, which it is impossible to explain on the notion of a direct operation of the mind upon the features." CHARLES BELL, *The Anatomy and Philosophy of Expression as Connected with the Fine Arts* (London: George Bell and Sons, 1877), 76. The first of many editions of Bell's widely published work appeared in 1806.

[29] DUCHENNE, *Mécanisme,* part 1, 59; Cuthbertson trans., 33–34.

[30] DARWIN, *The Expression of the Emotions in Man and Animals,* 353–7. Darwin credited Duchenne with having "greatly advanced" the study of the physiology of facial expression: "No one has more carefully studied the contraction of each separate muscle, and the consequent furrows produced on the skin. He has also, and this is a very important service, shown which muscles are least under the separate control of the will." Ibid., 5–6. Modern research has confirmed Duchenne's contention that certain muscles important to expressing emotions cannot be voluntarily activated; see PAUL EKMAN, "Duchenne and Facial Expression of Emotion," in Cuthbertson trans., 274–5.

[31] MICHEL FOUCAULT, *Madness and Civilization: A History of Insanity in the Age of Reason,* trans. Richard Howard (New York: Vintage Books, 1973), 212, 297 n. 9.

[32] HEGEL had signaled this decentering much earlier: "Being aware of what I am is conceptually inescapable from confronting what I am not but could become"; quoted in Alasdair MacIntyre, "Hegel on Faces and Skulls," in MacIntyre, ed., *Hegel: A Collection of Critical Essays* (Notre Dame: University of Notre Dame Press, 1976), 232.

to understand the source of a young woman's abnormal alienation ends with his loss of his essential self. The young man, who "like most men of his time, was still faintly under the influence of Lavater's *Physiognomy*,"[33] is initially drawn to the woman by her enigmatic countenance and continually intent on interpreting her true character from her expressions. Her physiognomy haunts him: "Even now," he exclaims, "her face rises before me. There is something in her. A knowledge, an apprehension of nobler things than are compatible with either evil or madness. Beneath the dross . . . I cannot explain."[34] Explaining what lay beneath the dross and vagaries of human expressions was Duchenne's principal aim, as it had been one of the concerns of Western science since Aristotle purportedly advised Alexander to select his counselors according to their appearances.[35]

Physiognomy Plain as Measles

Physiognomy—the term is derived from the Greek *phusis* (nature) and *gnomon* (interpretation)—is the precise science (or, if one must, the imprecise pseudoscience) of interpreting the neutral, static face in order to discern the hidden character and emotional qualities of the subject.[36] Both ancient and modern physiognomists believed that the face was an open book or secret narrative to be read or deciphered and decoded, with the true personality or character of the individual to be revealed at last. Like primitive hunters following an animal's spoor, early physiognomists applied what historian Carlo Ginzburg has called the "conjectural paradigm," divining or inferring interior essences from signs and scraps of visual evidence.[37] Medieval Arab and European treatises explicated the nuances of both human and animal physiognomies and often linked their specific appearances to astrological signs and the assorted temperaments, arguing, for instance, that white, the color of the moon, was the color of lunatics and shy people, or that a person with features like a lion was brave and one with features like a fox deceitful. Physiognomics was ushered into the modern era by Giambattista della Porta, who in *De Humana*

Maximum Caput.

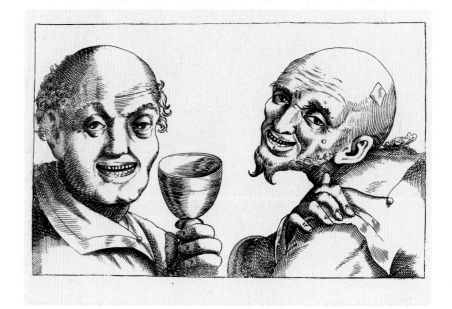

[33] FOWLES, *The French Lieutenant's Woman*, 119.

[34] Ibid., 226.

[35] See JURGIS BALTRUŠAITIS, "Animal Physiognomy," in *Aberrations: An Essay on the Legend of Forms*, trans. Richard Miller (Cambridge: MIT Press, 1989), 5.

[36] The history of physiognomics is detailed in JEAN-JACQUES COURTINE and CLAUDINE HAROCHE, *Histoire du visage: Exprimer et taire ses émotions (du XVIᵉ au début du XIXᵉ siècle)* (Paris: Editions Payot & Rivages, 1994); see also PATRIZIA MAGLI, "The Face and The Soul," trans. Ughetta Lubin, in Michel Feher, Ramona Naddaff, and Nadia Tazi, eds., *Fragments for a History of the Human Body, Zone* 4, part 2 (New York: Zone Books, 1989), 86–127.

[37] CARLO GINZBURG, "Clues: Morelli, Freud, and Sherlock Holmes," in Umberto Eco and Thomas A. Sebeok, eds., *The Sign of Three: Dupin, Holmes, Peirce* (Bloomington and Indianapolis: Indiana University Press, 1988), 88–103. No translator is listed for this version of Ginzburg's important essay, which was first published in Italian in 1979. It was also published as "Clues: Roots of an Evidential Paradigm" in Ginzburg, *Clues, Myths, and the Historical Method*, trans. John and Anne Tedeschi (Baltimore: The John Hopkins Press, 1989), 96–125. I am grateful to my colleague Paul Holdengräber for bringing this essay to my attention.

TOP
Giambattista della Porta, *Biggest Head*, from *De Humana Physiognomonia* (1586), engraving, photograph courtesy the Getty Research Institute, Research Library.

ABOVE
Giambattista della Porta, *Two Heads*, from *De Humana Physiognomonia* (1586), engraving, photograph courtesy the Getty Research Institute, Research Library.

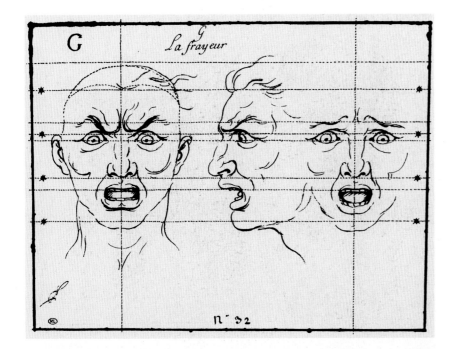

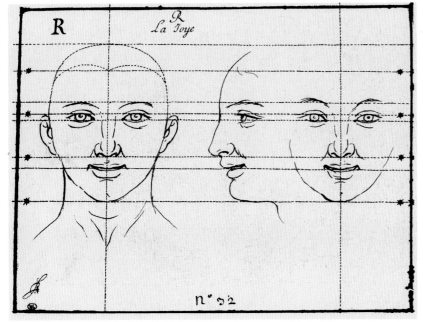

Physiognomonia (1586) stressed that this science had a divine basis. He formulated a system of correspondences between human and animal countenances and asserted that one could discern "particular passions of the soul from the particular shape of the body," most notably the face.[38] Later works elaborated on these passions: notably Cureau de la Chambre's *Charactères des passions* (1640) and especially René Descartes's *Les Passions de l'âme* (1649), which divided the emotions into orderly classes of six fundamental passions. These six "simple" passions, as well as their extremes and composites totaling forty-one models, were finally visually schematized and adroitly delineated by Charles Le Brun, first painter to Louis xiv, in his now-classic treatise *Conférence de M. Le Brun sur l'expression générale et particulière* (Conference by Mr. Le Brun on general and particular expression), 1678, which quickly became a standard reference for artists and was distributed widely in numerous posthumous editions, particularly *Expression des passions de l'âme, représentées en plusieurs têtes gravées d'après les dessins de feu M. Le Brun par J. Audran* (Expression of the passions of the soul, represented in a number of heads engraved after the drawings of the late Mr. Le Brun by J. Audran), published in 1727.[39]

The rote facial expressions and bodily gestures of classic theater relate directly to Descartes's and Le Brun's rules, as do the depictions of characters in history painting from Nicolas Poussin to Jacques-Louis David and beyond. Le Brun's opposing pairs of admiration/contempt, love/hatred, and joy/sadness are, in turn, analogous to the Racinian elocution of the soul that oscillates between poles of strictly articulated emotive states.[40] Physiognomics moreover sought to isolate what Leonardo da Vinci had called the "relevant traits" of the human face and to create a semiotics of immutable equations between certain features, such as full lips, and specific moral characteristics, such as sensuality.[41] The most influential theory of physiognomy was Johann Kaspar Lavater's four-volume *Physiognomische Fragmente zur Beförderung der Menschenkenntniss und Menschenliebe* (Essays on physiognomy, designed to promote the knowledge and the love of

TOP
Charles Le Brun,
Fear, before 1696,
pen-and-ink
diagrammatic
drawing,
Musée de Louvre,
Paris,
photograph
© R.M.N.

ABOVE
Charles Le Brun,
Joy, before 1696,
pen-and-ink
diagrammatic
drawing,
Musée de Louvre,
Paris,
photograph
© R.M.N.

[38] Giambattista della Porta, quoted in Magli, "The Face and the Soul," 87.

[39] For a good introduction to Le Brun, see Julien Philipe, "Présentation," in Charles Le Brun, *L'Expression des passions & autres conférences, Correspondance* (Maisonneuve and Larose: Editions Dédale, 1994), 7–45. See also Montague, *The Expression of the Passions: The Origin and Influence of Charles Le Brun's "Conférence sur l'expression générale et particulière"*; Norman Bryson, *Word and Image: French Painting of the Ancien Régime* (Cambridge:

Cambridge University Press, 1981), 29–57; and Barbara Maria Stafford, *Symbol and Myth: Humbert de Superville's Essay on Absolute Signs in Art* (Cranbury, N.J.: University of Delaware Press, 1979), 20.

[40] For Le Brun and the theater, see Wylie Sypher, "The Late-Baroque Image: Poussin and Racine," *Magazine of Art* 45, no. 5 (May 1952): 209–15; and Janet Browne, "Darwin and the Expression of the Emotions," in David Kohn, ed., *The Darwinian Heritage* (Princeton: Princeton University Press, 1985), 324 n. 8.

[41] See Magli, "The Face and the Soul," 89–92. An excellent survey of physiognomic expression in painting can be found in Flavio Caroli, *L'Anima e il Volto: Ritratto e fisiognomica da Leonardo a Bacon,* exh. cat. (Milan: Editions Electa, 1998).

PLATE III

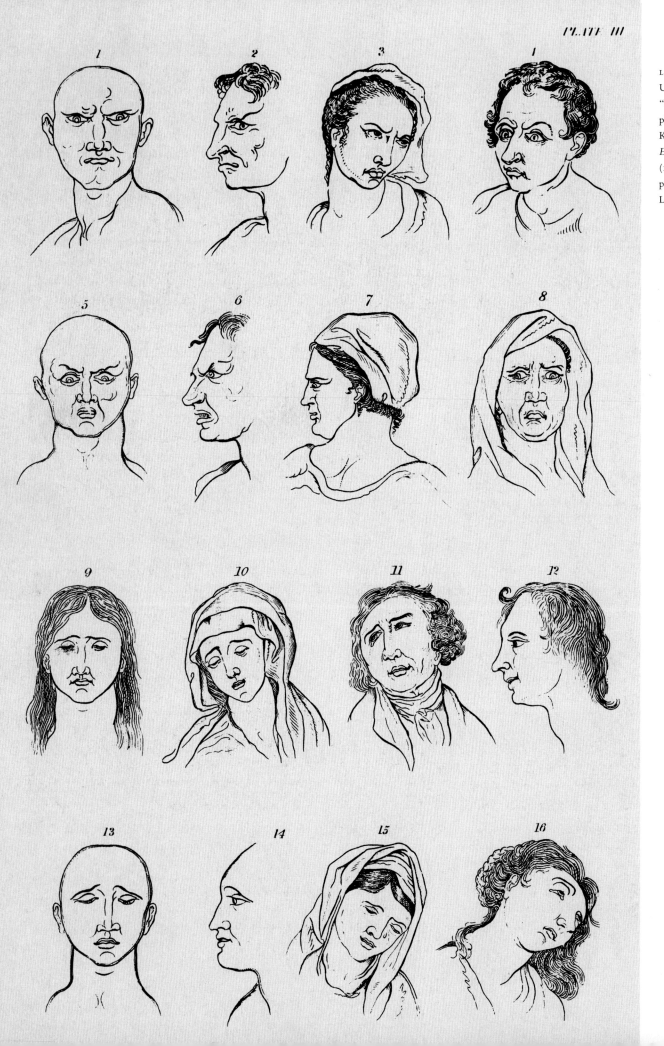

LEFT
Unidentified artist,
"Character Heads,"
pl. 3 from Johann
Kaspar Lavater,
Essays on Physiognomy
(1855), engraving,
private collection,
Los Angeles.

OPPOSITE
Unidentified artist,
"Unsympathetic
Countenances,"
pl. 12 from Johann
Kaspar Lavater,
Essays on Physiognomy
(1855), engraving,
private collection,
Los Angeles.

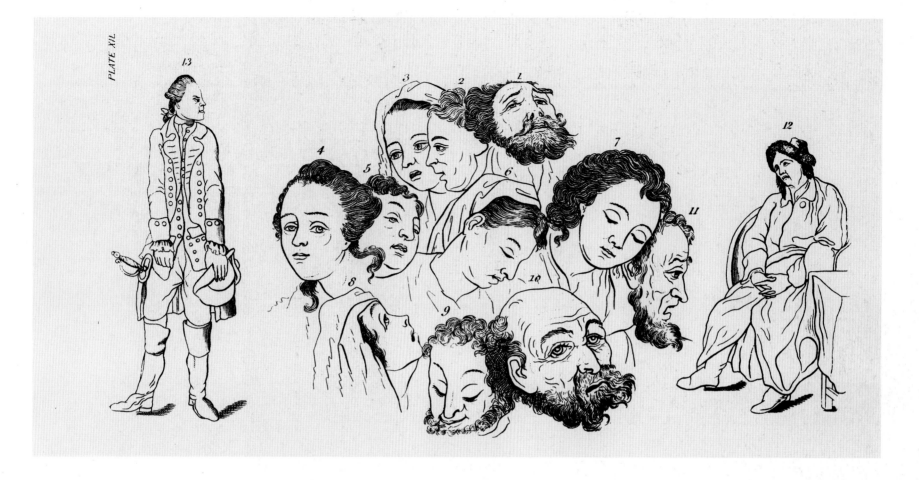

PLATE XII.

mankind), an unwieldy compilation of spurious observations, moralizing anecdotes, arcane mathematics, and importuning lectures published in Leipzig and Winterthur from 1775 to 1778. Despite the work's flaws, the ardor with which Lavater proselytized and defended his ideas brought the *Fragmente* almost instant success as well as sharp criticism, setting the stage for what would amount to nearly a century of physiognomic culture in Europe and America, the very context in which Duchenne would play out his experiments.[42]

Lavater, a Swiss theologian, believed that the human face was a clear and certain indicator of an individual's moral character. Facial beauty equaled virtue, and its opposite, ugliness, equaled vice; analysis of the face's forehead, eyes, eyebrows, nose, chin, and profile provided the key to intelligence and character. "The moral life of man, particularly," he wrote, "reveals itself in the lines, marks, and transitions of the countenance."[43] For Lavater the study of the expression of the emotions was a banal and secondary sideline to physiognomic studies.[44] Passions and emotions were fleeting and immaterial; certitude of absolute moral character was what mattered, and that could be achieved only by studying the static and fixed countenance. Lavater, like many before him, was convinced that character is displayed "by the form of the solid and the appearance of the moveable parts, while at rest." He distinguished between physiognomy and "pathognomy" (from the Greek *pathos,* meaning "suffering," "pain," or "disease"), which he defined as "the knowledge of the signs of the passions," of "character in motion," and of "character impassioned

[42] In a well-researched study of Lavater and his influence, GRAEME TYTLER labels the phenomenon a "physiognomic culture," a "physiognomic climate," and a "physiognomic cult." *Physiognomy in the European Novel: Faces and Fortunes* (Princeton: Princeton University Press, 1982), 78, 86, 90. See also

ELLIS SHOOKMAN, ed., *The Faces of Physiognomy: Interdisciplinary Approaches to Johann Caspar Lavater* (Columbia, S.C.: Camden House, 1993).

[43] JOHANN KASPAR LAVATER, *Essays on Physiognomy: Designed to Promote the Knowledge and the Love of Mankind,* trans. Thomas Holcroft, 9th ed. (London: William Tegg and Co., 1855), 9.

[44] For more on Lavater's dismissal of emotional expression, see TYTLER, *Physiognomy in the European Novel,* 65.

LEFT
Etienne Carjat,
Charles Baudelaire,
1863,
cat. no. 19.

OPPOSITE
Unidentified artist,
Fear with Wonder,
from Charles Bell,
*The Anatomy of
Expression* (1877),
lithograph,
private collection,
Los Angeles.

[as] manifested by the moveable parts, in motion."[45] Physiognomy was concerned with a fixed, unchanging sign system based on eternal and universal truths about the face's shape and contours; pathognomy, on the other hand, had to "combat the arts of dissimulation."[46] Lavater's critics, for their part, insisted that the static face revealed little, if anything, about a person; its expressive movements alone furnished a visual, albeit still untrustworthy, access into its owner's inner state. As Georg Christoph Lichtenberg pointed out, "Suppose the physiognomist ever did have a man in his grasp; it would merely require a courageous resolution on the man's part to make himself again incomprehensible for centuries."[47] Charles Baudelaire, an avid student of Lavater in his youth, came to believe by the mid-1850s that, like an actor, one merely had to comport one's face in a certain fashion in order to feel corresponding sentiments and thoughts.[48]

The physiognomic climate of the late eighteenth and nineteenth centuries fostered the development of a significant branch discipline of physiognomics, one that was much more scientific than Lavater's or his disciples' and increasingly concerned with facial myology and neurophysiology.[49] Duchenne used "physiognomy" in the scientific sense it had obtained by the 1860s in the title of *Mécanisme,* but he explained what distinguished his approach: "I shall not confuse authors who were specifically concerned with facial expression in movement (the *symptomatology* of emotion) with those who have especially studied the signs of inclinations and habits, the study of the shape of the face at rest (properly called *physiognomy*)."[50] Duchenne saw himself as part of the first tradition of theorists, those concerned with the symptomatic expression of emotions, a tradition in which he included Le Brun (somewhat erroneously) as well as Charles Bell, author of *Essays on the Anatomy of Expression in Painting* (1806).[51] Janet Browne, a specialist on Darwin, describes Bell as one of a number of medical philosophers who sought not only to discern

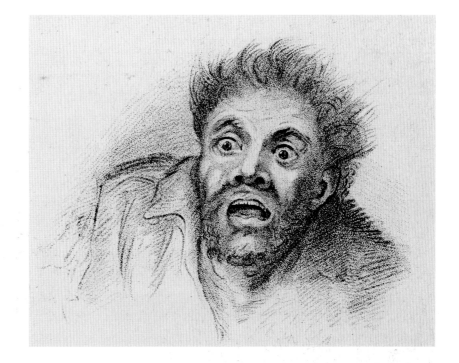

character and emotion in the face and to furnish a guide to painters but also to establish "rules for a new, medical, physiognomical science . . . for diagnosing the patient's internal state of mind."[52] Duchenne, therefore, aligned himself with a growing scientific and medical enterprise, which differed greatly from ancient zoological or astrological physiognomics as well as from classical, Lavaterian physiognomics of moral character and the ideal.

New Voices

This new branch's greatest break from Lavaterian physiognomics was its recognition that the inert form of the head was for all practical purposes devoid of either independent meaning or access to any true inner state. According to Bell, "expression is even of more consequence than shape:

[45] LAVATER, *Essays on Physiognomy,* 12.

[46] Ibid. Most late seventeenth-century treatises on physiognomy had stressed that "passion is a *movement* of the soul"; see COURTINE and HAROCHE, *Histoire du visage,* 95. Further, although Lavater recognized that the face could dissemble, he still trusted the physiognomic visage as even more truthful than verbal language; see CHRISTOPH SIEGRIST, "Letters of the Divine Alphabet—Lavater's Concept of Physiognomy," in Shookman, *The Faces of Physiognomy,* 29.

[47] GEORG CHRISTOPH LICHTENBERG, *Uber Physiognomik wider die Physiognomen* (1776); quoted in MacIntyre, "Hegel on Faces and Skulls," 224.

[48] CHARLES BAUDELAIRE, "Philibert Rouvière," in *Oeuvres complètes,* rev. and ed. Claude Pichois (Paris: Bibliothèque de la pléiade, 1961), 574. See also JEAN POMMIER, *La Mystique de Baudelaire* (Geneva: Slatkine Reprints, 1967), 48. JOHANN ENGEL, in *Ideen zu einer Mimik* (Berlin, 1785), had earlier suggested that outward actions could influence the soul; discussed in Stafford, *Symbol and Myth,* 20.

[49] See TYTLER, *Physiognomy in the European Novel,* 87.

[50] DUCHENNE, *Mécanisme,* part 1, 1; Cuthbertson trans., 3.

[51] DUCHENNE, *Mécanisme,* part 1, 2–6; Cuthbertson trans., 3–5. Duchenne refers to Bell's work but does not specify the edition. There were many revised editions, some under the title *The Anatomy and Philosophy of Expression.* Duchenne also cites Petrus Camper's *Discours sur les moyens de représenter d'une manière sûre les diverses passions qui se manifestent sur le visage* (1792) and Moreau de la Sarthe's

contribution to the French edition of Lavater's work (1806).

[52] BROWNE, "Darwin and the Face of Madness," in W. F. Bynum et al., eds., *The Anatomy of Madness: Essays in the History of Psychiatry,* vol. 1, *People and Ideas* (London: Tavistock Publications, 1985), 151.

it will light up features otherwise heavy; it will make us forget all but the quality of the mind."[53] In his turn, Duchenne argued that the "study of facial expression in movement, entirely omitted by Lavater, should precede the study of physiognomy at rest," adding that Lavater himself "certainly would not have neglected as much as he did of the study of facial expression in movement, which should serve as the basis for the examination of the physiognomy at rest, had he been either an anatomist or a physiologist or a doctor or even a naturalist."[54] Duchenne's words are revealing. The nineteenth-century study of physiognomy in motion, or pathognomy, followed the general development of what Foucault called the "anatomo-pathological perception" in clinical medicine, which increasingly became the diagnostic tool of choice for defining the human being as well as its maladies. The new hegemonic role of science and medicine allowed the voices of anatomists such as Bell, physiologists such as Duchenne, pathologists such as Jean-Martin Charcot of the Salpêtrière asylum in Paris (about whom more later), and naturalists such as Darwin to drown out the traditional voices of philosophers such as Descartes and theologians such as Lavater. The importance of these new voices, according to Foucault, "does not prove that they were philosophers as well as doctors, but [rather] that, in this culture, medical thought is fully engaged in the philosophical status of man."[55]

Earlier physiognomic syllogisms (if a man looks like a bear he must be fierce, etc.) were replaced now with a fully evolved language or semiotics of expression. In his critique of Lavater's *Fragmente,* Lichtenberg defined pathognomy as "the whole semeiotica of the passions, or the knowledge of the natural signs of the motions of the mind, according to all their gradations and combinations."[56] Bell wrote that "expression is to passion what language is to thought," and that "anatomy, in its relation to the arts of design, is, in truth, the grammar of that language in which they address us. The expressions, attitudes, and movements of the human figure are the characters of this language, adapted to convey the effect of historical narration, as well as to shew the working of human passion, and to give the most striking and lively indications of intellectual power and

energy."[57] Bell rejected animal physiognomics, arguing as a naturalist that the laws of "animal economy" suggest that necessary instinct rather than expression is at the root of animal appearances. From his position as a comparative anatomist, he further contended that humans alone have a "peculiar set of muscles to which no other office can be assigned than to serve for expression."[58] While not always physiologically accurate, Bell made an original contribution to pathognomy in describing the various muscular groups involved in such expressions as laughing, crying, pain, horror, and dementia.[59]

Duchenne drew heavily on Bell's work on facial muscles and seconded his insistence on the need for artists to fully grasp the lessons taught by anatomical observation, but he did not share the Scottish anatomist's interest in expressions of exaggerated or extreme passions as found in madness and insanity. Indeed, if anything, the emotions Duchenne describes in the scientific section are rather prosaic. To be sure, in figure 20 neither Duchenne nor the viewer can be certain if the subject is "tormented by mental anguish or by a physical ailment." Figure 42 illustrates a workman who has fallen into delirium tremens, and figure 45 illustrates a "mixture of *pain and depression:* It is the image of *despair.*"[60] And there are as many references to a "melancholic smile," the "features of a fury," and Lady Macbeth's "furious jealousy" in the aesthetic section as there are to "religious exaltation," "divine ecstasy," and "rapture." But for the most part Duchenne distanced himself from one of the last century's most intense medical and scientific discourses—the perception and thus the study of the insane—a discourse that had occupied many alienists and physiognomists in France, from Jean-Etienne-Dominique Esquirol and Etienne-Jean Georget at the start of the century to Henri Dagonet and Charcot toward its close. Even Darwin considered the expressions of the insane at some length in *The Expression of the Emotions.*[61]

The face of madness constitutes a special category of representation by artists, photographers, and alienists throughout this physiognomic climate. Works like Goya's late drawings *Utter Madness* and *The Idiot,* the paintings of monomaniacs made by Géricault around 1820, and Gustave Courbet's

53 BELL, *The Anatomy and Philosophy of Expression,* 55–56.

54 DUCHENNE, *Mécanisme,* part 1, 4–5; Cuthbertson trans., 4.

55 MICHEL FOUCAULT, *The Birth of the Clinic: An Archaeology of Medical Perception,* trans. A. M. Sheridan Smith (New York: Vintage Books, 1975), 198.

56 LICHTENBERG, most likely from *Uber Physiognomik,* quoted in Lavater, *Essays on Physiognomy,* 270.

57 BELL, *The Anatomy and Philosophy of Expression,* 179, 2.

58 Ibid., 113.

59 On Bell's inaccuracies, see GUILLY, *Duchenne de Boulogne,* 197–8.

60 DUCHENNE, *Mécanisme,* part 2, 49, 69, 79; Cuthbertson trans., 66, 75, 80. Cuthbertson translates "peine de l'âme" as "mental anguish"; "spiritual anguish" is closer to the original.

61 DARWIN, *The Expression of the Emotions in Man and Animals,* 289–300; see also SANDER L. GILMAN, "Darwin Sees the Insane," *Journal of the History of the Behavioral Sciences* 15 (1979): 253–62.

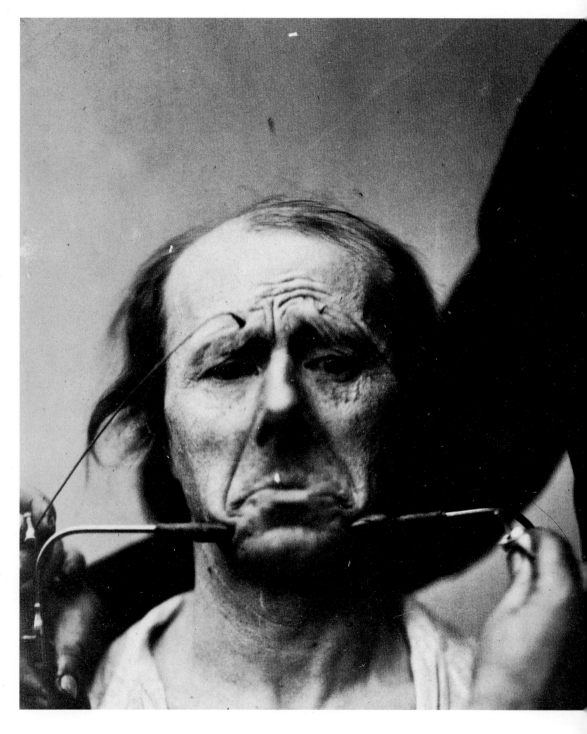

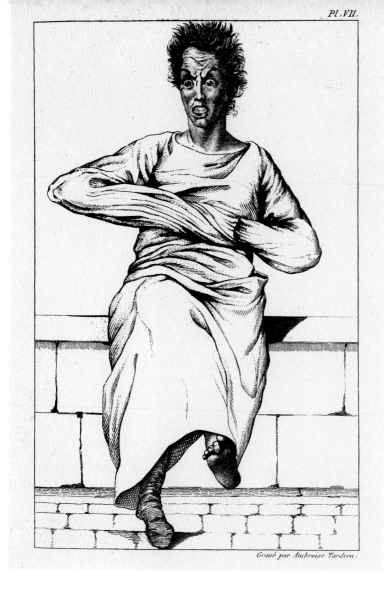

Pl.VII.

Gravé par Ambroise Tardieu.

self-portraits as an artist in desperation done around 1843 exemplify the modern portrayal of exaggerated mental states.[62] Géricault painted his portraits of delusional patients for the alienist Georget, who had been a student of Esquirol at the Salpêtrière. Esquirol had collected more than two hundred drawings, two hundred plaster casts, and six hundred skulls of the insane during the 1810s, contending somewhat grandly that the entire history of his time with its revolutions and wars could be read in the "human 'documents'" confined in the asylums of Charenton, Bicêtre, and the Salpêtrière.[63] Esquirol's *Des maladies mentales* (1838) included twenty-seven engravings from the drawings he had commissioned.[64]

Medical and psychiatric texts illustrated by photography began to proliferate during the 1850s. Newton Kerlin's *The Mind Unveiled; or, A Brief History of Twenty-Two Imbecile Children* (Philadelphia, 1858) was the first publication of psychiatric interest to be illustrated with reproductions of actual photographs.[65] John Conolly illustrated his thirteen-part essay "The Physiognomy of Insanity" (London, 1858–59) with engravings from photographs taken for the most part by the British alienist Hugh Welsh Diamond of his female patients at the Surrey County Asylum in Twickenham.[66] Diamond, an amateur photographer and member of the Calotype Club and the Photographic Society, stated poetically, "The Photographer catches in a moment the permanent cloud, or the passing storm or sunshine of the soul, and thus enables the metaphysician to witness and trace out the connexion between the visible and the invisible in one important branch of his researches into the Philosophy of the human

ABOVE
Ambroise Tardieu, "Figure in Restraining Garment," from J.-E.-D. Esquirol, *Des maladies mentales* (1838), engraving, The National Library of Medicine, Bethesda, photograph by Grant Williams.

[62] For a thorough treatment of this subject, see GILMAN, *Seeing the Insane,* 2nd ed. (Lincoln: University of Nebraska Press, 1996). For Goya, see ANDRÉ MALRAUX, *Saturn: An Essay on Goya* (London: Phaidon Press, 1957), 176–8; for Géricault, see LORENZ EITNER, *Géricault: His Life and Work* (Ithaca: Cornell University Press, 1983), 241–9; for Courbet, see ARTS COUNCIL OF GREAT BRITAIN, *Gustave Courbet: 1819–1877,* exh. cat. (London: Royal Academy of Arts, 1978), cat. no. 5, 81–82; and MARIE-THÉRÈSE DE FORGES, *Auto Portraits de Courbet,* exh. cat. (Paris: Musée de Louvre, 1973), 30. Dating Géricault's portraits of monomaniacs to about 1820 differs from the conventional date of 1822–24; I am following the revised dates of 1819–20 argued in CHRISTOPHER SELLS, "New Light on Géricault, His Travels and His Friends, 1816–23," *Apollo* 123, no. 292 (June 1986): 393–5.

[63] See EITNER, *Géricault,* 243, 354 nn. 32, 33.

[64] ETIENNE ESQUIROL, *Des maladies mentales, considerées sous les rapports médical, hygiénique, et médico-légal* (Paris: J.-B. Ballière, 1838). Other illustrated texts of the period include ALEXANDER MORISON, *The Physiognomy of Mental Diseases* (London: Longmans, 1838), and CHARLES BUCKNILL and DANIEL H. TUKE, *A Manual of Psychological Medicine* (Philadelphia: Blanchard and Lea, 1858).

[65] Cf. GILMAN, "Darwin Sees the Insane," 261 n. 9. GUILLY, Duchenne's biographer, is mistaken in claiming that the atlas of *Mécanisme* "inaugurated the era of photography applied to anatomy and biological sciences." *Duchenne de Boulogne,* 198.

[66] JOHN CONOLLY, "The Physiognomy of Insanity," *Medical Times and Gazette,* 16 (2 January 1858): 2–4; (16 January 1858): 56–58; (6 February 1858): 134–6; (6 March 1858): 238–41; (27 March 1858): 314–6; (17 April 1858): 397–8; (15 May 1858): 498–500; (19 June 1858): 623–5; 17 (14 July 1858): 81–3; (28 August 1858): 210–2; (9 October 1858): 367–9; (25 December 1858): 651–3; 18 (19 February 1859): 183–6. For Diamond, see ADRIENNE BURROWS and IWAN SCHUMACHER, *Portraits of the Insane: The Case of Dr. Diamond* (London/New York: Quartet Books, 1990); and GILMAN, ed., *The Face of Madness: Hugh W. Diamond and the Origin of Psychiatric Photography* (New York: Brunner/Mazel, 1976).

[67] HUGH WELSH DIAMOND, "On the Application of Photography to the Physiognomic and Mental Phenomena of Insanity," unpublished paper (22 May 1856), in Gilman, *The Face of Madness*, 20.

[68] ERNEST LACAN, "Portraits de folles par le Dr Diamond," *La Lumière* 4, no. 5 (December 1854): 202; "La Photographie en Angleterre," *La Lumiére* 5, no. 26 (30 June 1855): 101–2; and *Esquisses photographiques à propos de l'exposition universelle et de la guerre d'orient* (Paris: Grassart and A. Gaudin et frère, 1856), 73–76; see also ERNEST CONDUCHÉ, "La Photographie, la médecine, et la chirurgie," *La Lumière* 5, no. 18 (5 May 1855): 69.

[69] JAMES CRICHTON BROWNE, quoted in Gilman, "Darwin Sees the Insane," 258.

ABOVE LEFT
Dr. Hugh Welsh Diamond, *Seated Woman with Birds,* c. 1855, cat. no. 28.

ABOVE RIGHT
Dr. Hugh Welsh Diamond, *Seated Woman with Purse,* c. 1855, cat. no. 29.

mind."[67] He believed that the photograph was far more useful and exacting than the "vague terms which denote a difference in the degree of mental suffering." He also thought photographs could play a role in the treatment of patients by showing them how they appeared in agitated or depressed states. His photographs were frequently shown in London beginning in 1852. They were exhibited in Paris in 1854 and at the Universal Exposition of 1855 and on both occasions reviewed by photography critic Ernest Lacan—just after Duchenne had begun his photography and during his and Tournachon's most concentrated efforts.[68]

Although Duchenne did not experiment with the facial expressions of the insane, his photographs played a role in a correspondence between Darwin and Dr. James Crichton Browne on the subject. Browne, the director of the West Riding Asylum and also a photographer of his patients, borrowed Darwin's copy of Duchenne's album, tested the veracity of its photographs by having a number of people guess which emotion was illustrated, and wrote to Darwin that "we are beginning to take large photographs here the size of Duchenne['s]."[69] Darwin eventually abandoned his

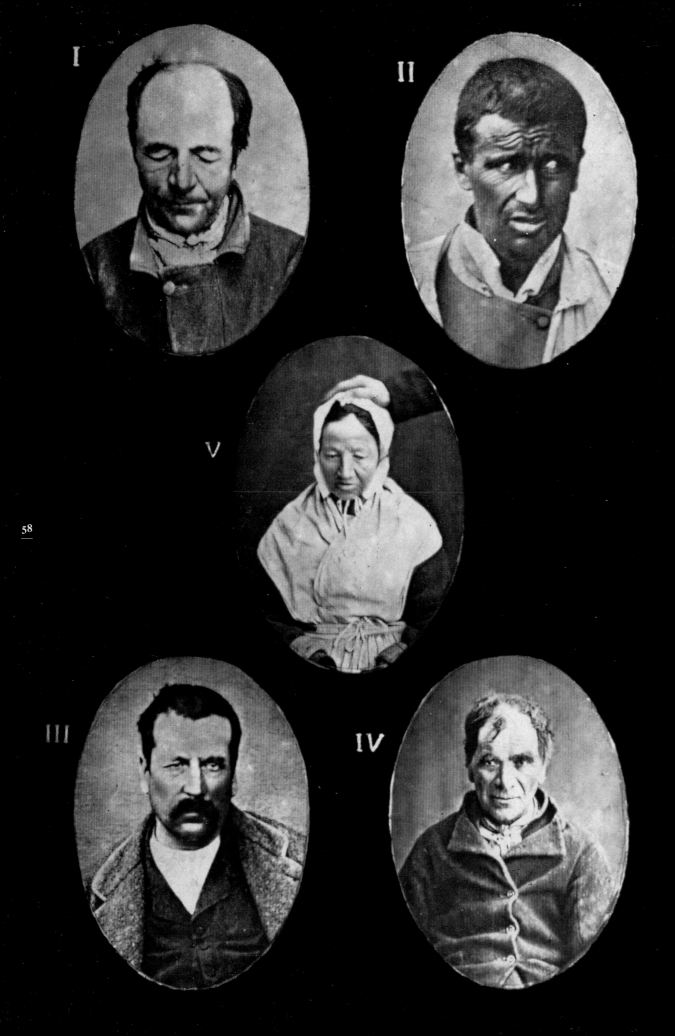

I II

V

58

III IV

desire to illustrate the "general paralysis of the insane," and especially those subjects whose movements were too fugitive and erratic. Photography was still too slow to capture such brief and explosive expressions in the 1860s; publications of the period, such as Henri Dagonet's *Nouveau Traité élémentaire et pratique des maladies mentales*, customarily portrayed the mentally ill as static types and often with their heads held steady by an attendant.[70] Only with technical advances such as greater emulsion speeds, faster lenses, and more brilliant light sources could tetanic spasms, cataleptic seizures, and the paroxysms of certain hysterics be documented as they were in the journals *L'Iconographie photographique de la Salpêtrière* (1876–80) by Désiré-Magloire Bourneville and Paul Regnard and *La Nouvelle Icono-*

graphie de la Salpêtrière, clinique des maladies du systeme nerveux, pub. sous la direction du professor Charcot (1888–1918), founded by Paul Richer, Gilles de la Tourette, and Albert Londe.[71]

Beauty and Truth

Duchenne may have avoided photographing the passions of the insane because of photography's technical limitations at the time, or perhaps he had arrived at Darwin's conclusion that such photographs, whether staged or not, were essentially too subjective to be of much scientific value.[72] It seems far more likely, however, that Duchenne did so for aesthetic reasons, since he simply did not regard the expressions of the insane as beautiful. Early in the scientific section Duchenne announces that he has sought to capture the "conditions that aesthetically constitute beauty,"[73] and he reiterates in the aesthetic section that his desire is to portray the "conditions of beauty: beauty of form associated with exactness of the facial expression, pose, and gesture"[74] and to prove that every human face, despite defects of shape and lack of plastic beauty, could be made "morally beautiful" through the "accurate rendering of the soul's emotions."[75]

In the interest of accurate renderings, at the end of the scientific section Duchenne "corrects" the expressions of three widely revered classic Greek or Roman antiquities: the bust of the *Arrotino* (also known as *The Knife Grinder* or *The Spy*) in Paris, the face of the father in two *Laocoön* groups, and the *Niobe* bust in Florence. In no manner, argues Duchenne, does any of these expressive countenances conform to nature as it has been revealed in his electrophysiological studies. He questions the Greek artist Praxiteles's accuracy in sculpting the *Niobe*:

> Would Niobe have been less beautiful if the dreadful emotion of her spirit had bulged the head of her oblique eyebrow as nature does, and if a few lines of sorrow had furrowed the median section of her forehead? On the contrary, nothing is more moving and appealing than such an expression of pain on a young forehead, which is usually so serene.[76]

He even remodeled and photographed plaster casts of the *Laocoön* in Rome and of the *Arrotino* to correct their physiological impossibilities and inconsistencies with the observable truth. To a nineteenth-century audience, Duchenne's "improvements" to these antique masterpieces must have

[70] HENRI DAGONET, *Nouveau Traité élémentaire et pratique des maladies mentales* (Paris: J. B. Ballière et fils, 1876).

[71] See GEORGES DIDI-HUBERMAN, *Invention de l'hystérie: Charcot et l'iconographie photographique de la Salpêtrière* (Paris: Macula, 1982).

[72] See GILMAN, "Darwin Sees the Insane," 261.

[73] DUCHENNE, *Mécanisme*, part 2, 8; Cuthbertson trans., 43.

[74] DUCHENNE, *Mécanisme*, part 3, 133; Cuthbertson trans., 102.

[75] DUCHENNE, *Mécanisme*, part 3, 130–1; my translation. Cf. Cuthbertson trans., 101, where "moralement" is translated as "spiritually" and "émotions de l'âme" as "his or her emotions."

[76] DUCHENNE, *Mécanisme*, part 2, 125; Cuthbertson trans., 100.

seemed nearly blasphemous; the modern viewer might find the results rather more academic and unremarkable.

Despite his interest in scientific precision, Duchenne did not align himself with the modern realist movement in France. To a critic who charged that in remodeling these revered sculptures he was reducing art to "anatomical realism along the lines of a certain modern school of art," he replied, "On the contrary, the principles arising from my experimental research allow art to attain the ideal of facial expression, by teaching how to render correctly and with perfect exactitude, like nature herself, the language of passions, and even certain operations of intelligence." The exact imitation of nature was for Duchenne the sine qua non of the finest art of whatever age. He writes that despite their anatomical errors, the ancient Greek sculptors unquestionably attained an ideal of beauty because the nature they imitated was a "beautiful nature": "in other words, they produced an *idealized naturalism*—two words whose combination may shock initially: but which perfectly convey my thought."[77] (Like others at the time, Duchenne simply ignored the contradiction implicit in this manner of thinking, which suggested that human perfection had been attained by the Greeks and modern humanity had degenerated from that ideal, leaving beauty itself no longer attainable.)[78] Finally, in his own defense, Duchenne went so far as to "correct" the late-baroque essayist and poet Boileau's famous adage, "Nothing is beautiful but truth, truth alone is to be admired," by proposing instead, "Nothing is beautiful without truth."

The "truth" of Duchenne's pathognomic experiments, moreover, could be rendered only by photography. The muscular contractions of his subjects' expressions were too fleeting to be drawn or painted:

"Only photography, as truthful as a mirror, could attain such desirable perfection."[79] Quoting from the Swiss writer Rodolphe Töpffer's *Essai de physionomonie* of 1845, Duchenne noted "the existence of a new kind of literature . . . *literature in pictures*." Its advantages included richness of details, comparative conciseness, great precision; finally, there were "far more people who look at pictures than those who read." Thus, Duchenne's photographs would "teach a thousand times more than extensive written descriptions."[80] He warned, however, "You can only transmit well what you perceive well. . . . Art does not rely only on technical skills. For my research, it was necessary to know how to put each expressive line into relief by a skillful play of light."[81] Admitting that the less-than-perfect German lenses used in the 1850s produced some distortion and lack of sharpness, Duchenne nonetheless insisted that these imperfections did not dilute the "truth and clarity" depicted in the photographs and that the "distribution of light is quite in harmony with the emotions that the expressive lines represent."[82]

For Duchenne, truth and beauty were inseparable, equally important, and essential elements of any work of art. He favored such Baroque artists as Rembrandt, Ribera, Guido Reni, and Salvator Rosa, and he condemned modern realism as a style of art that "only shows us nature with her imperfections and even deformities, and that seems to prefer the ugly, the vulgar, or the trivial."[83] Although he never mentioned the then-heated argument between the advocates of modern realism and academic classicism in art, his use of the phrase "idealized naturalism" places him in a moderate or centrist position, similar perhaps to the views of the art critic Ernest Chesneau. In July 1863 Chesneau published an article in the conservative *Revue des deux mondes* defending realism in contemporary French art but cautioning

[77] DUCHENNE, *Mécanisme,* part 3, 152 n; Cuthbertson trans., 110 n. It was the critic AMÉDÉE LATOUR who wrote that Duchenne had reduced art to anatomical realism "along the lines of a certain modern school of art" and also that the physiologist's conclusions would make Courbet "jump for joy." "Mécanisme de la physionomie humaine," *Union médicale* 15, nos. 100 and 101 (26 August and 2 September 1862); quoted in Roth, "Electrical Expressions: The Photographs of Duchenne de Boulogne," 116. (The dates of Latour's review lead Catherine Mathon to suggest that Duchenne may not have actually published the aesthetic section until early

1863; in conversation, 3 July 1998.) In his views of ancient art, Duchenne was also closer to Lavater than to any more recent theories of realist art; see ELLIS SHOOKMAN, "Pseudo-Science, Social Fad, Literary Wonder: Johann Caspar Lavater and the Art of Physiognomy," in Shookman, *The Faces of Physiognomy,* 21. Futher, Duchenne was far more of a naturalist than a realist. Photography critic FRANCIS WEY, arguing for naturalism and against realism in 1851, remarked that the realists "make the maxim 'Nothing is beautiful but truth' prevail in an absolute sense." "Du naturalisme dans l'art: De son principe et de ses conséquences," *La Lumière* 1, no. 8 (30 March 1851): 31.

[78] For more on this contradiction, see ANTHEA CALLEN, *The Spectacular Body: Science, Method and Meaning in the Work of Degas* (New Haven: Yale University Press, 1995), 11.

[79] DUCHENNE, *Mécanisme,* part 1, 65; Cuthbertson trans., 36.

[80] DUCHENNE, *Mécanisme,* part 1, 65; Cuthbertson trans., 37. Duchenne's actual phrase is "littérature en estamps," and since Töpffer is referring to Hogarth's engraving, the phrase may be read as "literature in prints." For Töpffer, see TYTLER, *Physiognomy in the European Novel,* 110. For an analysis of the his-

torical background of teaching through pictures, see STAFFORD, *Artful Science: Enlightenment Entertainment and the Eclipse of Visual Education* (Cambridge: MIT Press, 1994).

[81] DUCHENNE, *Mécanisme,* part 2, v–vi; Cuthbertson trans., 39.

[82] DUCHENNE, *Mécanisme,* part 2, ix; Cuthbertson trans., 40.

[83] DUCHENNE, *Mécanisme,* part 3, 152 n; Cuthbertson trans., 110 n.

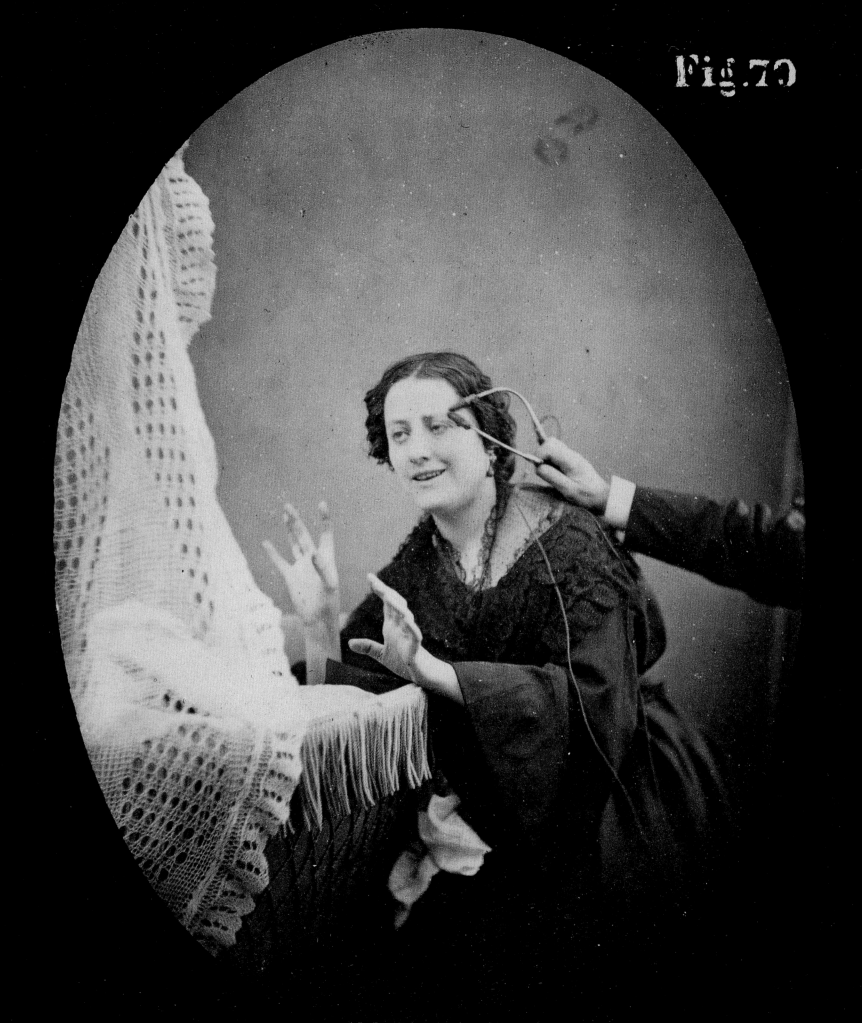

Fig.70

Fig 78

64

"Offended look, by
covering the parts of
the face below the
nose; haughty look,
by covering the left
side of the lower
half of the face;
mocking smile, by
covering the right
side of the lower
half of the face."

slightly drawn together and gaze directed slightly laterally; a mannered pose and exaggeratedly naked chest."[92] Clearly, we are quite far from Descartes's and Le Brun's six fundamental forms of passions, just as we are no longer strictly in the domain of pure physiognomic studies. Duchenne has, it might be said, moved from penetrative iconic portraits to absorptive narrative tableaux.[93]

Narrative genre scenes, so beloved by *Juste milieu* painters of the mid-nineteenth century, were equally taken up by camera artists around this time. French photographers such as Disdéri and Charles Nègre had produced genre scenes featuring vagabonds, street musicians, rag pickers, and washerwomen since the early 1850s.[94] Throughout the decade the pages of the premier photography journal *La Lumière* contained numerous references to naturalistic scenes and to seventeenth-century Dutch genre painters. One French photographer, an otherwise unidentified M. de C., assembled an album in 1862 of such inspiring interior scenes as *In the Family: Sisterly Solicitude* and *When Confidence in God Is Lacking: The Card of Misfortune*.[95] Art historian Elizabeth Anne McCauley reminds us that the Academy's yearly *tête d'expression* competitions had moved from simple emotions, such as "attention" in 1839 and "anguish of the soul" in 1840, to far more complicated states: In 1862 the subject was "Resignation," in which "a condemned man resigned to die . . . does not feel sorrow, he raises his eyes to the heavens . . . [but his] head should be slightly inclined to the earth."[96] It is not surprising, then, to read Duchenne's description of a nun's expression in figure 77:

With her eye slightly obscured and turned obliquely upward and to the side, and with her smile and half-open mouth, with her head and body leaning slightly backward, and with her hands crossed on her breast, and with her little cross around her neck. . . . thanks to all this arrangement I have been able to photograph the pure pleasure of a soul devoted to God. [97]

Elsewhere Duchenne prided himself on being able to effect a metamorphosis from the "purest, most angelic smile" into the "most provocative and licentious" smile by simply shocking a single muscle of his "coquette": "I transformed virgins into bacchantes."[98]

False Smiles

In 1863 Edouard Manet painted *Olympia,* one of the ultimate scenes of coquetry of the nineteenth century: The facial expression of the naked courtesan who stares directly at the viewer is a maze of indirection, not entirely unlike the expression of Duchenne's coquette. She is at once welcoming yet dominating, seductive yet disdainful, engaging yet removed. In 1870 Edgar Degas began work on a genre scene alternately entitled *Sulking* or *The Banker,* which portrays a brooding male figure seated at a desk, his back turned on a woman who leans over the back of a chair. Their attitudes and expressions are strained, conflicted, suggestively contemptuous and yet utterly ambiguous. The model Degas used for the banker was the critic Louis-Emile-Edmond Duranty, founding publisher of the journal *Réalisme* (1856–57), defender of Impressionism in his *La Nouvelle Peinture* (1876), and the author of an essay on physiognomy. In "Sur la physionomie" (1867), Duranty asserted that traditional theories of expression were the result of overabstraction and insufficient observation of individuals in their actual settings, and that "at the present moment, we are cleverer than Lavater, and he could not compete with a contemporary novelist."[99] He concluded, "The best counsel to give those who want to recognize a man or men is to have much wit and wisdom in unraveling the entanglements because speech is a liar, action is hypocritical, and the physiognomy is delusive."[100]

[92] DUCHENNE, *Mécanisme*, part 3, 139; Cuthbertson trans., 105.

[93] The terms "absorptive" and "penetrative" are those of critic ZACHARIE ASTRUC, who distinguished between the two qualities in "Salon de 1868," *L'Etendard* (1 July 1868); see also MICHAEL FRIED, *Manet's Modernism; or, The Face of Painting in the 1860s* (Chicago: University of Chicago Press, 1996), 233–5; and his *Absorption and Theatricality: Painting and Beholder in the Age of Diderot* (Berkeley: University of California Press, 1980).

[94] See McCAULEY, *A. A. E. Disdéri and the Carte de Visite Portrait Photograph*, 15–18.

[95] M. de C., *Essais photographiques* (n.p., 1862); one copy of this album is in the collection of the George Eastman House, Rochester, N.Y.

[96] McCAULEY, *A. A. E. Disdéri and the Carte de Visite Portrait Photograph,* 167.

[97] DEBORD, "The Duchenne de Boulogne Collection," 252. Debord's translation follows the original more closely than Cuthbertson's;

cf. DUCHENNE, *Mécanisme*, part 3, 151–3; and Cuthbertson trans., 110–1. Debord also notes, "The catalogues of the 'Salon' of this epoch are filled with this type of religious nonsense."

[98] DUCHENNE, *Mécanisme*, part 3, 151; Cuthbertson trans., 110.

[99] EDMOND DURANTY, "Sur la physionomie," *La Revue Libérale* 2 (1867): 510; trans. and quoted in Theodore Reff, *Degas: The Artist's Mind,* exh. cat. (New York: Metropolitan Museum of Art, 1976), 219. Duranty's essay appeared serially between 25 July and 25 August 1857. See MARCEL CROUZET, *Un Méconnu du Réalisme: Duranty (1833–1880), L'Homme, Le Critique, Le Romancier* (Paris: Librairie Nizet, 1964), 248 n. 73.

[100] DURANTY, quoted in Crouzet, *Un Méconnu du Réalisme,* 248. Descartes also declared that passions were easily feigned and often misleading; see TOM GUNNING, "In Your Face: Physiognomy, Photography, and the Gnostic Mission of Early Film," *Modernism/ Modernity* 4, no. 1 (January 1997): 4.

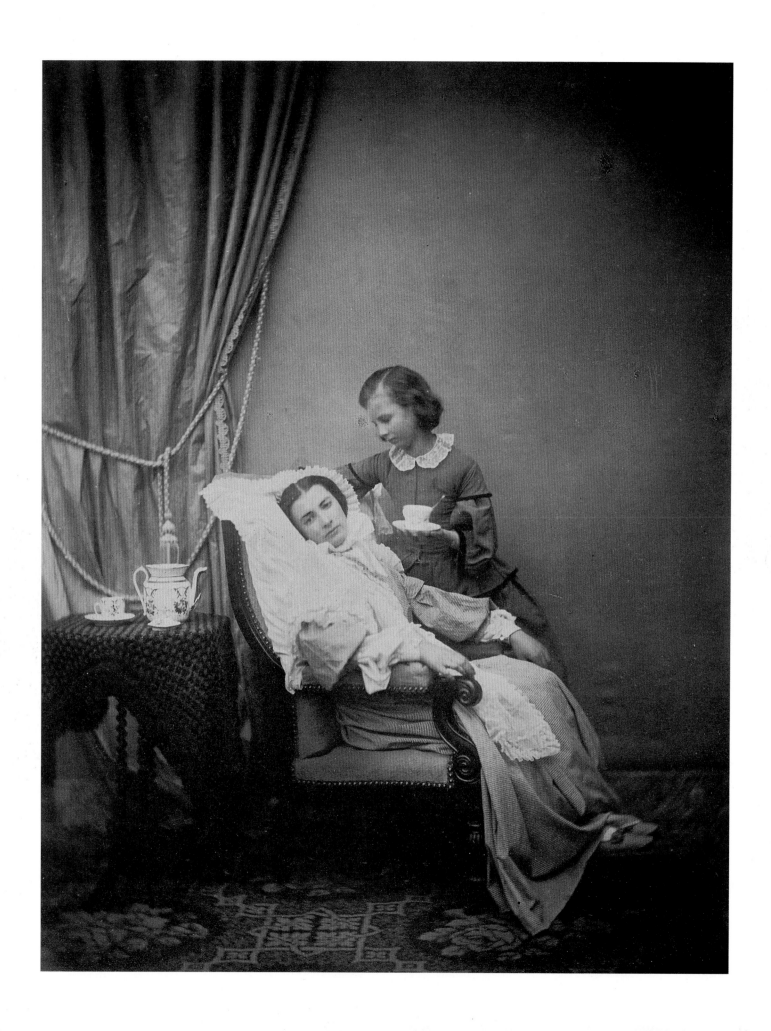

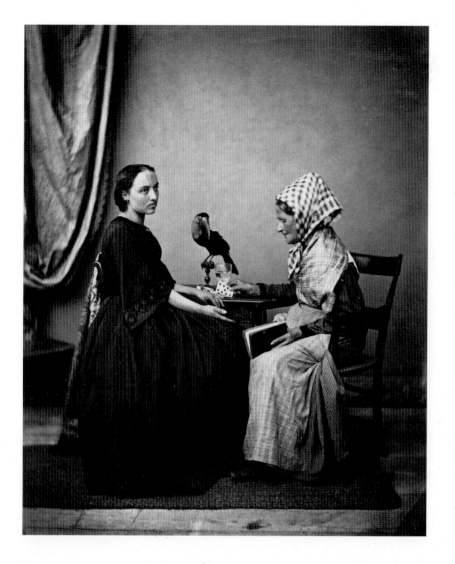

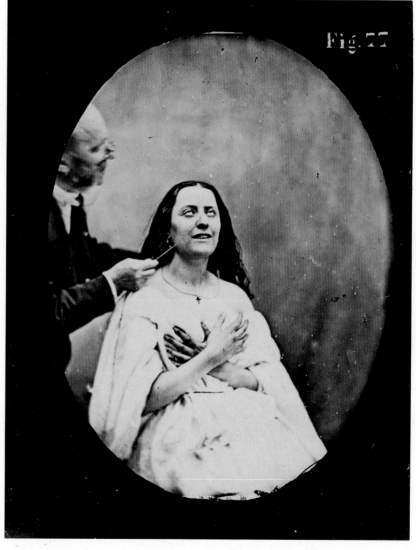

Edouard Manet,
Olympia, 1863,
oil on canvas,
Musée d'Orsay,
Paris, photograph
courtesy L'Agence
photographique
de la Réunion des
musées nationaux,
© R.M.N., photograph
by Gérard Blot.

Edgar Hilaire-
Germaine Degas,
Sulking, c. 1869–71,
oil on canvas,
The Metropolitan
Museum of Art,
New York, H. O.
Havemeyer

Collection, Bequest
of Mrs. H. O.
Havemeyer, 1929
(29.100.43),
photograph © 1987
The Metropolitan
Museum of Art.

Duranty was not alone in dismissing the conventional "lessons" of physiognomy and insisting on direct observation of individuals in their own context: Emile Zola's novels had begun to present far more complicated and penetrating psychological characterizations than those found in the works of, say, Honoré de Balzac, who had depended greatly on Lavater.[101] Degas wrote to himself, in a notebook used from 1868 to 1872, "Make of the *tête d'expression* (in academic parlance) a study of modern feelings. It is Lavater, but a Lavater more relative, as it were, with accessory symbols at times."[102]

Degas's "more relative" is a key to understanding the change in the physiognomic culture. Duchenne was convinced that he had inductively discovered the immutable laws of human facial expression; regardless of the infinite variety of facial features or the simultaneous expression of conflicting emotions, he steadfastly held to a positivist view of what expression signified. For him the expressions worn of the face were clearly determined by the inner workings of the self. More progressive writers such as Duranty and artists such as Degas could not remain so assured; for them personality was inherent in physically mutable and often artificial appearances. The critic Richard Sennett has described what he calls the "doctrine of secular immanence" of the nineteenth century, a belief that "personality varies among people, and is unstable within each person because appearances have no distance from impulse." Since appearances could be modified at any time, the self became destabilized, with "consciousness always following emotional expression."[103] In other words, the soul's emotions no longer caused facial expressions; facial expressions, it seemed, could affect the inner workings of the self. Degas also referred to the lessons of François Delsarte, a singer and teacher of music and oration whose course on aesthetics, begun in 1839, was concerned with the expressive attitudes, postures, features, and "movements of the eye" that were critical to public performance.[104]

Performance was not incidental to Duchenne's experiments, and quite probably he was more than familiar with the theater of pantomime. About 1854 Duchenne was assisted by the professional photographer Adrien Tournachon, then known as Nadar jeune, the younger brother of the famed Gaspard Félix Tournachon, or Nadar. In that year and early the next, the two Nadars collaborated on at least two *têtes d'expression* and a series of full-length portraits of the mime Jean-Charles Deburau costumed as the commedia dell'arte character Pierrot.[105] Charles Deburau's father, Baptiste, perhaps one of the greatest mimes of the century, had replaced Pierrot's traditional ruff and wide-brimmed hat with a simple black skullcap in order to accentuate his long white face. Jean-Charles continued in this fashion, and his face became, as photographed by the Nadars, "a sort of tabula rasa, neutral and composed, on which the slightest modulations of emotion were easily legible."[106] Pierrot's popularity during the late nineteenth century was a testament to the miming abilities of the Deburaus, and their performances provided clear evidence of the mutability and artifice of facial expressions. Duchenne might have based at least some of the

[101]BALZAC was dependent on Lavater for most of his physiognomic beliefs, but he was also fairly relativistic; in *Une Fille d'Eve,* he wrote that previously "the caste system gave each person a physiognomy which was more important than the individual; today the individual gets his physiognomy from himself"; quoted in Judith Wechsler, *A Human Comedy: Physiognomy and Caricature in 19th Century Paris* (Chicago: University of Chicago Press, 1982), 29. For Zola and the demise of physiognomics in the later nineteenth century, see CHRISTOPHER RIVERS, *Face Value: Physiognomical Thought and the Legible Body in Marivaux, Lavater, Balzac, Gautier, and Zola* (Madison: University of Wisconsin Press, 1994).

[102]DEGAS, notebook 23, p. 44; quoted in Reff, *Degas: The Artist's Mind,* 217. DURANTY had already pointed to the importance of symbolic accessories in discerning character, writing that after Lavater described "the complicated but always open book that is the physiognomy, it seems that people became discouraged and wanted to look for an explanation in accessory signs that no one knew how to decipher." "Sur la physionomie" (25 July 1867), 506; quoted in McCauley, *A. A. E. Disdéri and the Carte de Visite Portrait Photograph,* 169. Degas may also have been alluding to post-Lavaterian physiognomic theories such as those by the anthropologist Pierre-Paul Broca and the biological determinist Cesare Lombroso, especially as they applied to criminality and degeneration. In 1881 Degas exhibited two pastels entitled *Criminal Physiognomy* along with his famous wax sculpture *Little Dancer of Fourteen Years;* all three works display the simian features and facial structures discussed by these theorists. See CALLEN, *The Spectacular Body: Science, Method and Meaning in the Work of Degas,* 21–29.

[103]RICHARD SENNETT, *The Fall of Public Man* (New York: Vintage Books, 1978), 150–3. HEGEL anticipated this "doctrine" to some degree in 1807 in his comments on physiognomy and phrenology: "[T]he immediate being in which individuality clothes its appearance is one which either expresses the fact of its being reflected back out of reality and existing within itself, or which is for it merely a sign indifferent to what is signified, and therefore signifying in reality nothing; it is as much its countenance as its mask, which can be put off when it likes. Individuality permeates its own shape, moves, speaks in the shape assumed; but this entire mode of existence equally well passes over into a state of being indifferent to the will and the act." *The Phenomenology of Mind,* trans. J. B. Baillie (New York: Harper Colophon Books, 1967), 345–6.

[104]See REFF, *Degas: The Artist's Mind,* 218.

[105]Thirteen of these portraits are reproduced and discussed in HAMBOURG et al., *Nadar,* pls. 6–18, 224–7.

[106]HAMBOURG et al., *Nadar,* 224.

OPPOSITE
Nadar (Gaspard Félix Tournachon) and Adrien Tournachon, *Pierrot Listening,* 1854–55, cat. no. 82.

narratives depicted in the aesthetic section of *Mécanisme* on stock gestures and poses found in pantomime of the period.

Duchenne conceded that individuals with theatrical abilities could imagine specific emotional states and enact the appropriate expressions:

It is very true that certain people, comedians above all, possess the art of marvelously feigning emotions that exist only on their faces or lips. In creating an imaginary situation they are able, thanks to a special aptitude, to call up these artificial emotions.[107]

He had even included an actor of sorts in the photographs accompanying the scientific section of *Mécanisme,* "an artist of talent and at the same time an anatomist," who was able to "produce perfectly most of the expressions portrayed by each of the muscles of the eyebrow" simply by "calling on his feelings."[108] But his actor/model could produce only "most of the expressions" effected by the eyebrow's muscles; beyond that minimal mimicry, Duchenne was convinced, there were absolute limits to the feigning of emotions. "It will be simple for me," he writes, "to show that there are some emotions that man cannot simulate or portray artificially on the face; the attentive observer is always able to recognize a false smile."[109] Duchenne carefully described how to distinguish between a smile brought about by genuine enjoyment and one occasioned by social politeness: The muscle of the inferior region of the lower eyelid "is only brought into play by a genuine feeling, by an agreeable emotion. Its inertia in [feigned] smiling unmasks a false friend."[110]

72

[107] DUCHENNE, *Mécanisme,* part 1, 51–52; Cuthbertson trans., 30.

[108] Cf. DUCHENNE, *Mécanisme,* part 2, 8–9; Cuthbertson trans., 44. The artist was Jules Talrich, who planned to make wax versions of the heads in Duchenne's photographs; see MONTAGUE, *The Expression of the Passions: The Origin and Influence of Charles Le Brun's "Conférence sur l'expression générale et particulière,"* 93. Darwin commissioned Swedish-born photographer Oscar Gustave Rejlander to create self-portraits demonstrating expressions and gestures of surprise, disgust, helplessness, and indignation. See *The Expression of the Emotions in Man and Animals,* 23. Much of the scientific literature of the period, such as Theodor Piderit's *Grundsätze der Mimik und Physiognomik* (Braunschweig: Friedrich Vieweg und Sohn, 1858), saw no problem in comparing actual expressions of the emotions with emotions that were acted; see TYTLER, *Physiognomy in the European Novel,* 86–87.

[109] DUCHENNE, *Mécanisme,* part 1, 51–52; Cuthbertson trans., 30.

[110] DUCHENNE, *Mécanisme,* part 2, 63; Cuthbertson trans., 72. Duchenne apparently felt strongly about this discovery: He repeats these exact words in a discussion of his female model's enactments of Lady Macbeth; part 3, 188; Cuthbertson trans., 128.

ABOVE
G.-B. Duchenne de Boulogne, "The Muscle of Reflection," fig. 15 from *Mécanisme de la physionomie humaine* (1862), albumen print, Horblit Collection, The Houghton Library, Harvard University.

OPPOSITE (LEFT)
G.-B. Duchenne de Boulogne, "The Muscles of Joy and Benevolence," fig. 35 from *Mécanisme de la physionomie humaine* (1862), albumen print, Horblit Collection, The Houghton Library, Harvard University. "Depression" on the left, "false laughter" on the right.

OPPOSITE (RIGHT)
G.-B. Duchenne de Boulogne, "Lady MacBeth . . . Moderate Expression of Cruelty," fig. 81 from *Mécanisme de la physionomie humaine* (1862), albumen print, photograph courtesy the Getty Research Institute, Research Library.

"Had he not resembled/My father as he slept, I had done't.'"

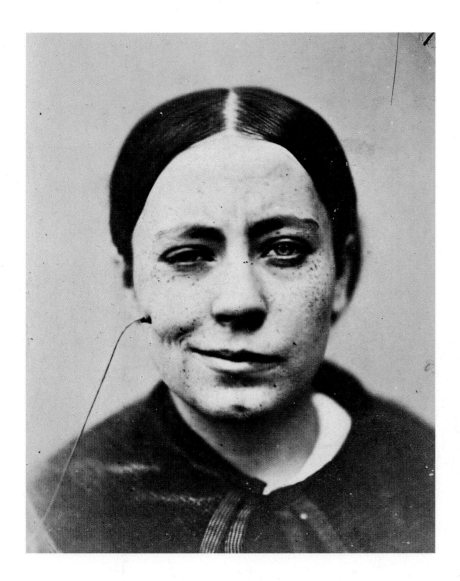

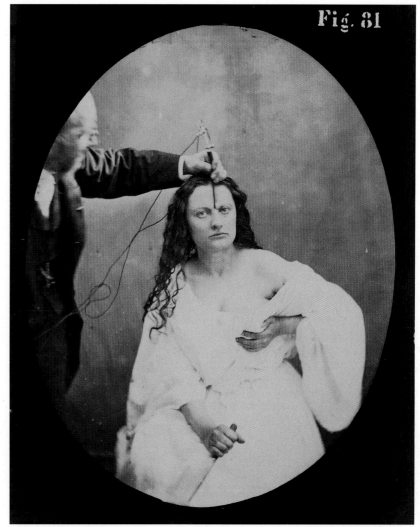

Duchenne sought, as far as he was able, to depict the complex combinatory expressions resulting from conflicted emotions and ambivalent sentiments, expressions that had already become part of the vocabularies of modern writers and artists. He attempted to articulate visually what historian Barbara Stafford has described as the "amorphous language of the inchoate feelings which exists below the rational articulation of the canonical Cartesian passions."[111] For Duchenne such expressions could be synthetically manufactured only by electroshock and in the setting of elaborately constructed theater pieces featuring gestures and accessory symbols. These melodramatic tableaux, which film historian Tom Gunning has called "nightmarish scene[s] of a meta-narrative of control and technological manipulation,"[112] include the nun in "extremely sorrowful prayer" experiencing "saintly transports of virginal purity"; the mother feeling both pain and joy while leaning over a child's crib; the bare-shouldered coquette looking at once offended, haughty, and mocking; and three scenes of Lady Macbeth expressing the "aggressive and

wicked passions, of hatred, of jealousy, of cruel instincts," modulated to varying degrees by contrary feelings of filial piety.[113] Indeed, not only did Duchenne stage specific scenes from *Macbeth,* he also reproduced sections of the play's dialogue in his text so that the reader could follow the scenario. This theater of pathognomic affect commands the aesthetic section of *Mécanisme.*

[111]STAFFORD, "'Peculiar Marks': Lavater and the Countenance of Blemished Thought," *Art Journal* 46, no. 3 (fall 1987): 186. Stafford is here discussing Lichtenberg's "semiotics of affects."

[112]GUNNING, "In Your Face: Physiognomy, Photography, and the Gnostic Mission of Early Film," 9.

[113]DUCHENNE, *Mécanisme,* part 3, 169–74; Cuthbertson trans., 120–2.

Ambiguous Mechanics

The first paragraph of *Mécanisme* functions as an epigraph and is drawn from Comte de Buffon's *Histoire de l'homme* (c. 1749):

When the spirit is roused, the human face becomes a living picture where the emotions are registered with much delicacy and energy, where each movement of the spirit is expressed by a feature, each action by a characteristic, the swift, sharp impression of which anticipates the will and discloses our most secret feelings.[114]

The quotation encapsulates the notion of the "mechanics of passion" that informed Buffon's and nearly all other physiognomic and pathognomic dissertations and their illustrations. Buffon was not completely wedded to a philosophy of Cartesian mechanics, but his ideas, like Duchenne's, can be traced back to Descartes, who believed that the soul was located in the pineal gland and that this gland drove the machine of the body by exciting the neural filaments.[115] For Duchenne the exact seat of the soul was unimportant, though wherever it lay, it controlled the machine of the body by contracting the muscles. And just as Le Brun's diagrammatic drawings suddenly immobilized and recorded the stormiest of passions in a "pictorial language that was always at the disposal of Reason,"[116] Duchenne's photographs immobilized the "expressive lines and . . . the truth of expression" in a newer form of pictorial language that was equally at the service of scientific observation.[117] Descartes's bodily mechanics had evolved into a mechanical body that could be perceived, measured, constructed by science, and pictured by photography.

But eighteenth-century reason and nineteenth-century positivism were coming to an end, and in many ways Duchenne represents their last efforts. He was already aware that the viewer's subjectivity contributed to his or her interpretation of expressions. He himself had fallen into this trap early in his research. He had assumed that in expressing pain, the isolated movement of the eyebrow muscle animated the entire face. When

he shocked this muscle into contracting at the exact moment when the model's veil accidentally fell over her upper face, he made the startling discovery that the lower portion remained inexpressive and neutral. Duchenne had, indeed, unmasked an "illusion" and a "mirage," but of what consequence was this revelation?[118] Novelists had long recognized the role of subjectivity in reading expressions, as had most revelers attending masked balls or any flirtatious ingenue hiding behind a fan. As the Austrian philosopher Ludwig Wittgenstein later observed, "Get a human being to give angry, proud, ironical looks; and now veil the face so that only the eyes remain uncovered—in which the whole expression seemed concentrated—their expression is now surprisingly *ambiguous*."[119] Expressions could deceive, and their meanings be rendered dubious by extraneous accessories such as a veil—so much so, in fact, that the German sociologist Georg Simmel declared in 1901 that "appearance [is] the veiling and unveiling of the soul."[120]

The use-value of facial expressions signifying precise emotions began to wane in the 1860s among both artists and critics. Duranty expressed a grave mistrust for and cynicism toward physiognomics, and Degas searched for a far more relativistic and embracing approach. In 1865 Pierre Gratiolet (his book on physiognomics was included in Chesneau's 1866 review) asserted that "there is no movement that does not have its physiognomy," including gestures, postures, and motions of the hands, feet, and limbs.[121] For Chesneau, Gratiolet's book showed "what secret links unite the signs that are spontaneously employed with what is signified, which is to say the idea or sentiments that they manifest. . . . directly, sympathetically, symbolically, or metaphorically in external organs."[122] Gratiolet was a trained neuroanatomist, among the first to suggest the notion of localized brain functions, and his concern for physiognomy was essentially scientific—though not entirely, it would seem: Creating taxonomies of sympathetic, symbolic, or metaphoric sentiments was hardly

[114]DUCHENNE, *Mécanisme,* part 1, 5; Cuthbertson trans., 1.

[115]For a fuller discussion of Buffon and mechanistic theories, see STAFFORD, *Body Criticism: Imaging the Unseen in Enlightenment Art and Medicine* (Cambridge: MIT Press, 1991), 322. Stafford also discusses the materialistic mechanics embodied in Descartes's writing, Julien Offray de La Mettrie's *L'Homme machine* (1748), and Diderot's *Eléments de physiologie*

(1778). Ibid, 253–4. See also SYPHER, "The Late-Baroque Image: Poussin and Racine," 212.

[116]ROGERSON, "The Art of Painting the Passions," 76.

[117]DUCHENNE, *Mécanisme,* part 3, 134; Cuthbertson trans., 103.

[118]DUCHENNE, *Mécanisme,* part 1, 20; Cuthbertson trans., 13.

[119]LUDWIG WITTGENSTEIN, *Zettel,* ed. G. E. M. Anscombe and G. H. Wright, trans. Anscombe (Berkeley: University of California Press, 1970), 41e.

[120]GEORG SIMMEL, "Aesthetic Significance of the Face," trans. Lore Ferguson, in Kurt H. Wolff, ed., *Essays on Sociology, Philosophy and Aesthetics* (New York: Harper & Row, 1959), 281.

[121]PIERRE GRATIOLET, *De la physionomie et des mouvements d'expression. Suivi d'une notice sur sa vie et ses travaux, et de la nomenclature de ses ouvrages par Louis Grandeau* (Paris: J. Hetzel, 1865); quoted in Chesneau, "De la physionomie," *Le Constitutionnel* 51, no. 288 (16 October 1866): [2].

[122]Ibid.

a scientific approach. Yet artists, from Degas to van Gogh and beyond, could easily render such sentiments, as well as other states of mind that were equally unchartable by positivist science. Furthermore, by the 1890s in France, a "new psychology" had begun to challenge the positivist conception of the self by emphasizing the clinical use of hypnosis and suggestion (both auto- and otherwise) and proposing that the mind not only received images but projected them on the external world. (The new psychology will be discussed further in the following chapters.) These ideas were quickly absorbed by Symbolist artists there and elsewhere.[123] In 1891 the French journalist Alfred Fouillée wrote that the "new psychology has wrested from us the illusion of a bounded, impenetrable, and autonomous ego" and described suggestion as a powerful force that affects our perceptions and completely compromises the sense of discrete individuality.[124] Still later Antonin Artaud, a French dramatist and artist keenly attuned to faces, wrote in his essay that van Gogh "could make of the human head a portrait which was the bursting flare of a throbbing, exploded heart," adding, "His own."[125] It was precisely this awareness of subjectivity in expressing emotions as well as in reading them that was lacking not only in Duchenne's but in nearly all standard theories of physiognomic expression.

Mechanical bodies, as well as the observation of them, had by now come to be seen as infected by the virus of subjectivity. Duchenne's pioneering work, therefore, can be positioned between Descartes's bodily mechanics and Gilles Deleuze and Félix Guattari's "abstract machine of faciality." Philosopher and psychoanalyst, respectively, the latter propose that the "face is not an envelope exterior to the person who speaks, thinks, or feels"; faces do not come "ready-made" but instead are "engendered by an *abstract machine of faciality (visagéité),* which produces them at the same time as it gives the signifier its white wall and subjectivity its black hole. Thus the black hole/white wall system is, to begin with, not a face but

the abstract machine that produces faces according to the changeable combinations of its cogwheels."[126] The human face is here considered as a fluid matrix of forces rather than an essentialist guide to the bearer's soul; it is a construction at once an opaque surface seen and dominated from without (a concept to be further discussed in chapter two) and an abysmal depth loaded with subjectivities that can shift and mutate at any moment (the basis of chapter three). Artists since Duchenne's time, of course, have continued to portray faces and their expressive countenances, but many other modernist and postmodernist artists have not. The face for many artists has evolved into what critic John Welchman calls a "double zone of distortion and reduction": "no longer a mirror for the soul or an assigned marker for the narrative flow[,] it has eventually become an arena of *facture* among other adjacent places, other marks."[127] And if the ultimate condition of subjectivity is Antonin Artaud's "body without organs" or a state of being exempted from physicality, one might infer that the face is itself an organ without a body, "alienated from the body and the social envelope alike, or . . . reconvened as a structure, invaded and controlled by the outside."[128]

A Theater of the Passions

After Duchenne a decided rupture between the soul and its physiognomic expression took place; our vision shifted, in the words of novelist Kōbō Abe, "from the classical harmony of heart and face to the representation of character devoid of harmony, completely collapsing into Picasso's eight-sided faces and Klee's *False Face*."[129] Cartesian mechanics became more fluid, the truth of photography more suspect, the normal and the pathological more alike, and the face and the mask more interchangeable. How, then, might we position Duchenne's *Mécanisme,* this rare and fascinating curiosity of medical literature and art theory? To be sure, in his search for a way to visualize the soul's emotions, Duchenne firmly established the modern, biological concept of emotional expression.[130] *Mécanisme* was the first essay on "psychophysiology" to be truly scientific in its methods, and it laid the foundation for most of the research that followed and that still continues to this day, despite Duchenne's many physiological errors, his myological oversimplifications, his insistence on observational description instead of explanation, his nearly complete

[123]See DEBORA L. SILVERMAN, *Art Nouveau in Fin-de-Siècle France: Politics, Psychology, and Style* (Berkeley: University of California Press, 1989), 84 and passim.

[124]ALFRED FOUILLÉE, "Les Grandes Conclusions de la psychologie contemporaine—La Conscience et ses transformations," *Revue des deux mondes* 107 (1891): 811–3; quoted in Silverman, *Art Nouveau in Fin-de-Siècle France,* 91.

[125]ANTONIN ARTAUD, "Le Visage humain . . ." trans. Roger McKeon, in Margit Rowell, ed., *Antonin Artaud: Works on Paper,* exh. cat. (New York: Museum of Modern Art, 1996), 95.

[126]GILLES DELEUZE and FÉLIX GUATTARI, *A Thousand Plateaus: Capitalism and Schizophrenia,* trans. Brian Massumi (Minneapolis: University of Minnesota Press, 1987), 167–8.

[127]JOHN WELCHMAN, "Face(t)s: Notes on Faciality," *Artforum* 27, no. 3 (November 1988): 135.

[128]Ibid., 131.

[129]KŌBŌ ABE, *The Face of Another,* trans. E. Dale Saunders (Tokyo: Charles E. Tuttle, 1967), 45.

[130]For more on this subject, see GUILLY, *Duchenne de Boulogne,* 214.

lack of interest in the expressive characteristics of the eyes, and his frequent references to God when in doubt. With this one work, in short, Duchenne created a monument, at once absurd and revealing, to what Welchman has called the "rationalism of biological (and spiritual) engineering."[131]

In medical terms, Duchenne's *Mécanisme* is poised between Giovanni Aldini's attempts in 1802 to reanimate cadavers with galvanic shock and the introduction of electroshock therapy for psychiatric patients by Ugo Cerletti in 1938. Scientifically, it is locatable at a point somewhere between Lavater's work on physiognomics in 1775–78 and Darwin's on expressions in 1872. Photographically, it bears as much relation to portraits of the 1850s by the Nadars as it does to Paul Regnard's photographic documentation of "alienated" patients in *L'Iconographie photographique de la Salpêtrière* of the late 1870s. Artistically, Duchenne's images are situated between Géricault's sensitive depictions of monomaniacs of the 1820s and Degas's psychologically penetrating portraits of the 1870s. And dramatically, Duchenne's *Mécanisme* holds lessons that echo the rules governing the late-Baroque theater of Racine, just as it anticipates, as it were, the organically expressive twentieth-century theater of Antonin Artaud.

Duchenne's most famous student, Jean-Martin Charcot, became director of the Salpêtrière in 1862, adopted Duchenne's photographic experiments, and named an examination room at the asylum after his teacher. Like Duchenne, Charcot sought taxonomically to chart the gestures and expressions of his patients and believed as well that these expressions were subject to laws that governed them with the "regularity of a mechanism."[132] Both men had inordinate faith in visual perception: Charcot considered himself metaphorically "absolutely nothing but a photographer, I inscribe what I see," and Freud considered him a "'visuel,' a man

who sees."[133] Unlike Duchenne, however, Charcot was interested exclusively in highly traumatized subjects, viewing the population of more than five thousand patients at the Salpêtrière as a "living pathological museum."[134] He encouraged the photographing of hysterics and epileptics by Paul Regnard, a doctor and amateur photographer, as well as the application of chronophotography in recording the writhings of epileptics, hystero-epileptics, and grand hysterics by Albert Londe, a photographer and amateur clinician.[135] Londe recounted that he had assembled a group of female hysterics in front of a camera ostensibly for their formal portrait, then sounded a loud gong that caused them to assume wildly extreme cataleptic poses, and photographed tableaux of histrionics that defy rational explanation.[136] If Duchenne felt obliged to pose his female subject like a mannequin, Charcot went so far as to animate each Galatea: A colleague described an experiment in which verbal suggestions induced a female patient to hallucinate and perform "like an actor who, beset by madness, imagines that the drama she plays is a reality, not a fiction," assuming and speaking the roles of a peasant, an actress, and a nun in quick succession.[137] Each Tuesday Charcot also staged what he called a "theater of the passions," in which an audience of high society and those devoted to scientific reason and medical jurisdiction were confronted by the "uncontrollable fits and rages of hysterical bodies" and by what sociologist John O'Neill has called the "transgressive possibilities" of an "erotics of a male science imposing itself upon a female body."[138]

As a student in late 1885 and early 1886, Freud had attended Charcot's theater of the passions, but he quickly abandoned a clinical method based on so-called objective observation for one based on the subjectivity of the patient's voice. Much of the mostly visual "unanalyzed/unanalyzable

[131]WELCHMAN, "Face(t)s: Notes on Faciality," 134.

[132]JEAN-MARTIN CHARCOT, *Oeuvres complètes,* vol. 3 (Paris: Aux Bureaux du Progrès médical/Lecrosnier & Babé, 1886–93), 15; quoted in Georges Didi-Huberman, *Invention de l'hystérie: Charcot et l'iconographie photographique de la Salpêtrière,* 78.

[133]CHARCOT, "L'Hystérie féminine," in *L'Hystérie: Textes choisis et présentés par E. Trillat* (Toulouse: Privat, 1971), 121; quoted in Ulrich Baer, "Photography and Hysteria: Toward a Poetics of the Flash," *The Yale Journal of Criticism* 7, no. 1 (spring 1994): 48; FREUD, "Charcot," in *The Standard Edition of the Complete Psychological Works of Sigmund Freud* (London: Hogarth Press, 1953–74), 3, 12; quoted in Gilman, *Seeing the Insane,* 204.

Freud was Charcot's student for a brief time in 1885–86. See L. C. MCHENRY, *Garrison's History of Neurology* (Springfield, Ill.: Charles C. Thomas, 1969), 282.

[134]CHARCOT, "Leçons sur les maladies du système nerveux," *Oeuvres complètes,* vol. 3, 4; quoted in Didi-Huberman, *Invention de l'hystérie,* 275.

[135]See DÉSIRÉ-MAGLOIRE BOURNEVILLE, preface to Bourneville and Paul Regnard, *L'Iconographie photographique de la Salpêtrière,* vol. 1 (Paris: Aux Bureaux du Progrès médical/Delahaye & Lecrosnier, 1876–77), iii–iv, in Didi-Huberman, *Invention de l'hystérie,* 277; and ALBERT LONDE, *La Photographie médicale: Application aux sciences médicales et physiologiques* (Paris: Gauthier-Villars, 1893), 3–4, in ibid., 279. While Regnard's images are disquieting,

they remain standard clinical portraits of patients frozen for a moment, not dissimilar to Duchenne's. In contrast, Londe's experimental chronophotographs of male and female hysterics flailing in their beds, recorded with a six-lens camera of his design, radically depart from nineteenth-century medical photography. They are no longer portraits in the strictest sense but documents in which the patient's writhing and grimacing body "becomes a photographic exercise, perceived as a landscape, a plastic object, a system of forms." DENIS BERNARD and ANDRÉ GUNTHERT, *L'Instant rêvé: Albert Londe, 1858–1917* (Nîmes and Laval: Jacques Chambon and Editions Trois, 1993), 132.

[136]LONDE, *La Photographie médicale,* 90; quoted in Didi-Huberman, *Invention de l'hystérie,* 284; see also fig. 89. Although both Charcot and

Freud were aware of male hysteria, they devoted most of their efforts to female hysterics. The illustrations in *L'Iconographie photographique de la Salpêtrière* are nearly exclusively of women; those in *La Nouvelle Iconographie de la Salpêtrière,* especially by the early 1890s, feature a far greater proportion of men.

[137]PAUL RICHER, *Etudes cliniques sur la grande hystérie ou hystéro-épilepsie,* 2nd ed. (Paris: Delahaye & Lecrosnier, 1881), 728–30; quoted in Didi-Huberman, *Invention de l'hystérie,* 287.

[138]JOHN O'NEILL, "The Question of an Introduction: Understanding and the Passion of Ignorance," in O'Neill, ed., *Freud and the Passions* (University Park, Pa.: Pennsylvania State University Press, 1996), 10.

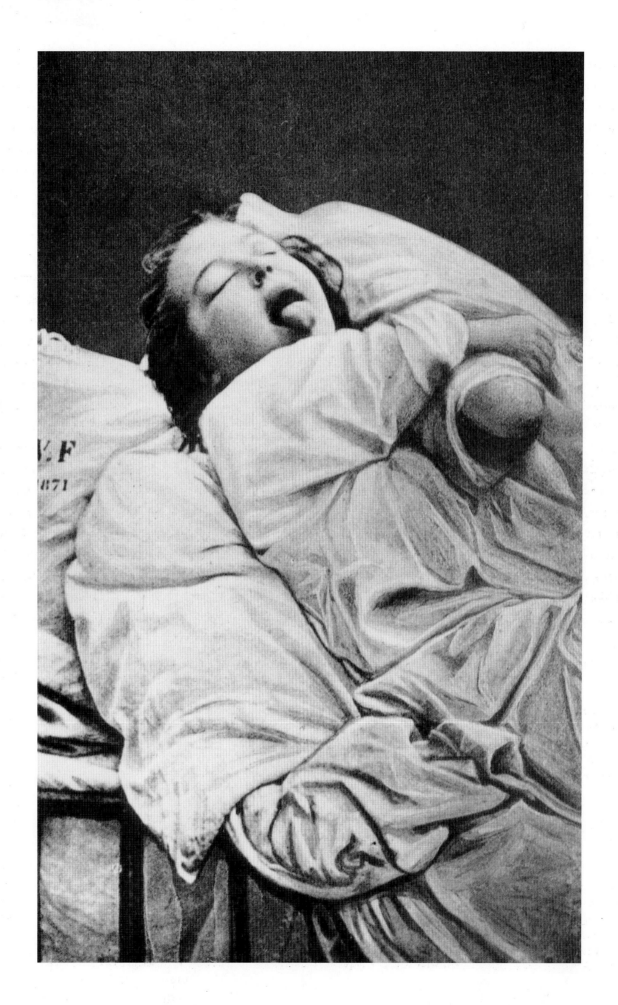

Paul Regnard,
*Beginning of an
Attack (Cry)*, from
*L'Iconographie pho-
tographique de la
Salpêtrière* (1878),
collotype print,
photograph courtesy
Yale University,
Harvey Cushing/
John Hay Whitney
Medical Library.

Eugène Pirodon,
*A Lesson by Charcot
at the Salpêtrière*
(after a painting
by P.-A. Brouiller),
c. 1885, etching,
photograph courtesy
The Welcome Trust,
London.

residue of hysteria, neurosis, and psychosis" was omitted from Freud's science.[139] Both Freud and Duchenne ignored the expressions of madness and insanity, Freud for reasons of political efficacy and methodology, Duchenne for reasons of beauty and aesthetics. Duchenne's *Mécanisme* and Charcot's theater of the passions (more about which in chapter three) effectively mark a terminus to the physiognomic culture that had flourished so vigorously since Lavater. What followed might be labeled a "psychoanalytic culture," in which the self and its soul were imploded and impacted within the mind and its subconscious, and the physiological face was rendered moot if not mute. When Freud described a "thousand unnoticed openings . . . which let a penetrating eye at once into a man's soul," he was referring metaphorically to the gaps in a patient's speech; his was a science of linguistic analysis, not one of visual interpretation.[140] Our emotions may still reveal themselves through our corporeal structures, but new ways of reading them have had to be developed, and new means, different from Duchenne's, must be inaugurated to portray the fundamental nature of the human psyche. "In effect," wrote critic François Dagognet, "the psychomotorial has been obliged to become 'virtual' to such an extent that it has almost disappeared from view. One must learn to represent it, to convert the interior to the exterior. Then it will be possible to put the 'mind' outside, to lay it bare."[141] In other words, we are still trying, albeit in a different fashion, to discover what lies beneath the surface.

Duchenne's ultimate legacy may be that he set the stage, as it were, for Charcot's visual theater of the passions and defined the essential dramaturgy of all the visual theaters, both scientific and artistic, that have since been conceived in the attempt to picture our psyches. Since the publication of Duchenne's largely forgotten masterpiece of nineteenth-century scientific documentation, photography as well as film and video has played an ever-expanding role in subsuming physiognomic studies, a role that will be further discussed in the following chapters.[142] There is a kind of Futurist theater of the face in Arturo Bragaglia's chronophotographic *Polyphysiognomic Portrait* of 1930 and a Surrealist theater of the emotions in Salvador Dalí's photomontage *The Phenomenon of Ecstasy* of 1933. A psychological theater, too, is surely at work in Diane Arbus's photographs, especially in her final images, and in the still melodramas of Cindy Sherman. The influence of Duchenne's (and Charcot's) dramaturgy may likewise be clearly seen in such early popular films as the American Mutoscope and Biograph Company's *Female Facial Expressions* (1902),[143] in Marion Davies's array of expressions in King Vidor's *Show People* (1928), in Richard Widmark's furtive aspect in the opening scene of Samuel Fuller's *Pickup on South Street* (1953), and in Madeline Kahn's swooning in Mel Brooks's *Young Frankenstein* (1974). The list could also include videos by Bruce Nauman and Douglas Gordon. Suffice it to say that what Le Brun's system was to eighteenth- and nineteenth-century theater and history painting, Duchenne's photography was, at least metaphorically, to twentieth-century photography and film, in their appeal to what Artaud called the "cruelty and terror" that "confronts us with all our possibilities."[144] In the end, Duchenne's *Mécanisme de la physionomie humaine* and the photographic stills from its experimental theater of electroshock excitations established the modern field on which the struggle to depict and thus discern the ever-elusive meanings of our coded faces continues even now to be waged.

[139]Ibid., 11.

[140]FREUD, "Symptomatic and Chance Actions," in *The Psychopathology of Everyday Life*, ed. James Strachey, trans. Alan Tyson (New York: W. W. Norton, 1965), 194. For an analysis of the differences between Charcot's and Freud's methods, see DAPHNE DE MARNEFFE, "Looking and Listening: The Construction of Clinical Knowledge in Charcot and Freud," *Signs* 17, no. 1 (autumn 1991): 71–111. BAER points out that the reappearance of images in Freud's later work suggests the importance of Charcot's photography to psychoanalysis. "Photography and Hysteria: Toward a Poetics of the Flash," 45. For more on Freud's rejection of images, see JOAN COPJEC, "Flavit et Dissipati Sunt," *October*, no. 18 (fall 1981): 20–40.

[141]FRANÇOIS DAGOGNET, "Toward a Biopsychiatry," trans. Donald M. Leslie, in Jonathan Crary and Sanford Kwinter, eds., *Incorporations, Zone 6* (New York: Zone Books, 1992), 517.

[142]Cf. WELCHMAN, "Face(t)s: Notes on Faciality," 136.

[143]This and similar films constitute what film critic Tom Gunning calls a "cinema of attractions," a genre of non-narrative spectacles sometimes featuring close-ups of faces and grimaces that, according to critic Lisa Cartwright, refuse "self-regulation." GUNNING, "Cinema of Attractions," in Thomas Elsaesser, ed., *Early Cinema: Space, Frame, Narrative* (London: British Film Institute, 1990), 56–62; CARTWRIGHT, *Screening the Body: Tracing Medi-* cine's Visual Culture (Minneapolis: University of Minnesota Press, 1995), 16. See also the film *Facial Expressions by Loney Haskell* (Biograph, 1897); mentioned in Charles Musser, *The Emergence of Cinema: The American Screen to 1907* (Berkeley: University of California Press, 1994), 4.

[144]ARTAUD, *The Theater and Its Double*, trans. Mary Caroline Richards (New York: Grove Press, 1958), 86.

An abridged version of this chapter appeared under the same title in Anne Anniger and Julie Melby, eds., *Six Exposures: Essays in Celebration of the Opening of the Harrison D. Horblit Collection of Early Photography* (Cambridge: The President and Fellows of Harvard College Press, 1999), 107–29. [A note on the footnotes: For texts written before the invention of photography, I have cited a later edition that would have been available to photographers of the time.]

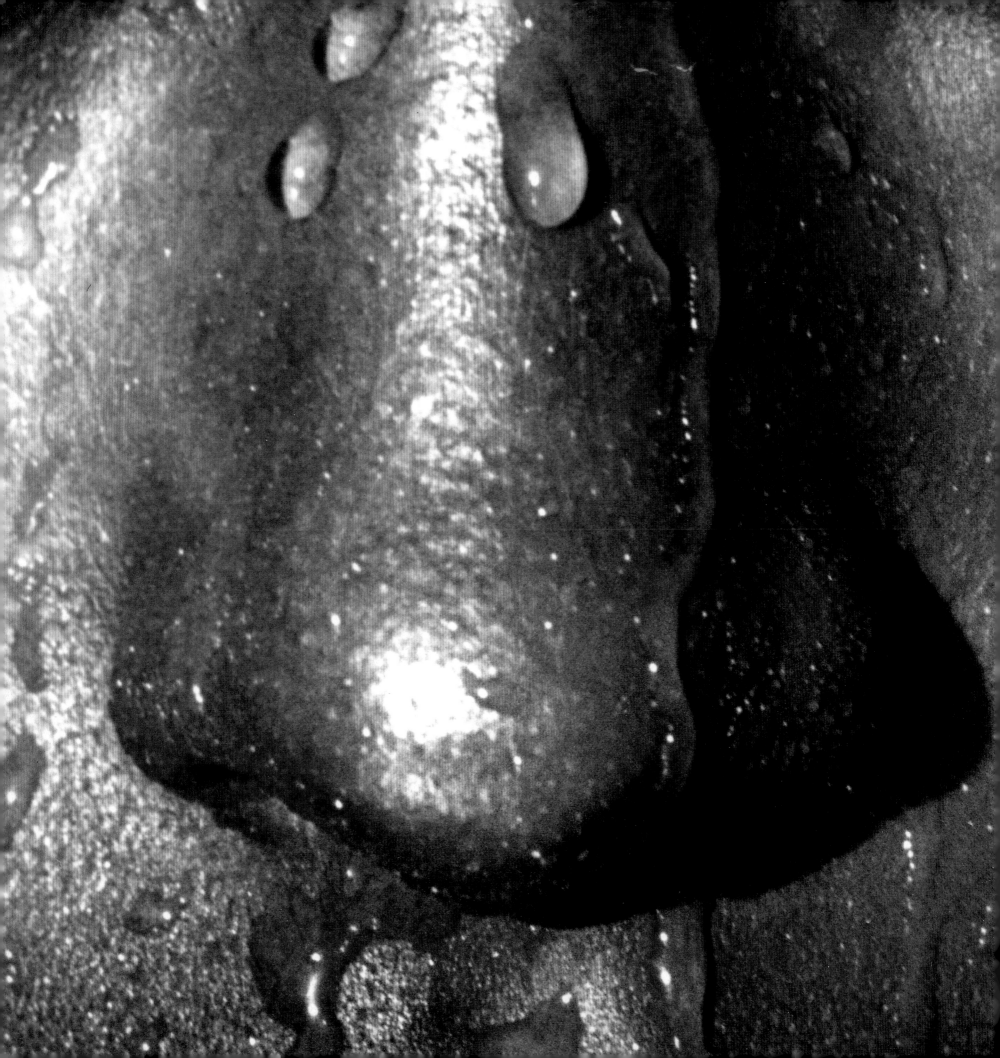

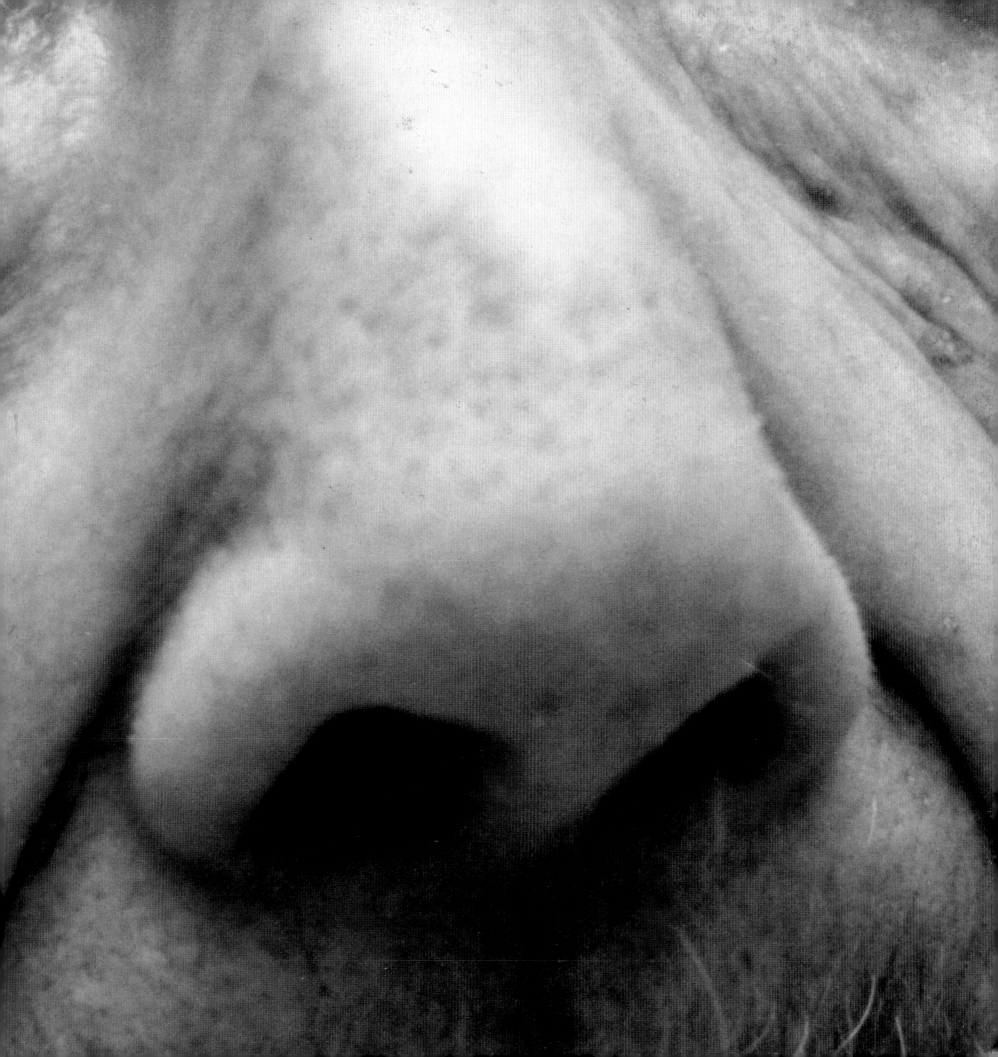

II

"Tolerances of the Human Face"

THE AFFECTLESS SURFACES OF

Andy Warhol

If you want to know all about Andy Warhol,
just look at the surface:
of my paintings and films and me,
and there I am.
There's nothing behind it. ANDY WARHOL, quoted in Gretchen Berg, "Andy: My True Story," *Los Angeles Free Press,* 17 March 1967.

RIGHT
Howland, *Points of Measurement* (detail), from George Combe et al., *Moral and Intellectual Science Applied to the Elevation of Society* (1848), engraving, private collection, Los Angeles.

OPPOSITE
Oskar Schlemmer, *Man in the Sphere of Ideas,* c. 1928, pen-and-ink drawing, © 1999 the Oskar Schlemmer Theater Estate, photograph courtesy Photograph Archive C. Raman Schlemmer, Oggebbio, Italy.

We will never know what is the other real mood / feel person.

[1] See LAILAN YOUNG, *The Naked Face: The Essential Guide to Reading Faces* (New York: St. Martin's, 1993); TERRY LANDAU, *About Faces: The Evolution of the Human Face* (New York and London: Doubleday, 1989); and JOHN LIGGETT, *The Human Face* (New York: Stein and Day, 1974). Duchenne's lessons, however, continue to influence life-drawing classes, such as those taught by Robert Beverly Hale at the Art

Students League in New York during the 1970s. According to HALE, "the expressions are limitless, depending on the muscles used. Artists know these things. For a real smile—not an airline-hostess smile—you employ the zygomaticus major, the smiling muscle. The circular muscles of the eye must act for a sincere smile"; quoted in Philip Hamburger, "All in the Artist's Head," *New Yorker,* 13 June 1977, 66.

In the century after the publication of Duchenne de Boulogne's *Mécanisme de la physionomie humaine,* the physiognomic culture all but disappeared, and the idea that the human face expresses inner character grew steadily suspect. Faces are no longer viewed as positivist conveyances of concrete signification, and what they convey, if anything, is considered so fractured and decentered as to render personalities utterly indeterminable by the examination of a single look or facial expression. We may continue to "read" faces in order to judge fleeting moods or feelings, but for the most part physiognomy, pathognomy, and phrenology have been reduced to incidental popular pastimes, on a par with palmistry and tarot-card reading.[1] According to the physiologist Paul Ekman, scientific research into human expression during the twentieth century can be apportioned into four general periods. From about 1914 to 1940, the field, or what remained of it,

Non visto come scienze ma beas come fantasia

"UG TO HG"
OTIUZZO DGI
GGGTI G DGLLG
GSPRGGGIONI
PGR GPPING
LA GUA
PSIGOG@

was marked by an essential pessimism, and facial gestures were largely discounted as accurate guides to a person's true emotions. From about 1940 to 1960, research waned further, and the little there was centered primarily on the vocabulary used in observing facial gestures. Clinical interest in the subject was renewed in the 1960s and concentrated on semiotics and behavioral measures primarily useful to psychotherapy.[2] During the 1970s and 1980s, Ekman and company revived and corrected Duchenne's experiments, and some clinical interest in physiognomics still persists,[3] but the face and its expressions are simply no longer vested, either culturally or artistically, with the authority and significance they had in Duchenne's era. Artists after Duchenne have responded to and further complicated this uncertainty with one of two basic approaches: treating the face either as a blank somatic surface expressive of absolutely nothing yet infinitely suggestive, or as a fluid matrix of constantly shifting identities at once true and false, assumed and genuine, feigned and imagined. This chapter explores the first of these approaches—the face as an expressionless surface—trusting essayist William Gass's words, "Make no mistake—it is *on* the surface and *with* the surface that we must make love, if even to the soul."[4]

The scientific faith with which Duchenne, and indeed most nineteenth-century researchers, approached the study of physiognomics began to wane in the decades following his and Darwin's publications. Certainty was first undermined by the "new psychology" developed in part by Duchenne's student, Jean-Martin Charcot, through his studies of hysteria and neurasthenia, and in part by another clinician, Hippolyte Bernheim of the Faculté de Médicine at Nancy, through his work with hypnosis, suggestion, visual hallucinations, and mental imaging.[5] Bernheim proposed that "sensorial hallucinations" were a vital part of human consciousness. In 1884 he wrote, "Poor human reason has taken flight. The most ambitious spirit yields to hallucinations."[6] He emphasized the lack of connection between these hallucinations and all scientifically measurable reality: "The hallucinatory image. . . . does not pass through the apparatus of vision, has no objective reality, follows no optical laws, but solely obeys the caprices of the imagination."[7] Projected onto the external world, Bernheim argued, such images radically shape the environment according to the fictions of individual inner visions. Art historian Debora Silverman has noted that Bernheim's theories anticipated the antipositivist, Symbolist manifestos of 1886, in which subjectivity was objectified and the mind's interior became "the emblem of self-fashioning." Furthermore, the new psychology also greatly influenced the philosopher Henri Bergson's concept of the fluid indeterminacy of the mind, outlined in his *Essai sur les données immédiates de la conscience* (Essay on the immediate data of consciousness, 1889).[8] Bernheim's and Charcot's work with hypnosis and hallucination affected novels, such as Joris-Karl Huysmans's *A rebours* (*Against the Grain,* 1884) and Marcel Proust's *Du côté de chez Swann* (*Swann's Way,* 1913), as well as the plays of Henrik Ibsen and August Strindberg. Bernheim's "hallucinations" and Charcot's "unsuspected realms of the mind"[9] fueled a widespread belief "that personality is neither really defined, nor permanent, nor stationary; that the sense of free will is essentially floating and illusive, memory multiple and intermittent; and that character is a function of these variable qualities and can be modified."[10] The doctrine of secular immanence (discussed in chapter one), which held that outward appearances controlled inner states, thus gave way to a new

86

[2] Paul Ekman, Wallace V. Friesen, and Phoebe Ellsworth, "Conceptual Ambiguities," in Ekman, ed., *Emotion in the Human Face,* 2nd ed. (Cambridge: Cambridge University Press, 1982), 7–8.

[3] See Ekman, *Emotion in the Human Face,* in which thirty-eight works by Ekman and others are cited in the bibliographical references. Other modern research of note includes the work of Robert Plutchik and Robert H. Frank; see Paul E. Griffiths, *What Emotions Really Are: The Problem of Psychological Categories* (Chicago: University of Chicago Press, 1997), 69–71. For a list of more recent work on facial analysis and expressions, see "Facial Analysis," *UCSC Perpetual Science Laboratory* (University of California, Santa Cruz), online: http://mambo.ucsc.edu (15 December 1998); and *7th European Conference: Facial Expression—Measurement and Meaning, 16–20 July 1997—Salzburg,* online: http://www.sbg.ac.at/psy/events/facs (15 December 1998).

[4] William H. Gass, "The Face of the City: Reading Consciousness in Its Tics and Wrinkles," *Harper's,* March 1986, 37.

[5] See Debora L. Silverman, *Art Nouveau in Fin-de-Siècle France: Politics, Psychology, and Style* (Berkeley: University of California Press, 1989), 84 and passim.

[6] Hippolyte Bernheim, *De la suggestion dans l'état hypnotique et dans l'état de veille* (Paris: Doin, 1884), 89–90; quoted in Silverman, *Art Nouveau in Fin-de-Siècle France,* 87.

[7] Bernheim, *Suggestive Therapeutics: A Treatise on the Nature and Uses of Hypnotism,* trans. Christian Herter (New York: Putnam, 1887), 103–4; quoted in Silverman, *Art Nouveau in Fin-de-Siècle France,* 88.

[8] Silverman, *Art Nouveau in Fin-de-Siècle France,* 76–91.

[9] Tribute to Charcot by the critic Téodor de Wyzewa, *Figaro* (1893); quoted in Henri F. Ellenberger, *The Discovery of the Unconscious: The History and Evolution of Dynamic Psychiatry* (New York: Basic Books, 1970), 99.

[10] Philippe Daryl, "La Suggestion et la personnalité humaine," *Le Temps,* 21 November 1885, 3; quoted in Silverman, *Art Nouveau in Fin-de-Siècle France,* 89.

doctrine of psychic immanence in which the fluidly indeterminate human ego was able to project its multiple and shifting subjectivities onto the phenomenal world. This doctrine clearly informs the subtle and evocative portraits made by such widely differing Symbolist photographers as Gertrude Käsebier and Alvin Langdon Coburn early in this century.

In such a climate, it is not surprising that traditional trust in the portrait's ability to reveal the inner workings of its subject began to unravel. By 1914, when medical science had all but abandoned its concern with physiognomics, avant-garde painting, especially in the guise of Cubism, was also divesting portraiture of interiority or subjectivity. Critic Benjamin Buchloh cites the portraits of Daniel Kahnweiler and others by Picasso in 1910 as examples of this dismantlement:

[These] antiportraits fuse the sitter's subjectivity in a continuous network of phenomenological interdependence between pictorial surface and virtual space, between bodily volume and painterly texture, as all physiognomic features merge instantly with their persistent negation in a pictorial erasure of efforts at mimetic resemblance.[11]

In Analytical Cubism, the mask, caricature, and a certain mechanization of facial features conspired to devalue the fluid range of human expression and reduce the face to complex repetitions and echoes of geometric forms. Of course, there are notable exceptions, such as Picasso's portrait of critic Wilhelm Uhde, also of 1910, with its caricatural pinched mouth.[12] Picasso abandoned this approach to portraiture as early as 1915 and in the late 1930s vested his representations of the human face with explicit

[11] BENJAMIN H. D. BUCHLOH, "Residual Resemblance: Notes on the Ends of Portraiture," in Melissa E. Feldman, *Face-Off: The Portrait in Recent Art*, exh. cat. (Philadelphia: Institute of Contemporary Art, University of Pennsylvania, 1994), 53–54. I am indebted to Norman Bryson for bringing this important essay to my attention.

[12] WILLIAM RUBIN, ed., *Picasso and Portraiture: Representation and Transformation* (New York: Museum of Modern Art, 1996), 281. I am grateful to Kirk Varnedoe for bringing this portrait to my attention at his lecture "Rethinking Picasso Today," Los Angeles County Museum of Art, 3 September 1998.

[13] GEORGE ELIOT, *Adam Bede* (London: J. M. Dent, 1994), 142–3.

[14] E. M. FORSTER, *Howards End* (New York: Knopf, 1991), 25.

[15] Ibid., 53.

LEFT
Pablo Picasso, *Portrait of Daniel-Henry Kahnweiler*, 1910, oil on canvas, 39⅘ x 29⅘ in. (101.1 x 73.3 cm). Gift of Mrs. Gilbert W. Chapman in Memory of Charles B. Goodspeed, 1948.561. Photograph © 1999, The Art Institute of Chicago, all rights reserved.

PAGE 88
Gertrude Stanton Käsebier, *Portrait (Miss N.)*, platinum print, c. 1902, cat. no. 61.

PAGE 89
Alvin Langdon Coburn, *W. B. Yeats, Dublin, January 24th, 1908*, 1908, courtesy George Eastman House, cat. no. 23.

emotions, as in his series of weeping women. Nonetheless, Cubism's rejection of interiority initiated what would become commonplace in nearly all modernist depictions of the face: the blank look and its neutral surfaces.

In *Adam Bede,* published in 1859 at the height of physiognomic culture, British novelist George Eliot describes a typical man being seduced by a pretty face as a "great physiognomist" who is attentive to all the shapes, textures, and nuances of that face: "Nature, he knows, has a language of her own, which she uses with strict veracity, and he considers himself an adept in the language." The narrator, however, adds a caveat: "Nature has her language, and she is not unveracious; but we don't know all the intricacies of her syntax just yet, and in a hasty reading we may happen to extract the very opposite of her real meaning."[13] A half-century later another British novelist, E. M. Forster, described human personalities as "not mere opportunities for an electrical discharge" of some "passing emotion," but actually capable of sustaining complex relations.[14] Yet Forster also noted that in a photographic portrait "The face—the face does not signify."[15] This shift from a trust in the universality of physiognomic expression, even without complete confidence in its syntax, to a dismissal of the face's signification, seems to have occurred suddenly during the first two decades of this century; and this nearly complete reversal of how faciality may communicate has lasted throughout the modern era. Of course the face can remain a site of social or psychological investigation even if we no longer believe the soul is legible in it. Simply put, the face can still reflect. What it reflects is of considerable consequence and informs most of the blank, expressionless faces in twentieth-century photographic portraiture, from those by August Sander and Walker Evans to those by Richard Avedon and Thomas Ruff.

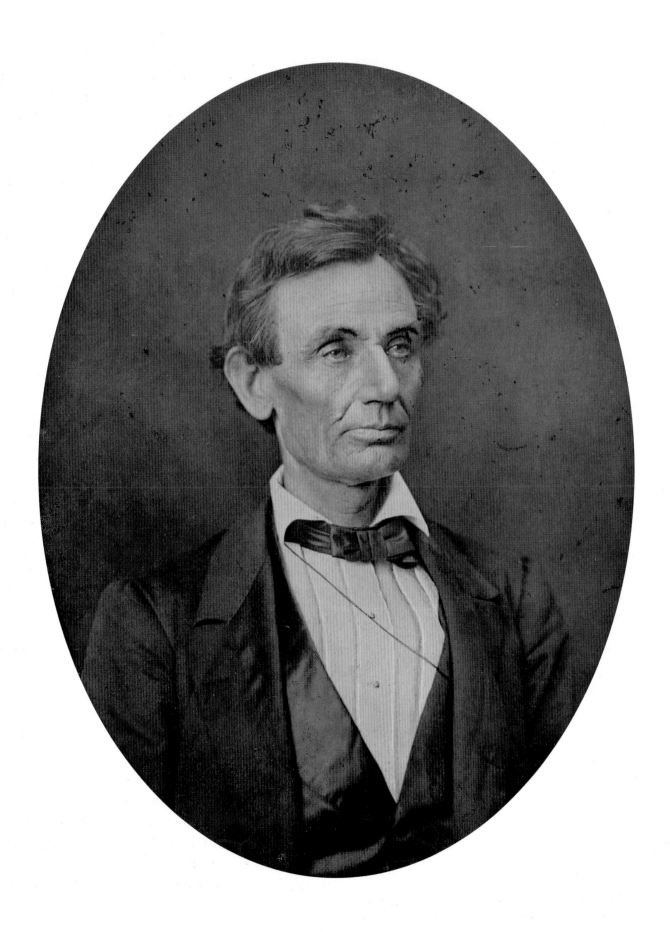

LEFT
Andy Warhol,
Triple Elvis, 1962,
silkscreen ink on syn-
thetic polymer paint
on canvas, Virginia
Museum
of Fine Arts,
Richmond, gift
of Sydney and
Frances Lewis,
© 1999 Virginia
Museum of Fine Arts
and the Andy
Warhol Foundation
for the Visual
Arts/ARS, New York,
photograph courtesy
The Andy Warhol
Foundation, Inc./Art
Resource Society,
New York.

OPPOSITE
Alexander Hesler,
Abraham Lincoln,
1860/printed
1870–80s,
cat. no. 56.

The neutral face, vacant of any expressive gestures, not only is an aesthetic construct of modernism; it also has been a component fundamental to a number of photographic practices since the middle of the last century. Passionate expression has little if anything to do with the nature of likeness, and it is the desire for likeness that commands the photographing of friends and family members as well as social and cultural figures. The satisfaction with neutral likeness explains the deadpan looks found in the majority of ordinary portraits from the slowly exposed daguerreotype to the formally posed salon portrait and to the instantly exposed modern snapshot. Likeness, as well, is the key to the portraiture of celebrities and public personalities from Lola Montez to Leonardo DiCaprio, from Abraham Lincoln to Princess Diana. And likeness forms the basis of pictorial identity, just as it is at the heart of nearly all systems seeking to visually classify or typify human beings according to predetermined criteria. Thus, we find the human face as a blank somatic surface in passports and driver's licenses as well as in all sorts of indexical practices such as those used in anthropology, ethnography, forensic criminology, and medical pathology. Devoid of any inherent subjectivity, twentieth-century portraits seem to be solely about surface, shape, and apparent details.[16] Yet, however at odds with traditional physiognomics these portraits appear to be, no matter how frustrated we may become in trying to interpret the "human essence" contained within them, they still manage to hold our attention.[17]

Nearly all of these issues are inherent in the photo-silkscreened portraits made by Andy Warhol beginning in 1962. Warhol had fully accepted the syntax of photographic portraiture and maximized its impact by enlarging it to a nearly unprecedented scale while personalizing each reproduction by printing it on a painted canvas. The results—the deadpan and lifeless faces of Troy, Elvis, Warren, Natalie, and Marilyn—epitomize the dispassionate twentieth-century portrait. Blank, bored, and consummately empty, the faces look out at us, opaque and insensate, lacking animation

[16] See JOHN WELCHMAN, "Face(t)s: Notes on Faciality," *Artforum* 27, no. 3 (November 1988): 131.

[17] Cf. MICHAEL KIMMELMAN, "Hypnotized by Mug Shots: Windows or Mirrors?" *New York Times,* 27 August 1997, B1.

and communicating no mental or moral feeling.[18] They are inactive anatomic visages first and foremost, constructed of their summary features. They have names; they are the faces of real people with identities, specific personas if not personalities. They carry the social validation of celebrity and, in some cases, the extra baggage of notoriety. They emote nothing at all, appearing to exist solely for us to stare at and in turn project our associations, desires, fantasies, and feelings onto them. What are we to make of these portraits? Are they merely pop-culture alternatives to soup cans or soda bottles? Or do they still function, tacitly or openly, as physiognomic portraits? An examination of facial abstraction, typological systems, and the iconic role of both identity and celebrity might assist in positioning these neutral surfaces within the history of portraiture.

Abstract Systems

For all of his diagrammatics and however idealized and heroic the expressions he depicted, Charles Le Brun's late seventeenth-century work on facial expression was linked to nature and naturalism. For him the appearance of the face at any given moment signified what lay behind it; the face's expression could, and did, change continuously, displaying a variety of shifting moods and temperaments, but his concern was with the momentary apogee of any given emotion. In the late eighteenth century, Johann Kaspar Lavater's physiognomic system, *Physiognomische Fragmente,* similarly relied on the direct observation of natural occurrences on the face's surface, but Lavater formalized this often subjective practice by using the static silhouette, taking measurements of various parts of the face, and expressing these measurements as deviations from a norm. That his norm was none other than the Apollo Belvedere did not seem to pose a problem to a European or American audience. In the Romantic era, the Dutch theorist D. P. G. Humbert de Superville

[18] Consider the definition of "insensate" in WILLIAM LITTLE et al., *The Oxford Universal Dictionary on Historical Principles,* ed. C. T. Onions, 3rd ed. (Oxford: The Clarendon Press, 1955), 1014: "Without sensation, senseless, inanimate; wanting in mental or moral feeling, devoid of sensibility."

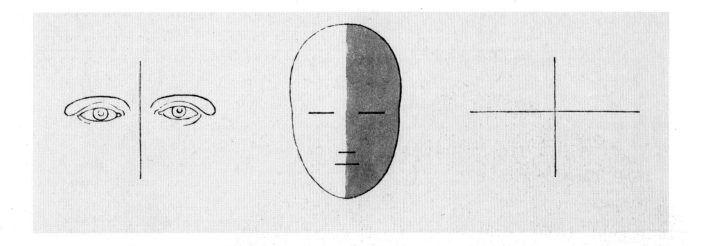

OPPOSITE

Anker Smith, *Apollo*, from Johann Kaspar Lavater, *Essays on Physiognomy* (1789–98), engraving, photograph courtesy the Getty Research Institute for the History of Art and the Humanities.

ABOVE

D. P. G. Humbert de Superville, *Colossus of Memnon* (detail), from *Essai sur les signes inconditionnels dans l'art* (1827–32), engraving and water-color, Printroom, Institute for Art History, State University, Leiden.

also attempted a system of physiognomics in his *Essai sur les signes inconditionnels dans l'art* (Essay on the unconditional signs in art) of 1827–32, one whose minimalist approach made it quite the opposite of Lavater's. Seeking to develop a "comprehensive theory of perception through the codification of human emotions," Humbert replaced Lavater's open-ended encyclopedia—which consisted of hundreds of Le Brun's diagrams, historical portraits, facial types, and isolated features—with a reductivist set of visual symbols, a few directional vectors, and associated colors.[19] He molded these elements into a transcultural semiotic that connected facial expression with religion, philosophy, politics, ethics, and the arts. Anatomically, the principal facial traits were marked by simple lines and their angles measured against a primary perpendicular vertical; morally, primitive moods

or sentiments such as anger or joy were associated with three primary colors—red, white, and black—and a handful of secondary hues.

As far from Lavater as Humbert was, however, both were motivated by one impulse—to link moral qualities to certain physical traits—and that agenda was to inflect nearly every system of face reading for more than a century. For Lavater a human being consisted of three kinds of interdependent yet separate states—physiological, intellectual, and moral—and "if the countenance be tranquil, it always denotes tranquility in the region of the heart and breast."[20] Beauty signified virtue and ugliness its lack: "Morally deformed states of mind have deformed expressions; consequently, if incessantly repeated, they stamp durable features of deformity."[21] He took this view to its logical extreme: "The morally best, the most beautiful. The morally worst, the most deformed."[22] He evaluated morality partly by measuring what he described as "angles of the lines of the countenance," concluding that "the more acute, in general, the angle of the profile is . . . the more brutal, inactive, and unproductive, is the animal."[23] In a series of twenty-four illustrations in later editions of the *Fragmente,* a profile of a frog is sequentially morphed into an ideal human

[19] According to BARBARA MARIA STAFFORD, Humbert cut through Lavater's "accumulative characterology to establish a radically delimited alphabet of root lines and primary colors." *Good Looking: Essays on the Virtue of Images* (Cambridge: MIT Press, 1996), 115–7; see also Stafford, *Symbol and Myth: Humbert de Superville's Essay on Absolute Signs in Art* (Cranbury, N.J.: University of Delaware Press, 1979).

[20] JOHANN KASPAR LAVATER, *Essays on Physiognomy: Designed to Promote the Knowledge and the Love of Mankind,* trans. Thomas Holcroft, 9th ed. (London: William Tegg, 1855), 10–11.

[21] Ibid., 98.

[22] Ibid., 99. This equation may ultimately be rooted in Lord Shaftesbury's "neo-Socratic concept of *kalkagathia,* the notion that physical beauty and moral goodness go hand in hand." ELLIS SHOOKMAN, "Pseudo-Science, Social Fad, Literary Wonder: Johann Caspar Lavater and the Art of Physiognomy," in Shookman, ed., *The Faces of Physiognomy: Interdisciplinary Approaches to Johann Caspar Lavater* (Columbus, s.c.: Camden House, 1993), 3.

[23] LAVATER, *Essays on Physiognomy,* 494.

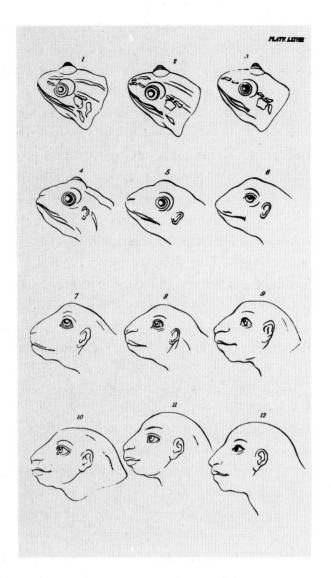

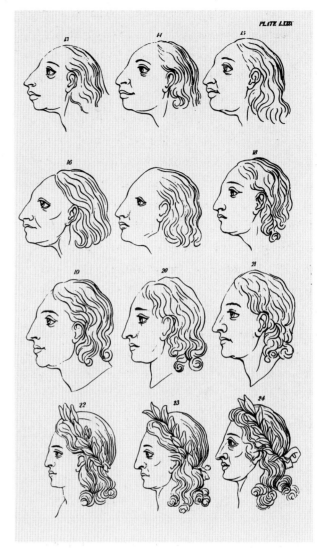

profile, concluding with three faces that resemble Apollo replete with laurel wreath. With the twelfth profile, halfway along this graphic evolution, "begins the lowest degree of humanity; the angle of the countenance is indeed not much larger than sixty degrees, very little raised above brutality, yet nearer to the negro than the orang-outang; and the projecting nose and defined lips decisively indicate commencing humanity."[24] In this schema, as the angles of the face from chin to nose and from nose along the forehead approach the perpendicular, the more noble, intelligent, and "human" the countenance becomes. For Humbert as well, verticality was the ne plus ultra in defining the human; he stressed that, unlike all other animals, "man is upright and turned toward heaven."[25]

Discussing Humbert's linear theories of human stature and expression, the historian Barbara Stafford concluded that for the Dutch thinker "vertical posture is . . . a symbol for an inner condition: anatomical straightness relates to moral uprightness."[26] Like Hogarth before him,

Humbert sought to reduce objects, including the human face, to their essential linear forms; but whereas the British artist's search for a line of beauty was mnemonic or optical and included the serpentine line, the Dutch theorist's was more metaphysical and allowed primarily for straight lines and their directional angles. Humbert's symbolic physiognomics depicted the face's main features as a vertical (nose) and two horizontals (eyes and mouth). Another linear theory of the time, found in Jean-Baptiste Rubejs's *Des portraits; ou, Traité pour saisir la physionomie* (On portraits; or, a treatise for understanding physiognomy, 1809), was so reductive that the human face was diagrammed as a mere cross within an oval, with the horizontal element signifying the preeminent carriers of

[24] Ibid., 496.

[25] D. P. G. HUMBERT DE SUPERVILLE, *Essai sur les signes inconditionnels dans l'art* (Leiden: C. C. van der Hoek, 1827), 3; quoted in Stafford, *Symbol and Myth*, 43.

[26] STAFFORD, *Symbol and Myth*, 44.

human expression, the eyes and brow, and the vertical representing the dominant upright axis of the face.[27]

Humbert's linear theory was indebted also to the Dutch anatomist Petrus Camper, whose posthumously published lectures (1791) promoted a doctrine of facial angles that in turn influenced Lavater's later editions.[28] Camper's was the first publication to represent the visual evolution of a monkey into an Apollo and to contend that the normal angle of the human profile was approximately eighty degrees to the horizon, slightly less than perpendicular.[29] Purely vertical, Camper acknowledged, the profile was that of an antique sculpture, an impossible ideal; leaning "backwards, of a negroe; still more backwards, the lines which mark an ape, a dog, a snipe, &c."[30] While Humbert was interested in such mathematical congruences as further support for his notion of an aesthetic ethics, Camper and Lavater were more concerned with measuring differences: between humans and animals, between virtue and degradation, between beauty and deformity, and between a Eurocentric male standard and other races and genders.

In Camper's work, according to historians Jean-Jacques Courtine and Claudine Haroche, "one no longer reads the temperament or the humors on the face, nor the character of the passions; but, rather, the underlying orders of species, race, nationality, and age."[31] Yet his doctrine of verticality became the prevailing rule for assessing human character during the next century, especially when applied to phrenology, ethnographic studies, and racial theories. It also appeared in art. For example, in two complementary lithographs of 1843 by the nineteenth-century caricaturist Grandville, *L'Homme descend vers la brute* (Man descends toward the brute) and *L'Animal s'élève vers l'homme* (The animal rises toward man), a handsome young boy devolves into a balding, one-eyed, simian-featured criminal who is collared and chained, and a meek little puppy evolves into a bespectacled, contemplative dog playing chess and dominoes. And in Grandville's *Têtes d'hommes et d'animaux comparées* (Heads of men and animals compared) of 1844, an Apollo-like profile transmutes into a frog in six steps, each accompanied by a line indicating declination away from the standard. Virtue has taken on the look of a European god (or golden retriever), and everything else is made to look lowly, brutish, and distinctly non-Aryan.[32]

[27] JEAN-BAPTISTE RUBEJS, *Des portraits; ou, Traité pour saisir la physionomie* (Paris: Arthus Bertrand, 1809), 41; cf. Stafford, *Symbol and Myth*, 50.

[28] PETRUS CAMPER, *Dissertation physique de Mr. Pierre Camper, sur les différences réelles que présentent les traits du visage chez les hommes de différents pays et de différents âges; sur le beau qui caractèrise les statues antiques et les pierres gravées. Suivie de la proposition d'une nouvelle méthode pour déssiner toutes sortes de têtes humaines avec la plus grande sûreté. Publiée après le décès de l'auteur par son fils Adrien Gilles Camper*, trans. from the Dutch by Denis Bernard Quatremère d'Isjonval (Autrecht: B. Wild & J. Altheer, 1791). Camper's work appeared in various editions and translations well into the nineteenth century, in English as *The Works of the Late Professor Camper, on the Connexion Between the Science of Anatomy and the Arts of Drawing, Painting, Statuary in Two Books* (hereafter *The Works of the Late Professor Camper*), trans. Thomas Cogan (London:

C. Dilly, 1794). Lavater's rendition of this evolutionary schema first appeared posthumously in the last volume of the recast French edition published in The Hague (1781–1803). Lavater did claim, however, that the idea for it came to him before he read Camper's dissertation; see JURGIS BALTRUŠAITIS, *Aberrations: An Essay on the Legend of Forms*, trans. Richard Miller (Cambridge: MIT Press, 1989), 46; and JUDITH WECHSLER, "Lavater, Stereotype, and Prejudice," in Shookman, *The Faces of Physiognomy*, 107. For the influence of Camper's theory of facial angles on nineteenth-century anthropology, see MARY COWLINGS, *The Artist as Anthropologist* (Cambridge: Cambridge University Press, 1989), 60–62 and passim.

[29] "When the *maximum* of 80 degrees is exceeded by the facial line, it is formed by the rules of art alone: and when it does not rise to 70 degrees, the face begins to resemble some species of monkies." *The Works of the Late Professor Camper*, 40.

[30] *The Works of the Late Professor Camper*, 19; see also HUGH HONOUR, *The Image of the Black in Western Art*, vol. 4, *From the American Revolution to World War I*, part 2 (Cambridge and Houston: Harvard University Press and Menil Foundation, 1989), 14. That Apollo came to represent the Caucasian ideal of perfect human form and beauty most likely had its roots in the neoclassical idealism of Johann Joachim Winckelmann, which in turn was appropriated by prerevolutionary Enlightenment anthropology; see HONOUR, *The Image of the Black in Western Art*, 13. See also BRIAN WALLIS, "Black Bodies, White Science: Louis Agassiz' Slave Daguerreotypes," *American Art* 9, no. 2 (summer 1995): 52–53. Camper even referred to Winckelmann when discussing the improbable facial angle of 100 degrees: "This antique beauty is not in nature; but to use the term of Winckelman [sic], it is an ideal beauty." *The Works of the Late Professor Camper*, 99.

[31] JEAN-JACQUES COURTINE and CLAUDINE HAROCHE, *Histoire du visage: Exprimer et taire ses émotions (du XVIᵉ siècle au début du XIXᵉ siècle)* (Paris: Editions Payot & Rivages, 1994), 119.

[32] The unique verticality of the modern human skull appears to have evolved about 125,000 years ago, occasioned by the shortening of the sphenoid bone that extends across the width of the skull at the base of the brain case, behind the palate, and in front of the vertebral column. Theoretically the shortening of this bone may have facilitated speech by modifying the larynx. See JOHN NOBLE WILFORD, "Scientist Links Shift in a Skull Bone to Shape of the Face of Modern Man," *New York Times*, 19 May 1998, B13.

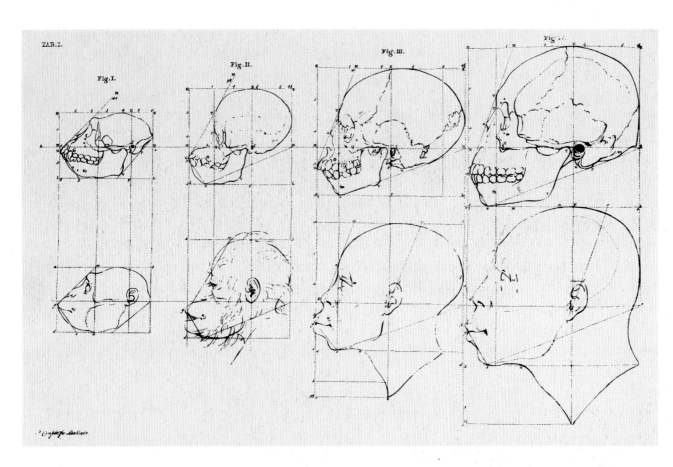

LEFT AND BELOW
Petrus Camper,
Measurements of Facial Angles, 1768,
pls. 1 and 2 from
Dissertation physique (1791), engraving,
photograph courtesy B. & L. Rootenberg Fine & Rare Books.

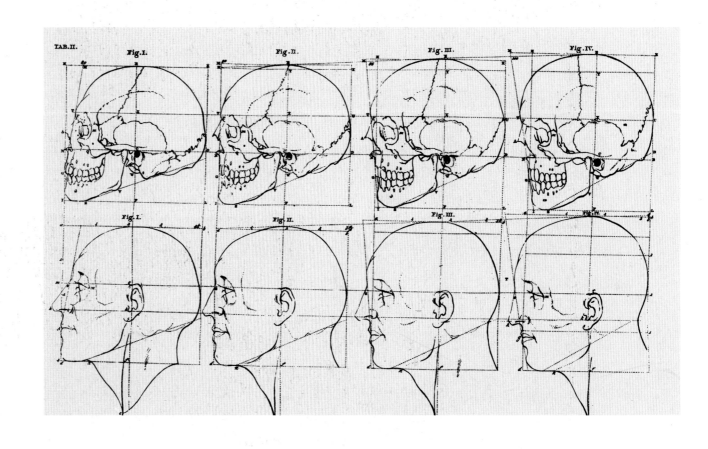

TOP
Grandville
(Jean-Ignace-Isidore
Gérard), *Heads of
Men and Animals
Compared*, from
Le Magazin pittoresque
(1844), lithograph,
Bibliothèque
nationale de France.

CENTER
Grandville
(Jean-Ignace-Isidore
Gérard), *Man
Descends toward
the Brute*, from
Le Magazin pittoresque
(1843), lithograph,
Bibliothèque
nationale de France.

BOTTOM
Grandville
(Jean-Ignace-Isidore
Gérard), *The Animal
Rises toward Man*,
from *Le Magazin
pittoresque* (1843),
lithograph,
Bibliothèque
nationale de France.

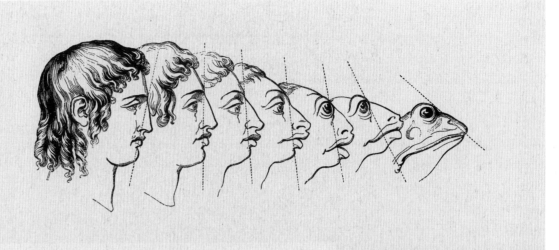

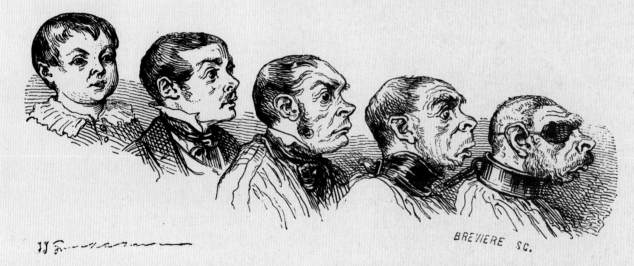

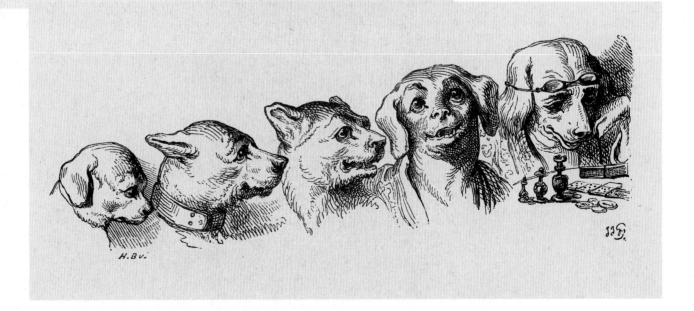

97 | Warhol

Bumps and Hollows

Moral issues were also at the very heart of the various systems of phrenology that had developed during the early nineteenth century, especially those of Franz Joseph Gall and Johann Caspar Spurzheim in Vienna and George Combe in Edinburgh. Gall was the first to devise the theory that moral and intellectual faculties were not only controlled by individual organs of the brain but were also measurable by the protruberances these organs caused on the exterior of the head: "Whenever I believed that I had determined a primitive or fundamental power . . . and I thought that I had found the seat of its organ, I marked the place of this organ, and designated its form on the cranium. . . . From this has arisen the craniological chart, seized by the public with so much avidity."[33] This chart, or phrenological head, with the organs or faculties outlined and numbered on the cranial surface, became popular with the artistic community.[34] Gall's original set of twenty-seven faculties, published in 1807, was quickly expanded by both him and Spurzheim.[35] In 1825 Spurzheim's *Phrenology; or, The Doctrine of the Mind* listed thirty-five specific organs, including "Propensities" such as amativeness, concentrativeness, combativeness, destructiveness, acquisitiveness; and "Sentiments" such as self-esteem, veneration, benevolence, ideality, compassion, and mirthfulness.[36] Intellectual faculties included thirteen related to perception and two to reflection.

In an address given in the 1840s, "Phrenology: Its Nature and Uses," Scottish physician Andrew Combe articulated some of the goals of this science:

> If Phrenology be true, it is destined one day to unfold the whole philosophy of human nature; and, therefore, to all who live in society, and wish either to improve themselves or exercise an influence over others, Phrenology is of indisputable use. By unfolding to us the nature and sphere of action of the different powers of intellect and moral feeling, and their laws of operation, it throws a flood of light on the principles of education, on the moral government of the world, and on the means for elevating and improving the condition of all classes of society.[37]

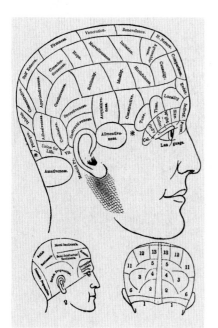

James Stratton, secretary of the Phrenological Society of Aberdeen, elsewhere described the mathematical foundation of phrenology and its use in measuring the cubic size of the human cranium. He compiled a table that listed the measurements

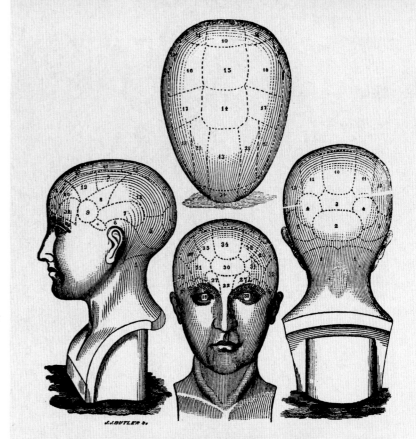

NAMES OF THE PHRENOLOGICAL ORGANS,

REFERRING TO THE FIGURES INDICATING THEIR RELATIVE POSITIONS.

AFFECTIVE.		INTELLECTUAL.	
1. Propensities.	*2. Sentiments.*	*1. Perceptive.*	*2. Reflective.*
1 Amativeness.	10 Self-esteem.	22 Individuality.	34 Comparison.
2 Philoprogenitiveness.	11 Love of Approbation.	23 Form.	35 Casuality.
3 Concentrativeness.	12 Cautiousness.	24 Size.	
4 Adhesiveness.	13 Benevolence.	25 Weight.	
5 Combativeness.	14 Veneration.	26 Colouring.	
6 Destructiveness.	15 Firmness.	27 Locality.	
† Alimentiveness.	16 Conscientiousness.	28 Number.	
7 Secretiveness.	17 Hope.	29 Order.	
8 Acquisitiveness.	18 Wonder.	30 Eventuality.	
9 Constructiveness.	19 Ideality.	31 Time.	
	? Unascertained.	32 Tune.	
	20 Wit or Mirthfulness.	33 Language.	
	21 Imitation.		

[33] F. J. Gall, *The Functions of the Brain and of Each of Its Parts: with Observations on the Possibility of Determining the Instincts, Propensities, and Talents, or the Moral and Intellectual Dispositions of Men and Animals, by the Configuration of the Brain and Head,* vol. 3 (Boston, 1835), 129–30; quoted in M. H. Kaufman and N. Basden, "Marked Phrenological Heads: Their Evolution, with Particular Reference to the Influence of George Combe and the Phrenological Society of Edinburgh," *Journal of the History of Collections* 9, no. 1 (1997): 140. I am indebted to my colleague J. Patrice Marandel for bringing the latter reference to my attention.

[34] Kaufman and Basden, "Marked Phrenological Heads," 140.

[35] The earliest located engraving of a marked cranium by Gall is dated 1807. Kaufman and Basden, "Marked Phrenological Heads," 148.

[36] J. Spurzheim, *Phrenology; or, The Doctrine of the Mind; and of the Relations Between Its Manifestations and the Body,* 3rd ed. (London, 1825); discussed in Kaufman and Basden, "Marked Phrenological Heads," 150.

[37] Andrew Combe, "Phrenology: Its Nature and Uses," in George Combe et al., *Moral and Intellectual Science Applied to the Elevation of Society* (New York: Fowlers & Wells, 1848), 62.

OPPOSITE
J. J. Butler, *Names of the Phrenological Organs*, from George Combe, *A System of Phrenology* (1844), engraving, private collection, Los Angeles.

OPPOSITE (LOWER LEFT)
Unidentified artist, *Phrenological chart*, from O. S. Fowler, *Fowler's Practical Phrenology* (1851), engraving, private collection, Los Angeles.

RIGHT
Howland, *Points of Measurement*, from George Combe et al., *Moral and Intellectual Science Applied to the Elevation of Society* (1848), engraving, private collection, Los Angeles.

POINTS OF MEASUREMENT.

in cubic inches of different types of people, including scholars (Dr. Gall, 170), murderers (Adam of Inverness, 143), and criminals ("Chinese assassin," 109), as well as the average sizes of various nationalities and races ("Swiss," 112; "Hindoo," 103; "Negro," 101; "Esquimaux," 90; "North American Indian," 87, and "New South Wales Female," 80).[38] In arguing against the death penalty, even for homicide, George Combe pointed to fairly developed faculties of cautiousness, secretiveness, and intellect in certain criminals; in others, those prone to violence, he found well-developed organs of combativeness and destructiveness and smaller ones of cautiousness, intellect, and all the moral organs.[39] One of the leading American advocates of phrenology, O. S. Fowler, was convinced that a phrenologist was able to "pronounce decisively whether a man is a liar, a thief, or a murderer" by examining his cranium, and could do so even "without reference to physiognomy." He also contended that Gall could not only determine that the individuals he visited in prison were rogues, but could also "determine the *class* of their crimes—whether they were sent there for stealing, for assault and battery, or for murder."[40]

Like physiognomy, phrenology enjoyed an enormous popularity among specialists and the general public for the first half of the nineteenth century. After all, if phrenology were an exact science, the race or nationality that manifested the largest and best-proportioned skull measurements could claim intellectual and moral superiority. Humans could be measured for a disposition to criminal or other socially proscribed behavior and preemptively treated. Where passions were fleeting and easily dissimulated, protruberances and declinations of foreheads were permanent. The popularity of both sciences can be "linked to the entrance of crowds onto the [urban] scene" at the end of the eighteenth century and the perceived need for individual identification.[41] Populations in the developing nineteenth-century metropolises were larger than ever before; displaced labor and individual alienation under a growing capitalist and industrial system were unprecedented; unemployment was rampant; destitution, alcoholism, and criminality were out of control; and global trade and colonization presented Europeans and Americans with a wide range of "others" who, it was believed, had to be understood and kept in their places. To keep pace, even medical science came up with newer pathologies by which an individual could be classified.[42] Indeed, by the end of the century Lavater's equation of beauty with virtue had changed to one of beauty with normality (and, conversely, ugliness with the abnormal, the deviant, and the degenerate).[43] Taxonomic classifications had already been used to organize nature neatly into phyla and species. Phrenologists proposed that the same process be used to catalogue and analyze the character and moral foundations of humanity, providing a handbook for, in Andrew Combe's frightening words, the "moral government of the world." Simply put, if phrenology had not existed, it would have been necessary to invent it.

The principal assumptions of phrenology held sway for decades. Although the theory had its challengers, it remained popular well into the 1850s and 1860s, sustained in part by the cerebral mappings of neurologists like Jean-Baptiste Bouillaud and neuroanatomists and anthropologists like Paul Broca.[44] Hegel denounced physiognomy's illogical assumptions, but he accepted the "logic" of phrenology and located the actuality and existence of the human in the skull bone.[45] British painter William Hazlitt wrote, "Phrenology is the grave or epitaph of the understanding," and Herman Melville satirized the science in chapter eighty of *Moby-Dick,* but Walt Whitman, Horace Greeley, and Hiram Powers were all converts, and

[38] James Stratton, "Mathematics of Phrenology," in Combe et al., *Moral and Intellectual Science Applied to the Elevation of Society,* 173–5.

[39] George Combe, "Capital Punishment," in Combe et al., *Moral and Intellectual Science Applied to the Elevation of Society,* 213–4.

[40] O. S. Fowler, "Phrenology Not Dependent upon Physiognomy," in *Fowler's Practical Phrenology: Giving a Concise Elementary View of Phrenology* . . . (New York: Fowlers & Wells, 1851), 370–1.

[41] Courtine and Haroche, *Histoire du visage,* 143.

[42] For general consideration of these issues, see Richard Sennett, *The Fall of Public Man: On the Social Psychology of Capitalism* (New York: Random House, 1974); and Marshall Berman, *All That's Solid Melts into Air: The Experience of Modernity* (New York: Simon & Schuster, 1982).

[43] See Anthea Callen, *The Spectacular Body: Science, Method and Meaning in the Work of Degas* (New Haven: Yale University Press, 1995), 12 and passim.

[44] See Kaufman and Basden, "Marked Phrenological Heads," 147; and Anne Harrington, "Au-delà de la phrénologie: théories de la localisation à l'époque contemporaine," in Jean Clair, ed., *L'Ame au corps: Arts et sciences, 1793–1993,* exh. cat. (Paris: Réunion des musées nationaux and Editions Gallimard, 1993), 376–80. See also Callen, *The Spectacular Body,* 14–16. In America, the team of Orson Squire Fowler, his brother Lorenzo, and Samuel Wells, in 1844, formed the publishing firm of Fowlers & Wells, which continued publishing on phrenological subjects well into the first decade of this century; see Carl Carmer, "That Was New York: The Fowlers: Practical Phrenologists," *New Yorker,* 13 February 1937, 27. I am indebted to the contemporary phrenologist Grant Rohmer for the last reference.

[45] G. W. F. Hegel, *The Phenomenology of Mind,* trans. J. B. Baillie (New York: Harper & Row, 1967), 351–72. Hegel's ideas about phrenology are discussed in Mark Taylor, *Hiding* (Chicago: University of Chicago Press, 1997), 13–15.

Ralph Waldo Emerson considered Spurzheim one of the greatest minds of the world.[46] That the brain consisted of discrete, measurable organs whose size determined the strength of a corresponding trait, that the standard used for comparative studies was a Western European or eastern American male (infrequently female), and that phrenological beauty corresponded perfectly to beaux-arts aesthetics—these premises were too convenient not to be accepted. Like physiognomy, phrenology promised both photographers and spectators a simple analytic system. But unlike physiognomy, phrenology required no costumes, histrionic poses, or dramatic lighting to expose a subject's nobility or flaws. From a pair of candid shots, a front view and a profile, the psychological, social, and moral character of the sitter could be easily ascertained.

Comparative Types

There is a good reason that certain photographic portraits of the mid-nineteenth century stand out so clearly: Photographers such as the team of David Octavius Hill and Robert Adamson, Julia Margaret Cameron, the elder Nadar, and Antoine Samuel Adam-Salomon had artful ambitions. Certainly a reasonable approximation of the subject's appearance was mandated in their works, but they sought to transcend mere likeness by thoughtful posing, picturesque composition, theatrical lighting, and the attempt to delineate the ineffable soul or personality. Cameron wrote about her portraits of notable men, "When I have had such men before my camera my whole soul has endeavored to do its duty towards them in recording faithfully the greatness of the inner as well as the features of the outer man."[47] For a poet or artist, aspirations like this are commendable; for the phrenologist, they only get in the way. The precise shape of

[46] WILLIAM HAZLITT, "Phrenological Fallacies," *The Atlas* (5 July 1829), in *The Complete Works of William Hazlitt*, ed. P. P. Howe (London: J. M. Dent, 1934), 20, 249. See also MARTIN GARDNER, "Bumps on the Head," *The New York Review of Books*, 17 March 1988, 8; and CARMER, "That Was New York: The Fowlers: Practical Phrenologists," 24.

[47] JULIA MARGARET CAMERON, "Annals of My Glass House" (1874), in Violet Hamilton, *Annals of My Glass House: Photographs by Julia Margaret Cameron*, exh. cat. (Claremont, Calif.: Ruth Chandler Williamson Gallery, Scripps College, 1996), 15.

ABOVE
David Octavius Hill
and
Robert Adamson,
*Portrait of William
Etty, Royal Academy*,
1844,
cat. no. 57.

PAGE 102
Nadar
(Gaspard Félix
Tournachon),
George Sand,
c. 1864,
cat. no. 81.

PAGE 103
Antoine Samuel
Adam-Salomon,
*Charles Garnier
(of the Opéra)*,
c. 1866,
cat. no. 1.

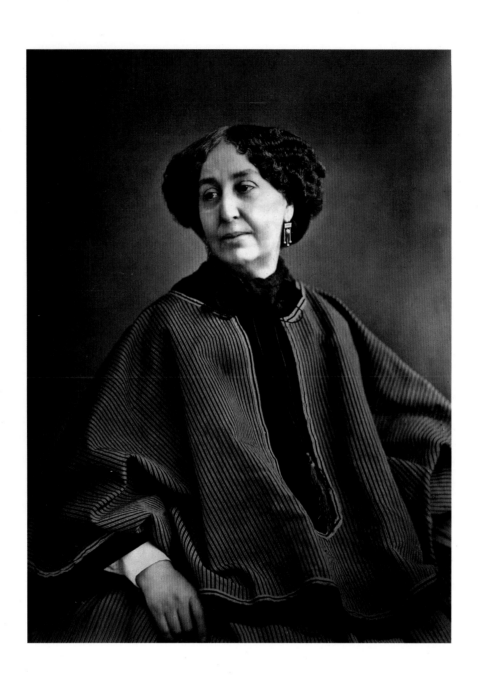

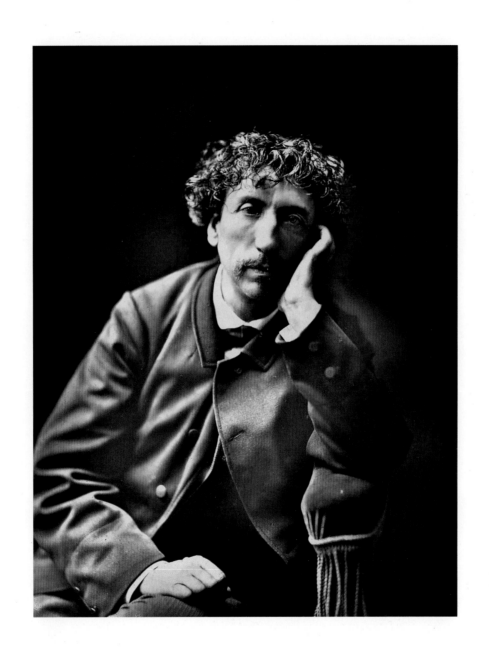

the overall face and the details of each and every feature are, after all, what count. Prior to photography, only the machine-delineated silhouette or the bare skull could furnish the unmediated truth of a person's face or head; muscles and flesh were too manifold and transitory.[48] In terms of character reading and physiological comparison, therefore, the photographic portrait's clinical objectivity was welcomed, leading to a strain of straightforward, formulaic, and banal photographic portraits that thrived during the last century alongside the more memorable work of artist-photographers.

By the mid-1850s, two French photographers, Dodero and André-Adolphe-Eugène Disdéri, had invented the *carte-de-visite* portrait, a pocket-sized card bearing a small full- or bust-length albumen-print likeness in place of the person's name. This invention dramatically ushered in a period of what has been called a "cartomania"—an impulse to own and trade portraits not only of oneself and one's friends and family but also of the famous and even the notorious—and an industry that encouraged and satisfied this need.[49] In his photographic manuals, Disdéri stressed the need for the photographer to interpret the inner character of the sitter as well as justly record the likeness, and decreed that the portrait "must not be only a facsimile of the face [but] must be, beyond material resemblance, a moral resemblance."[50] Yet what is immediately striking about his or other *carte* portraits is their utter banality: their formulaic poses, lack of expressions, and indistinguishable costumes and studio backgrounds. Photography historian Gisèle Freund makes a similar argument and adds that in these portraits "real personalities are almost entirely obscured, buried beneath conventional social types."[51] The only advance by the *carte* over its predecessor, the daguerreotype portrait, was, apparently, economic. Neither,

104

[48] See COURTINE and HAROCHE, *Histoire du visage,* 126–8; and CHRISTOPH SIEGRIST, "Letters of the Divine Alphabet: Lavater's Concept of Physiognomy," in Shookman, *The Faces of Physiognomy,* 33.

[49] See JEAN SAGNE, "Le Portrait carte de visite," in Centre national de la photographie, *Identités: De Disdéri au photomaton* (Paris: Photo Copies, 1985), 10–17. On Disdéri and the social and industrial implications of the *carte-de-visite,* see ANDRÉ ROUILLÉ, *L'Empire de la photographie: 1839–1870* (Paris: Le Sycomore, 1982), 97–179; and ELIZABETH ANNE MCCAULEY, *A. A. E. Disdéri and the Carte de Visite Portrait Photograph,* Yale Publications in the History of Art, vol. 31 (New Haven and London: Yale University Press, 1985).

[50] A.-A.-E. DISDÉRI, *Renseignements photographiques indispensable à tous* (Paris: chez Disdéri, 1855), 13–14; quoted in Rouillé, *L'Empire de la photographie: 1839–1870,* 171.

[51] GISÈLE FREUND, *Photography and Society,* trans. Richard Dunn et al. (Boston: David R. Godine, 1980), 61. See also Freund, *Photographie et société* (Paris: Editions Seuil, 1974), 67; quoted in Rouillé, *L'Empire de la photographie,* 172; Rouillé also discusses this issue at length.

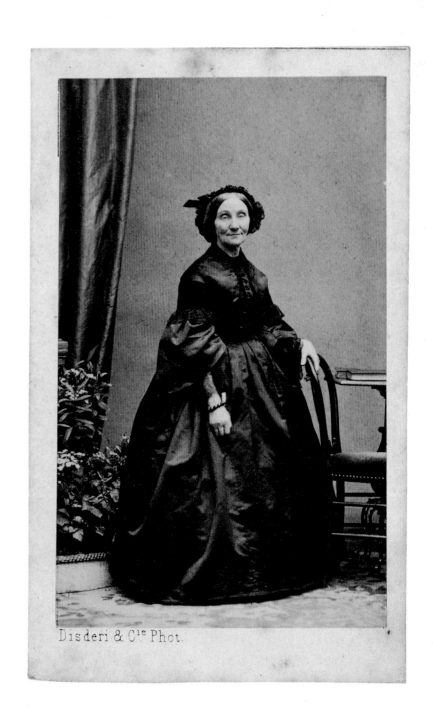

Disderi & Cⁱᵉ Phot.

ABOVE
A.-A.-E. Disdéri,
Unidentified Female,
c. 1859–60,
cat. no. 31.

OPPOSITE
(LEFT)
A.-A.-E. Disdéri,
Unidentified Male,
c. 1859–60,
cat. no. 34.

OPPOSITE
(RIGHT)
A.-A.-E. Disdéri,
Unidentified Female,
c. 1859–60,
cat. no. 32.

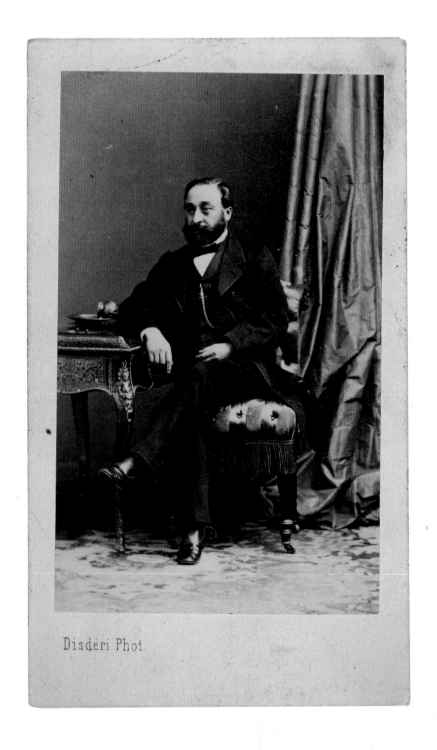

Disdéri Phot.

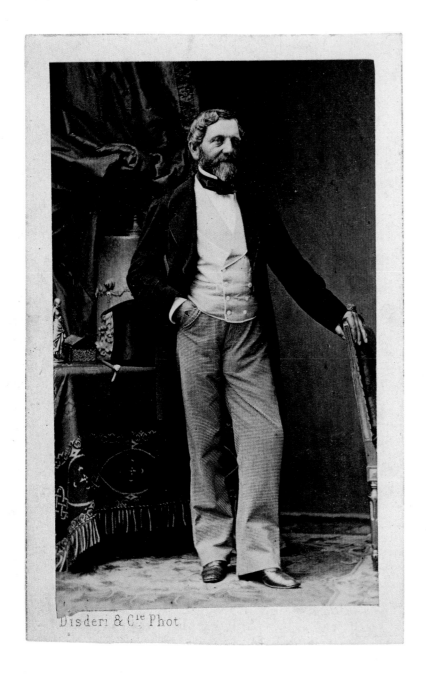

Disderi & Cie Phot

OPPOSITE
(LEFT)
A.-A.-E. Disdéri,
Unidentified Male,
c. 1859–60,
cat. no. 35.

OPPOSITE
(RIGHT)
A.-A.-E. Disdéri,
Unidentified Male,
c. 1859–60,
cat. no. 36.

BELOW
A.-A.-E. Disdéri,
Unidentified Female,
c. 1859–60,
cat. no. 33.

given its quotidian manufacture, can be called a portrait in any interpretive, artistic sense; for the most part they are visual images of social types. By substituting the likeness for the subject's name, the *carte* portrait made the photographed visage the equivalent of the name and, in short, the identity of the subject. Thus portrait photographers doubled, however inadvertently, as social ethnographers or cultural anthropologists.[52]

Ethnographic photographers invented what became the classic mug shot during the height of the physiognomic and phrenological cultures and at a time when the cataloguing of indigenous peoples, especially those in colonized lands, was rapidly advancing. In 1844 the French daguerreotypist E. Thiésson photographed Botocudo natives in Brazil in both profile and front face, and he did the same with the natives of Sofala, in Portuguese Mozambique, the following year.[53] In 1850 Louis Agassiz, professor of natural history at Harvard University, hired daguerreotypist Joseph T. Zealy to document African slaves from South Carolina and had him photograph them unclothed, bust-length, and from the front, the side, and the back.[54] The French Academy of Sciences recommended in 1852 that hand-drawn likenesses of American natives were not to be trusted: only the "naked and artless truth furnished by the daguerreotype . . . gives to those figures obtained by this process a certainty that no other could hope to achieve. We therefore could not overly recommend to our travelers the use of this process and the increased documentation of native types including male and female adults as well as their children."[55] In 1869 Thomas H. Huxley, president of the British Ethnological Society, devised a system whereby the "various races of men comprehended within the British Empire" would be photographed naked, full- and bust-length, and

[52] MICHEL FRIZOT, "Corps et délits: Une Ethnophotographie des différences," in Frizot, ed., *Nouvelle Histoire de la photographie* (Paris: Bordas, Editions Adam Biro, 1995), 259; see also FRIZOT, "Idem, ou le visage de l'autre," in Centre national de la photographie, *Identités: De Disdéri au photomaton,* 8.

[53] FRIZOT illustrates a pair of daguerreotypes, from the collection of the Musée de l'homme in Paris, showing the profile and front view of a Botocudo native. "Corps et délits: Une Ethnophotographie des différences," 268. Although no frontal portraits from Sofala seem to have survived, it seems likely that Thiésson used the same technique there.

[54] See WALLIS, "Black Bodies, White Science: Louis Agassiz' Slave Daguerreotypes," 38–61. In an otherwise well-argued essay, Wallis differentiates between the full-length shots, which he says reflected a "physiognomic approach, an attempt to record body shape, proportions, and posture," and the torso-length shots, which he claims "adhered to a phrenological approach, emphasizing the character and shape of the head." Lavater and other physiognomists did mention a body's proportions and posture incidentally, but these were hardly central to physiognomic studies.

[55] *La Lumière* (7 August 1852); quoted in Christian Phéline, *L'Image accusatrice, Les Cahiers de la Photographie* 17 (1985): 20.

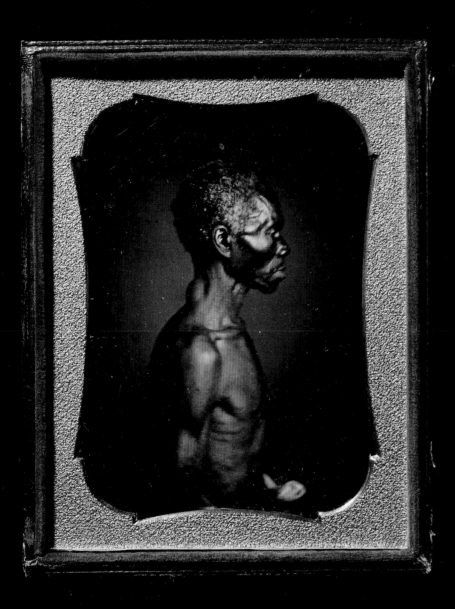
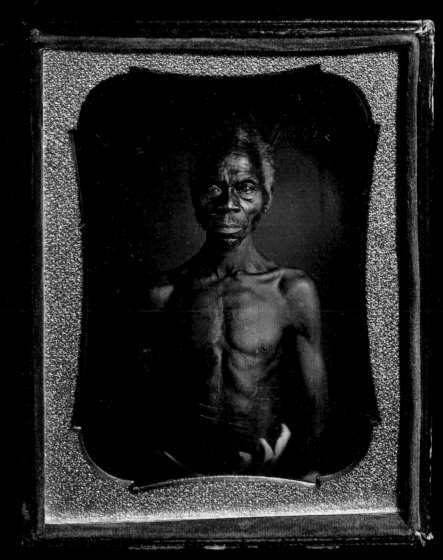

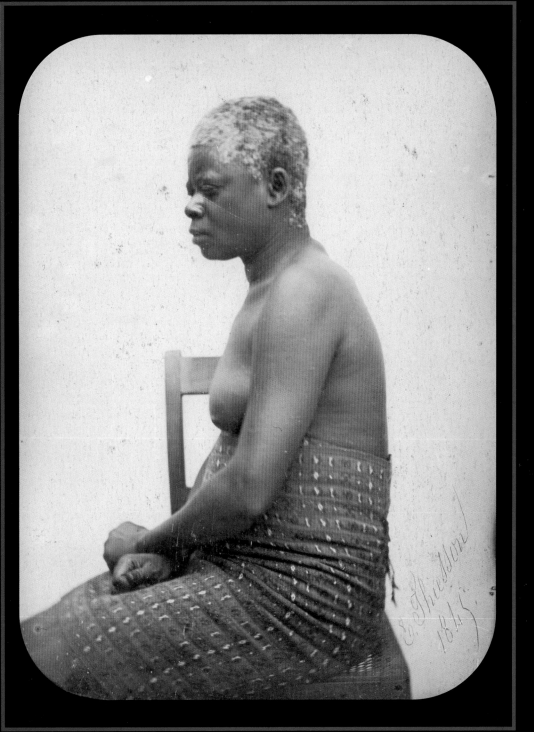

adjacent to a measured ruler; and the anthropologist John H. Lamprey suggested the use of a metrological grid against which the subjects were posed and photographed facing front and in profile.[56] By the 1870s and 1880s, photographers were circling the globe in search of ethnographic and anthropological subjects. One of the most prolific was Prince Roland Bonaparte, who was responsible for publishing and, at times, taking ethnographic mug shots of North Americans (taken in about 1860), of South Americans in Surinam (taken in 1883, published in 1884), and of

Laplanders in Finland (1884).[57] Bonaparte stressed that "each Lapp was photographed in full face and in profile, the two positions being rigorously exact, whence it follows that all these photographs are comparable among themselves." Using this data, he calculated the average Lapp's physiology and pigmentation.[58]

Such photography was undertaken, according to historian Frank Spencer, "in an effort to produce a photographic document that would permit the subsequent recovery of reliable comparative and morphometric data."[59] This effort forms the backdrop for the three classic publications of anthropological photographs of the late nineteenth century: the eight volumes of *The People of India: A Series of Photographic Investigations* (1868–75) edited by Dr. John Forbes and Sir John William Kaye; John

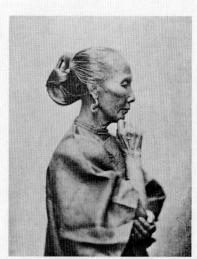

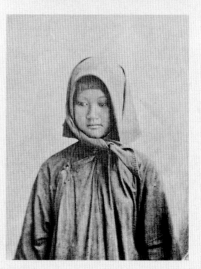

110

[56] See FRANK SPENCER, "Some Notes on the Attempt to Apply Photography to Anthropometry during the Second Half of the Nineteenth Century," in Elizabeth Edwards, ed., *Anthropology and Photography, 1860–1920* (New Haven and London: Yale University Press and the Royal Anthropological Institute, 1992), 99–103.

[57] See CENTRE NATIONAL DE LA PHOTOGRAPHIE, *Identités: De Disdéri au photomaton*, 44–45; FRIZOT, "Corps et délits: Une Ethnophotographie des différences," 269; and ANDRÉ JAMMES and ROBERT SOBIESZEK, *French Primitive Photography*, exh. cat. (New York: Aperture, 1970), unpag.

[58] PRINCE ROLAND BONAPARTE, *Notes on the Lapps of Finmark* (Paris: privately printed by George Chamerot, 1886), 9.

[59] SPENCER, "Some Notes on the Attempt to Apply Photography to Anthropometry During the Second Half of the Nineteenth Century," 100. Of course, there was a political agenda at work as well. WALLIS correctly points out that Zealy's daguerreotypes were "designed to analyze the physical differences between European whites and African blacks, but at the same time they were meant to prove the superiority of the white race." "Black Bodies, White Science: Louis Agassiz' Slave Daguerreotypes," 40.

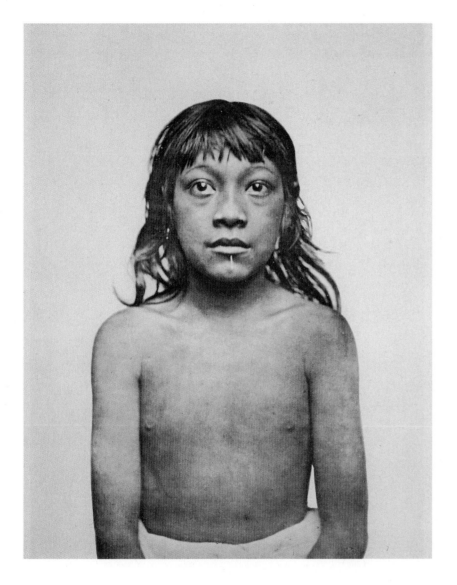
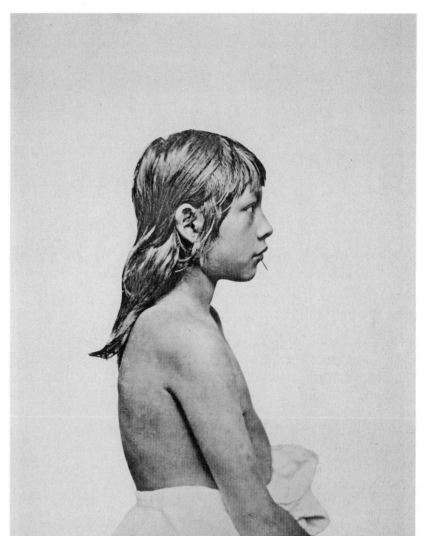

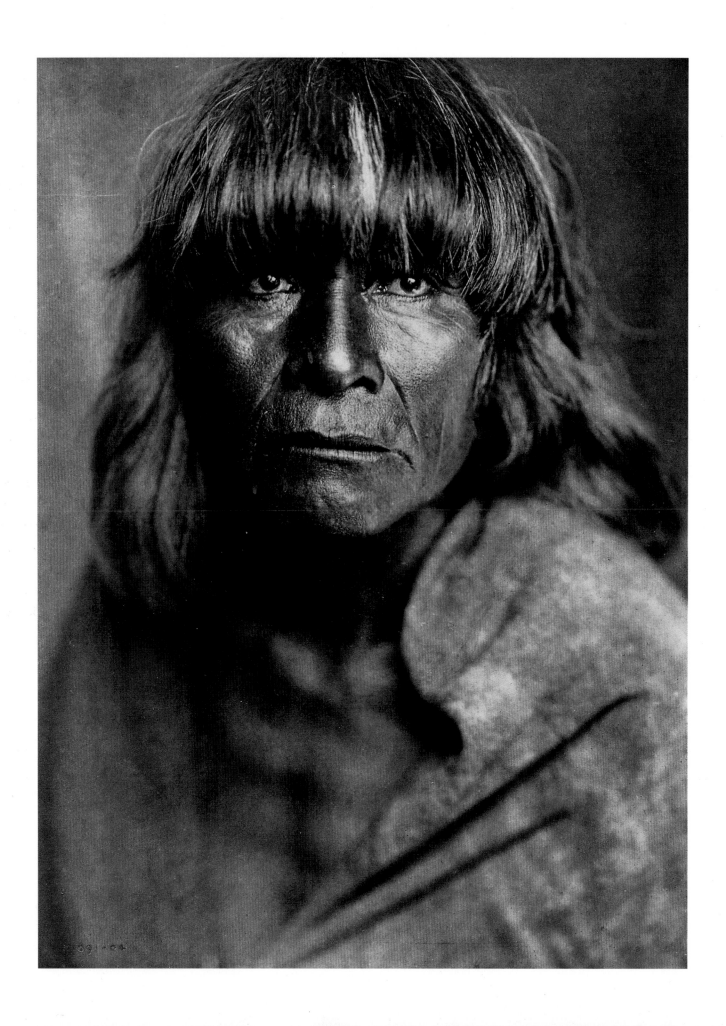

Thomson's *Illustrations of China and Its People* (1873–74); and the theatrically monumental work *The North American Indian, Being a Series of Volumes Picturing and Describing the Indians of the United States and Alaska* (begun in 1896, published 1907–30) by Edward S. Curtis. The photographs in these works are not exactly what we would call mug shots or scientifically measurable isolated heads. Pictorially they can be compared to the more sociologically driven tradition of documenting social types, classes, mores, and costumes such as Thomson's and Adolphe Smith's *Street Life in London* (1877–78), or the picturesque depictions of the Japanese by Felice Beato and Baron von Stillman, and those of North American natives by J. K. Hillers and Adam Clark Vroman. But all three of these mammoth productions bear witness to the encounter of a colonial power with another population: the United States with its Native American people, and England with India and China. Even Curtis, admittedly the most artful of the photographers and one who stressed an abiding concern for the nobility and sacredness of Native American cultures, was not above viewing his subjects as others, nor was he immune from the faith of his time in face reading and stereotypes that now seem condescending and naive. Describing one of his most compelling frontal portraits, *A Hopi Man* (1921), Curtis wrote: "In this physiognomy we read the dominant traits of Hopi character. The eyes speak of wariness, if not downright distrust. The mouth shows great possibilities of unyielding stubbornness. Yet somewhere in this face lurks an expression of masked warmheartedness and humanity."[60]

Mug Shots

Municipal police departments were as quick as anthropologists and ethnologists to adopt the photographic format that would become the mug shot. As early as 1843–44, the Brussels police had taken photographs of criminals or suspected criminals, as would the police in Birmingham around 1850. Photographs were used in research on criminality in Lausanne beginning in 1854, and soon afterward the distribution of four hundred prints of the portrait of a cashier accused of stealing from the Banque Rothschild in Paris led to his arrest in the United States.[61] Penal reformer Eliza Farnham had Mathew Brady take a series of portraits of inmates in two New York prisons, and engravings from these daguerreotypes were included in Marmaduke Sampson's *Rationale of Crime and Its Appropriate Treatment* (1846).[62] In 1854 the critic Ernest Lacan reported in *La Lumière* that an Alsatian inspector general of prisons, Louis-Mathurin Moreau-Christophe, had advanced a "biométrophotographique" system to refine the photographic documentation of criminals. This system consisted of a photograph, a "graphometric" report in which hidden or obscure features were measured and annotated, a dossier on the subject's personal life, and a "penitentiary" description or what now would be called a rap sheet.[63] Two years later Lacan, writing about police photographs displayed at the Universal Exposition of 1855, stated that even after a convicted criminal was released from prison after serving his sentence, he would still not be able to "escape the vigilance of the police," since "his portrait is in the hands of the authorities" and he would be forever "recognized by this accusatory image."[64]

The criminological portrait was therefore established at about the same time that the alienist Hugh Welsh Diamond was photographing the

[60] EDWARD S. CURTIS, *Native Nations: First Americans as Seen by Edward S. Curtis*, ed. Christopher Cardozo (Boston: Little, Brown, 1993), 134.

[61] See PHÉLINE, *L'Image accusatrice*, 15–17.

[62] See ALLAN SEKULA, "The Body and the Archive," in Richard Bolton, ed., *The Contest of Meaning: Critical Histories of Photography* (Cambridge: MIT Press, 1989), 348–9. Sekula's important essay on criminological and stereotypical photography in the nineteenth century covers much of the material discussed in this chapter from a more political viewpoint.

[63] ERNEST LACAN, "Photographie signalétique ou application de la photographie au signalement des libérés," *La Lumière* (22 July 1854); quoted in Phéline, *L'Image accusatrice*, 17.

[64] LACAN, *Esquisses photographique à propos de l'exposition universelle et de la guerre d'Orient* (Paris: Grassart, 1856), 39–40; quoted in Phéline, *L'Image accusatrice*, 17.

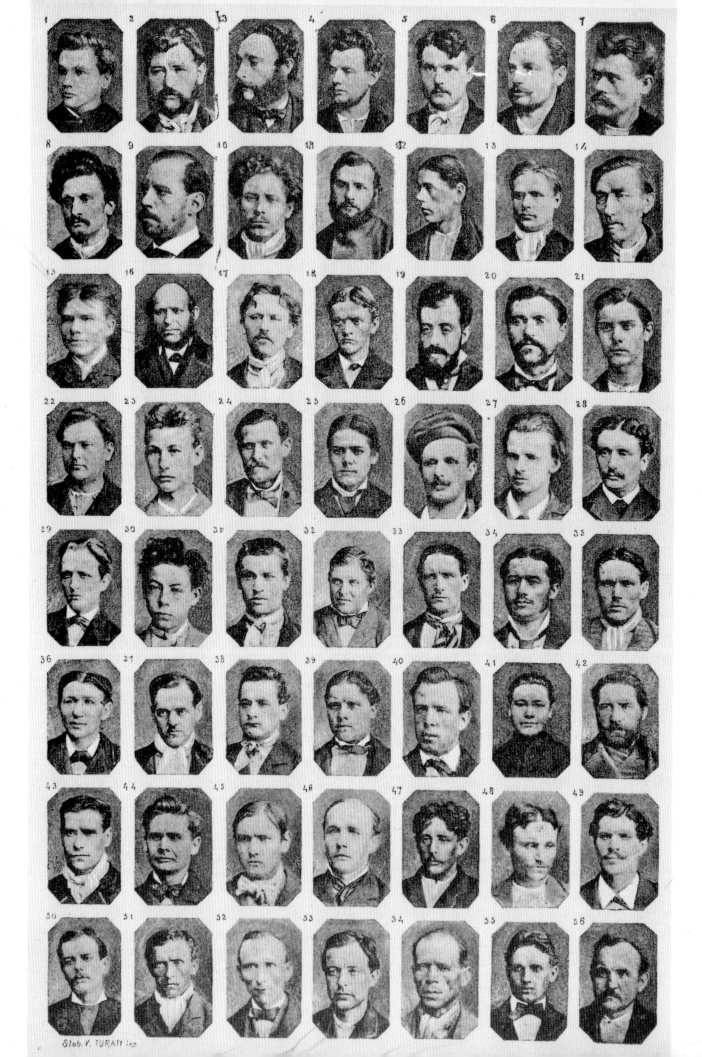

114

Stab. V. TURATI inc

countenances of the insane in Great Britain, the physiologist Duchenne was photographing the myological enactments of human emotions in Paris, the ethnographer Agassiz was having daguerreotypes taken of American slaves, and the society portraitist Disdéri was patenting his *carte-de-visite*. The medical/psychiatric, anthropological/ethnographic, scopophilic/celebrity, and, now, the judiciary/forensic agendas of the period all used portraiture to present the appearance of a certain individual or type, without the flattering or idealizing goals of artistic portraiture. Nearly all of these photographic agendas of typification are conflated in the Italian physician and criminologist Cesare Lombroso's *L'Homme criminel, criminel-né, fou moral, épileptique: Etude anthropologique et médico-légale* (The criminal man, the born-criminal, the morally insane, the epileptic: an anthropologic and medical-legal study) of 1887, the culmination of this order of thinking.[65]

In France during the 1870s, criminal recidivism increased steadily, and by the end of the 1880s, almost as if in response to this increase, criminological portraiture had gained a greater precision as well as, to some degree, the status of a scientific endeavor conforming to the dominant positivist view that reality consisted solely of objective and observable phenomena.[66] Beginning about 1871, Dr. Thomas John Barnardo's Home for Destitute Lads in England kept a photograph of each boy along with a form listing facts of his history, which were used together to connect him with prior crimes or to locate him if he fled.[67] England and New York City institutionalized policies of routinely photographing convicted prisoners about this time, and in 1872 the French director of public security approved the identification photography of criminals, arguing that such records were a critical means of controlling future crime. By 1881 the authorities in Paris had amassed approximately 50,000 portraits of jailed inmates.[68] Because each police department used different photographers, however, and because there were no standards to guide them, style, scale, posing, and lighting varied so greatly that the same person could look completely different in two sets of photographs. To solve this problem, Alphonse Bertillon, a transcriber with the prefecture of police in Paris, developed in 1879 exacting pictorial standards and a system of frontal-profile photography of criminals, which was implemented in 1882, the year before he published his blatantly racist *Les Races sauvages*.[69]

Bertillon's system, called "bertillonnage," created the modern mug shot. He insisted that standardization of equipment, procedures, lighting, and formats would "produce an image with the most physical resemblance to the sitter . . . and one that is easy to recognize and to identify with the original prisoner."[70] Although he claimed to accord as much importance to "physiognomic expression" as did artistic photographers of the time, his scheme for a technically objective photography signaled a radical departure, a shift from the aesthetic conventions of nineteenth-century portraiture.[71] When in 1865 Alexander Gardner took his series of full-plate portraits of eight prisoners who had conspired to assassinate President Abraham Lincoln and who were being held aboard the ironclad USS *Saugus* on the Potomac River, he posed them against a background of rough-forged iron plating and rivets (opaqued out in some prints). Most are in hand restraints and seated, and one is portrayed standing against an improvised backdrop of a white sheet. More artful portraits than bureaucratic mug shots, they depict the subjects in poses and with expressions that convey a range of dramatic moods: introspection, dejection, apathy, and defiance.[72] Twenty-five years later, when Bertillon published *La Photographie judiciaire* (Judiciary photography), the portrait of the criminal was reduced to two deadened planometric views of the front and side of the sitter's head and shoulders, shot against an absolutely featureless light-colored backdrop and mounted on a card with filled-in blanks for statistics such as date of birth, height, measurements of head and right ear,

[65] CESARE LOMBROSO, *L'Homme criminel, criminel-né, fou moral, épileptique: Etude anthropologique et médico-légale*, trans. Régnier and Bournet (Paris: Alcan, 1887). The first Italian edition was *L'uomo deliquente in rapporto all'antropologia, alla giurisprudenza ed alle discipline carcerarie* (Turin: Bocca, 1876). Lombroso conceptualized an atavistic criminal as one "who represented a biological regression to a more primitive stage of evolution." MARTIN KEMP, "'A Perfect and Faithful Record': Mind and Body in Medical Photography before 1900," in Ann Thomas, *Beauty of Another Order: Photography in Science*, exh. cat. (New Haven: Yale University Press, 1997), 141–2.

[66] See CARLO GINZBURG, "Clues: Morelli, Freud, and Sherlock Holmes," in Umberto Eco and Thomas A. Sebeok, eds., *The Sign of Three: Dupin, Holmes, Peirce* (Bloomington and Indianapolis: Indiana University Press, 1988), 105.

[67] See JOHN PULTZ, *The Body and the Lens: Photography, 1839 to the Present* (New York: Harry N. Abrams, 1995), 27–28.

[68] DONALD E. ENGLISH, *Political Uses of Photography in the Third French Republic: 1871–1914* (Ann Arbor, Mich.: UMI Research Press, 1984), 75.

[69] ALPHONSE BERTILLON, *Les Races sauvages* (Paris: Masson, 1883); discussed in Phéline, *L'Image accusatrice*, 47.

[70] BERTILLON, *La Photographie judiciare* (Paris: Gauthier-Villars, 1890), 11; quoted in English, *Political Uses of Photography in the Third French Republic*, 75.

[71] PHÉLINE, *L'Image accusatrice*, 99, 88.

[72] See SOBIESZEK, *Masterpieces of Photography from the George Eastman House Collections* (New York: Abbeville Press, 1985), 130–1. Recent research indicates that one of the conspirators, Lewis Payne, was photographed on the USS *Montauk*, the rest on the USS *Saugus*; see D. MARK KATZ, *Witness to an Era: The Life and Photographs of Alexander Gardner* (New York: Viking, 1991), 164.

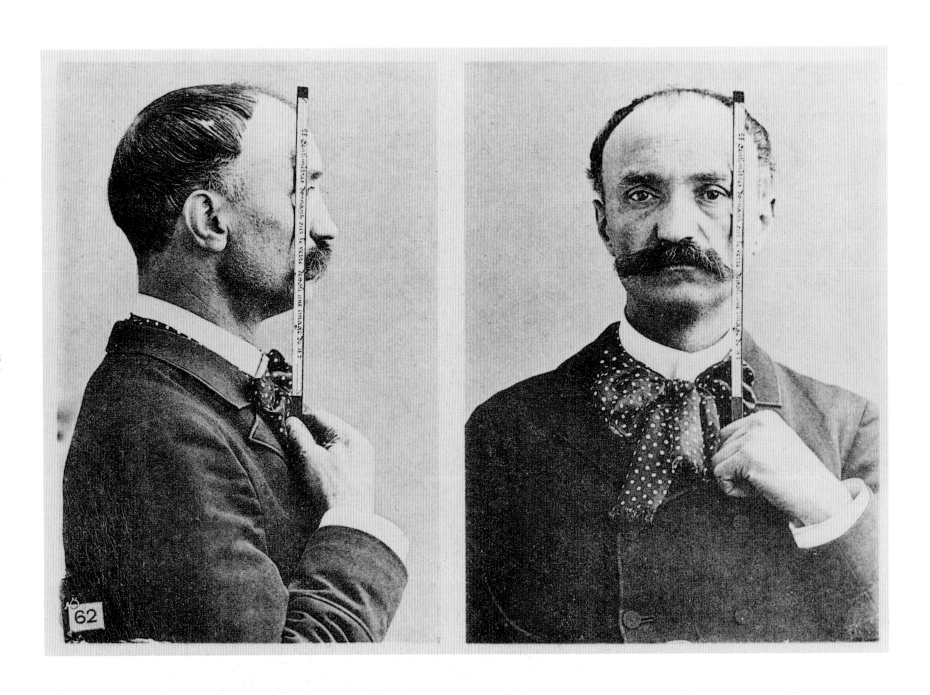

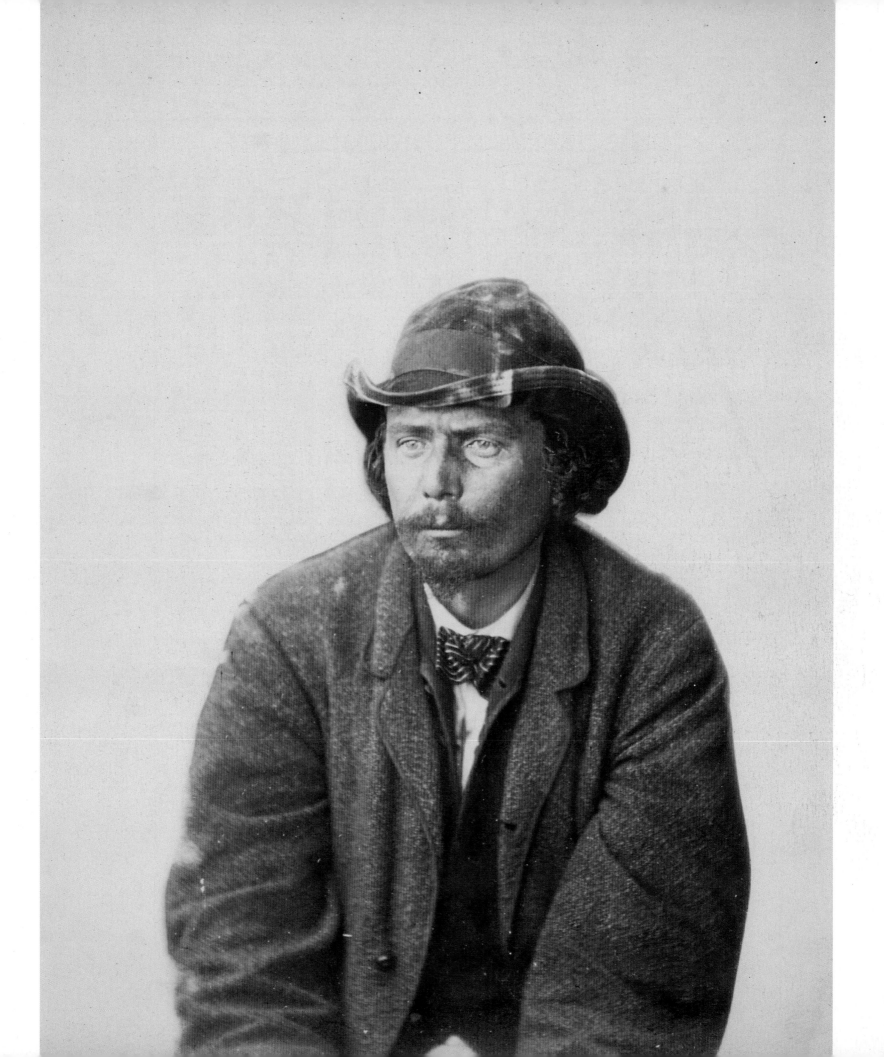

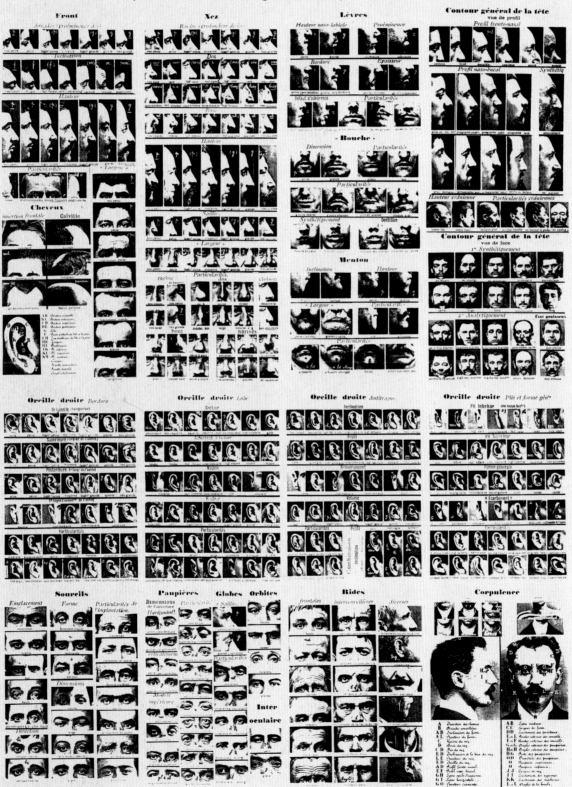

TABLEAU SYNOPTIQUE DES TRAITS PHYSIONOMIQUES

pour servir au relevé du signalement descriptif (Méthode A. Bertillon)

118

descriptions of the forehead and nose, hair color, and further details about the right ear. Usually the criminal wore a metal brace that placed him or her in relatively the same position opposite the camera, and each was accompanied by a number tag.[73]

Precise descriptions of the criminal's features were important in the bertillonnage system. In 1893 Bertillon arranged a guide to the "spoken portrait," the *Synoptic Table of Physiognomic Traits,* which featured hundreds of photographic details of the male human face.[74] According to him, "direct identity is affirmed by the particular marks that, alone, can give judicial certainty [whereas] anthropometry, which is a mechanism of elimination, demonstrates above all non-identity."[75] Bertillon had particular faith in the ear: "It is nearly impossible to encounter two ears that are identical in each of their parts, and the numerous formal variations that make up that organ seem to continue without modification from birth to death."[76] While Duchenne defined human emotions or passions by the contraction of distinct muscles or muscular groups, and while Combe found moral character and predisposition in the proportional shapes of the skull's features, Bertillon believed he had discovered an absolute key to human identification in the smallest parts of the face. This focus on detailed measurement ultimately led him to question photography's value in defining identity:

"Measurements are an infinitely less deceptive basis for identification than photographic resemblances."[77] After 1902 the fingerprint displaced the ear as key to an individual's identification in France, rendering photography less important to the judicial system. Nevertheless, mug shots still retain their place in police records, whether they are of Jewish prisoners during the Vichy era in France, of Cambodian captives during the Khmer Rouge era, or of suspected criminals in New York City at most any time. Bertillon's detailed photographs of the right ear even resurfaced in 1933 as crucial components in *The Phenomenon of Ecstasy* by Surrealist artist Salvador Dalí.

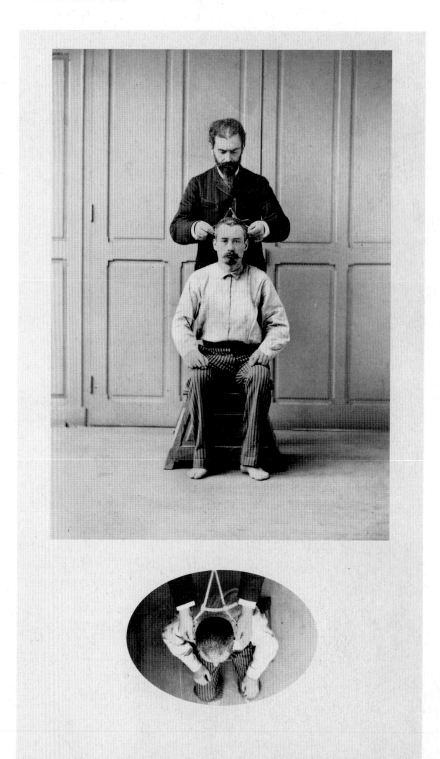

[73] See CENTRE NATIONAL DE LA PHOTOGRAPHIE, *Identités: De Disdéri au photomaton,* 61–63.

[74] Ibid., 76–77. Actually, Bertillon's "spoken portrait" consisted of verbal descriptions of the face's features in addition to the photographs; cf. GINZBURG, "Clues: Morelli, Freud, and Sherlock Holmes," 106.

[75] BERTILLON, *Indentification anthropométrique, instructions signalétiques,* new ed. with *Album* (Melun: Imprimerie administrative, 1893), lxv; quoted in Phéline, *L'Image accusatrice,* 129.

[76] BERTILLON, quoted in Phéline, *L'Image accusatrice,* 120–3. GINZBURG also draws attention to the significance of the detail as a clue

to identity and compares the analysis of ears in Italian Renaissance paintings by Giovanni Morelli in the mid-1870s with the deductive reasoning about shapes of ears by Sherlock Holmes in Sir Arthur Conan Doyle's "The Cardboard Box" of 1892. "Clues: Morelli, Freud, and Sherlock Holmes," 81–84.

[77] BERTILLON, *Les Signalements anthropométrique, méthode nouvelle de détermination de l'identité individuelle* (Paris: Masson, 1886), 15; quoted in Phéline, *L'Image accusatrice,* 130. The image of the face for identification purposes seems to be regaining utility with the advent of newer, biometric technologies; see SAUL HANSELL, "Is This an Honest Face?" *New York Times,* 20 August 1997, C1–3.

Height	1 m **74.6**	Head length	**19.5**	L. Foot	**26.5**		Class No.		Age **27 13.**
Stretch	1 m **78.5**	Head wdth	**14.9**	L Mid. F.	**11.0**	Color of Eye	Areola **Lt. Blue**		Apparent Age
Trunk	**93.7**	Cheek wdth	**13.7**	L, Lit. F	**8.5**		Periph		Nativity **N. C.**
Curve		R. Ear lgth	**6.1**	L. Cubit	**46.4**		Pecul		

Eng. Height	**5.8 ¾**	Remarks Relative to Measurements	

Indexed

SAN DIEGO, CAL
1549

SAN DIEGO, CAL
1549

Forehead	Inc. **R.**	Nose / Profile	Bridge **R.**	R. Ear	B.	Hair **LT CH**
	Height **M**		Base **EL.** Root **M**		L. **DEC.**	Complexion **RUDDY**
	Width **M**		DIMENSIONS			Weight **149**
			Heigh **M.** Projection **M.** Breadth **M.**		Teeth **Poor.**	Build **M.**
	Pecul.		Pecul.		Chin **RND.**	Beard

Right						
Left			**25** MM	Examined **10. 27. 13.**		
			16 I	By **W.A.G.**		

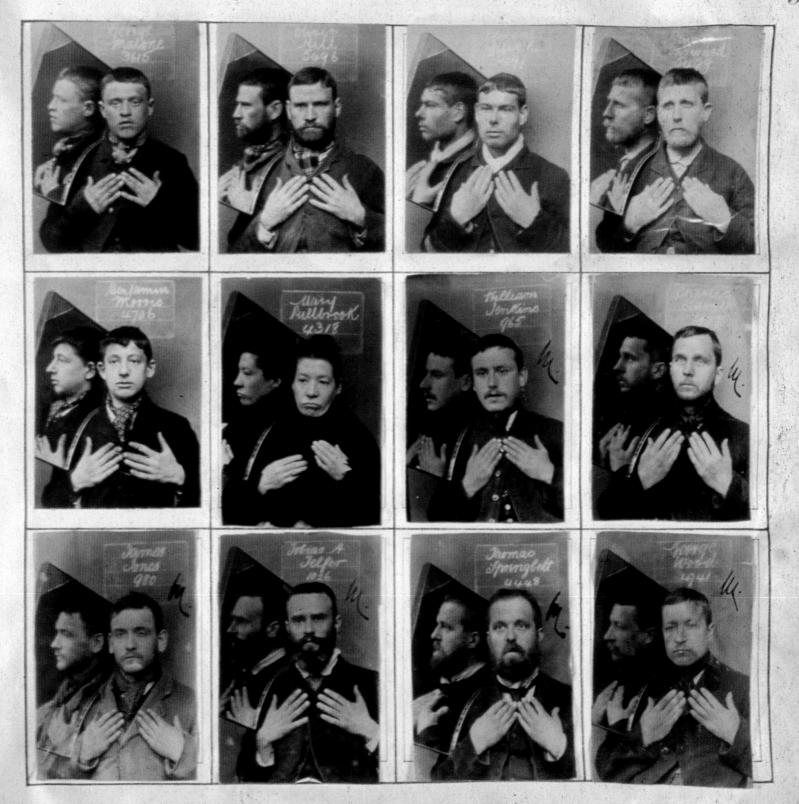

A Reversed Subjectivity

Albert Londe, the author of *La Photographie médicale: Application aux sciences médicales et physiologiques* (1893), believed that "certain afflictions . . . give a sick person an entirely special physiognomy which does not strike the observer in an isolated case, but does become typical if one sees it in others afflicted with the same illness."[78] Bertillon, similarly, trusted that there were criminal types with distinct physiognomic traits, and that his system could just as easily be extended to occupational and ethnic types. As French critic Christian Phéline points out in his closely argued study on Bertillon and criminological portraiture, "in this phase of industrial and colonial development the only function of the bertillian portrait is in the production of domination to which 'inferior' classes and races are then submitted."[79] Moreover, according to Phéline, since these images tend to be used as an index to the communal characteristics of a predetermined category,

the *identity* no longer designates the individual singularity but, rather, the conformity to a *type*. The "dogmatic" form of the police photograph itself experiences a sort of reversal: conceived at first to *differentiate* individuals, the signalizing image [*l'image signalétique*] came to totally *banalize* personal traits: the models tend to resemble each other like so many monotone variants of a single and same facial expression.[80]

Phéline's observation touches on one of the fundamental differences between nineteenth-century and modern portraits: The replacement of the traditional conviction that the face or skull expressed something of the subject's interiority with the belief that the face was a site or surface onto which feelings, stereotypes, or preconceived ideologies could be projected. Not unlike Bernheim's notion of hallucinations in the 1880s,

this modern view of the portrait reverses the traditional idea of subjectivity. Instead of expressing an inner condition, the face has become a screen that reflects only what the viewer or the portraitist sees in it.

"Knowledge based on making individualizing distinctions," historian Carlo Ginzburg warns, "is always anthropocentric, ethnocentric, and liable to other specific bias."[81] When journalist Walter Lippmann first used the word "stereotype" in a metaphorical sense, he defined it as the "projection upon the world of our own sense of our own value, our own position, and our own rights."[82] Along these lines, the creation of photographic "stereotypes" was largely due to the work of British eugenist Francis Galton, a phrenologist interested in ethnography and criminology working at about the same time as Bertillon. Galton promoted the thesis that there was a biological hierarchy of human intelligence that could be quantifiably measured. He advocated the regulation of marriages and procreation and promoted the new vocabulary of eugenics to ensure a controlled hereditary lineage and racial purity.[83]

To illustrate his theories, Galton conceived the notion of combining a number of underexposed photographic negatives of social types (such as criminals) into a "sandwich" that could then be used to print a single, composite positive of that type.[84] Each stereotype represented "no one in particular, but an imaginary figure possessing the average characteristics of a given group of persons." "The word generic," Galton wrote, "presupposes genre, which is to say a collection of individuals who have much in common and among whom the average characteristics are much more frequent than extreme characteristics. The same idea is often expressed by

[78] ALBERT LONDE, *La Photographie médicale: Application aux sciences médicales et physiologiques* (Paris: Gauthier-Villars, 1893); quoted in Phéline, *L'Image accusatrice*, 62.

[79] PHÉLINE, *L'Image accusatrice*, 112.

[80] Ibid., 113.

[81] GINZBURG, "Clues: Morelli, Freud, and Sherlock Holmes," 98.

[82] WALTER LIPPMANN, *Public Opinion* (1922; reprinted, New York: Macmillan, 1956), 96; quoted in Richard Dyer, *The Matter of Images: Essays on Representations* (London and New York: Routledge, 1993), 11. The word "stereotype," of course, had a rich usage during the nineteenth century, when it signified a mold for creating multiple copies of printing type and thus connoting "generalized replication." WALLIS, "Black Bodies, White Science: Louis Agassiz' Slave Daguerreotypes," 48.

[83] Galton wished to "further the ends of evolution more rapidly and with less distress than if events were left to their own course" and in so doing keep the social "residuum" of those exhibiting mental or physical deficiencies from reproducing and thereby further weakening the national character. *Inquiries into Human Faculty and Its Development*, 2nd ed. (London: Dent and Co., 1907); quoted in David Green, "Veins of Resemblance: Photography and Eugenics," in Patricia Holland, Jo Spence, and Simon Watney, eds., *Photography/Politics: Two* (London: Comedia/Photography Workshop, 1986), 14. I am indebted to Victor Burgin for sharing this insightful essay with me. Lavater had promoted a similar agenda; see COURTINE and HAROCHE, *Histoire du visage*, 150.

[84] In his discussion of the "shadow archive," a repository of portraits amassed by authorities that "encompasses an entire social terrain while positioning individuals within that terrain," ALLAN SEKULA contrasts Bertillon's nominalist system with Galton's essentialist system: "Bertillon sought to embed the photograph in the archive, Galton sought to embed the archive in the photograph." "The Body and the Archive," 347, 373.

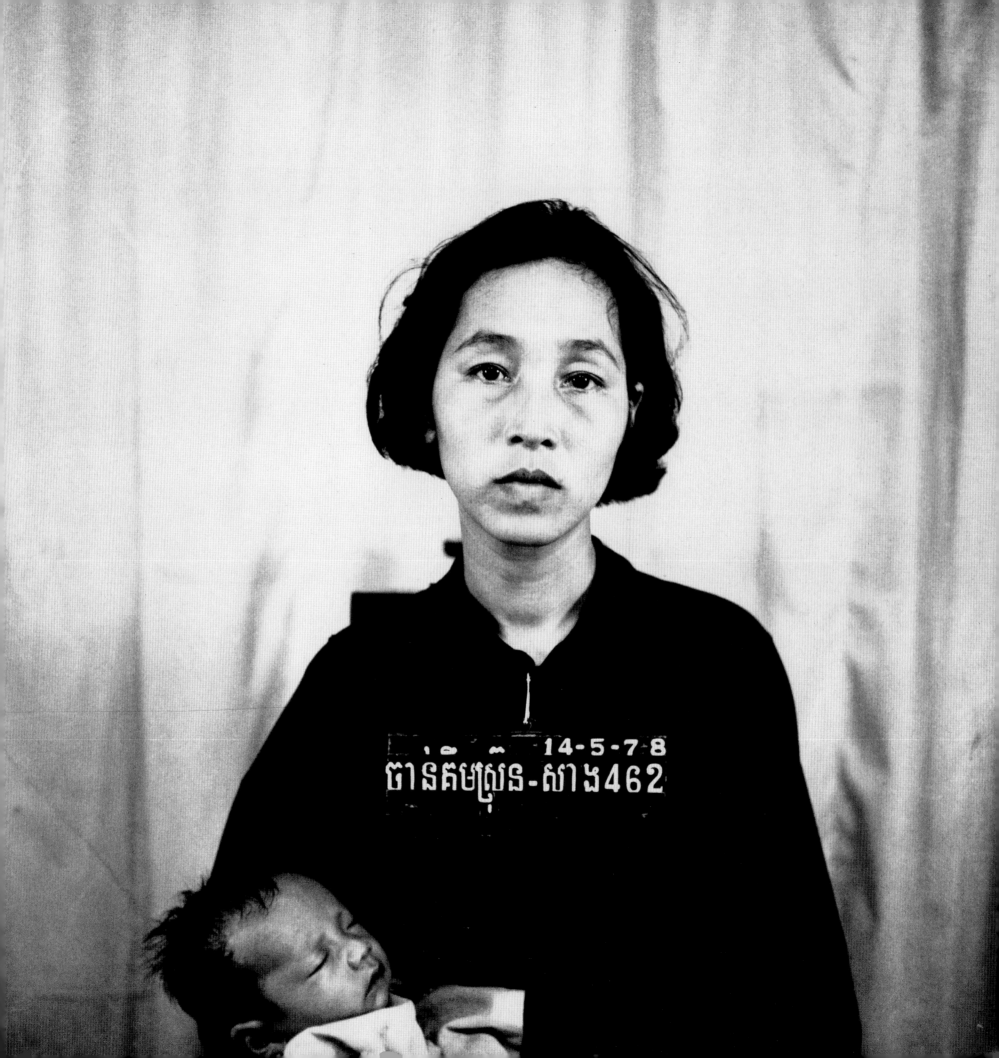

Oct. 30 years.

miller.

10/9/77.

Mania.

Fright.
Fever.

Eltham.

William Hawkins.

Says people are watching him & follow
him about. Imagines his wife is not
behaving properly towards him & threatens
her & others.
Says he will kill his wife, & set her
down & commit suicide.
Says he was completely turned round
by lightning while in the mill
some time ago.

SPECIMENS OF COMPOSITE PORTRAITURE

PERSONAL AND FAMILY.

Alexander the Great
From 6 Different
Medals.

Two Sisters.

From 6 Members
of same Family
Male & Female.

HEALTH,	DISEASE.	CRIMINALITY,

23 Cases.
Royal Engineers,
12 Officers,
11 Privates

6
Cases

9
Cases

Tubercular Disease

8
Cases

4
Cases

2 Of the many
Criminal Types

CONSUMPTION AND OTHER MALADIES

I

20
Cases

II

36
Cases

56 Cases
Co-composite of I & II

Consumptive Cases.

100
Cases

50
Cases

Not Consumptive.

the word typical."[85] The plates in his *Inquiries into Human Faculty and Its Development* (1883) include composite portraits of various Jewish types, members of the Royal Engineers (representing "health"), female and male tubercular patients (representing "disease"), different criminal types, fifty-six consumptives, and one hundred non-consumptives. Galton's search for a photographic validation of his theories, well-intentioned as it might have been, was, according to art historian Norman Bryson, a search for "proof positive that the face carried social meanings (crime, pathology, degeneration) in the very structure of its features."[86]

Galton's ideas, the basis of many racist, classist, and eugenist theories of the twentieth century, are themselves the culmination of all the nineteenth-century attempts to objectify, classify, and typify humans through portraiture. Documenting generic types instead of individuals was not greatly different from what contemporary anthropologists, ethnographers, criminologists, and social portraitists were trying to do. All in their way used their subjects as proofs of what they already suspected or, at least, as raw material with which their particular agendas could be represented. In depicting cultural difference (race, criminality, pathology, etc.), these programs explicitly or implicitly contrasted their subjects to an Apollonian standard. They anticipate such widely divergent projects as Curtis's photographs of Native Americans, E. J. Bellocq's Storyville portraits, and Nicholas Nixon's blank faces of patients suffering from Alzheimer's disease. In depicting social similarity (class, occupation, beauty, etc.), these programs might be viewed as the conceptual beginnings of such later photographic undertakings as August Sander's documentation of German social types, the government-sponsored portraits of farm laborers by Walker Evans, and even the studio-sponsored glamour

portraits of Hollywood stars. Specifically, Galton's technique of sandwiching multiple faces to create average or fictive types constitutes the aesthetic foundation for later composite portraits by a number of artists including William Wegman and Nancy Burson. To Norman Bryson, Burson's composites, such as her playful Lizard/Man or her generic *5 Vogue Models* (both 1989), prove "photography's own power to evacuate the referent, to erode the presence of the face and put in its place a cloud, a cathode ghost."[87] In this tradition, the face is the "site not of truth but of manipulation."[88]

Two drawings by the Bauhaus dance instructor Oskar Schlemmer, done during the Weimar Republic, symbolically articulate modernist portraiture's reversal of subjectivity. In one, *Man in the Sphere of Ideas* (c. 1928), a figure is surrounded by the words "time," "constructed space," "natural space," "Earth," "vegetation," and "art." Words suggesting physical interactions are written on or about the figure: "kinetics" is just below a foot, "mechanics" begins at a knee, "musculature" at a shoulder. "Organs" and "blood" are located within the torso. The figure's head contains only two terms, "nerve center" and "phrenology," the latter in rather small lettering. All other concepts related to personality, character, and consciousness are distinctly removed from the figure: "circle of ideas" floats somewhat above the head, "ethics" somewhat farther away, and "psychology" in front of the face. The vertical line drawn down the center of the upright sprinting figure is clearly labeled as such. Schlemmer's man is rendered as a machine of muscles, organs, and fluids. Everything physiognomy and pathognomy sought to discover about human character and expression is external to that machine, leaving only phrenology.

[85] GALTON, *Inquiries into Human Faculty* (London: Macmillan, 1883), 350, 340; quoted in Phéline, *L'Image accusatrice,* 64–65.

[86] NORMAN BRYSON, "Façades," in Maurice Tuchman and Virginia Rutledge, eds., *Hidden in Plain Sight: Illusion in Art from Jasper Johns to Virtual Reality,* unpublished exh. cat. (Los Angeles: Los Angeles County Museum of Art, [1996]), 55, galleys.

[87] BRYSON, "Façades," 55.

[88] Ibid.

ABOVE
Oskar Schlemmer, *Man in the Sphere of Ideas* (detail), c. 1928, pen-and-ink drawing, © 1999 the Oskar Schlemmer Theater Estate, photograph courtesy Photograph Archive C. Raman Schlemmer, Oggebbio, Italy.

OPPOSITE
Nicholas Nixon, *M. A. E., Boston,* 1985, cat. no. 85.

PAGE 128
Nancy Burson, *5 Vogue Models,* 1989, printed 1999, © 1999 Nancy Burson with David Kamlich, cat. no. 13.

PAGE 129
William Wegman, *Twins Lynn/Terry,* 1971, cat. no. 144.

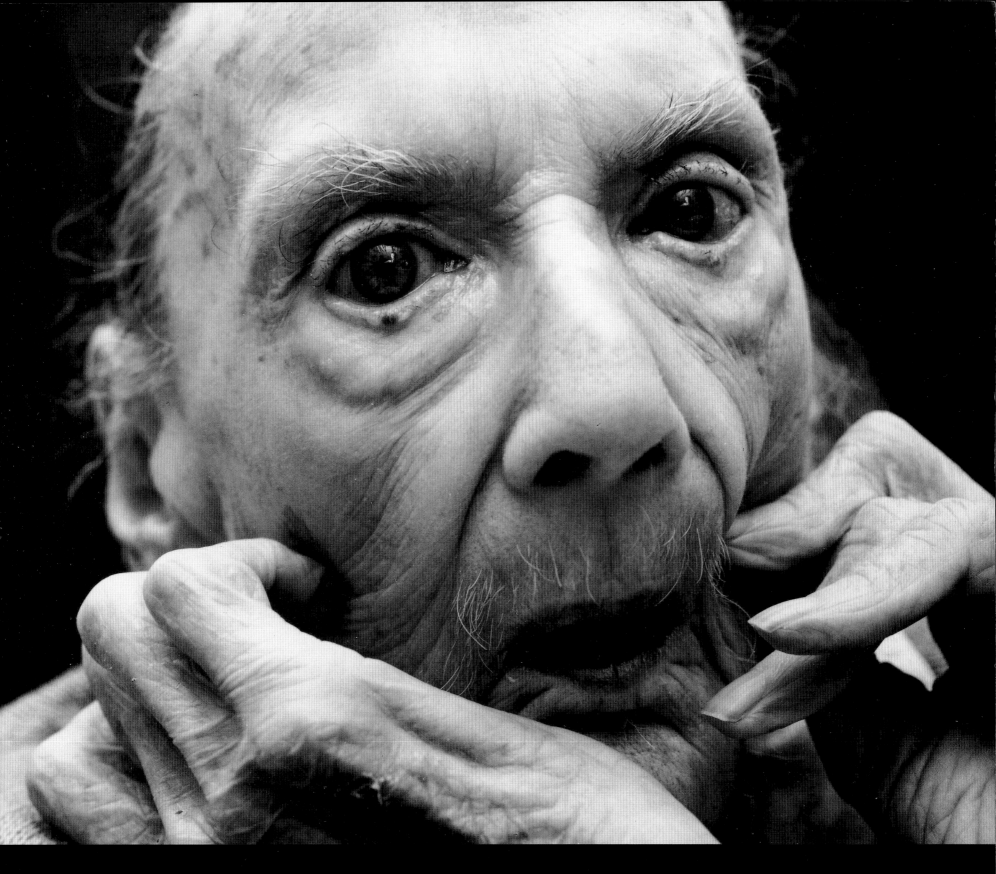

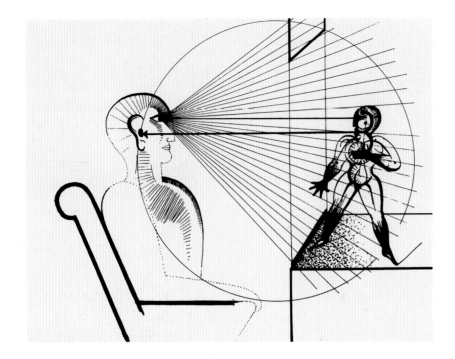

In another of Schlemmer's drawings, *Man the Dancer (Human Emotions) I: Performer and Spectator II* (c. 1924), a vastly oversized figure sits observing a smaller one on a proscenium stage, performing with legs splayed and hand to the chest. Besides the striking disproportion of the two figures, which ascribes a greater significance to the observer than to the performer, the critical features of this image are the set of vision lines emanating from the observer's eye and encompassing the performer and the entire stage, and the single linear vector proceeding from the performer's mouth to the observer's ear. The performer's role is minimal and auditory; the observer, merely by looking at the scene, creates everything else.

Modern painters since Expressionism had long considered plastic form a means of personal expression, since the personality of the artist shaped that form. According to Wassily Kandinsky, "Form is the external expression of inner content. . . . Thus, form reflects the spirit of the individual artist. Form bears the stamp of personality."[89] The inner content was the artist's, and form was its conveyance. Van Gogh wished for a "portraiture with the thoughts, the soul of the model in it," and required a model because "in the matter of form I am too afraid of departing from the possible and the true."[90] Kandinsky, on the other hand, argued that if an artist purposely "dislocated" or "distorted" a model's facial features, what remained relevant and essential was "the artistic aim."[91] Schlemmer's gargantuan observer, then, may be seen as the modernist turning the tables on traditional views of expressions of the emotions. The observer projects his or her sight and sensibility onto the performer, submitting the performer to the observer's subjectivity, and not the other way around.

The New Objectivity

Weimar Germany during the 1920s was home to two entirely dissimilar artistic movements: Dada, with its emphasis on cut-and-paste cacophony, and the New Objectivity *(Neue Sachlichkeit)* and its coolly disinterested realism. Certain artists, however, among them George Grosz and Christian Schad, shared some of the sensibilities of both. Both Grosz and Schad had experimented with Dada montage early in the

decade, and both had turned to differing forms of realist painting, especially portraiture, following the collapse of Dada. Grosz's virulently scabrous and satiric portraits of middle-class Berliners earned him more than a fair amount of enmity and criticism. Dramatist Bertolt Brecht claimed that Grosz looked on the bourgeoisie in the same way the bourgeoisie looked down on the proletariat: "I think what has made you an enemy of the bourgeoisie, George Grosz, is its physiognomy. . . . Drawing for you was a diversion and the physiognomies of people occasions for it. . . . I imagine that you had discovered a violent and irresistible love for a certain, typical face one day . . . [and] it was the 'face of the dominant class'."[92] In his turn, Grosz wrote, "Man is no longer a clear individual, but rather a collective notion, almost mechanical. His individual destiny is no longer of interest." He painted accordingly:

Lines are drawn in a technical fashion, photographically. I construct the volumes. Construction, solidity, functionalism. I control the lines, the forms. No more painted expressionist paper on canvas, no more states of souls. Sober and precise, the engineer's drawing is worth more than all the mystical bla-bla-bla.[93]

[89] Wassily Kandinsky, "On the Question of Form," *Blaue Reiter* (Munich, 1912), in *Kandinsky: Complete Writings on Art,* ed. Kenneth C. Lindsay and Peter Vergo (New York: Da Capo Press, 1994), 237.

[90] Vincent van Gogh, "To Theo, Arles, n.d. [August 1888]" and "To Emile Bernard, Arles, first half of October 1888," in Herschel B. Chipp, ed., *Theories of Modern Art: A Source Book by Artists and Critics* (Berkeley: University of California Press, 1968), 35, 40.

[91] Kandinsky, *On the Spiritual in Art and Painting in Particular,* 2nd ed. (Munich, 1912), in *Kandinsky: Complete Writings on Art,* 171.

[92] Bertolt Brecht, quoted in Uwe M. Schneede, "Vérisme et nouvelle objectivité," trans. Henri-Alexis Baatsch, in Pontus Hulten, ed., *Paris-Berlin: Rapports et contrastes France-Allemagne, 1900–1933,* exh. cat. (Paris: Centre national d'art et de culture Georges Pompidou, 1978), 187.

[93] George Grosz, "Zu meinen neuen Bildern," *Das Kunstblatt* 5, no. 1 (1921); quoted in Schneede, "Vérisme et nouvelle objectivité," 194.

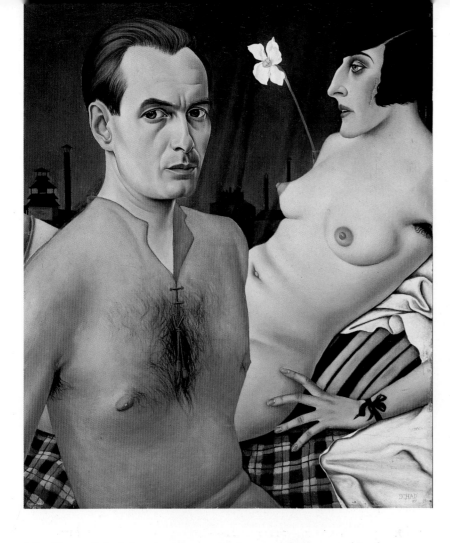

Like Grosz, Schad foreclosed on sentiment and feelings; to him human-kind was doomed to emotional attenuation. Describing a sense of modern alienation, Schad's friend Walter Serner wrote, "Man is alone, powerless to make contact with those close by; there is no bridge between individuals. Even sexuality creates only fictive links. Fusion between man and woman is impossible; they cannot rise above the metaphysical antagonism that separates them."[94] About Schad's portraits of alienated, decadent, and dispassionate Berliners, with their cold, expressionless eyes and clinical detachment, art critic Calvin Tomkins remarked more recently, "Does this sensibility ring a bell? As a portrait artist, Schad seems to have been the Andy Warhol of his day."[95]

The law of modernist photographic portraiture was laid down in 1925–27 by another Bauhaus artist, the Hungarian-born László Moholy-Nagy, who claimed that the new "objective portrait" was one in which the sitter was "to be photographed as impartially as an object so that the photographic result shall not be encumbered with subjective intention."[96] Moholy-Nagy believed that "in the photographic camera we have the most reliable aid to a beginning of objective vision," and that "everyone will be compelled to see that which is optically true, is explicable in its own terms, is objective, before he can arrive at any possible subjective position."[97] Because of photography and film, he wrote, "we see the world with entirely different eyes"; but even that was not enough: "We wish to produce systematically, since it is important for life that we create *new relationships*."[98] First, the only subjectivity allowed was that of the person who saw objectively, and second, only through objective vision was it possible to create these "new relationships" among either heterogeneous or homogeneous things, persons, or types. With their precision, the camera media were perfect tools for creating formal correspondences where none may have been seen before. Primarily interested in the aesthetics of formal abstraction, Moholy-Nagy seems nonetheless to have adopted the very arguments used by earlier phrenologists, anthropologists, and criminologists in his insistence on creating relational comparisons through the "objective" lens of the camera.[99]

Outside commercial portrait studios, talk about the inner personality of the sitter has been noticeably absent from the discourse of photographic portraiture since the 1920s. Instead, the "sur-

94 WALTER SERNER, "Inferno," *Sirius* (1915–16); quoted in Günter Metken, "Un Art démocratique: Le Portrait de la 'Neue Sachlichkeit,'" in Hulton, ed., *Les Réalismes: 1919–1939*, exh. cat. (Paris: Centre national d'art et de culture Georges Pompidou, 1980), 114.

95 CALVIN TOMKINS, "Urbane Decadent," *New Yorker*, 29 September 1997, 58.

96 LÁSZLÓ MOHOLY-NAGY, *Painting Photography Film*, trans. Janet Seligman (Cambridge: MIT Press, 1967), 96. This work was originally published as *Malerei, Fotografie, Film*, vol. 8 of the Bauhausbücher series in 1925, and was followed by a second German edition in 1927.

97 MOHOLY-NAGY, *Painting Photography Film*, 28.

98 Ibid., 29.

99 To be fair, Moholy-Nagy's desire to improve the state of modern visual education puts him as much in line with the seventeenth- and eighteenth-century creators of *Wunderkammeren* who sought edification through visual appearances. For a different approach to the same subject, see STAFFORD, "The Visualization of Knowledge from the Enlightenment to Postmodernism," in *Good Looking: Essays on the Virtue of Images* (Cambridge: MIT Press, 1996), 20–40.

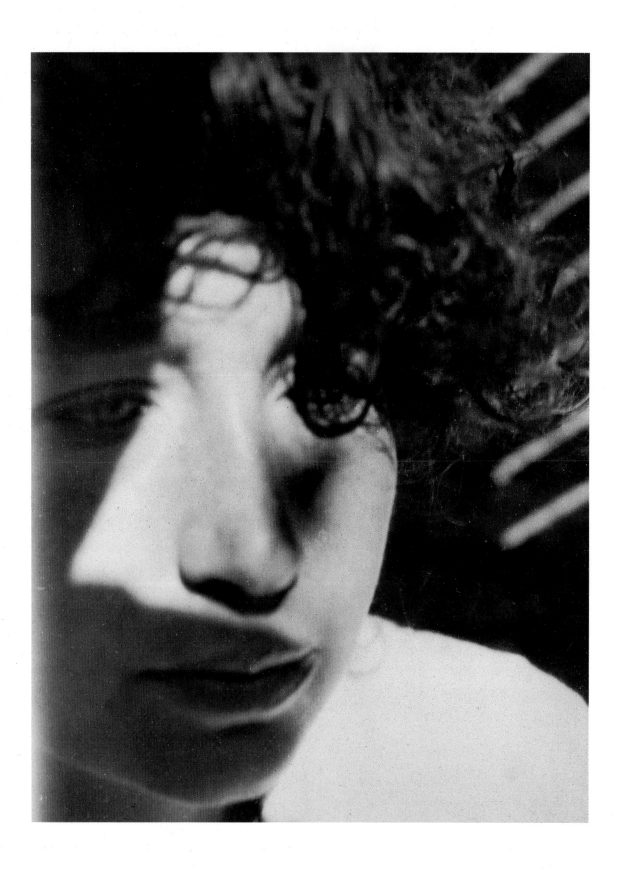

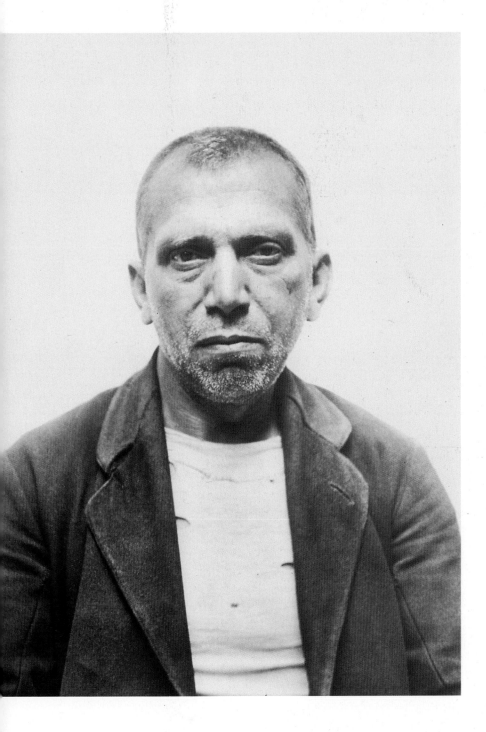

face" seems to have been the locus of all that is meaningful. In the context of an aesthetics based on the belief that "a heightened form is always extracted from the essence of the objects," in the words of critic Carl Georg Heise, the face became material for a manipulated picture rather than a penetrative portrait.[100] German novelist Alfred Döblin, introducing August Sander's famed *Antlitz der Zeit* in 1929, wrote that Sander represented a new kind of realist, whose photographs of people were not likenesses of "Mr. X and Mrs. Y" but rather "photographs of faces" in which the *comparative anatomy* of "the culture, class, and economic history of the last 30 years" could be studied.[101] In his introduction to Helmar Lerski's book of portraits of German workers (*Köpfe des Alltags,* 1931), critic Curt Glaser wrote that the photographer

PAGE 134
Helmar Lerski
(Israel
Schmuklerski),
*Veit Harlan,
Film Director,*
c. 1927,
cat. no. 68.

PAGE 135
Helmar Lerski
(Israel
Schmuklerski),
German Housekeeper,
1928–31,
courtesy George
Eastman House,
cat. no. 67.

uses light to model the features of a human face, to make it speak in a particular way. He works with mirrors that reflect sunbeams, and he uses shadows to draw sharp lines on a face, to make furrows and hollows; he allows light to play upon salient forms so that the whole surface becomes lively and the expressive, plastic image of a human countenance comes into view. In photography of this kind the model is only raw material, to be shaped by the artist's creative will.[102]

The only "soul" displayed in these images was that of the photographer, who had to "express his own opinion of the sitter's nature,"[103] while defining a new "physiognomical-psychological accord" through which only inferences were possible.[104] The face had become only "raw material," like paint or clay.

Considered in this light, the modern portrait has been an artistic enterprise that at times speaks more eloquently about photographers' agendas than the inner nature of their models. Paul Strand's famous portraits of the mid-1910s or Alfred Stieglitz's poignant, extended series of

OPPOSITE
László Moholy-Nagy,
*Portrait of Lucia
Moholy,* c. 1926–29,
© 1999 Artists Rights
Society (ARS),
New York/
VG Bild-Kunst, Bonn,
cat. no. 76.

ABOVE
August Sander,
Inmate of an Asylum,
1930, © 1999 Die
Photographische
Sammlung—
August Sander
Archiv/SK Stiftung
Kultur, Cologne;

ARS, New York/
VG Bild-Kunst,
Bonn, cat. no. 106.

[100]CARL GEORG HEISE, preface to *Die Welt ist schön* (1928), by Albert Renger-Patzsch, in David Mellor, ed., *Germany: The New Photography, 1927–33* (London: Arts Council of Great Britain, 1978), 13.

[101]ALFRED DÖBLIN, "About Faces, Portraits and their Reality," introduction to *Antlitz der Zeit,* by August Sander (1929), in Mellor, *Germany: The New Photography,* 57; emphasis mine.

[102]CURT GLASER, introduction to *Köpfe des Alltags* (1931), by Helmar Lerski, in Mellor, *Germany: The New Photography,* 63.

[103]Ibid., 62.

[104]KENNETH MACPHERSON, "As Is," review of *Köpfe des Alltags* (1931), by Helmar Lerski, in Mellor, *Germany: The New Photography,* 68.

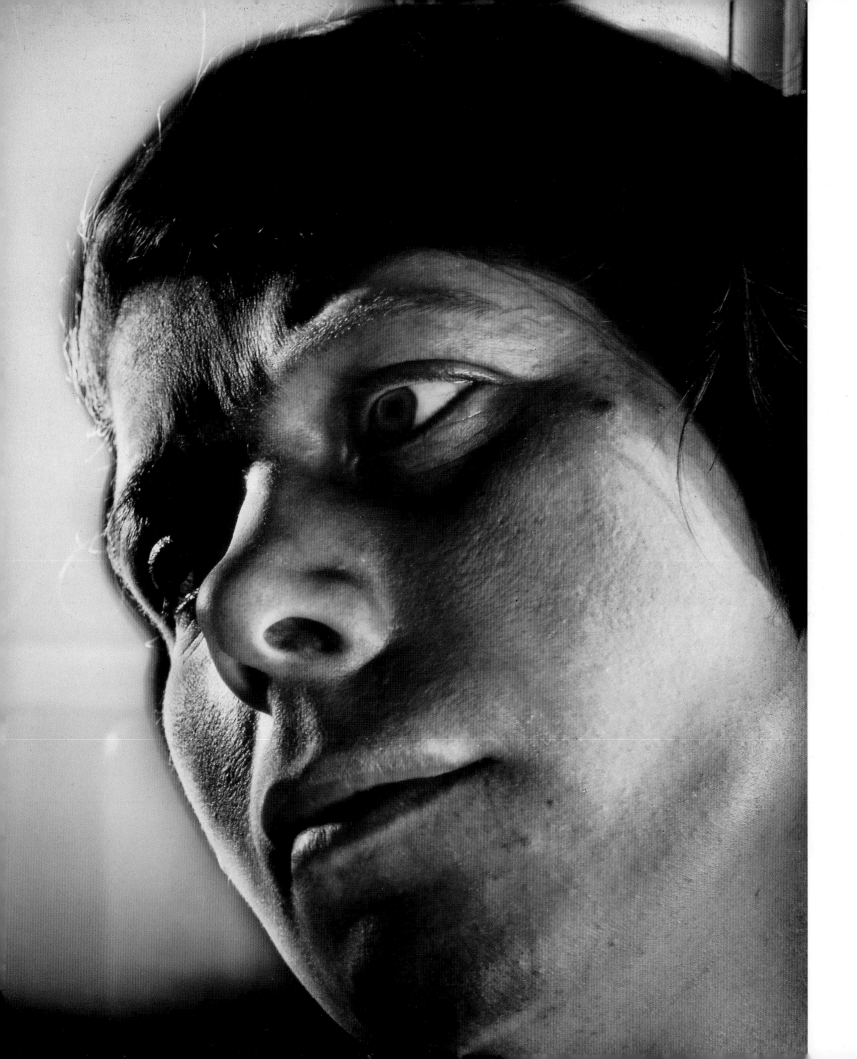

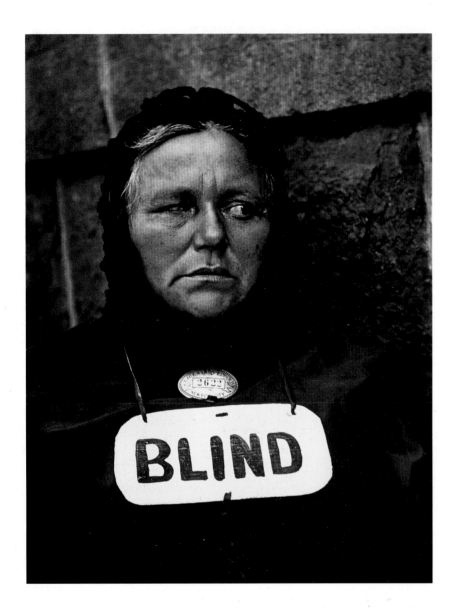

LEFT
Paul Strand, *Blind Woman, NY*, 1915/printed 1945, courtesy George Eastman House, © 1971 Aperture Foundation, Inc., Paul Strand Archive, cat. no. 120.

OPPOSITE
Max Burchartz, *Lotte's Eye*, c. 1928, © 1999 Artists Rights Society (ARS), New York/VG Bild-Kunst, Bonn, cat. no. 12.

portraits of Georgia O'Keeffe begun in 1917; Alvin Langdon Coburn's softly transfixed likenesses of British poets and writers done around 1908; Edward Weston's dramatic depictions of Mexican artists and poets taken in the 1920s; Lucia Moholy's clinical close-ups of avant-garde photographers done in the late 1920s; or Max Burchartz's extremely cropped photograph *Lotte's Eye* of about the same time—what makes each of these images so riveting is the photographer's own eye, his or her drive to formal design and style, the desire for pictorial boldness. The structure of the face that once signified inner feelings or states has given way to differing structures of aesthetic manipulation. As critic John Welchman has written,

In Modernism, that is, in the heyday of structures, the painted and sculpted face became a double zone of distortion and reduction. . . . The face is no longer a visible token of public esteem or self-aggrandizement; it is no longer a mirror for the soul or an assigned marker for the narrative flow: it has eventually become an arena of *facture* among other adjacent places, other marks.[105]

In the now-classic modernist portrait, the face is customarily isolated from both the body and its context; it is pictured as a blank arena or site for external investigation. Even when the face is not isolated, even when the face and the body are contextualized, say, in an interior or landscape, the artist must still manipulate the details to convey his or her intention.

Portrait photographer Arnold Newman has dismissed the possibility of ever depicting the subject's interiority: "I'm convinced that any photographic attempt to show the complete man is nonsense, to an extent. We can only show, as best we can, what the outer man reveals; the inner man is seldom revealed to anyone, sometimes not even to the man himself. We have to interpret."[106] Interpretation is manipulation, and portrait and fashion photographer Richard Avedon expressed this idea most succinctly:

The point is that you can't get at the thing itself, the real nature of the sitter, by stripping away the surface. The surface is all you've got. You can only get beyond the surface by working with the surface. All that you can do is to manipulate that surface—gesture, costume, expression—radically and correctly.[107]

Isolated in close-up or contextualized by an envelope of social meanings, the modern portrait remains a surface that is "invaded and controlled by the outside."[108]

[105]Welchman, "Face(t)s: Notes on Faciality," 135.

[106]Arnold Newman, "A *Popular Photography* Tape Interview: Arnold Newman on Portraiture," interview by Arthur Goldsmith, *Popular Photography* 40, no. 5 (May 1957): 125–6.

[107]Richard Avedon, "Borrowed Dogs," in Ben Sonnenberg, ed., *Performance and Reality: Essays from Grand Street* (New Brunswick and London: Rutgers University Press, 1989), 17. Nearly two decades earlier, Avedon had said, "My photographs don't go below the surface. They don't go below anything. They're readings of what's on the surface. I have great faith in surfaces. A good one is full of clues." Artist's statement in Caroll T. Hartwell, ed., *Avedon*, exh. cat. (Minneapolis: Minneapolis Institute of Art, 1970), unpag.

[108]Welchman, "Face(t)s: Notes on Faciality," 131.

Seen in this context, this type of portrait is truly more indexical than interpretive or penetrative, and the modernist photographer more interested in similarities and differences among types. The anthropological/ethnographic agendas of the nineteenth century were aestheticized, as it were, by many individual photographers and state-sanctioned programs during the first three decades of the twentieth century. Lewis Hine's project of photographing ordinary children, men, and women at work; Sander's epic documentation of social and cultural types of German people; Lerski's monumentalizing of the faces of laborers in Berlin or an actor on a kibbutz in Palestine; Walker Evans's photographs of the humble faces of tenant farmers in Alabama, families in mining towns, or the blank, public faces of subway riders; and Dorothea Lange's portraits of abjection in Texas, Oklahoma, and California—these all portray similarity within difference, and therein discover difference amidst similarity. They offer us the chance to compare ourselves to these mirrors that happen to be the faces of others.[109] What the poet William Carlos Williams said about Evans's pictures might just as easily be said about all of these: "It is ourselves we see, ourselves lifted from a parochial setting. We see what we have not heretofore realized, ourselves made worthy in our anonymity."[110] Wondering whether Lange's iconic *Migrant Mother, Nipomo* of 1936 expressed suffering or perseverance, Roy Stryker

RIGHT
Walker Evans,
*Alabama Cotton
Tenant Farmer's Wife*,
1936, photograph
© 1999 The Art
Institute of Chicago,
all rights reserved,
cat. no. 46.

OPPOSITE
Dorothea Lange,
*Migrant Mother,
Nipomo, California*,
1936/printed later,
cat. no. 64.

(who headed the photographic services of the Farm Security Administration for which Lange took the photograph) concluded, "You can see anything you want to in her. She is immortal."[111]

The same thing occurs at the other end of the spectrum. Celebrity portraiture can also be traced to mid-nineteenth-century origins, to the French photographer Charles Nègre's portrait of Rachel, a popular actress who in 1853 commissioned him to produce fifty prints of her image to take on a tour of Russia.[112] And what Disdéri and others accomplished in the mid-nineteenth century—the picturing of celebrities for mass-market consumption—was carried through with a vengeance by the Hollywood studios during the 1920s and 1930s. The normative Hollywood portrait by photographers such as George Hurrell, Clarence Sinclair Bull, and László Willinger is a static, iconic emblem of fame and stardom to be admired, adored, and desired. And it has not altered dramatically over the years. According to critic Vicki Goldberg,

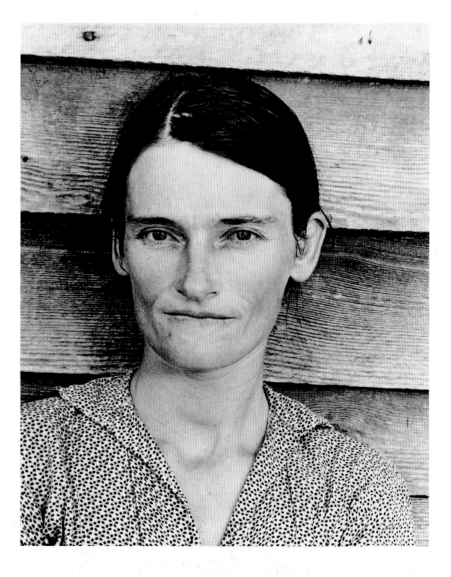

[109] Cf. CHRISTOPHER PINNEY, "The Parallel Histories of Anthropology and Photography," in Edwards, *Anthropology and Photography, 1860–1920*, 87–90. Pinney advances a comparison of traditional anthropological photographs with Dorothea Lange's documentary photography of the 1930s but concludes that such a comparison is merely "paradigmatic" or metaphoric as opposed to "syntagmatic" or signifying.

[110] WILLIAM CARLOS WILLIAMS, "Sermon with a Camera," *New Republic*, 12 October 1938: 282; quoted in John Szarkowski, *Walker Evans*, exh. cat. (New York: Museum of Modern Art, 1971), 16.

[111] ROY STRYKER, in Stryker and Nancy Wood, *In This Proud Land, America 1935–1943, as Seen in the FSA Photographs* (Greenwich, Conn.: New York Graphic Society, 1973), 19; quoted in Martha Rosler, "In, Around, and Afterthoughts (On Documentary Photography)," in Bolton, *The Contest of Meaning: Critical Histories of Photography*, 315.

[112] See JAMES BORCOMAN, *Charles Nègre: 1820–1880*, exh. cat. (Ottawa: National Gallery of Canada, 1976), 37; and FRANÇOISE HEILBRUN, ed., *Charles Nègre: Photographe, 1820–1880*, exh. cat. (Paris: Editions de la Réunion des Musées Nationaux, 1980), 112.

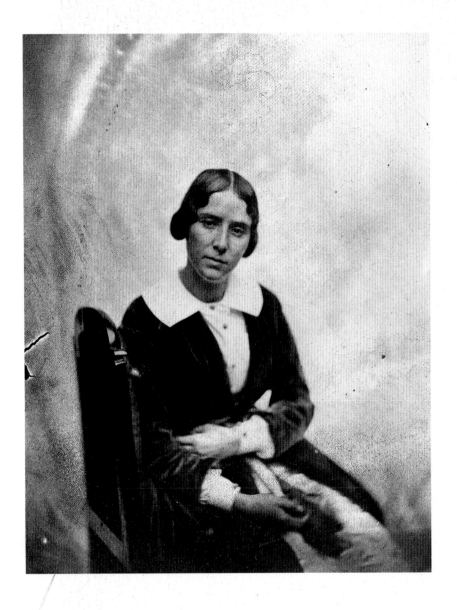

Recent big-time celebrity photographers, including Ritts, Newton, Leibovitz, the late Robert Mapplethorpe, Matthew Ralston and Bruce Weber, have no illusions that photography can picture the soul. (And celebrities who step into a photographer's studio don't have much incentive to nurture their souls, which don't go into reruns in America anyway). The images, Ritts's as much as anyone's, are about surfaces, and the surfaces are described with enormous clarity, for basically the subjects are objects—sex objects, decorative objects, but mainly symbolic objects.[113]

Certainly, some of these portraits are more beautiful than others, but ultimately they are as much symbolic types (masculine hunk, feminine beauty, melancholy loner, femme fatale, rugged individualist, anguished youth, etc.) as any of the various classificatory portraits of the last century.

The same can also be said about the photographed faces of fashion models that have stared out from the covers and pages of *Vogue, Harper's Bazaar,* and other journals since the 1930s: those cultural gods and goddesses that show us what forms to assume, from Lisa Fonssagrives by Irving Penn and Jean Shrimpton by Avedon, to Christy Turlington by Patrick Demarchelier, Claudia Schiffer by Ellen von Unwerth, Marcus Schenkenberg by Herb Ritts, and Kate Moss by Sante d'Orazio.[114] In an interview with Moss, actor Dennis Hopper suggested that she had created her own image, but she disagreed:

Moss: *In a way, it's like the photographer always has his vision of me. The pictures that I'm known for are not really my image, they're always the photographer's vision of me. I can look a hundred different ways, but what people see of me in pictures is not really my image.* Hopper: *But yet whatever that image is, we can develop all kinds of fantasies about it.*[115]

Celebrity portraits may, like other "type" photographs, be indexical, but what they index has nothing to do with the model photographed; rather, they are indices to our fantasies, our passions, and our dreams. These are faces, whether male or female, onto which the photographer has projected his or her desires and onto which we in turn may project ours. They are laconic, like images in dreams, just as nearly all fashion

ABOVE
Charles Nègre,
Rachel, 1853,
salted-paper print,
photograph courtesy
the Musée d'Orsay
and André Jammes,
Paris, photograph
by Patrice Schmidt.

OPPOSITE
László Willinger,
Portrait of Unidentified Young Woman,
c. 1933–37,
cat. no. 147.

PAGE 142
Herb Ritts,
Karen, 1989,
cat. no. 190.

PAGE 143
Robert
Mapplethorpe,
Ken Moody, 1983,
© The Estate
of Robert
Mapplethorpe,
used by permission,
cat. no. 75.

PAGE 144
Victor Skrebneski,
*Vanessa Redgrave,
Hollywood,*
1967/printed 1991,
cat. no. 117.

PAGE 145
Sante d'Orazio,
*Kate Moss,
West Village,
NYC,* 1992,
cat. no. 38.

[113]Vicki Goldberg, "Fixated on Famous People," *New York Times,* 22 November 1992, H33.

[114]Cf. Glenn O'Brien, "Like Art," *Artforum* 26, no. 9 (May 1988): 18; and "Like Art," *Artforum* 27, no. 5 (January 1989): 9.

[115]Dennis Hopper, "The Society of Models: Conversations with Lauren Hutton, Christy Turlington, Kate Moss, and Naomi Campbell," *Grand Street* 50 (fall 1994): 148.

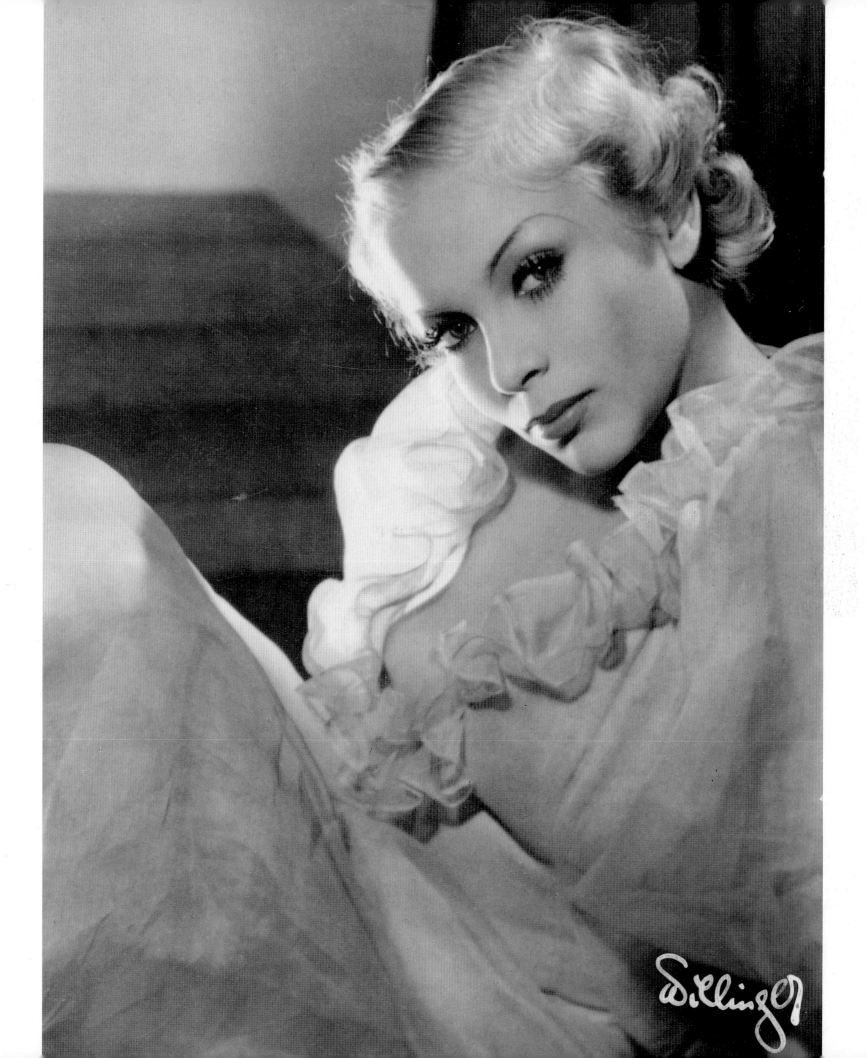

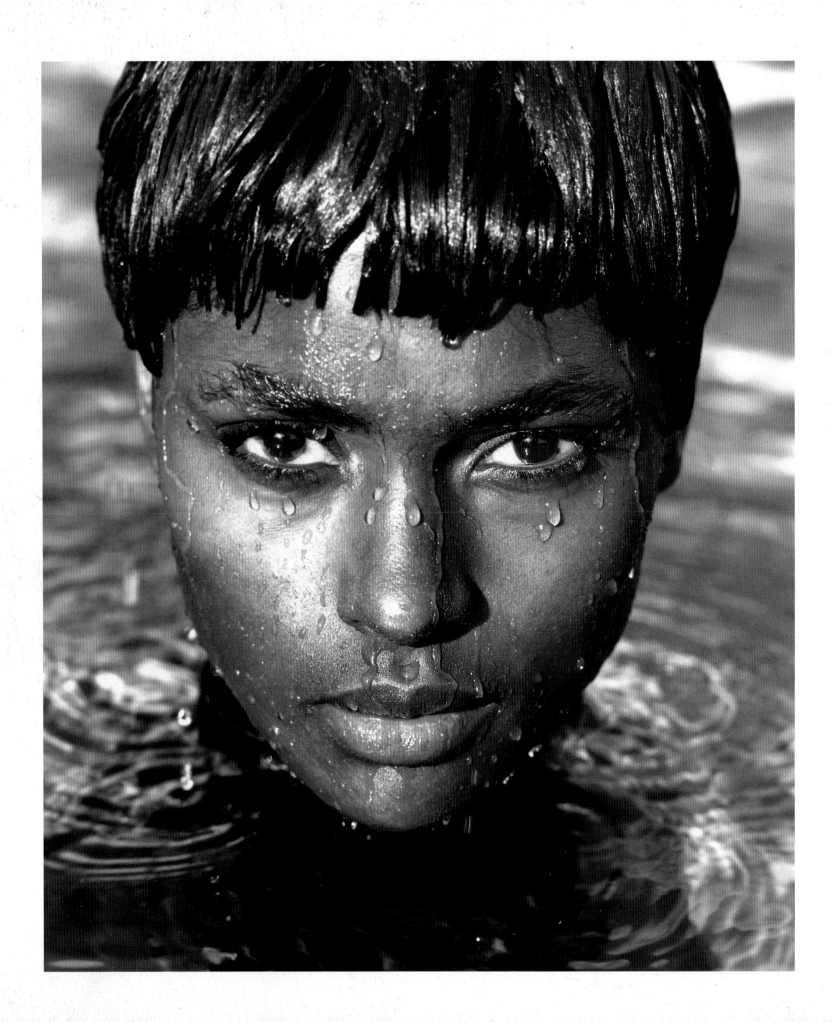

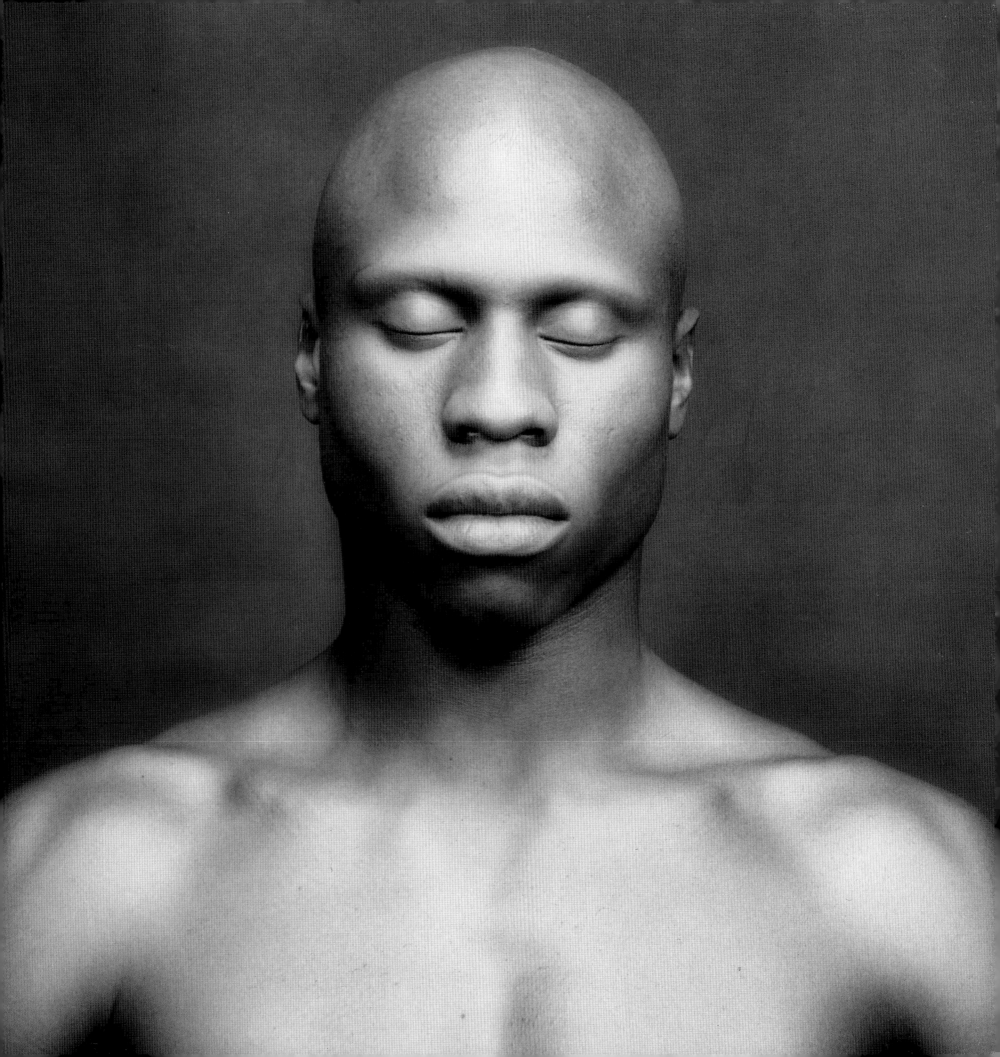

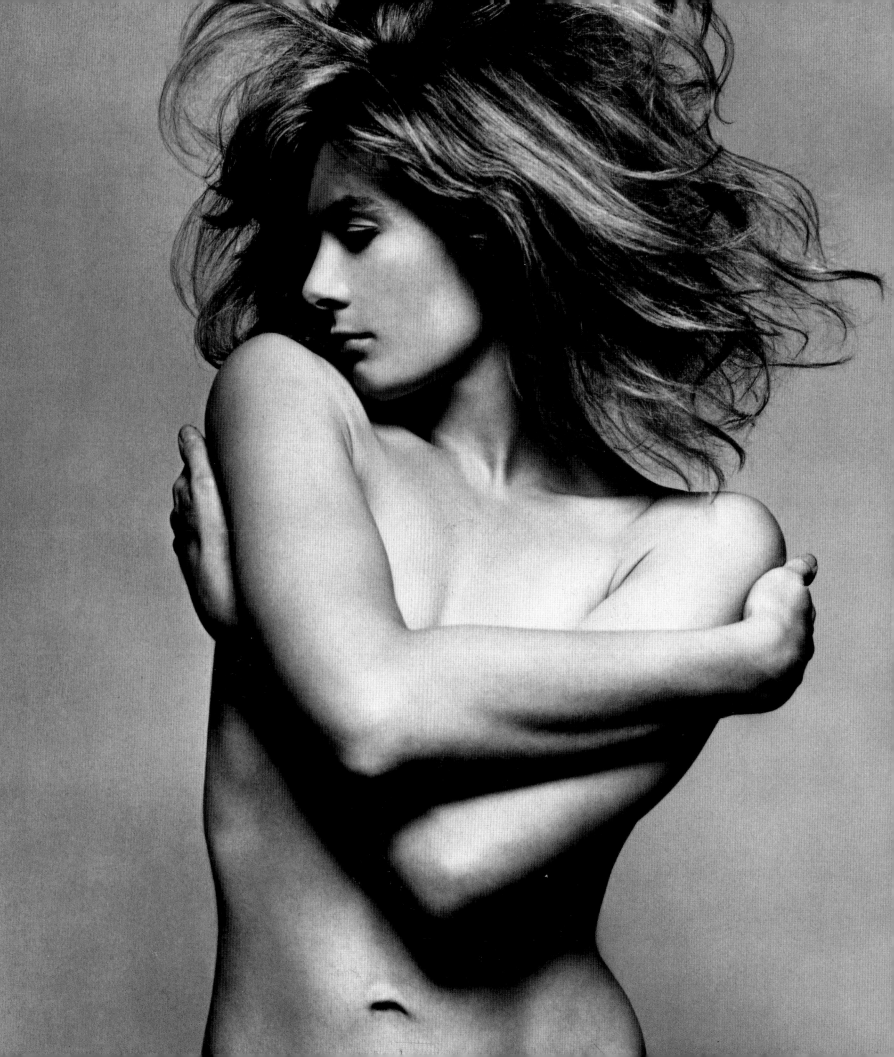

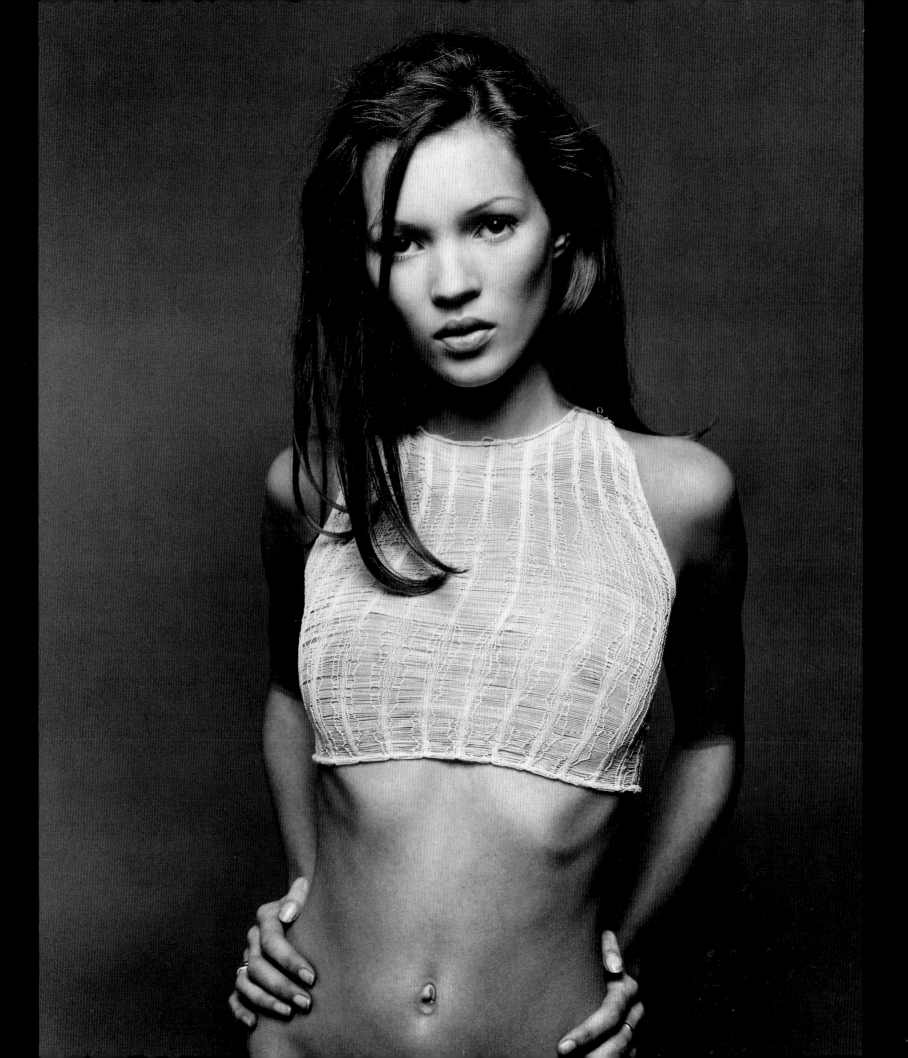

and advertising photography is in the end.[116] Like portraits of movie stars, portraits of models function primarily as objects of desire within scopic fields; according to critic Craig Owens, "the model poses as an object *in order to be a subject*."[117] Or, better, as model Linda Evangelista says in a TV commercial, "I don't have identity."[118]

Andy Warhol

In 1962, exactly one hundred years after the publication of Duchenne's *Mécanisme de la physionomie humaine,* at the center of this century's most intense production of fame and celebrity, Warhol began work on his series of photo-silkscreened "portraits" of movie stars. His subjects included Troy Donahue, Natalie Wood, Warren Beatty, Elvis Presley, Elizabeth Taylor, and especially Marilyn Monroe. He appropriated the vapid likenesses of these popular celebrities from cheesy mass-media publicity stills and elevated their expressionless faces to even greater iconic status. Like his boxes of Brillo scouring pads, cans of Campbell's soups, and bottles of Coca-Cola, these faces belonged unabashedly to our popular consumer culture. Their intrusion into art was hard enough for the world of high culture of the period to accept, but Warhol further radicalized his approach to painting, and subsequently that of later artists, by electing to use the prosaic, commercial technique of photo-silkscreening, a photomechanical means of cheaply reproducing images in any array of colors and on any flat surface, including primed or painted canvas. "In my art work," he explained, "hand painting would take much too long and anyway that's not the age we're living in. Mechanical means are today. . . . Silkscreen work is as honest a method as any, including hand painting."[119] For more than a century, photographers had defended their art with any number of arguments, and most of their stratagems involved aspirations toward, if not comparisons with, painting. But Warhol, a *painter,* chose photography for the very facility that earlier photographers had tried to complicate. Calling his portraits "paintings," Warhol often added a second, blank canvas painted the same background color: "*Liz Taylor,* for instance, three feet by three feet, in any color you like, with the blank costs $1600. Signed of course."[120]

The clinical remoteness of these portraits emphasizes both the quotidian nature of their origins in the mass press and the level to which modern emotions have become abstracted and unimpassioned. The banality of the image and the pedestrian print quality of the screen process are further accentuated by Warhol's almost careless underpainting. As critic Benjamin Buchloh points out, "When paint is in fact added manually (as in many of the Marilyn and Liz portraits), it is applied in such a vapid manner, detached from gesture as expression as much as it is dislocated from contour as depiction . . . that it increases rather than contradicts the laconic mechanical nature of the enterprise."[121] Repeating the same publicity shot in gridded arrays hundreds of times further accentuates its bankruptcy of expression. As he had done in *Two Hundred Campbell's Soup Cans* and *210 Coca-Cola Bottles,* Warhol applied the factor of multiplicity to a number of his portraits: Thus, *Marilyn x 100* alludes as much to the indefinite reproducibility of the media image as it does to the countless guises the actress by definition assumes. Sometimes Warhol overscreened the same portrait slightly off-register, giving it either a *faux* sense of chronophotographic sequencing, as in *Triple Elvis* (1962), or a sense of composite approximation in the manner of Galton, as in *Natalie* (1962).[122] In Warhol's portraits of movie stars, the celebrity is not the subject as much as the publicity shot is an object to be manipulated.

OPPOSITE
Andy Warhol, *Halston,* c. 1974, © 1999 Andy Warhol Foundation for the Visual Arts/ARS, New York, cat. no. 137.

[116]See VICTOR BURGIN, "Modernism in the *Work* of Art," in *The End of Art Theory: Criticism and Postmodernity* (Atlantic Highlands, N.J.: Humanities Press, 1986), 21. In the late 1990s the innate laconism of fashion photographs was combined with an even more exaggerated sense of disenfranchisement, as in the mode of "heroin chic"; and the style of alienation and disconnectedness once found in the paintings of Alex Katz during the 1970s and in films like Ingmar Bergman's *Persona* (1966) or Woody Allen's *Interiors* (1978) was appropriated by Steven Meisel in his images for Calvin Klein in 1997. See AMY M. SPINDLER, "Tracing the Look of Alienation," *New York Times,* 24 March 1998, A25.

[117]CRAIG OWENS, "Posing," in *Difference: On Representation and Sexuality* (New York: New Museum of Contemporary Art, 1985), 17.

[118]LINDA EVANGELISTA, Visa Check Card commercial (NBC, broadcast 6 January 1999, 8:21 A.M.).

[119]WARHOL, in Douglas Arango, "Underground Films; Art or Naughty Movies," *Movie TV Secrets* (June 1967), unpag.; quoted in Benjamin H. D. Buchloh, "Andy Warhol's One-Dimensional Art: 1956–1966," in Kynaston McShine, ed., *Andy Warhol: A Retrospective,* exh. cat. (New York: Museum of Modern Art, 1989), 50.

[120]WARHOL, interview by Glenn O'Brien, *High Times* 24 (August 1977); quoted in Buchloh, "Andy Warhol's One-Dimensional Art: 1956–1966," 48.

[121]BUCHLOH, "Andy Warhol's One-Dimensional Art, 1956–1966," 50.

[122]See MARCO LIVINGSTONE, "Do It Yourself: Notes on Warhol's Techniques," in McShine, *Andy Warhol: A Retrospective,* 72.

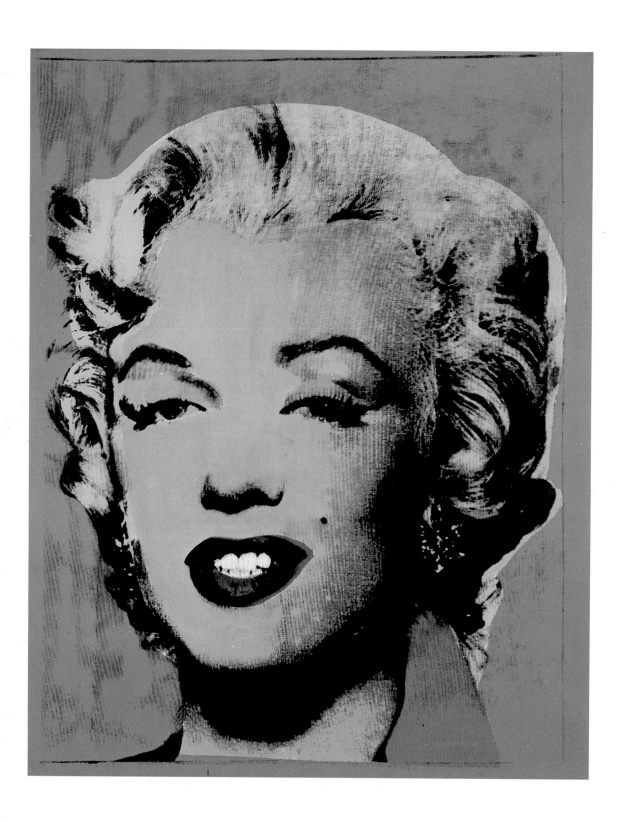

LEFT
Andy Warhol,
Blue Marilyn, 1964,
© 1999 Andy Warhol
Foundation for
the Visual Arts/ARS
New York,
cat. no. 135.

OPPOSITE
Andy Warhol,
210 Coca-Cola Bottles,
1962, silkscreen ink
on synthetic polymer
paint on canvas,
collection Martin and
Janet Blinder,
© 1999 Andy Warhol
Foundation for the
Visual Arts/ARS,
New York,
photograph courtesy
The Andy Warhol
Foundation, Inc./
Art Resource
Society, New York.

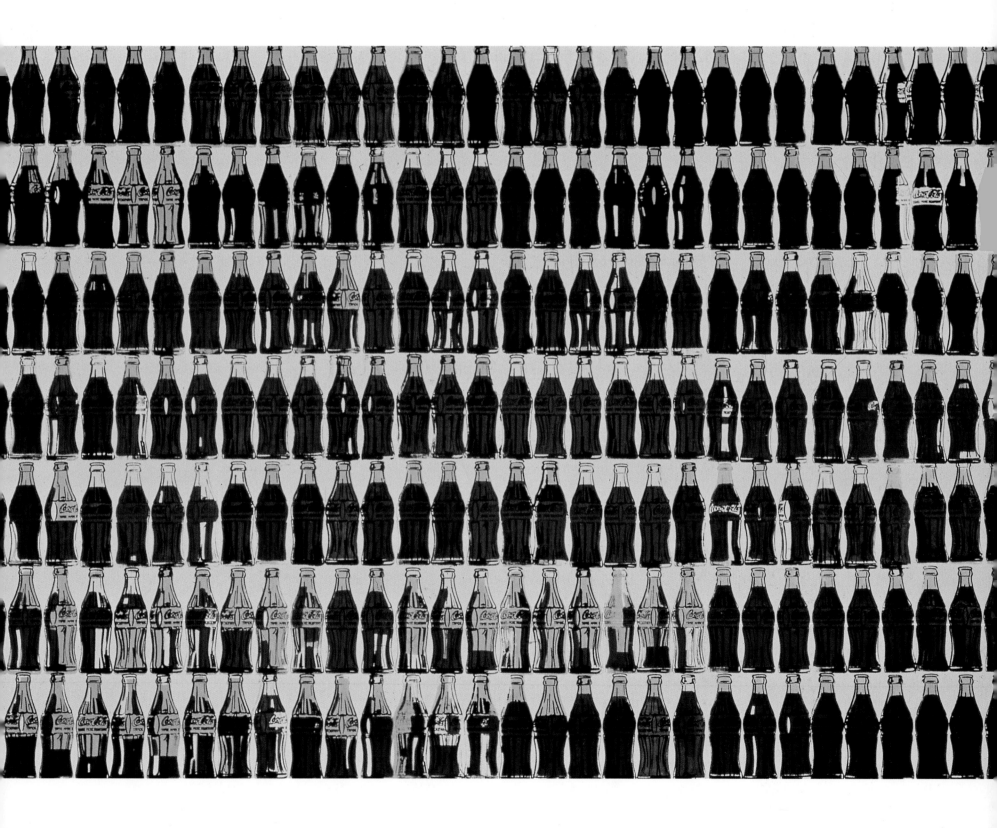

Granted, Warhol had no interest in deciphering the inner character or emotional state of his portrait subjects; their public façades were far more interesting to him than their private feelings. Nonetheless, with these canvases he placed into relief the dominant shift in modern portraiture, especially photographic portraiture; namely, the reversal of subjectivity between subject and observer discussed above. Schopenhauer had asserted that people are always anxious to see anyone famous or notorious and that photography satisfies that desire very well.[123] Fame itself, the modern fame that consists of being recognized by one's face, is, of course, like glamour, a direct by-product of photography.[124] Fame and glamour are what attracted Warhol to the subjects of his photo-silkscreened portraits, for images of stars are at once much more and far less than portraits. According to critic John Gross, "The images [that celebrities] project are inseparable from our knowledge of what they are; and as their fame grows, their features evolve into something more than faces—into masks, trademarks, icons."[125] For Schopenhauer, at the height of the European physiognomic culture, the importance of a celebrity portrait was its ability to make visible the famous subject's inner character. Uninvolved with any physiognomic agenda, Warhol cared only about the iconic nature of fame; its multiple identities were blanks, both reflective mirrors and projection screens.

Warhol's star portraits of 1962 are essentially identity portraits, mug shots without the profiles. His later work—fey and fashionable portraits of artists, collectors, art dealers, models, rock stars, and friends enlarged from Polaroids and "painted" in the 1970s and 1980s; his silk-screened self-portraits from 1964 to the camouflaged ones of 1986—shares this quality. One self-portrait of 1963–64 features a blue and lilac grid containing four faces of the artist wearing dark sunglasses.[126] His head slightly tilts in two of the panels, but his expression is utterly unreadable. Significantly, these images were enlarged from a strip of four inexpensive portraits taken in an automated photobooth customarily found in arcades and in five-and-dime stores. The absence of a human operator must have appealed to

Warhol, who often expressed a desire to be a "machine" and make "machine-like pictures." Between 1963 and 1966, he frequently made photobooth self-portraits and collected them from friends and associates. In his self-portraits, he generally stares blankly at the machine's lens with his signature affectless mien; only a few are animated by hand gestures. It was left to his friends (most notably Taylor Mead, Edie Sedgwick, Ethel Scull, and John Giorno) to do the usual thing in the situation: grimace, make faces, and have fun in the privacy of the curtained booth.

[123] ARTHUR SCHOPENHAUER, "Physiognomy," in *Religion: A Dialogue and Other Essays,* trans. T. Bailey Saunders (London: George Allen & Unwin, n.d.), 75.

[124] Cf. JOHN BERGER, *Ways of Seeing,* (London: British Broadcasting Corporation, 1972), 146.

[125] JOHN GROSS, "How Different Are the Famous from the Faces in the Crowd?" *New York Times,* 18 September 1988, 39H.

[126] SUSANNE F. HILBERRY notes that this portrait was commissioned by Mr. and Mrs. S. Brooks Barron of Detroit in 1963, and that it took Warhol nearly a year and a half to complete it. "Two Andy Warhol Self-Portraits," *Detroit Institute of Arts Bulletin* 50 (1971): 63–65.

OPPOSITE
Andy Warhol, *Natalie,* 1962, silkscreen ink on synthetic polymer paint on canvas, Andy Warhol Museum, Pittsburgh, © 1999 Andy Warhol Foundation for the Visual Arts/ARS, New York, photograph courtesy The Andy Warhol Foundation, Inc./ Art Resource Society, New York.

ABOVE
Andy Warhol, *Martha Graham,* c. 1970, © 1999 Andy Warhol Foundation for the Visual Arts/ARS, New York, cat. no. 138.

RIGHT

Andy Warhol,
Truman Capote, 1978,
© 1999 Andy Warhol
Foundation for the
Visual Arts/ARS,
New York,
cat. no. 141.

OPPOSITE

Andy Warhol,
Farrah Fawcett,
1979–80, © 1999
Andy Warhol
Foundation for the
Visual Arts/ARS,
New York,
cat. no. 136.

Warhol's associate David Rimanelli, in conversation with Gary Indiana and Tina Lyons, described the dual nature of the photobooth strips:

RIMANELLI: *They're like talismans of someone's existence. Indexical. That's true of all photographs, but it's especially pointed in the case of something like this. They're objective and subjective at the same time, they give you some claim on two different kinds of reality. I mean, what's the feeling you have about them retrospectively, when you find these things in your files? Little pictures of people who used to be important in your life?* INDIANA: *The ones that got made into [silkscreened] portraits, like Ethel Scull and Holly Solomon, have this kind of historical dimension because the portraits have some place in the history of iconography. But the others are more indexical in the sense of footnotes.*[127]

Like police mug shots, passport photos, the faces on iden-tification cards and in school yearbooks, these portraits bear witness to a subject's presence for a moment before a truly mechanical and utterly objective gaze, while they chart not the essence, but the essential features of the face.

Warhol monumentalized social and celebrity portraits in his screened paintings of movie stars, and he dramatically shifted the use-value of standard identity portraits with his photobooth strips and the paintings from them. About the same time, he also transformed the conventional criminological mug shot into art. In 1964 he screen-printed police photographs of alleged criminals for his Thirteen Most Wanted Men, a series of nine diptychs of front faces and profiles and four single panels of mostly frontal shots. Taking the portraits from a booklet issued by the New York Police Department, he printed each of the images onto a masonite panel measuring approximately four-by-three feet, which he installed on the exterior of the New York State Pavilion at the New York

World's Fair of that year. Ordered to deinstall them (in part because of legal restrictions on displays of apprehended suspects), Warhol responded by painting them out with silver-aluminum paint. What is most striking about the set that survives is the absolute baseness of the images: half-tone reproductions of bigger-than-life, grainy, black-on-white records from some police hand-outs, made progressively grittier by the very process of screen printing itself. Art historian Thomas Crow views the effects of transforming photographs into screen prints as "inherently flattering and simplifying":

The screened image, reproduced whole, has the character of an involuntary imprint. It is a memorial in the sense of resem-bling memory: powerfully selective, sometimes elusive, sometimes vividly present, always open to embellishment as well as loss.[128]

In the Thirteen Most Wanted Men series, however, the screen process serves to make the portrait even more clandestine, more *noir* than the originals could possibly have been; thrice removed from their subjects, they are mere ghosts.

Warhol began his celebrity portraits while working on his now-famous Disaster series in the sum-mer of 1962. In June of that year, art critic Henry Geldzahler per-suaded Warhol to deal with more serious themes than American consumerism. Showing him a front page of the *New York Mirror* that announced and illustrated a fatal col-lision of two planes over Brooklyn,

[127]GARY INDIANA, "History," in *Andy Warhol: Photobooth Pictures*, exh. cat. (New York: Robert Miller Gallery, 1989), unpag.

[128]THOMAS CROW, "Saturday Disasters: Trace and Reference in Early Warhol," in Serge Guilbaut, ed., *Reconstructing Modernism: Art in New York, Paris, and Montreal, 1954–1964* (Cambridge: MIT Press, 1990), 315–6; I am grateful to my colleague at USC, Richard Meyer, for bringing this article to my attention.

RIGHT
Andy Warhol, *Self-Portrait*, 1964, © 1999 Andy Warhol Foundation for the Visual Arts/ARS, New York, cat. no. 140.

Andy Warhol, *Most Wanted Men No. 1, John M.*, 1964, The Herbert F. Johnson Museum of Art, Cornell University, Purchase Funds from the National Endowment for the Arts and individual donors, © 1999 Andy Warhol Foundation for the Visual Arts/ARS, New York, cat. no. 139.

Geldzahler suggested that the painter illustrate "Not just life, but death, too."[129] Warhol hand-painted a copy of the entire front page the next day and almost immediately afterward incorporated other disaster subjects in his photo-silkscreen work: large canvases of images of suicides, race riots, atomic blasts, fatal car crashes, electric chairs, and fires, often arranged and repeated in grids. Completely unsensational, Warhol's scenes of carnage and death are as blankly vacant and uncoded as his portraits of celebrities and himself. Endlessly repeated and replicated, their expression becomes null. Together, Warhol's mythologizing celebrity portraits and his depersonalized disaster paintings are seminal works of the 1960s that address the "same maximizing of violence and sensation, the same alphabet of unreason and the fictionalizing of experience"[130] that British novelist J. G. Ballard cites as largely contributing to "the most terrifying casualty of the century: the death of affect."[131] Warhol's themes had indeed become more serious with such references to attenuation and death, and, regarded in terms of the disaster paintings, his portraits take on a far more chilling aspect.

All portraits are talismans of sorts, iconic memento mori of their subjects at some point in the past. After fifteen minutes of fame, what else is left? Warhol commenced his series of Marilyn portraits shortly after hearing of her death in August of 1962; according to one commentator, they were "a lengthy act of mourning, much of the motivation for which lies beyond our understanding."[132] The gold background for the Museum of

[129]HENRY GELDZAHLER, "Andy Warhol: Virginal Voyeur," in Geldzahler and Robert Rosenblum, *Andy Warhol: Portraits of the Seventies and Eighties* (London: Anthony d'Offay Gallery, 1993), 15.

[130]J. G. BALLARD, "Alphabets of Unreason," in *A User's Guide to the Millennium: Essays and Reviews* (New York: Picador USA, 1996), 221.

[131]BALLARD, "Introduction to *Crash,*" in *J. G. Ballard,* ed. V. Vale and Andrea Juno, *RE/Search,* no. 8/9 (San Francisco: RE/Search

Publications, 1984), 96; see also BALLARD, "The Innocent as Paranoid," in *A User's Guide to the Millennium: Essays and Reviews,* 91.

[132]CROW, "Saturday Disasters: Trace and Reference in Early Warhol," 313. See also BRADFORD R. COLLINS, "The Metaphysical Nosejob: The Remaking of Warhola, 1960–1968," *Arts Magazine* 62, no. 6 (February 1988): 53; Collins is, however, wrong in identifying the source photograph Warhol used of Marilyn.

LEFT

Andy Warhol, *Shadows,* 1978, silkscreen ink on synthetic polymer paint on canvas, Dia Art Foundation, New York, courtesy the Menil Collection, Houston, © 1999 Andy Warhol Foundation for the Visual Arts/ARS, New York, photograph courtesy The Andy Warhol Foundation, Inc./ Art Resource Society, New York, photograph by Paul Hester.

OPPOSITE

Andy Warhol, *Black and White Disaster,* 1962, silkscreen ink on synthetic polymer paint on canvas, Los Angeles County Museum of Art, gift of Leo Castelli and Ferus Gallery through the Contemporary Art Council, © 1999 Andy Warhol Foundation for the Visual Arts/ARS, New York, photograph courtesy The Andy Warhol Foundation, Inc./ Art Resource Society, New York.

Modern Art's *Gold Marilyn Monroe,* for instance, is a traditional reference to the hereafter found in medieval icons and religious paintings; and in the Tate Gallery's *Marilyn Diptych,* the colorful left panel seems to be drained of all its life and vitality in the monochromatic right panel which, again according to Crow, "stands in a plain and simple way for death and also for what lies beyond the possibility of figuration."[133] Death is also the obvious subtext of Warhol's obsession with photographs of Jackie Kennedy following the assassination of John F. Kennedy in 1964, it is most definitely a text in the screened portraits of skulls he made in 1976, and it is quite possibly more than obliquely alluded to in the Shadows series he painted in 1978.[134] In the end, Warhol's portraits "scrupulously refuse banal notions of 'character,' supposedly revealed in physiognomy,"[135] yet they all reflect, in the words of art historian Robert Rosenblum, "exactly that state of moral and emotional anesthesia which, like it or not, probably tells us more truth about the realities of the modern world than do the rhetorical passions of *Guernica.*"[136] What else is left? Anesthetized, we only can suffer Ballard's "death of affect."

[133]Crow, "Saturday Disasters: Trace and Reference in Early Warhol," 322. TREVOR FAIRBROTHER also considers "the idea of death as the nothingness of a blank afterimage," in "Skulls," in Gary Garrels, ed., *The Work of Andy Warhol,* Dia Art Foundation Discussions in Contemporary Art 3 (Port Townsend, Wash.: Bay Press, 1989), 104.

[134]See FAIRBROTHER, "Skulls," 105–6.

[135]SIMON WATNEY, "The Warhol Effect," in Garrels, *The Work of Andy Warhol,* 119.

[136]ROBERT ROSENBLUM, "Warhol as Art History," in McShine, *Andy Warhol: A Retrospective,* 36.

ABOVE

Andy Warhol, *Marilyn Diptych,* 1962, silkscreen ink on synthetic polymer paint on canvas, Tate Gallery, DACS, London, © 1999 Andy Warhol Foundation for the Visual Arts/ARS, New York, photograph by John Webb.

Semantic Blanks

Since Warhol, from Diane Arbus's portraits of people encountered on city streets to Bill Henson's shots of teens in shopping malls, the vacant countenance has had ubiquitous currency in the photographic arts of portraiture. As in anthropological and ethnographic albums of times past, the blank face has been collected and anthologized by photographer Ken Ohara and made exotically captivating by Irving Penn. It has been portrayed as elementally sensuous by Robert Mapplethorpe, prolonged in its existential isolation by Thomas Ruff, solarized by Katharina Sieverding, kept fashionable by photographers such as Victor Skrebneski and Matthew Ralston, and fractured into various planes and panes by artists such as Dawoud Bey. In all of its guises, the neutral visage underscores the fact that the material face is just that: raw material to be manipulated. The philosopher Jean-Paul Sartre, contemplating a portrait of an acquaintance, once wrote, "I say: 'This is a portrait of Peter', or, more briefly: 'This is Peter.' Then the picture is no longer an object but operates as material for an image. . . . Everything I perceive enters into a projective synthesis which aims at the true Peter, a living being who is not present."[137] This observation has led artist Victor Burgin to observe that "the mind is not simply a *screen* upon which the world projects its appearances; in 'making something' of appearances the mind, in a sense, is also a *projector,* projecting a world of things *onto* those appearances."[138] Along similar lines, science writer Rupert Sheldrake has conducted photographic experiments in London based on the premise that many people are sensitive to being stared at by someone or a camera without seeing either and concludes, "Why shouldn't vision involve an inward movement of light and an outward projection of images? So that we're actually projecting images onto the world around us."[139]

The expressionless visage has lately been monumentalized by artists like Andreas Serrano and Craigie Horsfield, enlarged into immense photographic prints by Marie Jo Lafontaine and Thomas Struth, and translated into giant paintings by Chuck Close. Close, who began painting his oversized portraits of friends from photographs toward the end of the 1960s, goes Warhol one better in attenuating faciality in portraiture. At least in Warhol's portraits

PAGE 160
Ken Ohara,
Untitled,
1970/printed 1998,
cat. no. 86.

PAGE 161
Ken Ohara,
Untitled,
1970/printed 1998,
cat. no. 87.

PAGE 162
Dawoud Bey,
Amishi, 1993,
cat. no. 9.

PAGE 163
Katharina Sieverding,
*Stauffenberg-Block
III/XI,* 1969–96
cat. no. 115.

RIGHT
Bill Henson, *Untitled,*
1985–86,
cat. no. 55.

OPPOSITE
Irving Penn, *Cat Woman, New Guinea,*
1970/printed 1979,
courtesy *Vogue,*
cat. no. 92.

158

[137]JEAN-PAUL SARTRE, *L'Imaginaire,* quoted in Burgin, "Re-reading *Camera Lucida,*" in *The End of Art Theory: Criticism and Postmodernity* (Atlantic Highlands, N.J.: Humanities Press International, 1986), 80.

[138]BURGIN, "Re-reading *Camera Lucida,*" 80.

[139]RUPERT SHELDRAKE, "Eye Contact," *Creative Camera,* no. 341 (September 1996): 18.

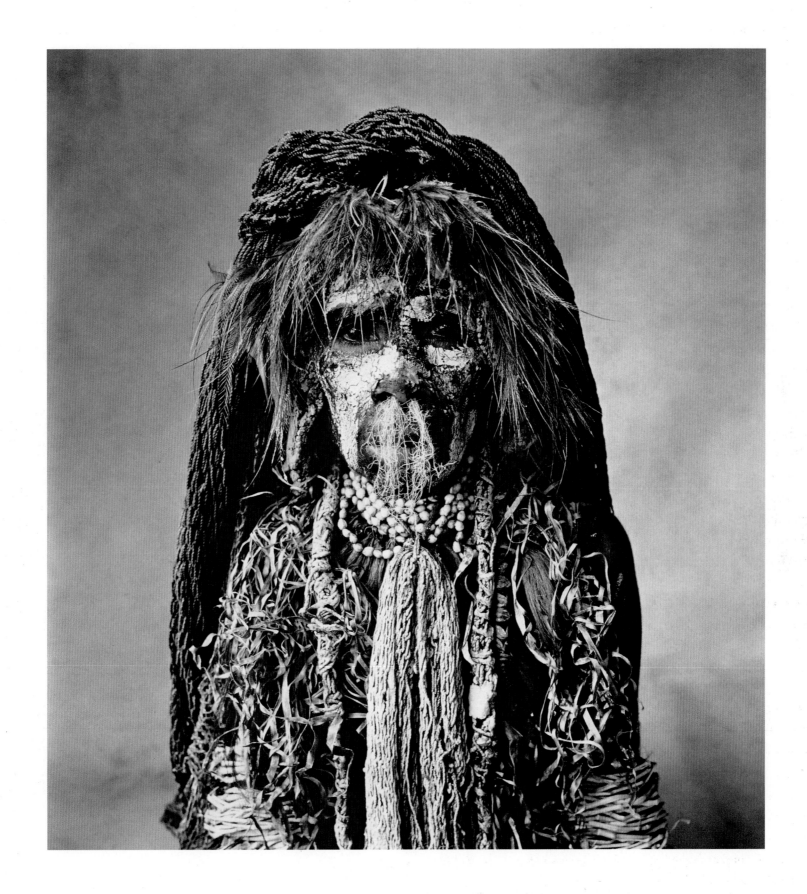

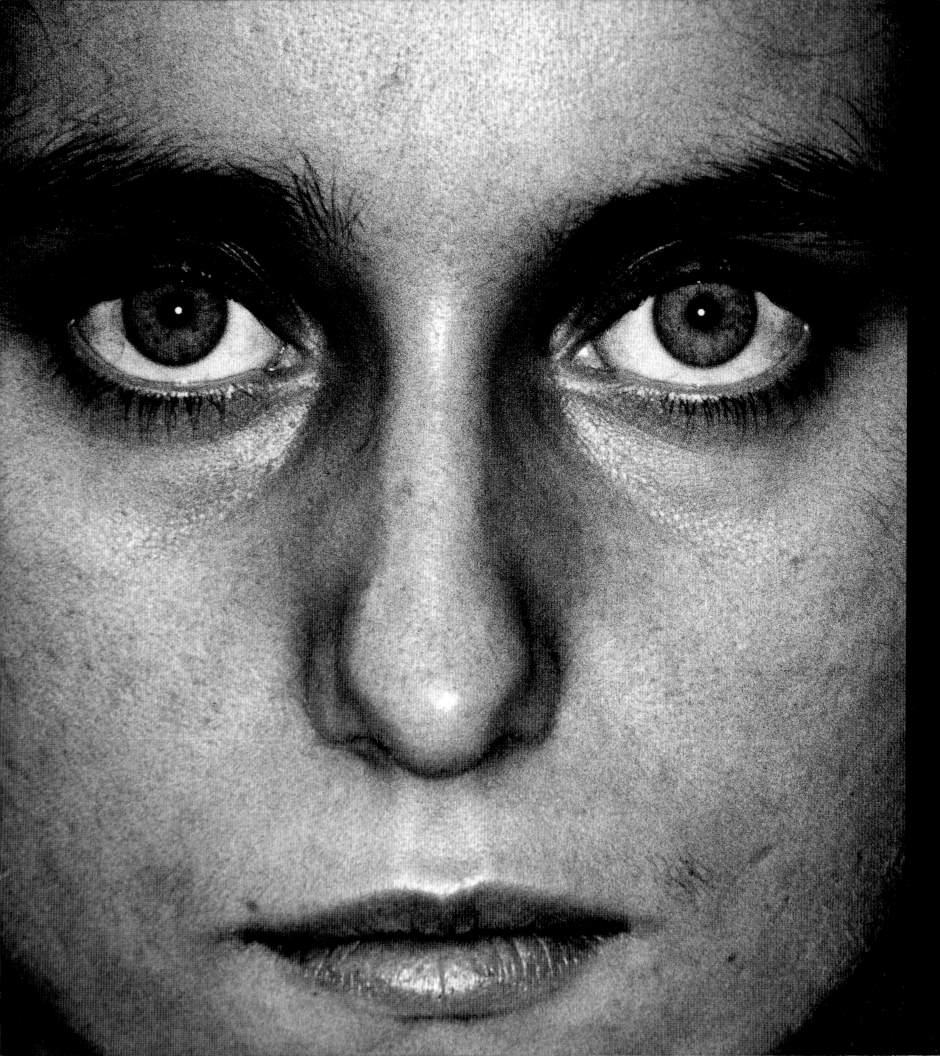

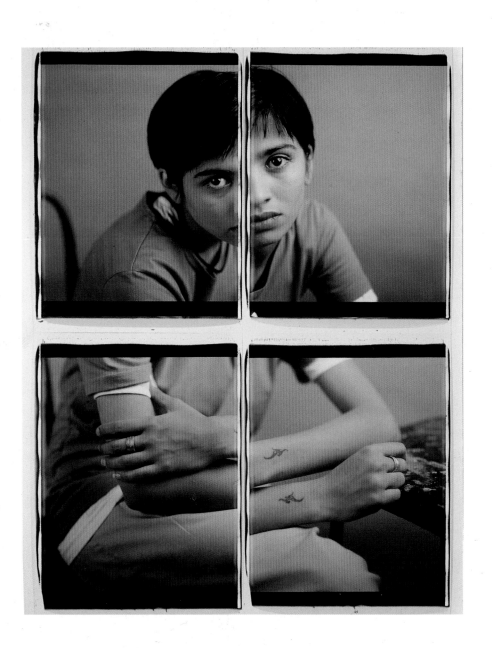

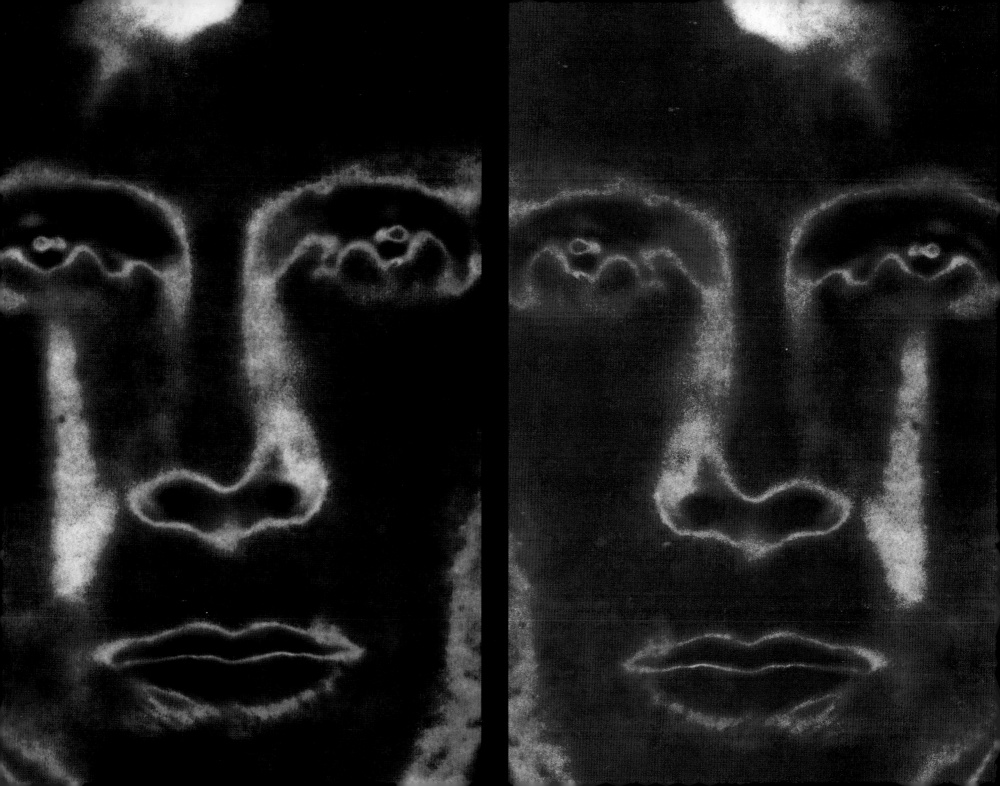

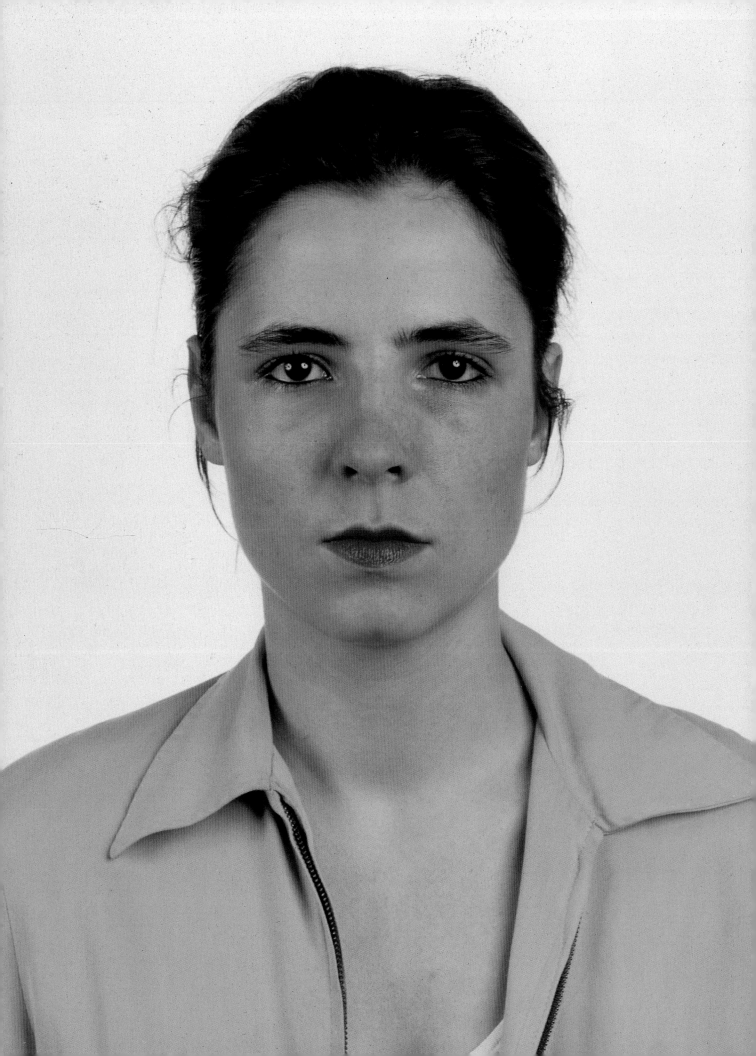

there is a superficial semblance of personality and celebrity; as banal as they are, they are still likenesses of Marilyn, Jackie, or the artist himself. In Close's portraits, all we are given are the subjects' first names or even nicknames: "Phil," "Linda," or "Alex." Just who they are matters even less than before. In an as-yet unpublished essay, Norman Bryson characterizes Close's transformation of the photographic portrait into a giant painting as an "assault on the face." As he observes, "The transcription's deterioration of the image joins forces with the world's fatiguing of the face to reveal the photograph's potential for an obliteration of personal presence in the very instant when personal presence is captured in representation."[140] The greatest tragedy of the twentieth century, the "death of affect," is now coupled with a "fatiguing of the face."

Individual subjectivity is absolutely nonexistent in Close's work and in Thomas Ruff's gigantic photographic heads.[141] Mimicking the look of identity portraits in their frontal aspect and even lighting, Ruff's heads are like immense idealizations of what every phrenologist and authority figure desired in the last century: the "face's central and abiding form."[142] Significantly, Ruff distances himself from the realm of portraiture. "My images," he explains, "are not images of reality, but show a kind of second reality, the image of the image."[143] But the material reality of the face's features more than impresses itself on us, and Bryson even argues that in Ruff's authoritarian images of people

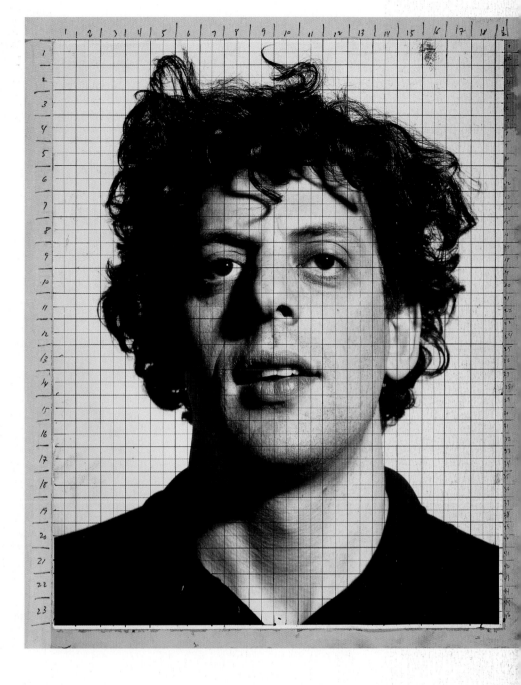

the viewer's gaze travels past that utilitarian schema and loses itself in the expansive terrain of supplementary data. When that stage is reached (and it is difficult to imagine this happening in any medium except photography), the face becomes unreadable, mute, physically real yet semantically blank. It is no longer made of signs and social signals; we are in the orbit of the real, not of the persona.[144]

With all the details captured in the photographic print, and with all the information embedded in those details, some contemporary artists appear to have eradicated everything that Le Brun, Lavater, and Duchenne de

[140]Bryson, "Façades," 53–54.

[141]See Anelie Pohlen, "Deep Surface," Artforum 29, no. 8 (April 1991): 116–7. According to the British critic Marina Warner, Ruff's work is focused on "the ungraspable frontier between body and spirit, between physical individual forms and the animating character of persons." "Stealing Souls and Catching Shadows," tate 6/7 (1995): 41. I am indebted to Michael Mack for this reference.

[142]Bryson, "Façades," 51.

[143]Thomas Ruff, "Thomas Ruff: Reality So Real It's Unrecognizable," interview by Thomas Wulffen, Flash Art International, no. 168 (January/February 1993): 64–67.

[144]Bryson, "Façades," 52.

OPPOSITE
Thomas Ruff,
Portrait (Anna Giese),
1989, © 1999 Artists
Rights Society (ARS),
New York/VG Bild-
Kunst, Bonn,
cat. no. 103.

ABOVE
Chuck Close,
Working Photograph for
Phil, 1969,
courtesy George
Eastman House,
cat. no. 22.

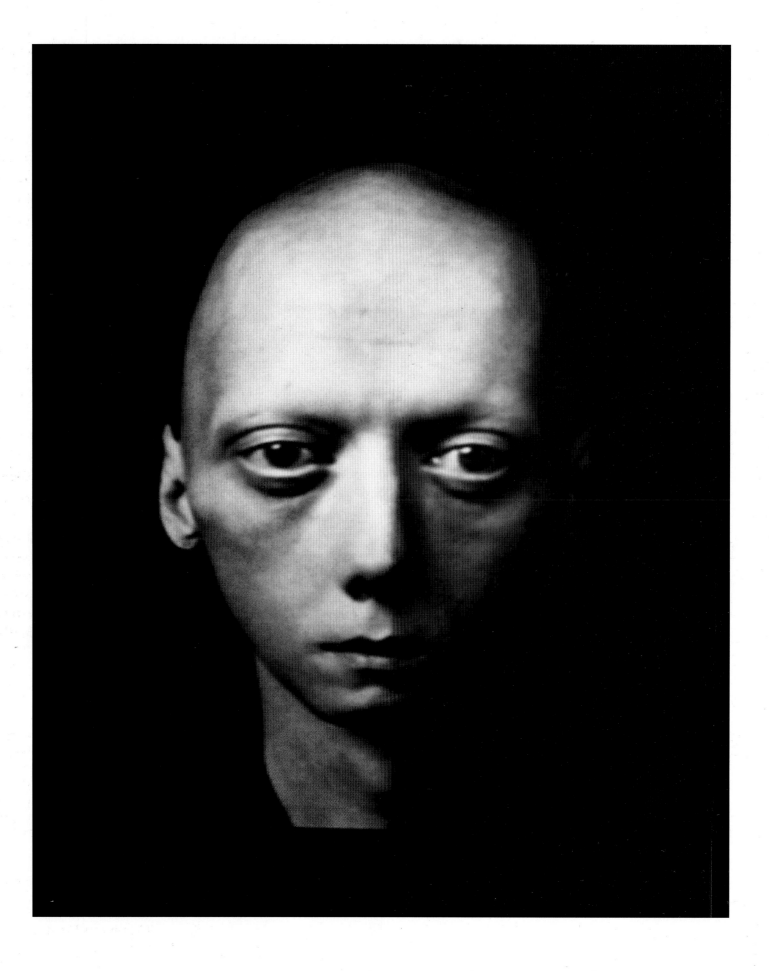

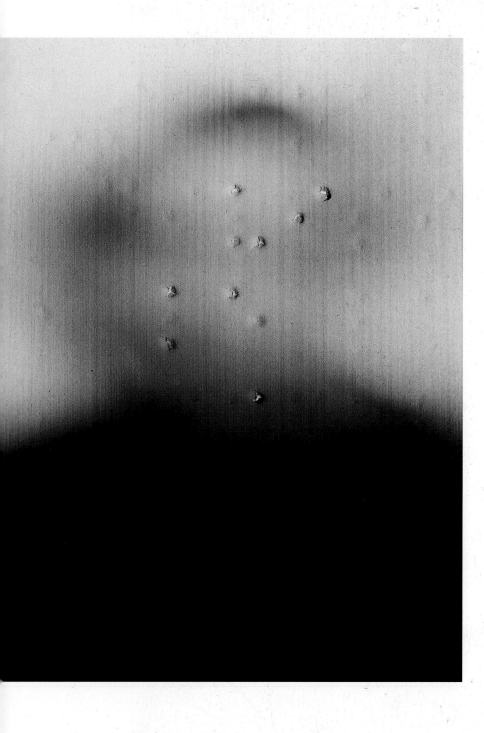

Boulogne worked so hard to establish. Enlargement to great sizes still constitutes manipulation of the raw materials we call the face, but it becomes progressively more difficult either to project any sense of subjectivity onto something this vast, or to see any of our dreams or desires reflected from such facial panoramas. It is as if we are here in the realm of topology, where the surface geometries or physical "tolerances of the human face"[145]—the limits beyond which a face no longer looks like a face at all—are kept resolutely intact. (In the postmodern tradition considered in chapter three, however, these surfaces are rent and punctured; they often exceed their tolerances and lose their integrity.)

Modern, blank faces have been compiled from multiple likenesses and extrapolations by William Wegman and Nancy Burson, morphed into hybrids of animals and humans by Daniel Lee,[146] rendered tactile and sensible to the blind by Patrick Tosani, and even deprived of every facial sense organ by Anthony Aziz and Sammy Cucher. Using Photoshop, a graphic software program, the team of Aziz + Cucher erase the subject's eyes, ears, nostrils, and lips and substitute visual skin grafts in their place. Critic Patrick Roegiers describes their insensate portraits, such as *Maria* (1994):

A smooth, stripped, featureless surface. . . . Denying the relation of inner and outer, abrogating the fascination of resemblance at the heart of photography along with the particular details that fashion identity, these atomized, expressionless portraits annul any possibility of identification and banish any self-projection (the eye itself being a mirror in which the other meets his own reflection). Like a support struck from the flesh, the face or rather the head forces us with pitilessly clinical precision to affront the enigma of the visage.[147]

[145]See J. G. BALLARD, *The Atrocity Exhibition* (London: Jonathan Cape, 1969), 96, 98. The complete title of the scientific paper that is referred to here, as well as in Ballard's *Crash,* is "Tolerances of the Human Face in Crash Impacts." Cf. *Crash* (New York: Farrar, Straus and Giroux, 1973), 123.

[146]Lee's hybrids clearly refer to earlier animal physiognomics such as della Porta's; they also evoke the survivor of H. G. WELLS's *The Island of Dr. Moreau* (1896), who, back in London and surveying faces in the crowds, felt "as though the animal was surging up through them." *Seven Famous Novels* (New York: Alfred A. Knopf, 1934), 155.

[147]PATRICK ROEGIERS, "Invisible Figures," in Fabrizio Caleffi and Roegiers, *Aziz + Cucher: Unnatural Selection,* exh. cat. (Paris: Espace d'Art Yvonamor Palix, 1996), 9–11.

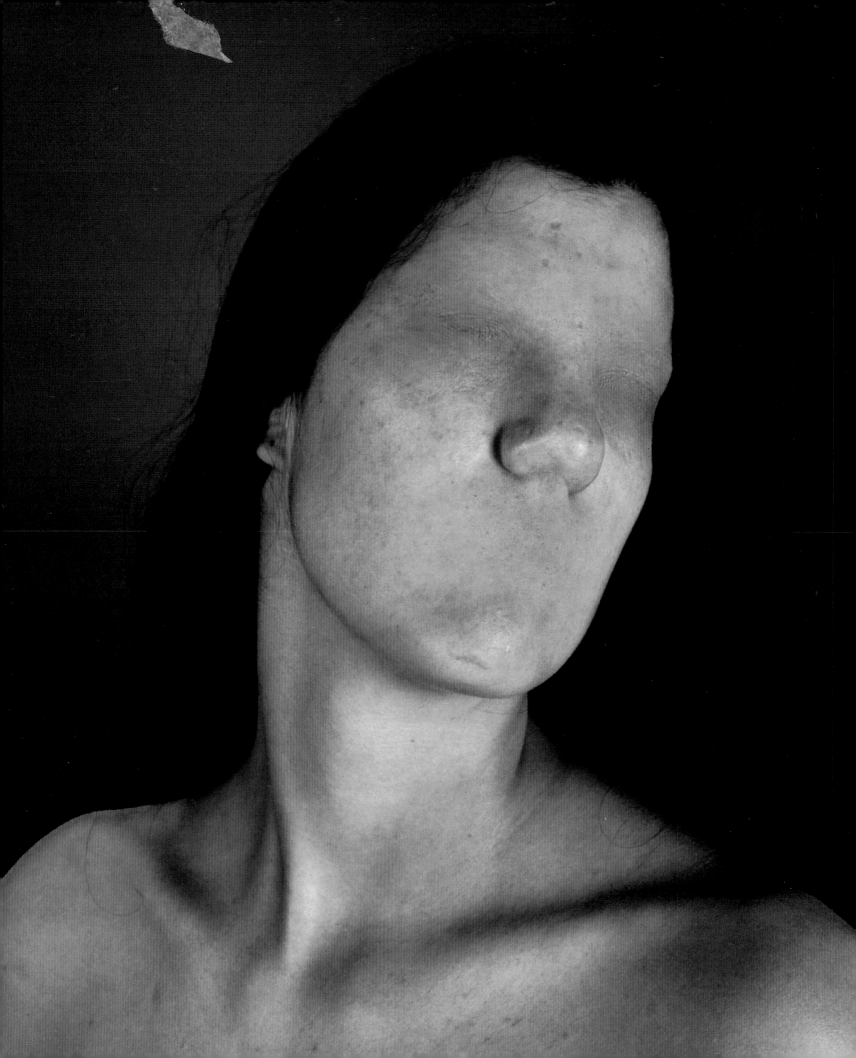

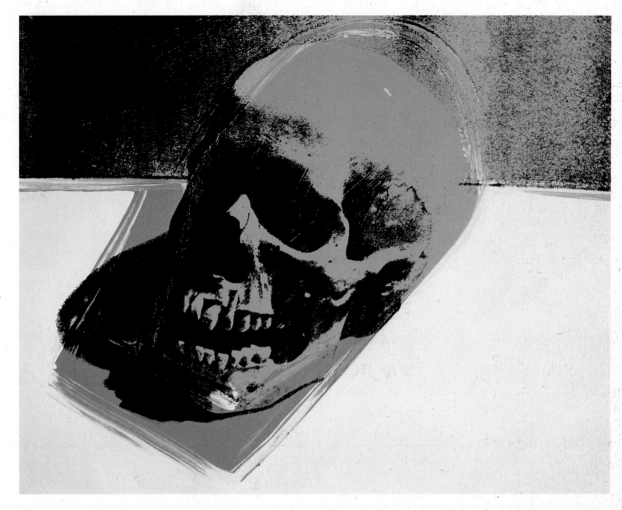

OPPOSITE
Aziz + Cucher,
Maria, 1994,
cat. no. 6.

RIGHT
Andy Warhol, *Skull,*
1976, silkscreen ink
on synthetic polymer
paint on canvas,
the Andy Warhol
Museum, Pittsburgh,
© 1999 Andy Warhol
Foundation for the
Visual Arts/ARS,
New York,
photograph courtesy
the Andy Warhol
Museum.

Although the very organs in which physiognomists tried to read the inner person are gone, these portraits make us all the more aware of what even the featureless face can convey—a sense of the human. Such modern experiments with subjectivity evoke the French writer Georges Bataille's comment, "To break up the subject and re-establish it on a different basis is not to neglect the subject; so it is in a sacrifice, which takes liberties with the victim, and even kills it, but cannot be said to *neglect* it."[148]

Andy Warhol has been frequently quoted as saying, "I want everybody to think alike"; he also said, discussing the similarities between Russians and Americans during the Cold War, "Everybody looks alike and acts alike, and we're getting more and more the same way."[149] Returning from Paris with a skull he bought at a flea market, Warhol asked his Factory associates about its suitability as a subject for his silkscreen paintings. Ronnie Cutrone, a studio assistant, replied that it would be "like doing the portrait of everybody in the world."[150] Stripped not only of its sense organs and its gender, but of its flesh and hair as well, the skull becomes the universal portrait of the human head. With no features to convey traits or emotions, such a portrait would have left pathognomists and physiogno-

mists utterly baffled, and only a phrenologist partially satisfied. Following the skull series, Warhol embarked on a series of paintings of abstract shadows in 1979, which critic Trevor Fairbrother has called a "subject with no physical reality, nothing."[151] Fairbrother looks to Warhol's other activities of this period, such as disco and set decoration, to mitigate the abject nihilism of the skulls and the nullity of the shadows, concluding that "unless one accepts all this as signs of life, one is faced with death of the spirit."[152] Somehow, even in the utterly vacant, expressionless, death's-head portrait, there still lingers a contingent faciality, suggesting that even in the face of anonymous mortality the elusive human persists.

[148]GEORGES BATAILLE, *Manet* (New York: Rizzoli, 1983), 95; quoted in Yve-Alain Bois and Rosalind Krauss, *Formless: A User's Guide* (New York: Zone Books, 1997), 21.

[149]WARHOL, "What Is Pop Art?" interview by G. R. Swenson, *Art News* 62 (November 1963): 26.

[150]RONNIE CUTRONE, quoted in Fairbrother, "Skulls," 96–97.

[151]FAIRBROTHER, "Skulls," 105.

[152]Ibid.

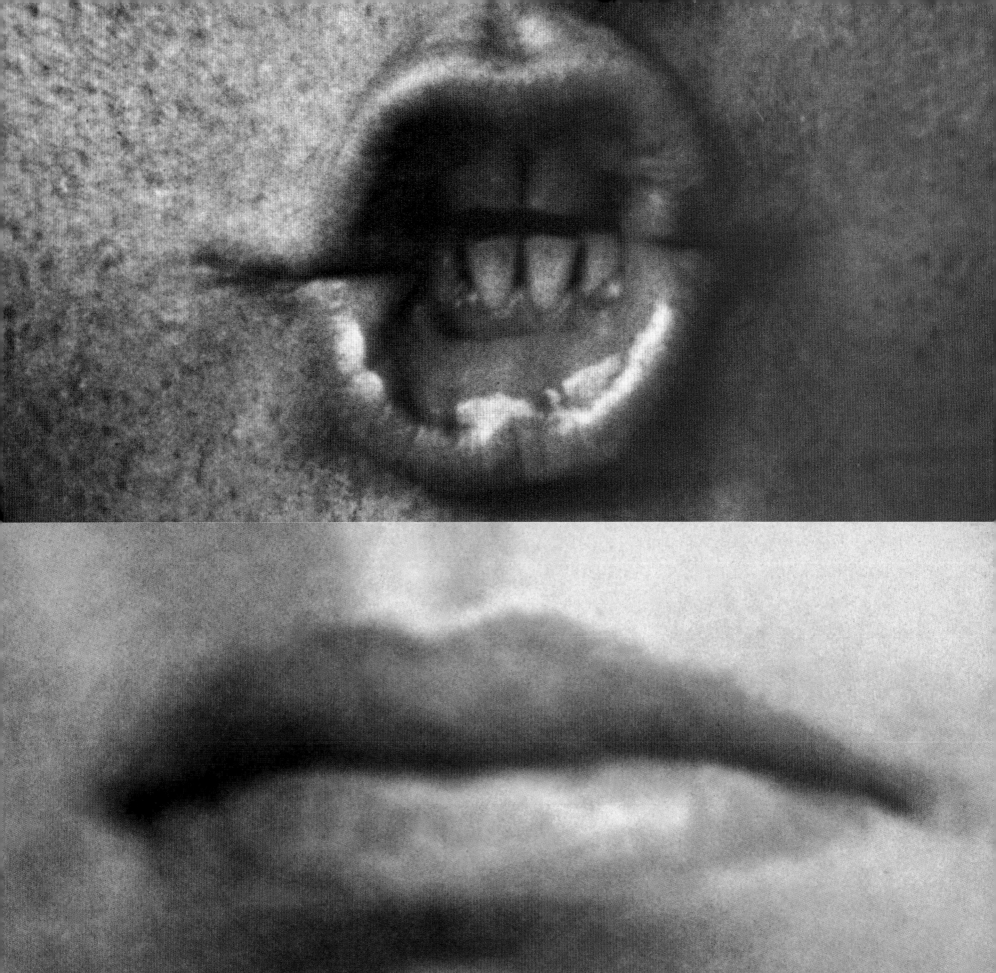

"Abstract Machines of Faciality"

THE DRAMATURGICAL
IDENTITIES OF

Cindy Sherman

*But you are still thinking in terms of a life with a real face.
The mask does not deceive and is not deceived. How about putting on a
new mask, turning over a new leaf, and starting another life?
On these days of masks, we can put on a new look unconcerned
with yesterday or tomorrow.* KŌBŌ ABE, *The Face of Another,* translated by E. Dale Saunders
(Tokyo: Charles E. Tuttle, 1967), 163.

RIGHT

Ambroise Tardieu,
"Figure in
Restraining
Garment" (detail),
from J.-E.-D.
Esquirol, *Des
maladies mentales*
(1838), engraving,
The National
Library of Medicine,
Bethesda,
photograph by
Grant Williams.

OPPOSITE

Egon Schiele,
Grimacing Self-Portrait,
1910, gouache
and black crayon
on paper, Leopold
Museum,
Privatstiftung,
Vienna.

The mute, vacant face may be commonplace in modernist portraiture, but there is another, quite different kind of late-nineteenth- and twentieth-century face that bears consideration. If the traditionally expressive face signifies a subjectivity or soul emanating outward, and if the modern expressionless visage invites the projection of the artist's or viewer's subjectivity onto its surface, this third order of faciality selects its subjectivity from a menu of multiple choices, rends and punctures the once-inviolable surface of the human countenance, and establishes what might be called a participatory theater of false smiles, feigned psyches, faked characterizations, and fictional souls. In short, it is a theatrical face that dons its personalities as easily as it assumes its masks. The dramas range from the heat of passionate excess to the coolness of subdued irony, and they are customarily played before an audience presumed to be willingly complicitous in the artifice. Unlike the blank, modern faces discussed in the previous essay, with their isolated iconicity, faces in this scheme are actively narrative and the products of a dramaturgy consciously engaged with the camera and the viewer. It is as though the hysterics and cataleptics whose seizures were triggered before

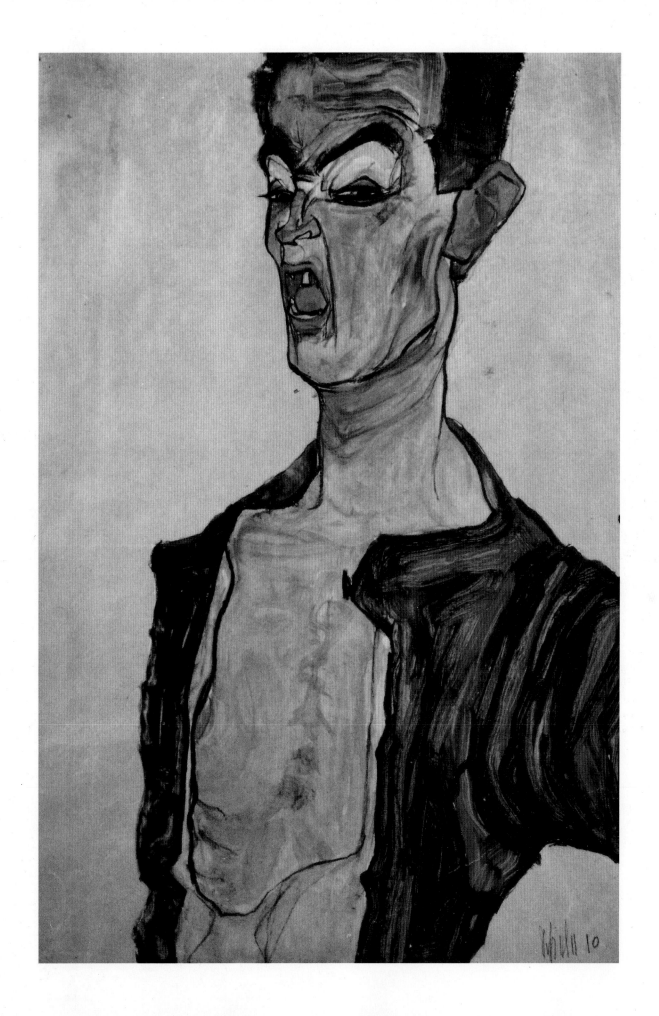

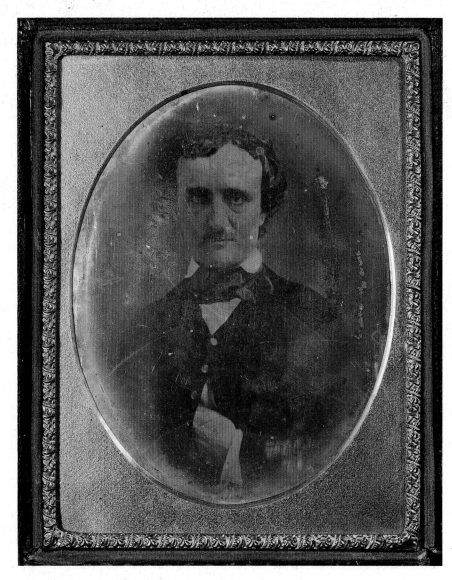

an audience in Jean-Martin Charcot's theater of the passions had deliberately contrived their own reactive performances (many believed they had, in fact). In place of Oskar Schlemmer's drawing *Man the Dancer (Human Emotions),* the key to this portraiture could be Egon Schiele's *Grimacing Self-Portrait* of 1910. Here, according to historian Klaus Schröder, the "conspiratorial understanding" created by the model's direct gaze at the viewer is thoroughly undermined and rebuffed by the subject's grimace: a toothless, gaping snarl that "blocks all attempts to interpret the nature of a human individual through physiognomy."[1] We are back in the realm of Duchenne de Boulogne's old and toothless, grimacing male patient, only now the patient deliberately grimaces without the aid of electroshock.

Of course, there is a degree of dramatics in nearly all portrait photography. In one of the earliest American treatises on photographic art, the daguerreian artist Marcus Aurelius Root advised portrait photographers to suggest certain roles or characterizations to their sitters in order to arouse desired expressions.[2] Contemporary portraitist Richard Avedon has asserted that "portraiture is performance, and like any performance, in the balance of its effects it is good or bad, not natural or unnatural."[3] The theatricality under discussion in this essay, however, is far more mannered and insistent

[1] KLAUS ALBRECHT SCHRÖDER, *Egon Schiele: Eros and Passion,* trans. David Britt (Munich and New York: Prestel, 1995), 64

[2] MARCUS AURELIUS ROOT, *The Camera and the Pencil; or, The Heliographic Art* (Philadelphia: M. A. Root, 1864), 161–2.

[3] RICHARD AVEDON, "Borrowed Dogs," in Ben Sonnenberg, ed., *Performance & Reality: Essays from Grand Street* (New Brunswick and London: Rutgers University Press, 1989), 17.

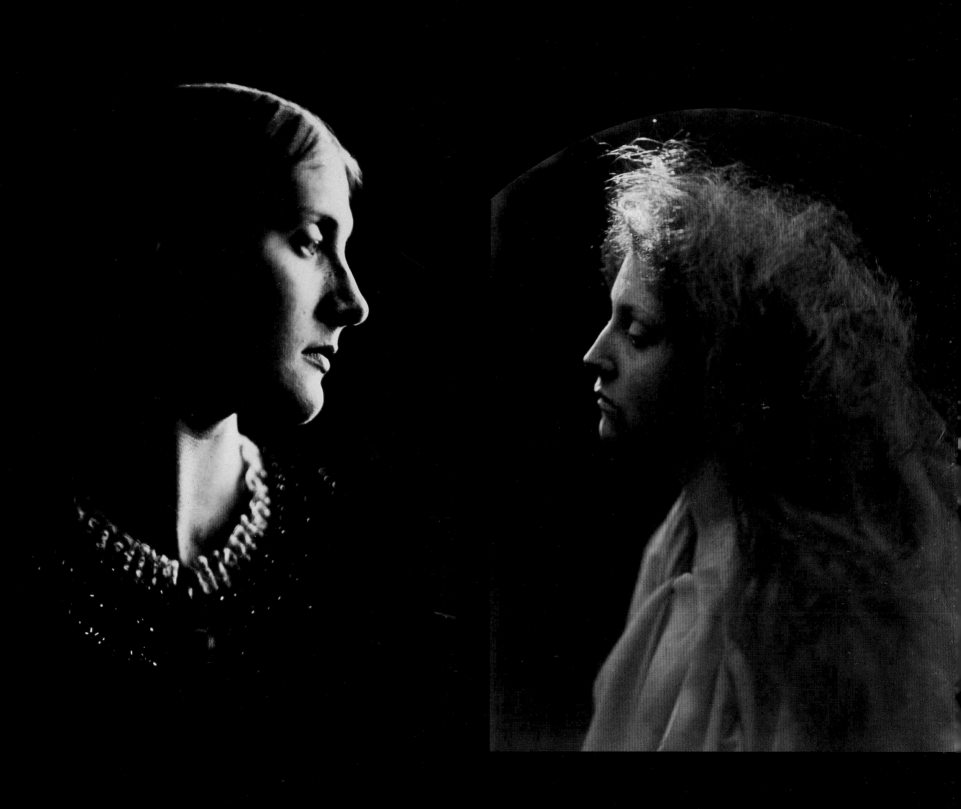

than the poses and heightened moods of traditional portraiture. This kind of theater is what differentiates, say, Julia Margaret Cameron's portrait of Mrs. Herbert Duckworth, née Julia Jackson (1867) from her depiction of a wistful angel in *The Angel at the Tomb* (1870), or a self-portrait of F. Holland Day from his performance as the dying Christ in *The Seven Last Words* (1898).[4] Or consider

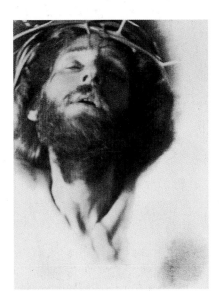

the clinical depiction of a rigid cataleptic patient horizontally supported in space by the backs of two chairs in Paul Regnard's *Lethargy: (Muscular Hyperexcitability)* (1880) as a foil to Bruce Nauman's *Failing to Levitate in the Studio* (1966), a double exposure in which the artist is pictured both propped up by two chair seats and haplessly fallen to the ground.

Regnard's image is the result of a logical and analytical, even if naïve, enterprise that firmly trusted in the value of probing a patient's inner nature. Nauman's farce, on the other hand, dramatically symbolizes the distance our culture has come from the positivism of Duchenne's and Charcot's investigations. The fundamental lessons of modernism have been that certainty, even subjective certainty, is doomed to collapse, and that human nature can be explored only through ambiguity and irony.[5] And it is with these two tactics that many twentieth-century artists, from the Surrealists Claude Cahun and Salvador Dalí to the postmodernists Nauman and Cindy Sherman, have created their most memorable excursions into physiognomic uncertainties.

[4] See ESTELLE JUSSIM, *Slave to Beauty: The Eccentric Life and Controversial Career of F. Holland Day—Photographer, Publisher, Aesthete* (Boston: David R. Godine, 1981), 121–35.

[5] Cf. WILLIAM R. EVERDELL, *The First Moderns: Profiles in the Origins of Twentieth-Century Thought* (Chicago: University of Chicago Press, 1997), 99.

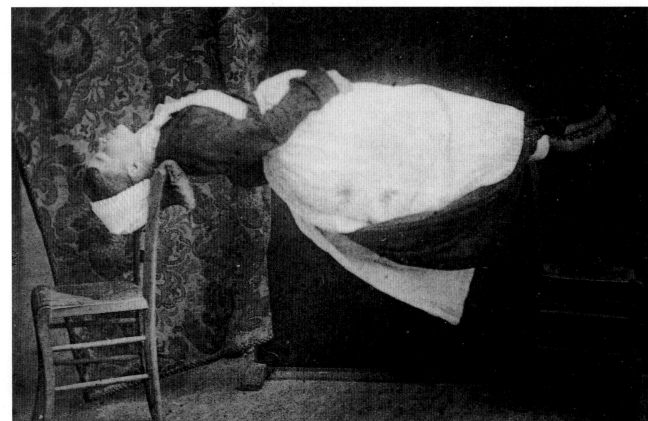

novelist William S. Burroughs said it perfectly: "Nothing is true— everything is permitted."[9]

Although physiognomy and phrenology have been all but dis-credited and debunked during the twentieth century,[10] science has continued to apply progressively more complex technologies to probing the face's significance and charting our recognition of its emotions, tangling the issues even further.[11] Now neurosurgeons use electrodes to record electrical signals from the individual neurons in the human brain that create memories.[12] Some of these neurons, they have discovered, respond to a single emo-tion, others to identity or gender; and a single neuron in the hippocam-pus reacts with different intensities to specific facial expressions. Researchers at the Science University of Tokyo have invented a "face robot," a life-sized, soft plastic model of a female head with a video camera in its left eye, designed to "detect emotions in the person it's 'looking at' by sens-ing changes in the spatial arrangement of the person's eyes, nose, eye-brows, and mouth." After comparing these configurations with its data-

Faces denote the culture that surrounds them, and modern culture has been progressively viewed as discontinuous, fragmented, and rup-tured. In the late twentieth century Cartesian logic may not be capable of determining the correct response, the laws of classical thermodynamics no longer hold, instead of scientific certainty there are the "uncertainty principle" and a "chaos theory," and any cosmology or metaphysics sug-gesting anything approaching definitiveness is largely suspect. According to British novelist J. G. Ballard, "we live in quantified non-linear terms— we switch on television sets, switch them off half an hour later, speak on the telephone, read magazines, dream and so forth. We don't live our lives in linear terms in the sense that the Victorians did."[6] Nonlinear, atomized, illogical, and lacking any pretense to objectivity, modern life has become a "dynamic system of local, interdependent, self-updating movements, perceptions and gestures,"[7] where the sensation of a fluid consciousness "sets an axe to the roots of formal logic and ends by mak-ing it impossible to know even the simplest things that the nineteenth century took for granted."[8] Within such a cultural experience, fixed cer-tainty of the laws of physiognomic expression—Duchenne's immutable and universal "gymnastics of the soul"—has given way to a view of the face as a matrix of constantly shifting, multiple identities at once true and false, assumed and genuine, feigned and sincere. In 1965 the American

[6] J. G. BALLARD, interview by George MacBeth, BBC, 1 February 1967, in V. Vale and Andrea Juno, eds., *J. G. Ballard, RE/Search,* no. 8/9 (1984), 160.

[7] JONATHAN CRARY and SANFORD KWINTER, foreword to *Incorporations, Zone* 6 (New York: Zone Books, 1992), 12–13.

[8] EVERDELL, *The First Moderns,* 11.

[9] WILLIAM S. BURROUGHS, *Nova Express* (New York: Grove Press, 1965; reprinted, 1992), 149. Burroughs was actually quot-ing the twelfth-century Persian assassin Hassan I Sabbah.

[10] The two pseudosciences occasionally appear in contemporary fiction: In Mario Vargas Llosa's historical novel *La Guerra del fin del mundo* (1981) the character Galileo Gall, a revolutionary and phrenologist, has named himself after the Viennese inventor of phrenology; Caleb Carr's *The Alienist* (1994), set in New York in 1896, includes a discussion of the failure of Alphonse Bertillon's criminal anthropometry and its replacement by finger-printing; Cesare Lombroso's cranial theories of criminality are revived in Philip Kerr's futurist novel *A Philosophical Investigation* (1992); and the narrator of Jeffrey Ford's futurist science-fiction parable *The Physiognomy* (1997), despite the title, is a phrenologist who determines character by measuring facial features with chromed instruments. I am indebted to Paul Holdengräber, Eve Schillo, and Rick Hock for bringing these novels to my attention.

[11] See PAUL EKMAN, *Emotion in the Human Face,* 2nd ed. (Cambridge: Cambridge Uni-versity Press, 1982).

[12] See ROBERT LEE HOTZ, "Watching Memories in the Making," *Los Angeles Times,* 28 August 1997, B2. Earlier, scientists had discovered that the amygdala, a small group of cells at the base of the brain, was entirely responsible for the recognition of fear and a "suite of emotions in more complex facial expressions." Hotz, "Tiny Structure in Brain May Be Key to Recognizing Fear," *Los Angeles Times,* 15 December 1994, A1, A32.

The notion of physiognomy (the art of judging temperament and character from outward appearances) emerges in England in the late 1880s along with phrenology, photography and other pseudo sciences. The accelerating tendency to accept the basic physiognomic premise is predictable in technologically jaded cultures. This phenomenon parallels and is inexorably bound to the belief systems about photography – and to all its commercial media step-children.

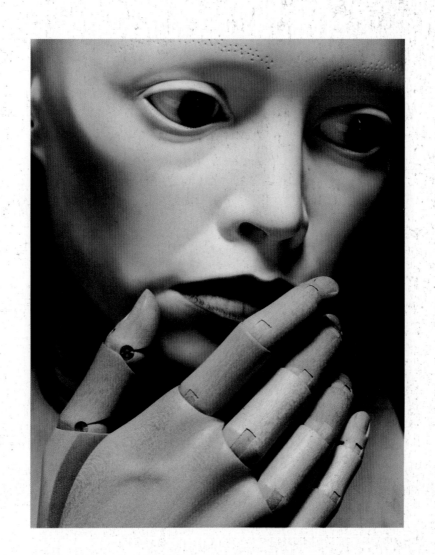

base of standard facial expressions, the robot guesses the person's emotion and adjusts its plastic face "into an appropriate emotional response."[13]

Three centuries ago, Descartes pointed to six elemental passions of the soul; now the face robot has an expressive repertoire of the same number of (synthetic) emotions: "anger, sadness, fear, surprise, happiness and disgust."[14] With machines like this, we may very well be approaching a world anticipated by Masamune Shirow's futurist *manga, Ghost in the Shell,* in which a cyborg questions her nature: "Sometimes I wonder if I've really already died, and what I think of as 'me' isn't really just an artificial personality comprised of a prosthetic body and a cyberbrain."[15] Writing about Inez van Lamsweerde's portraits of young girls with adult mouths seamlessly morphed onto their faces, critic Christiane Schneider similarly asks, "How can we find the point where the prosthesis ends and the homunculus begins?"[16] At the end of the century, machines have fully become a dominant metaphor of the human. This chapter is thus about the fluid nature of the contemporary "me" that proffers a multitude of emotional expressions, as well as the synthetic theatricality of those expressions complicitously emoted by the postmodern "we."

A Polity of Denizens

If Mary Shelley's *Frankenstein; or, The Modern Prometheus* (1818), with its theme of reanimation, is the symbolic background to Duchenne's physiognomics, then Robert Louis Stevenson's *Strange Case of Dr. Jekyll and Mr. Hyde* (1886) and its notion of a regressively "divided self" may be said to foreground late twentieth-century expression. Stevenson's story, well known from print or the screen, is about the struggle between good and evil, moral repression and libertine freedom, Calvinist ethics and the Freudian id. The good Jekyll is elderly, tall, fair, and professorial; the evil Hyde younger, dwarfish, swarthy, and decidedly simian. There is something wrong with Hyde's appearance: His face signifies "deformity without any nameable malformation" and elicits in all who behold it the compound sense of disgust, loathing, and fear.[17] Stevenson is clearly aware of the moral lessons of the physiognomic culture in which he is writing: Jekyll is white, vertically upright, and "turned toward heaven"; Hyde, on the other hand, appears darker than his alter-ego, much farther down on the evolutionary chain, and to use the words of Humbert de Superville, "very little raised above brutality."[18] Furthermore, whereas Dr. Frankenstein's creature is brought to life by external forces, not unlike the facial expressions of Dr. Duchenne's patients, Dr. Jekyll's alter-ego is inseparable from himself and generated from within, albeit with the aid of a tainted chemical potion.

[13] Curt Suplee, "Robot Revolution," *National Geographic,* July 1997, 85.

[14] "Japanese Scientists Develop Robotic Face Run by Computer," *Los Angeles Times,* 29 February 1996, B2. See also Andrew Pollack, "Japanese Put a Human Face on Computers, *New York Times,* 28 June 1994, B5, B10.

[15] Masamune Shirow, *Ghost in the Shell,* trans. Frederik Schoot and Toren Smith (Milwaukie, Oreg.: Dark Horse Comics, 1995), 106.

[16] Christiane Schneider, "Inez van Lamsweerde: The Soulless New Machine," *Camera Austria* 51/52 (1995): 86.

[17] Robert Louis Stevenson, *Strange Case of Dr. Jekyll and Mr. Hyde* (New York: Alfred A. Knopf, 1992), 15–16.

[18] D. P. G. Humbert de Superville, *Essai sur les signes inconditionnels dans l'art* (Leiden: C. C. van der Hoek, 1827), 3; quoted in Barbara Maria Stafford, *Symbol and Myth: Humbert de Superville's Essay on Absolute Signs in Art* (Cranbury, N.J.: University of Delaware Press, 1979), 43.

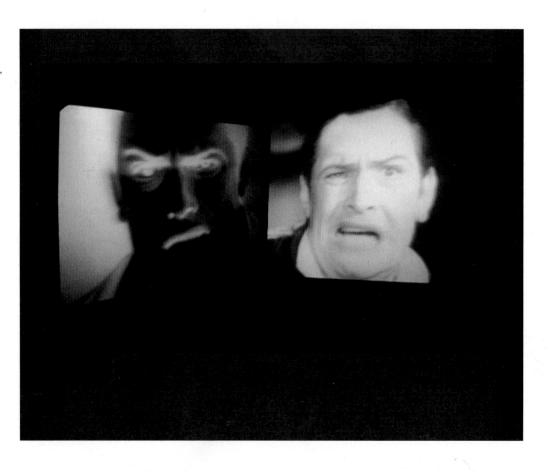

LEFT
Douglas Gordon, *Confessions of a Justified Sinner,* 1996, video installation, The Cartier Foundation, Paris, photograph courtesy the Lisson Gallery, London.

OPPOSITE
Inez van Lamsweerde, *Final Fantasy, Ursula,* 1993, cat. no. 131.

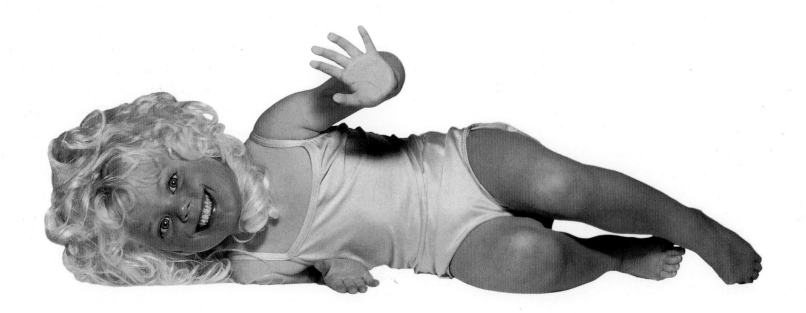

Jekyll's scientific studies produced the means of separating or dissociating the "polar twins" of human consciousness, the id and the superego, and physically manifesting them in two distinct personifications of one person.[19] This doppelgänger story is a classic depiction of a personality split into two warring factions, each with its own very distinct physicality, and as such it is comparable to E. T. A. Hoffmann's *Das Fräulein von Scuderi* (1818), James Hogg's *Confessions of a Justified Sinner* (1824), or Fyodor Dostoyevsky's *The Double* (1846). Jekyll admits to his own as well as to all humankind's dual nature, but at the end of his story he suspects that his reasoning is far too simplistic and that his case is only the beginning:

Man is not truly one, but truly two. I say two, because the state of my own knowledge does not pass beyond that point. Others will follow, others will outstrip me on the same lines; and I hazard the guess that man will be ultimately known for a mere polity of multifarious, incongruous and independent denizens.[20]

If modernist artists used the human face as raw material for their own and viewers' projected sentiments, others since the late nineteenth century have been increasingly involved with investigating and depicting the polity of multifarious denizens inhabiting each human being and taking their turns expressing themselves.

The nineteenth-century historian Adolphe Thiers called the face "the theater of the mind," but it remained for the twentieth-century drama critic Lionel Trilling to suggest that the characteristic disease of the actor was "the attenuation of selfhood that results from impersonation."[21]

More recently, sociologist Sherry Turkle and critic Steven Shaviro have both claimed that, a century or so after Freud, multiple-personality disorder has replaced hysteria as a fashionable disease and may just be, as Shaviro puts it, the "best paradigm we have for postmodern consciousness."[22] And according to philosopher Ian Hacking, "There is one thing, dissociation, and everyone is slightly dissociative, some are more so, and multiples are the most dissociative of all."[23] In our culture of discontinuous spectacles and imploded simulations, where coherent narrative successions are replaced by destabilized electronic switching,[24] where schizophrenic scrambling alters all the codes and coordinates that once seemed to work,[25] where fluid multiplicities of selves displace an essential, existential self,[26] and where the possibility of cloning adult humans is far more than a matter of science fiction[27]—in such a culture the nineteenth-century poet Arthur Rimbaud's assertion "*Je* est *un autre*" (I *is* an other) seems prescient.[28] If "I" is an "other," then precisely whose soul does the face reveal? And, if everyone is dissociative, precisely how many selves are there displaying the gymnastics of whose soul?

Modern literature, popular culture, and film have extensively surveyed this terrain. Three distinct identities share a single body in Nunnally Johnson's *The Three Faces of Eve* (1957), minds and personalities trade bodies in Ingmar Bergman's *Persona* (1966), an impossible doubling of identities is central to Luis Buñuel's *That Obscure Object of Desire* (1977), and a paranoid wife on her Caribbean honeymoon coexists as a professional killer in Seattle in Raúl Ruiz's *Shattered Image* (1998). Crazy Jane, a superhero in Grant Morrison's comic book *Doom Patrol* (1989), has

OPPOSITE
Keith Cottingham,
Triplets, 1993,
cat. no. 24.

184

[19] STEVENSON, *Strange Case of Dr. Jekyll and Mr. Hyde*, 61.

[20] Ibid.

[21] ADOLPHE THIERS, quoted in Rémy G. Saisselin, *Style, Truth and the Portrait*, exh. cat. (Cleveland: Cleveland Museum of Art, 1963), 17; LIONEL TRILLING, quoted in Donald Kuspit, "'Antonin Artaud Works on Paper,'" *Artforum* 35, no. 5 (January 1997): 81.

[22] STEVEN SHAVIRO, *Doom Patrols: A Theoretical Fiction about Postmodernism* (New York: Serpent's Tail Books, 1997), 148; see also SHERRY TURKLE, "Sex, Lies, and Avatars," interview by Pamela McCorduck, *Wired* 4, no. 4 (April 1996): 164.

[23] IAN HACKING, *Rewriting the Soul: Multiple Personality and the Sciences of Memory* (Princeton: Princeton University Press, 1995), 24. Actually, MPD might be better characterized as a culturally and historically determined "idiom of distress," much like somnambulism at the end of the eighteenth century and hysteria at the close of the nineteenth; see JOAN ACOCELLA, "The Politics of Hysteria," *New Yorker*, 6 April 1998, 72. The doctor who hypnotized but did not psychoanalyze the famous "Sybil" in the 1960s points out that MPD is almost exclusively an American disorder and dismisses much of it as a "hysterical response to hysteria." MIKKEL BORCH-JACOBSEN, "Sybil—The Making of a Disease: An Interview with Dr. Herbert Spiegel," *The New York Review of Books*, 24 April 1997, 63.

[24] SCOTT BUKATMAN, *Terminal Identity: The Virtual Subject in Post-Modern Science Fiction* (Durham and London: Duke University Press, 1993), 14–15.

[25] GILLES DELEUZE and FÉLIX GUATTARI, *Anti-Oedipus: Capitalism and Schizophrenia*, trans. Robert Hurley, Mark Seem, and Helen R. Lane (Minneapolis: University of Minnesota Press, 1983), 15. See also AVITAL RONELL, *The Telephone Book: Technology, Schizophrenia, Electric Speech* (Lincoln: University of Nebraska Press, 1989), 117.

[26] TURKLE, "Sex, Lies, and Avatars," 164. Cf. the idea of the self as a composite of myriad selves in Nathalie Sarraute, *You Don't Love Yourself*, trans. Barbara Wright (New York: George Braziller, 1990).

[27] See, e.g., GINA KOLATA, "Scientist Reports First Cloning Ever of Adult Mammal," *New York Times*, 23 February 1997, 1 and 20Y.

[28] See Luís Serpa, *"Je est un autre" de Rimbaud*, exh. cat. (Lisbon: Galeria Cómicos/Luís Serpa, 1990).

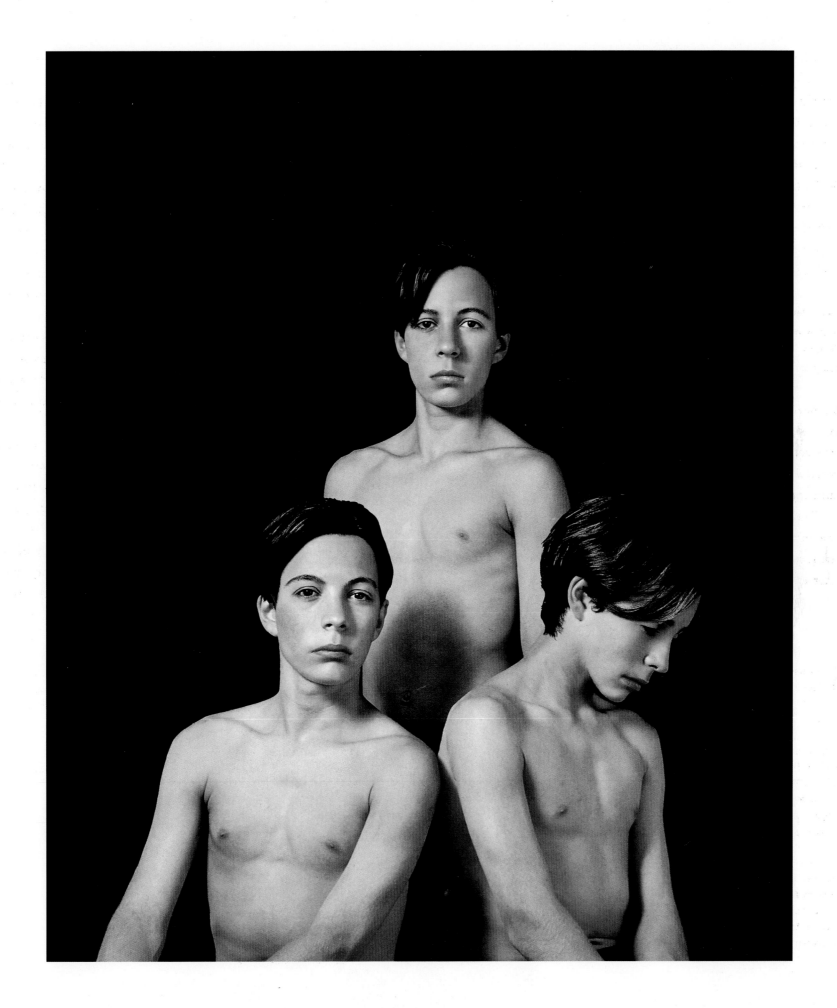

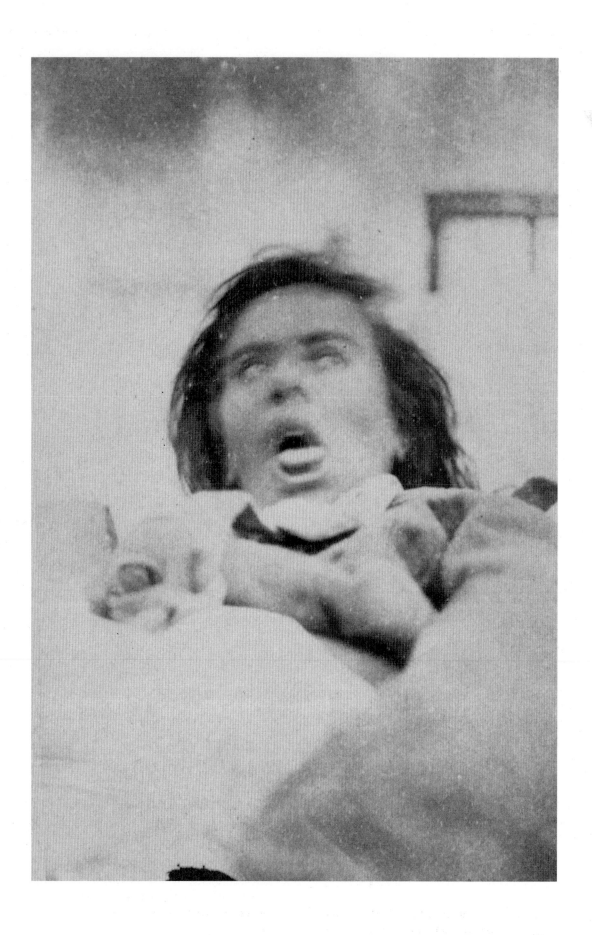

sixty-four personas and is modeled on the real-life Truddi Chase, who has ninety-two.[29] In apparent contrast to, or as a direct result of, a seemingly pandemic "demise of feeling and emotion,"[30] there seems to be a kind of rapturous embracing of multiplicity at the close of this century. "The search for the absolute 'self'," writes critic Jeffrey Deitch, "has been replaced by a constant scanning for new alternatives."[31] For the last two decades, computers, too, have aided this enterprise. Linearity, homogeneity, and a single-point perspective hardly pertain any longer; single views onto a coherent and unified world have been shattered and replaced by a "multi-threading," "memory addressing," and fluid arrangement of unparallel, multitasking Windows.[32] Forget about the Lacanian "imago" and the single vertical mirror in which one confronts oneself.[33] Users of computer windows programs confront the self as a "multiple, distributed system" on a daily basis. Sherry Turkle quotes one multi-user domain participant: "I split my mind. I'm getting better at it. I can see myself as being two or three or more. And I just turn on one part of my mind and then another when I go from window to window."[34] Duchenne sought to define the "grammar and orthography of human facial expression." But now, just who is present to chart the virtual physiognomies of so many multiple and multiplied faces written in cyberspace?[35]

OPPOSITE
Paul Regnard,
*Hystero-epilepsy:
Hallucinations
(Anguish),* 1877,
cat. no. 97.

Masquerade, drag, and cross-dressing have become commonplace, if not cliché; Divine, Madonna, and RuPaul are well-worn pop-culture icons. A character in Mark Herrier's film *Popcorn* (1990) declares proudly, "In truth, I've perfected the quick transition from face to face. You might say I'm multi-identical. Now, with a little nip here and little tuck there, I become multisexual, I can look like anybody I want to. It's one of the few advantages of not having a face."[36] Michael Jackson has radically and physically molded his appearance over the years, each furtive changeover signaling a new character or persona. Perhaps human evolution is no longer a simple matter of Darwinian natural selection but of "posthuman" synthetic selection from an unprecedented menu of options including elective surgery, biomechanics, genetic engineering, nanotechnologies, and cyborgization.[37] Despite Duchenne, and despite all the efforts of Darwin and Freud, the ineffable element of human character or consciousness remains hidden behind the dross of facial expression and has receded even further to become a ghost in the shell of the human body.

Hysterical Discontinuities

A number of recent studies have focused on Jean-Martin Charcot's "theater of the passions," held Tuesday evenings at the Salpêtrière in Paris, and on this institution's two most famous journals of photographs, *L'Iconographie photographique de la Salpêtrière* (1876–80) by Désiré-Magloire Bourneville and Paul Regnard, and *La Nouvelle Iconographie de la Salpêtrière* (1888–1918) founded by Paul Richer, Gilles de la Tourette, and Albert Londe. Common to most of these studies is the emphasis on Charcot's concept of hysteria,[38] his photographers' techniques (chronophotography, flash, etc.) to capture on film a "disease that defied anatomy (and thus physical examination),"[39] and his female hysterics' tendency to imitate their examiners and fake their symptoms to such a degree that the "history of hysteria is tied to a conception of hysterics as theatrical."[40] At one point Charcot even described the hysteric's theatrics as a kind of disinterested art

187

Sherman

29 See THE TROOPS FOR TRUDDI CHASE, *When Rabbit Howls* (New York: Jove Books, 1990); SHAVIRO, *Doom Patrols: A Theoretical Fiction about Postmodernism,* 147–56; GRANT MORRISON et al., *Doom Patrol: Crawling from the Wreckage* (New York: DC Comics, 1992). See also the character Copycat in MIKE HEISLER et al., *Dv8* (Fullerton, Calif.: Image Comics, 1996–98).

30 BALLARD, "Introduction to *Crash,*" in Vale and Juno, *J. G. Ballard,* 96.

31 JEFFREY DEITCH, *Post Human,* exh. cat. (New York: DAP/Distributed Art Publishers, 1992), unpag.

32 Cf. ROBERT A. SOBIESZEK, *Ports of Entry: William S. Burroughs and the Arts,* exh. cat. (Los Angeles: Los Angeles County Museum of Art, 1996), 29–31.

33 See JACQUES LACAN, *Ecrits: A Selection,* trans. Alan Sheridan (New York: W. W. Norton, 1977), 1–7; and SHERIDAN, translator's note in Lacan, *The Four Fundamental Concepts*

of Psycho-Analysis, ed. Jacques-Alain Miller (New York: W. W. Norton, 1981), 279–80.

34 Quoted in TURKLE, *Life on the Screen: Identity in the Age of the Internet* (New York: Simon & Schuster, 1995), 13–14.

35 For a contemporary critique of life on the screen, see TURKLE, "Minds and Screens: Mirrors for the Postmodern," in Kathy Halbreich, *Culture and Commentary: An Eighties Perspective,* exh. cat. (Washington, D.C.: Hirshhorn Museum and Sculpture Garden, Smithsonian Institution, 1990), 150.

36 MARK HERRIER, dir., *Popcorn,* prod. Torben Johnke (Studio Three Film Corp., with Movie Partners and Century Films, 1990).

37 For a discussion of these topics, see DEITCH, *Post Human;* and IARA LEE, dir., *Synthetic Pleasures,* prod. George Gund (Caipirinha Productions, 1996).

38 For the most thorough study of Charcot, see GEORGES DIDI-HUBERMAN, *Invention de*

l'hystérie: Charcot et l'iconographie photographique de la Salpêtrière (Paris: Macula, 1982).

39 ULRICH BAER, "Photography and Hysteria: Toward a Poetics of the Flash," *The Yale Journal of Criticism* 7, no. 1 (spring 1994): 44.

40 FELICIA McCARREN, "The 'Symptomatic Act' circa 1900: Hysteria, Hypnosis, Electricity, Dance," *Critical Inquiry* 21, no. 4 (summer 1995): 765. Along similar lines, DAPHNE DE MARNEFFE notes that many of the photographs in the *Iconographie* are far closer to theatrical portraiture of the period than to average portraits or studies of the insane; see "Looking and Listening: The Construction of Clinical Knowledge in Charcot and Freud, *Signs* 17, no. 1 (autumn 1991): 81. RAE BETH GORDON considers the images in the *Iconographie* and Charcot's use of the term "clownisme" for the second stage of a hysteric seizure in terms of the theater, café-concerts, popular dance, and pantomime; see "Le Caf'conc' et l'hystérie," *Romantisme,* no. 64 (January/March 1989): 58–64.

for art's sake. Less interested in aesthetics, the French psychiatrist Jules Falret flatly charged,

These patients are veritable actresses: their greatest pleasure is to deceive everyone with whom they come into contact. The hysterics, who exaggerate their convulsive movements, make corresponding travesties and exaggerations of their feelings, thoughts, and actions. . . . In a word, the lives of hysterics are one long falsehood.[41]

Charcot, who believed that hysteria was a real disease, wished to master the hysterical patient and visually decode the conditions of her pathology, unmasking her malingering and putting a stop to her performances.[42] To those ends he turned to photography and hypnotism in his work with female patients.[43]

A patient, in Charcot's view, was merely a "mechanical contraption void of any cognitive dimension," a veritable *homme-machine* that could be physically activated and "regulated."[44] In Charcot's hands, the technique of flash photography actually triggered the cataleptic seizure at the

exact moment it recorded the symptoms that previously had gone unseen and uncharted by the human eye, an example of the way in which, in the words of German critic Walter Benjamin, "the camera introduces us to unconscious optics as does psychoanalysis to unconscious impulses."[45]

RIGHT
Paul Regnard, *Catalepsy (Suggestion),* from *L'Iconographie photographique de la Salpêtrière* (1879–80), collotype print, photograph courtesy Yale University, Harvey Cushing/ John Hay Whitney Medical Library.

OPPOSITE
Paul Regnard, *Catalepsy Provoked by a Sudden Light,* 1879, cat. no. 96.

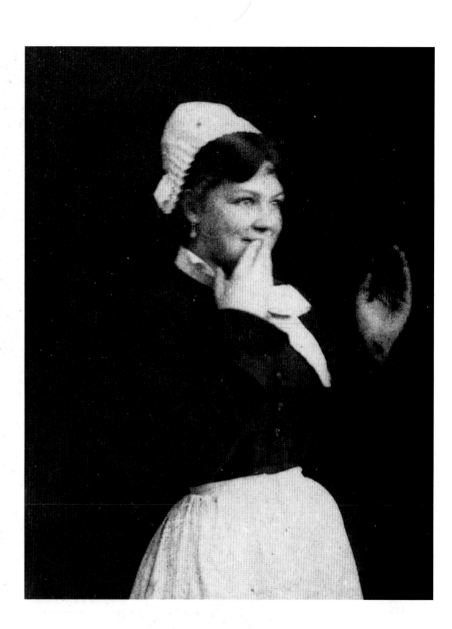

[41] JULES FALRET (1890); quoted in Schröder, *Egon Schiele: Eros and Passion,* 86.

[42] Cf. McCARREN, "The 'Symptomatic Act' circa 1900," 765. There are fundamental problems of diagnostic labeling in Charcot's iconographies that are not addressed in many studies of his work. To be sure, the photographs in his publications are mostly of female patients, a fact that by itself lends them to a feminist critique; yet the pathologies, if that is the correct word, of epilepsy (a chronic disease of the nervous system), catalepsy (a condition of muscular rigidity sometimes found in epileptics), and hysteria (a psychiatric condition of excited emotions and motor disturbances) are seldom differentiated. Malingering, it must be noted, is hardly an attribute of epilepsy, at least by today's standards.

[43] Much has been written on Charcot's emphasis on female hysteria. Charcot may have been the first to demonstrate the existence of male hysteria by exhibiting hysterical men in his classes and lecturing on the subject, but only female hysterics are pictured in his publications of the 1870s; see JOAN COPJEC, "Flavit et Dissipati Sunt," *October,* no. 18 (fall 1981): 40; and MARK S. MICALE, "Charcot and the Idea of Hysteria in the Male: Gender, Mental Science and Medical Diagnosis in Late-Nineteenth Century France," *Medical History* 34 (October 1990): 363–411. Only in *La Nouvelle Iconographie* do male subjects begin to be discussed and pictured.

[44] BAER, "Photography and Hysteria," 47 and 62; cf. JEAN-MARTIN CHARCOT, *Oeuvres complètes,* vol. 3 (Paris: Aux Bureaux du Progrès médical/Lecrosnier & Babé, 1890), 337. The concept of *l'homme machine* ultimately stems from Julien Offray de La Mettrie's *L'Homme machine* (1748); see STAFFORD, *Body Criticism: Imaging the Unseen in Enlightenment Art and Medicine* (Cambridge: MIT Press, 1991), 253–4. The distinction between the human and the machine has been addressed in detail by philosophers since the Enlightenment (Kant, Nietzsche, e.g.), and the lack of any distinction was more than hinted at in SAMUEL BUTLER's classic novel *Erewhon; or, Over the Range* (1872): "Man's very soul is due to the machines; it is a machine-made thing." *Erewhon* (Harmondsworth: Penguin, 1985), 207.

[45] WALTER BENJAMIN, "Art in the Age of Mechanical Reproduction," trans. Harry Zohn, in Vicki Goldberg, ed., *Photography in Print: Writing from 1816 to the Present* (New York: Simon & Schuster, 1981), 332; see also BAER, "Photography and Hysteria," 63.

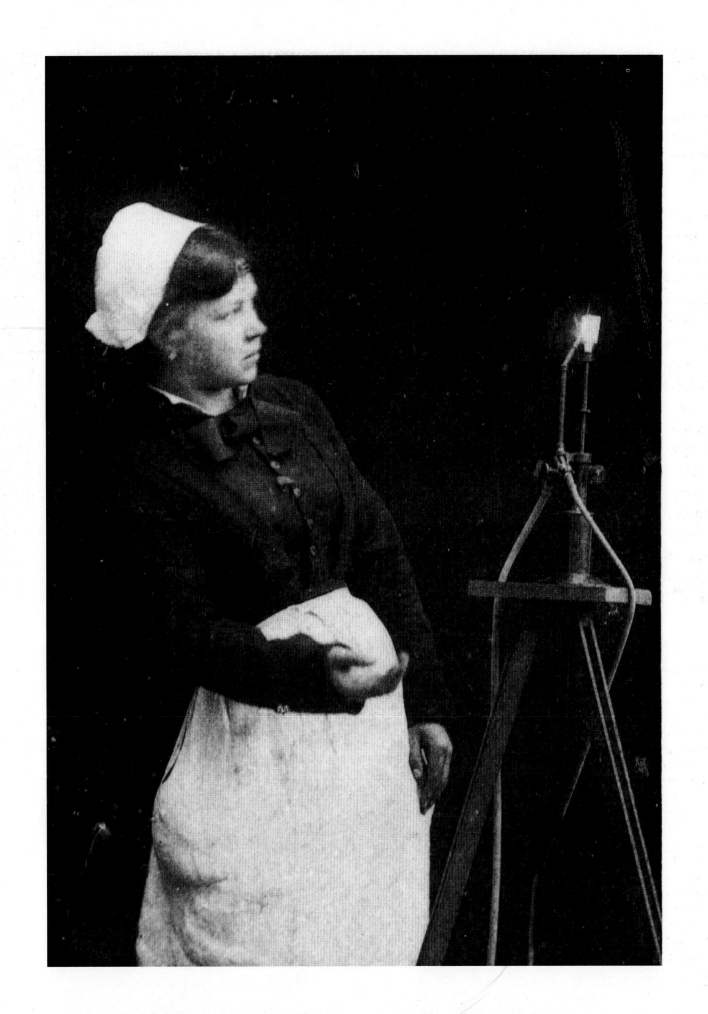

One of Charcot's patients, the prepubescent and somewhat coquettish Augustine, was repeatedly "provoked by a sudden light" and pictured in states of utter immobility in the *Iconographie:* frozen in blowing a kiss, steadfastly fixated on the light source, arching her upper torso severely backward in near horizontality, and spanning the space between two chair backs.[46] Hortense, another patient, was found to present a unique cataleptic phase, described by Charcot as a kind of photophobia wherein her eyes could be opened or closed by the attending *experimenteur* and their position maintained for the duration of the episode. A photograph of her staring directly back at the camera with her left eye closed has led critic Ulrich Baer to conclude that she, like others, was a mimic and in this instance was imitating the monocular gaze of the camera's lens that confronted her.[47]

Charcot believed, as Freud did later, that hysteria was occasioned by a traumatic prior event, and that the recollection of this trauma remained submerged in the patient's subconscious. The hidden memory of a trauma was seen as the root cause of hysteria, and hypnosis was the only proce-dure that could expose it and potentially cure it. Unlike Freud, Charcot did not place any great emphasis on what the "stored event" signified. According to historian Michael Roth, "The initial experience was treated like an electrical charge that continued to have consequences on the nervous system, [and] not as an event that was cognitively or emotionally unbearable for the conscious subject."[48] The "electrical" shock of the traumatic episode essentially divided the memory into two isolated facul-ties, one hidden and the other conscious, and this divided or "doubled" memory ultimately led to the formation of a "split personality." Through hypnotic suggestion Charcot was able to reestablish the lost memory and

OPPOSITE
Albert Londe,
Hysterical Photophobia,
1889,
cat. no. 71.

alleviate the disjunction between the two selves, not in order to unify them into one seamless personality (as would be the goal of psychoanalysis) but, rather, to allow them to function in equilibrium.[49] Stevenson fictionalized the notion of the multiple personality in *Dr. Jekyll and Mr. Hyde* in 1886, at about the same moment that medical science was experimenting with much the same thing. And more than a century later, Sherry Turkle echoed Charcot: "The goal of healthy personality development is not to become a One, not to become a unitary core, it's to have a flexible ability to negotiate the many [and to] cycle through multiple identities."[50]

Common to much of the culture of the belle époque was the notion of the divided and multiple self. Human personality was no longer always thought of as a unified, immutable character; instead, it was frequently seen as split into multiple emotions and psychic states, most of which at least bordered on hysteria. This idea is expressed, in one way or another, in the works of the psychologist Ernst Mach, the art critic Hermann Bahr, the writer Hugo von Hofmannsthal, and the sociologist Georg Simmel; it is also found in the short stories of Guy de Maupassant, the poetry of Arthur Rimbaud, and the novels of Emile Zola and Joris-Karl Huysmans.[51] In Huysmans's *La-Bas* (*Down There,* 1894), for example, the character Durtal contemplates the mysterious identity of a woman who is anony-mously writing provocative letters to him: "In short, he said to himself, one must admit to a real doubling into two. From one visible side, a woman of the world, a discreet salon-goer; and from the other, in this case unknown, side, a passionate madwoman, a piercing romantic, an hys-teric of the body, a nymphomaniac of the soul. This is quite improbable!"[52]

190

[46] DÉSIRÉ-MAGLOIRE BOURNEVILLE and PAUL REGNARD, *L'Iconographie photographique de la Salpêtrière*, vol. 3, plates 18, 17, 15, 14. For a discussion of Augustine's "affectionate senti-ments," see ibid., 3, 192; also cf. Regnard, *Les Maladies épidémiques de l'esprit—Sorcellerie, magnétisme, morphinisme, délire des grandeurs* (Paris: Plon-Nourrit, 1887), 247; and DIDI-HUBERMAN, *Invention de l'hystérie: Charcot et l'iconographie photographique de la Salpêtrière*, 217.

[47] PAUL RICHER, G. GILLES DE LA TOURETTE, and ALBERT LONDE, *La Nouvelle Iconographie de la Salpêtrière, clinique des maladies du systeme nerveux, pub. sous la direction du professor Charcot*, vol. 2 (Paris: Lecrosnière and Babé, 1889), plate 17; BAER, "Photography and Hysteria," 68.

[48] MICHAEL ROTH, "Hysterical Remember-ing," *Modernism/Modernity* 3, no. 2 (April 1996): 5. FREUD, in his unpublished MS *Outline of a Scientific Psychology* (1895) also believed that the physiology of the brain consisted of mere patterns of electric transmissions within a neural net, a position he renounced soon after; discussed in Jean Clair, *Five Notes on the Work of Louise Bourgeois*, trans. Michael Gibson (New York: Cheim & Read, 1998), unpag.

[49] ROTH, "Hysterical Remembering," 6–8. See also PIERRE JANET, *L'Etat mental des hys-tériques* (Paris: Félix Alcan, 1911), 215; quoted in Roth, 1.

[50] TURKLE, "Sex, Lies, and Avatars," 164. But then, RALPH WALDO EMERSON once wrote, "We live among surfaces, and the true art of life is to skate well on them"; quoted in William H. Gass, "The Face of the City: Reading Consciousness in Its Tics and Wrinkles," *Harper's*, March 1986, 39.

[51] Cf. SCHRÖDER, *Egon Schiele: Eros and Passion*, 86; and JACQUELINE CARROY, "L'Hystéria, l'artiste et le savant," in Jean Clair, ed., *L'Ame au corps: Arts et sciences, 1793–1993*, exh. cat. (Paris: Réunion des musées nationaux and Gallimard/Electa, 1993), 447, 453; adapted from Carroy, *Les Personnalités doubles et multiples, Entre science et fiction* (Paris: Presses Universités de France, 1993).

[52] J. K. HUYSMANS, *La-Bas* (Paris: Plon, Le Livre de poche, 1963), 99; discussed in Carroy, "L'Hystéria, l'artiste et le savant," 453.

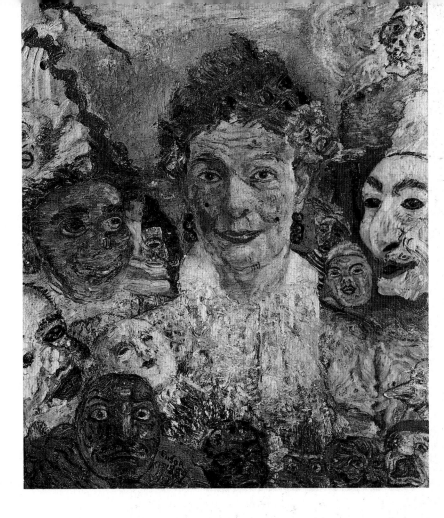

LEFT
James Ensor, *Portrait of Old Woman with Masks*, 1897, oil-on canvas, Belgium, Ghent, Museum of Fine Arts, © IRPA-KIK, Brussels.

OPPOSITE
Anton Josef Trčka, *Portrait of the Painter Egon Schiele*, 1913, photograph by D. James Dee, cat. no. 124.

herself as a hysteric as often or with as much pathological intensity as the Viennese painter Egon Schiele, whose *Grimacing Self-Portrait* foregrounds this essay. Schröder has argued quite convincingly that Schiele was aware of the photographs in Charcot's *Iconographie,* and that his use of them as generic sources reflects the artist's "conviction that a personality no longer embodied an immutable character, a temperament, an essential being. On the contrary, every ego was multiple, because it was composed of alarmingly contradictory elements."[58] For Schiele, the value of Charcot's photographs lay in their demonstration that humans had far more facial expressions and bodily gestures available to them than had been imagined; they "exploded the traditional concept of personality."[59] Schiele also portrayed other subjects with troubled grimaces and awkwardly contorted figures; just as many of the portraits taken by Anton Joseph Trčka and others depict Schiele at strange angles, his hands oddly splayed or entwined, and his expressions somewhat trancelike.

In *Grimacing Self-Portrait,* Schiele is seen "concealing himself behind a corporeal or facial facade. The grimace is a mask, which screens out the physiognomy that has become inseparably interwoven with character and personality."[60] The disturbing facial grimaces in Schiele's work, the violent contortions of the poses, and the unnerving faces that are really masks unhinged from physiognomic expression—these elements dramatically contribute to a sense that the continuity of face and personality, and the

Other writers even aestheticized hysteria. Stéphane Mallarmé, André Gide, and Paul Valéry considered themselves male hysterics at one point or another; Gide wrote to Valéry: "Poor hysteria! Don't say anything bad about it, it is the most amusing of illnesses."[53] Following the advent of Charcot's and Bernheim's "new psychology" in the 1890s, French Symbolists completely inverted outer and inner reality by objectifying subjectivity and emphasizing dreams, and by the fin-de-siècle the ego became a sight of "nervous vibration, spatial self-fashioning, and unconscious projection" at the same time it was being divided into the autonomous halves of conscious and unconscious by psychologists.[54] Hysteria became central to the interrogation of the self and to the conditions for creativity; art historian Klaus Albrecht Schröder has pointed out that "the semiotics of hysteria fitted perfectly into the pathologization of art" and into the formation of the "genius-and-madness myth."[55]

As the exhibitions *Wunderblock* (Vienna, 1989) and *L'Ame au corps* (Paris, 1993) amply illustrated, contortions and grimaces of the hysteric are frequently encountered in portraits and self-portraits of the turn of the century.[56] There is also the example of the Belgian painter James Ensor, whose paintings, such as *Portrait of Old Woman with Masks* and *Masks and Death* (both 1897), repeatedly present frightful masks as substitutes for the human face.[57] No other artist, however, positioned him- or

53 ANDRÉ GIDE, letter to Paul Valéry (2 December 1894), in Gide and Valéry, *Correspondence* (Paris: NRP, 1955); quoted in Carroy, "L'Hystéria, l'artiste et le savant," 455. CARROY also points out that Charles Baudelaire expected the physiological mystery of hysteria to become the basis of a literary work. Ibid., 456.

54 DEBORA L. SILVERMAN, *Art Nouveau in Fin-de-Siècle France: Politics, Psychology, and Style* (Berkeley: University of California Press, 1989), 75–77.

55 SCHRÖDER, *Egon Schiele: Eros and Passion,* 84, 73.

56 See JEAN CLAIR, CATHRIN PICHLER, and WOLFGANG PIRCHER, eds., *Wunderblock: Eine Geschichte der modernen Seele,* exh. cat. (Vienna: Wiener Festwochen and Löcker Verlag, 1989), 532 (Oscar Kokoschka), 257 (Giacomo Balla), 531 (Clara Siewert), and 536 (Richard Gerstl); and CLAIR, *L'Ame au corps: Arts et sciences, 1793–1993,* 459–63 (Carlos Schwabe), 465 (Max Klinger), 482 (Edvard Munch), and 483 (Léon Spilliaert).

57 See JOHN DAVID FARMER, *Ensor,* exh. cat. (New York: George Braziller, 1976), plates 42, 29.

58 SCHRÖDER, *Egon Schiele: Eros and Passion,* 86.

59 Ibid., 84.

60 Ibid., 64.

singular integration of body and soul, are irrelevant to the modern experience and the twentieth-century artist. Instead, the link between the inner and outer worlds is permanently shattered, the human face is no longer a trusted venue of human emotions, and the affecting of distorted countenances leaves the realm of the physiognomic and approaches the schizophrenic.[61] This order of faciality is obviously about staging or striking a pose for the audience's benefit. It includes us in its abjectly existential or rudely sarcastic farces, but it rebuffs all intimate probing into its personality.[62] For Schiele, since there was no central core to be expressed, the grimace and contorted gestures were precisely what mattered.

Passionate Grimaces

In *Mécanisme de la physionomie humaine,* Duchenne de Boulogne advises his readers to study each side of his subject's face separately; otherwise, they will see a "mere grimace" rather than a legible expression. His warning suggests that he considered grimaces and facial expressions to be diametrically opposed: expressions signified; grimaces, lacking any grammar, did not. But well before Duchenne there had been, and there continues to be, a rhetoric of the grimace designed to impress by exaggeration and often accompanied by at least the implication of insincerity. Throughout the nineteenth century, this rhetoric was a fundamental staple for actors and caricaturists alike, and it was similarly outlined to painters and sculptors whenever a distinction between expression and passion was made. As the British writer Matthew Pilkington pointed out in 1805,

Frequently, the term Expression is confounded with that of Passion; but the former implies a representation of an object agreeably to its nature and character, and the use or office it is intended to have in the work; and Passion, in painting, denotes a motion of the body, accompanied with certain airs of the face, which mark an agitation of soul. So that every Passion is an Expression, but not every Expression a Passion.[63]

We are again in the province not of physiognomy but rather of pathognomy, where agitations of the soul are marked by bodily motions and "certain airs of the face." The difference between passion and expression is, to borrow the earlier phrases of Alexander Pope, a matter of "false eloquence" as distinguished from "true expression."[64]

194

[61] Ibid., 66.

[62] Cf. Maria Morris Hamburg and Christopher Phillips, *The New Vision: Photography between the World Wars,* exh. cat. (New York: Metropolitan Museum of Art, 1989), 158–9.

[63] Matthew Pilkington, *A Dictionary of Painters from the Revival of Art to the Present Period,* ed. Henry Fuseli (London, 1805); quoted in Morris Eaves, *William Blake's Theory of Art* (Princeton: Princeton University Press, 1982), 47.

[64] Alexander Pope, *An Essay on Criticism* (London, 1711); quoted in Eaves, *William Blake's Theory of Art,* 47.

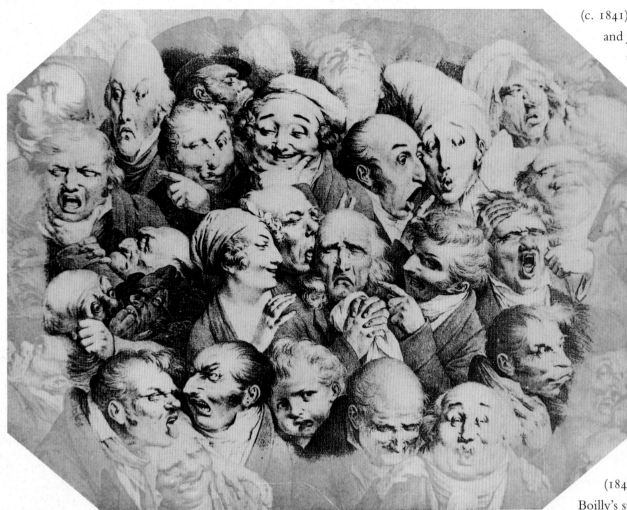

(c. 1841),[65] in caricatures by Honoré Daumier and Joseph Traviès, and most notably in the Viennese artist Franz Xaver Messerschmidt's series of convulsively distorted, sculptural self-portraits representing "magic heads" whose deliberate grimaces are "mask-like in their schematic artificiality."[65] Artificial displays of grimaces also form the basis of the French artist Louis-Léopold Boilly's suite of more than ninety lithographic prints entitled *Collection des Grimaces*, which was published between 1823 and 1828 and reprinted in 1837.[67] Boilly grouped multiple heads into masses of grimacing faces smoking, crying, eating oysters, and wearing masks, or expressing states such as avarice, fear, and envy. A plate in William Henry Fox Talbot's *The Pencil of Nature* (1844–46) is a photographic facsimile of Boilly's study of thirty-five grotesque heads gagging, sneering, frowning, and acting surprised; a baldish man cries at the center, figures grapple with one another at the left, someone is having a tooth removed, and near the top right, with a quizzical or surprised expression, is the mime Pierrot, some ten years prior to Nadar's and Adrien Tournachon's photographs of Jean-Charles Deburau

Grimaces and expressions of extreme passion are common in Western art: in codices and sketchbooks from Leonardo to Géricault, in drawings by Goya and Thomas Rowlandson, in artists' self-portraits such as Joseph Ducreux yawning (c. 1783) or Gustave Courbet maddened with fear

[65] For DUCREUX, see his *Self-Portrait Yawning* in the collections of the J. Paul Getty Museum, Los Angeles; see also JEAN ADHEMAR, "Ducreux's *Le Discret:* An Attribution Established," *The Register of the Museum of Art* (The University of Kansas, Lawrence) 2, no. 6 (June 1961): 2–7. For Courbet, see ARTS COUNCIL OF GREAT BRITAIN, *Gustave Courbet: 1819–1877,* exh. cat. (London: Royal Academy of Arts, 1978), cat. no. 5, 81–82. On professional *grimaciers* during the eighteenth and nineteenth centuries, see ERNEST DUCHANGE, "Sur deux cartes de visite de grimaciers à Paris," *Gazette de beaux-arts* 100, no. 1364 (September 1982): 79–84.

[66] LORENZ EITNER, "The Artist Estranged: Messerschmidt and Romako," in Thomas B. Hess, ed., *The Grand Eccentrics, Art News Annual* 32 (October 1966): 88; see also BARBARA BÜCHERL, "Franz Xaver Messerschmidt: Charakterköpfe," in Clair et al., *Wunderblock: Eine Geschichte der modernen Seele,* 55–67. NANCY ANN ROTH tentatively suggests a parallel between the forced grimaces of Messerschmidt's heads and Duchenne's portraits; see her "Electrical Expressions: The Photographs of Duchenne de Boulogne," in Daniel P. Younger, ed., *Multiple Views: Logan Grant Essays on Photography, 1983–89* (Albuquerque: University of New Mexico Press, 1991), 115.

[67] For more on this series, see JUDITH WECHSLER, *A Human Comedy: Physiognomy and Caricature in 19th Century Paris* (Chicago: University of Chicago Press, 1982), 77, 194; and DUCHANGE, "Sur deux cartes de visite de grimaciers à Paris," 82.

ABOVE
William Henry Fox Talbot [Louis-Léopold Boilly, *Grimaces #23*], pl. 11 from *The Pencil of Nature* (1844–46), salted-paper print, courtesy George Eastman House.

OPPOSITE
Franz Xaver Messerschmidt, *The Ill-Humored One,* 1770–83, lead-tin alloy, Osterreichische Barockmuseum, Vienna, photograph © 1997 Pierre Picot.

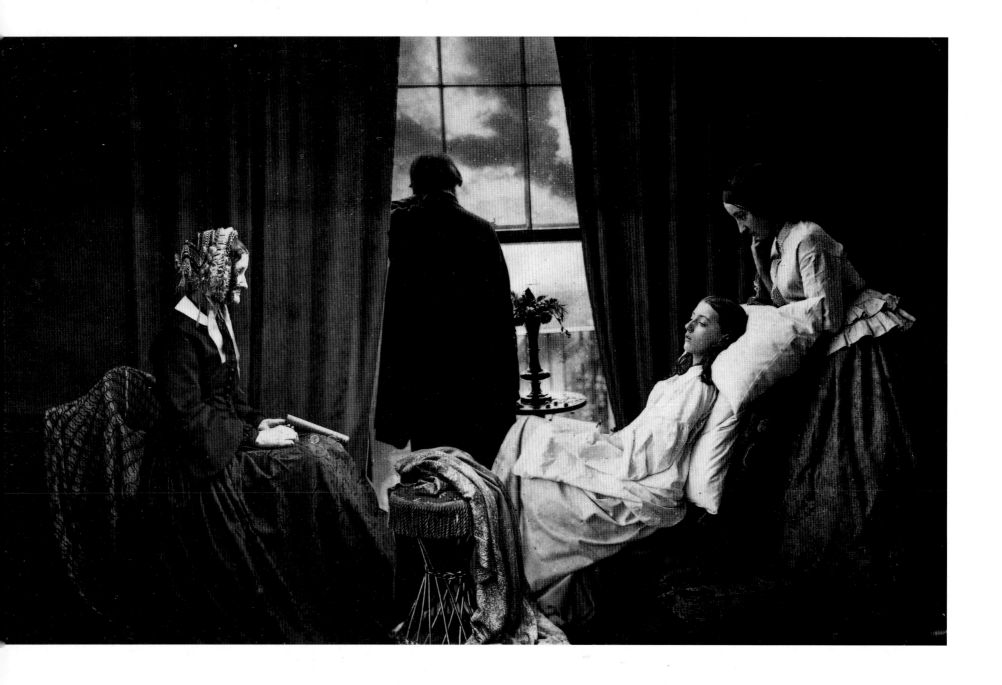

in the guise of this commedia dell'arte character.[68] Thus the grimace found its way into the first major publication illustrated by photography.

Since then, enactments of dramatic and melodramatic emotions and contortions of facial expressions in front of the camera have become a genre of photographic portraiture, admittedly minor in the last century, but much more prominent since.[69] A panoply of emotional expressions is found in Oscar Gustave Rejlander's histrionic *The Two Ways of Life* (1857), discreet pathos is rendered in Henry Peach Robinson's melodramatic *Fading Away* (1858), and various romantic vignettes are delineated in the two volumes of Julia Margaret Cameron's *Idylls of the King and Other Poems* (1874–75). In her short poem "On a Portrait," Cameron lists

[68] See WILLIAM HENRY FOX TALBOT, *The Pencil of Nature* (London: Longman, Brown, Green and Longmans, 1844–46), plate 11. The image that Talbot reproduced appears to have been a lithograph, since the scene is laterally reversed from Boilly's original oil painting entitled *Thirty-five Expressive Heads* (1823–28); see SUSAN L. SIEGFRIED, *The Art of Louis-Léopold Boilly: Modern Life in Napoleonic France* (New Haven and London: Yale University Press, 1995), 122, fig. 101. See also CLAIR, *L'Ame au corps: Arts et sciences, 1793–1993*, 228.

[69] In nineteenth- and early-twentieth-centry popular culture, there were, of course, the countless boilerplate melodramas in stereograph cards and lantern slides, such as Underwood and Underwood's stereograph series *The New French Cook* (Arlington, N.J., 1900).

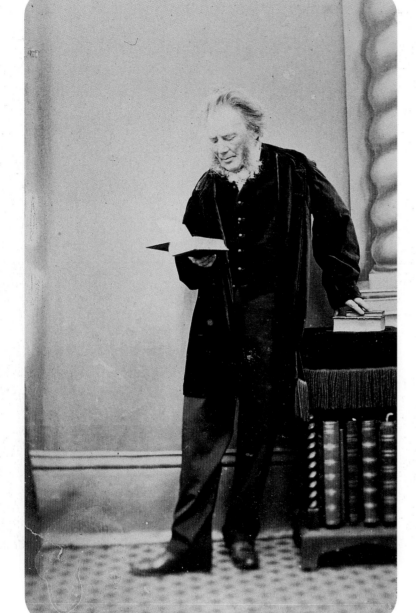

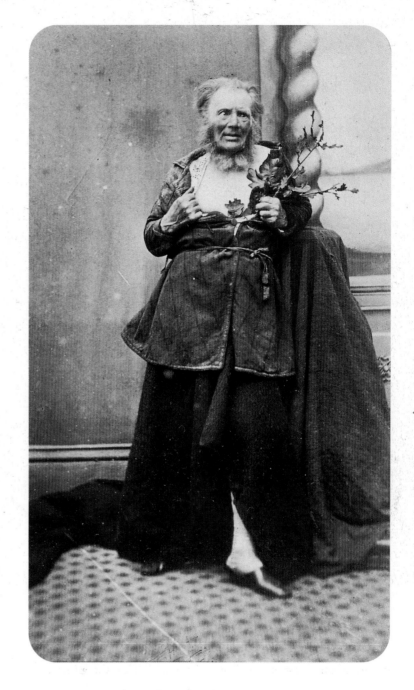

OPPOSITE
Henry Peach
Robinson,
Fading Away,
1858,
albumen print,
courtesy George
Eastman House.

LEFT
Richard Cockle
Lucas, *He Studies
"Divine Philosophy,"*
1865,
courtesy George
Eastman House,
cat. no. 72.

RIGHT
Richard Cockle
Lucas, *And "He Tears
a Passion to Tatters,"*
1865,
courtesy George
Eastman House,
cat. no. 73.

the emotions "stamped forever on the immortal face"—"fervent love," "sorrow's touch," "true courage," "great resolve," and "tragic woes"—and although all these expressions would be rather difficult to find in a single portrait, they are amply demonstrated throughout her Arthurian illustrations.[70] In an extraordinary album of fifty *cartes-de-visite* entitled *50 Studies of Expression* (1865), British sculptor Richard Cockle Lucas assembled a set of self-portraits representing various impersonations and rather belabored passions. In his studio he assumed the roles of Shakespearean characters: King Lear, Othello, Iago, and Shylock; he became an adventurer, necromancer, Jesuit, Puritan, conspirator, and student. His album consists of facing *cartes* portraying him in opposing roles: saint and sinner, winner and loser, druid and hermit, a "hopeful lover" and a "disappointed one." One pair in particular summarizes Lucas's project: In one image, "he studies 'Divine Philosophy';" in the other, "he tears a passion to tatters." Here Lucas may have been ironically self-aware of his fiction since "he tears a passion to tatters" comes from Hamlet's famous speech warning the court players not to overly emote on stage.[71] Nevertheless, the precise "passion" expressed is completely unclear, perhaps incidental, and lost to his histrionic gesture and caricatural grimace.

The Swedish-born Rejlander continued exploring human emotions photographically throughout the 1860s and 1870s. His subjects were for the most part commonplace sentiments, such as playful anticipation in a child's game of chance or the rueful anger of a matron finding a street urchin breaking into the house's strongbox. Occasionally, however, as in *The Sisters Nower* (1860) the depth of probing into the complexities and

RIGHT
Edgar Hilaire-Germaine Degas, *Giovanna and Giuliana Bellelli*, 1862–64, oil on canvas, Los Angeles County Museum of Art, Mr. and Mrs. George Gard de Sylva Collection.

OPPOSITE
Oscar G. Rejlander, *The Sisters Nower*, 1860, courtesy George Eastman House, cat. no. 99.

indeterminacies of the human spirit approaches the modernity of Degas's portraits, such as *The Bellelli Sisters* of 1862–64. Rejlander's success at photographing human emotions led Charles Darwin not only to include a number of his portraits of women and children in *The Expression of the Emotions in Man and Animals* but also to commission him to act out certain emotions in front of the camera.[72] In the collotype illustrations to this book, Rejlander's exaggerated expressions of disgust and disdain are

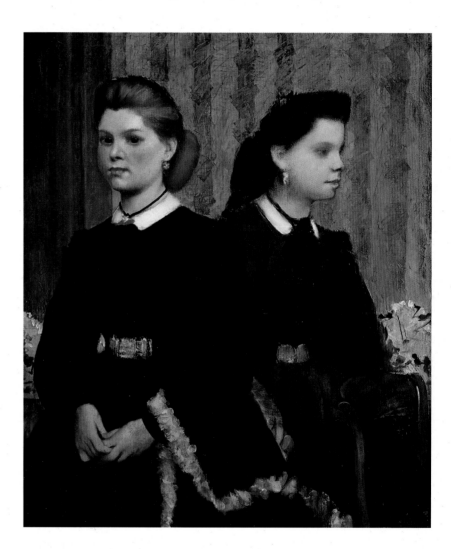

[70] Julia Margaret Cameron, "On a Portrait," *Macmillan's Magazine* 33 (February 1876): 372, in Mike Weaver, *Julia Margaret Cameron: 1815–1879,* exh. cat. (Southampton: John Hansard Gallery and the Herbert Press, 1984), 158.

[71] *Hamlet,* 3.2.10.

[72] See Charles Darwin, *The Expression of the Emotions in Man and Animals* (London: John Murray, 1872), 23. Rejlander and Darwin were both, apparently, comfortable with these staged enactments of the emotions; in 1871 Rejlander explained to Darwin why he took on the role of model: "It is very difficult to get, at will—those emotions you wish—Few have the command or imagination to appear real. In time I might catch some—So I have tried *in propria persona*—even cut my moustach shorter to try to please you. . . ." Rejlander to Charles Darwin, als 30 April 1871, Darwin Manuscripts Collection, Cambridge University Library, vol. 176, no. 115; quoted in Phillip Prodger, "Photography and *The Expression of the Emotions,*" in Darwin, *The Expression of the Emotions in Man and Animals,* 3rd and definitive ed. (New York and Oxford: Oxford University Press, 1998), 408–9.

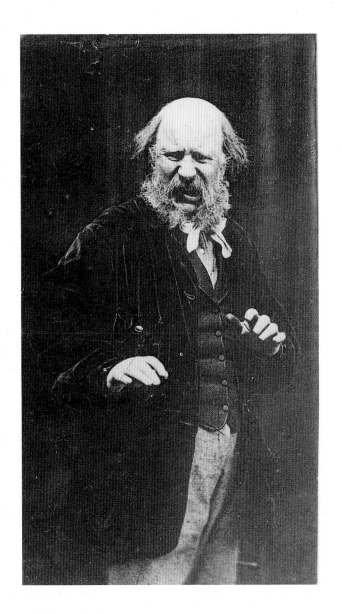
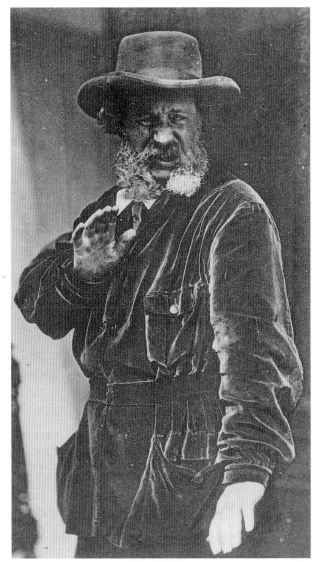

OPPOSITE
Oscar G. Rejlander,
Disdain and Disgust,
1872,
cat. no. 98.

RIGHT
Oscar Gustave
Rejlander,
*Rejlander the Artist
Introducing Rejlander
the Volunteer,*
c. 1870,
albumen print,
The Royal
Photographic
Society Collection,
Bath.

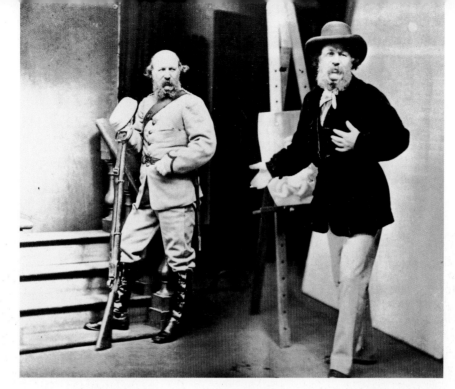

reproduced along with Duchenne's grimacing old man. At about the same time, Rejlander created *Rejlander the Artist Introducing Rejlander the Volunteer.* In front of an easel and dressed as an aesthete (in the same coat and hat he wears in an expression of "disgust" in Darwin's book), the artist looks out directly at us while dramatically gesturing toward himself, or rather his photographic double, attired as a militiaman holding a rifle. Gesturing, grimacing, and doubling himself, Rejlander clearly anticipated more contemporary artistic conventions of feigning passions and self-referentiality.

For early twentieth-century Expressionists, the face was a field of grimaces and angst; for Cubists, a deconstruction site; for Futurists, the battleground of frenetic displacements; and for Dadaists, the arena of rictal laughter. Many avant-gardes of this century seem simply to have turned their backs on traditional physiognomics. Picasso believed that "it is not important if the physiognomic traits are exactly those of the person portrayed";[73] Boccioni declared that "in art the human figure . . .

must exist apart from the logic of physiognomy";[74] and Hugo Ball wrote, "the human countenance has become ugly and outworn. . . ."[75] The second decade of the twentieth century was ushered in with rupture, derision, and gaping grins. In 1913 Anton Giulio Bragaglia published *Fotodinamismo futurista,* in which he affirmed that his technique of multiple exposures decomposed motion and for the first time created "a mutilated and multiplied reality towards the mystical finalities of form."[76] In the same year, Bragaglia depicted himself "unconsciously divided into two" by multiple exposures on the same negative.[77] Boccioni photographed himself multiplied by mirrors into five distinct characters standing in a circle and staring at themselves and titled the work *I-We-Boccioni.*[78] Marcel Duchamp created a similar self-portrait in 1917.[79] Multiplied realities suggest multiplied personalities in these works as well as in Arturo Bragaglia's *Polyphysiognomic Portrait* (1930), in which, again through multiple exposures, the subject is divided into three distinct personas in one figuration.[80] The subject beside itself (both literally and figuratively) is a leitmotif in much modernist photography, beginning with the Futurists and Dadaists and continuing in certain works by artists as diverse as Stanislaw Ignacy Witkiewicz (nervous), Umbo (menacing), Tato (mechanicized), Man Ray (doubled and redoubled), and Victor Skrebneski (split into two and watching).

[73] PABLO PICASSO, in Felipe Cossio del Pomar, *Con las Buscadores del Camino* (Madrid: Ediciones Ulises, 1932), 129; quoted in Dore Ashton, ed., *Picasso on Art: A Selection of Views* (New York: Penguin Books, 1977), 110.

[74] UMBERTO BOCCIONI, *Technical Manifesto of Futurist Sculpture* (11 April 1912), trans. Richard Chase, in Joshua C. Taylor, *Futurism* (New York: Museum of Modern Art, 1961), 131. Other futurists wanted the human to be identified with the machine and voided of those "corrosive poisons" such as "moral suffering, goodness of heart, affection, and love." FILIPPO TOMMASO MARINETTI, "Multiplied Man and the Reign of the Machine," in

Marinetti: Selected Writings, ed. R. W. Flint, trans. R. W. Flint and Arthur A. Coppotelli (New York: Noonday Press, 1972), 91.

[75] HUGO BALL, diary entry (5 March 1917), quoted in Hans Richter, *Dada: Art and Anti-Art* (New York: McGraw-Hill, 1965), 41.

[76] ANTON GIULIO BRAGAGLIA, *Fotodinamismo futurista: Sedici tavole* (Rome: Nalato Editore, 1913); quoted in Giovanni Lista, *Photographie futuriste italienne: 1911–1939,* exh. cat. (Paris: Musée d'art moderne de la ville de Paris, 1981), 38. One of Bragaglia's manifestos, presumably from 1911, contains the argument that a photodynamic image "will not exist as a

passive object over which an unconcerned public can take control for its own enjoyment. It will be an active thing that imposes its own extremely free essence on the public." This concept in itself differentiates a photodynamic portrait from all others in terms of tracing "the expression of passing states of mind, as photography and cinematography have never been able to, but also the immediate shifting of volumes that results in the immediate transformation of expression." "Futurist Photodynamism 1911," trans. Caroline Tisdall, in Umbro Apollonio, ed., *Futurist Manifestos* (New York: Viking, 1973), 44 and 41.

[77] LISTA, *Photographie futuriste italienne: 1911–1939,* 8.

[78] PONTUS HULTEN, ed., *Futurismo & Futurismi,* exh. cat. (Milan: Gruppo Editoriale Fabbri, Bompiani, 1986), 429.

[79] ANNE D'HARNOCOURT and KYNASTON McSHINE, eds., *Marcel Duchamp,* exh. cat. (New York and Philadelphia: Museum of Modern Art and Philadelphia Museum of Art, 1973), 76.

[80] Arturo and Anton Giulio Bragaglia were brothers.

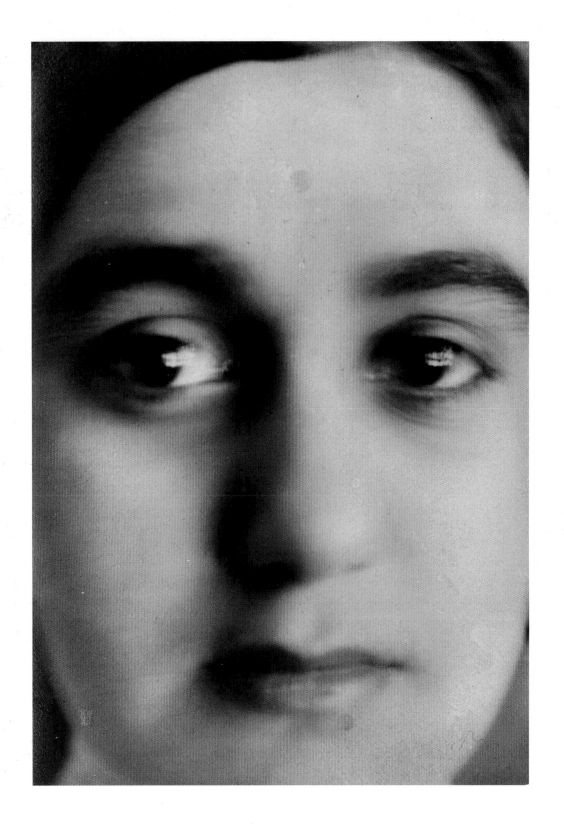

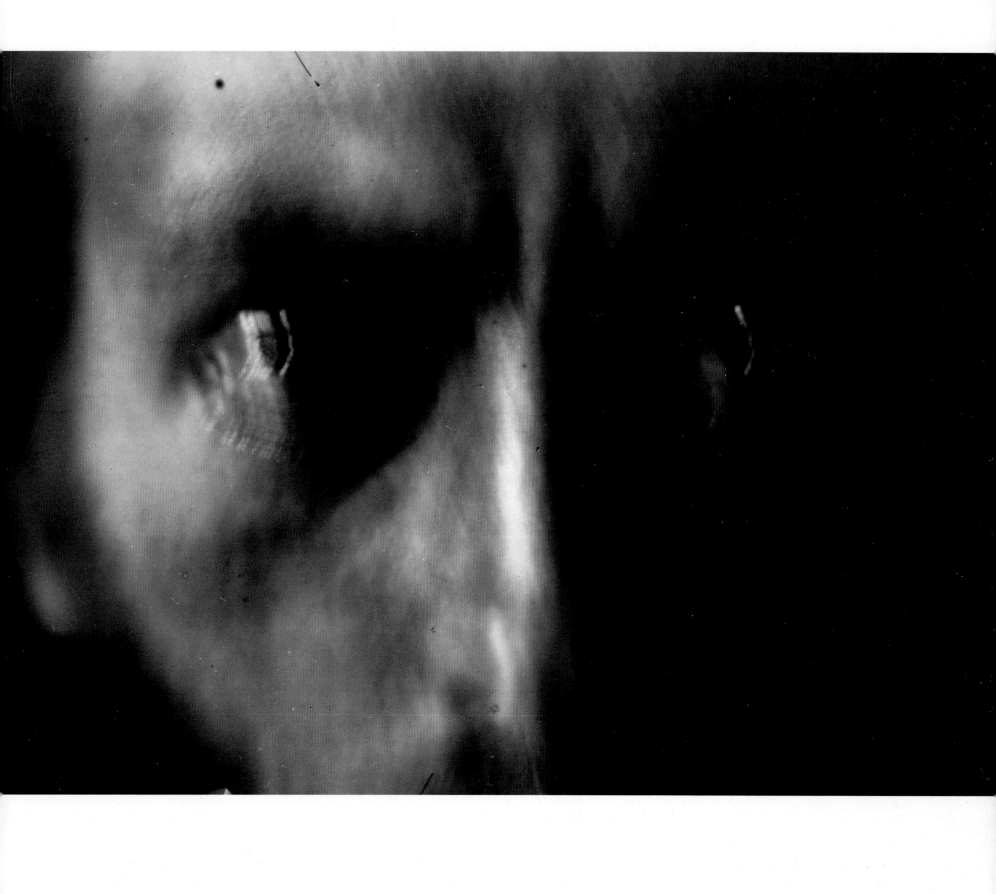

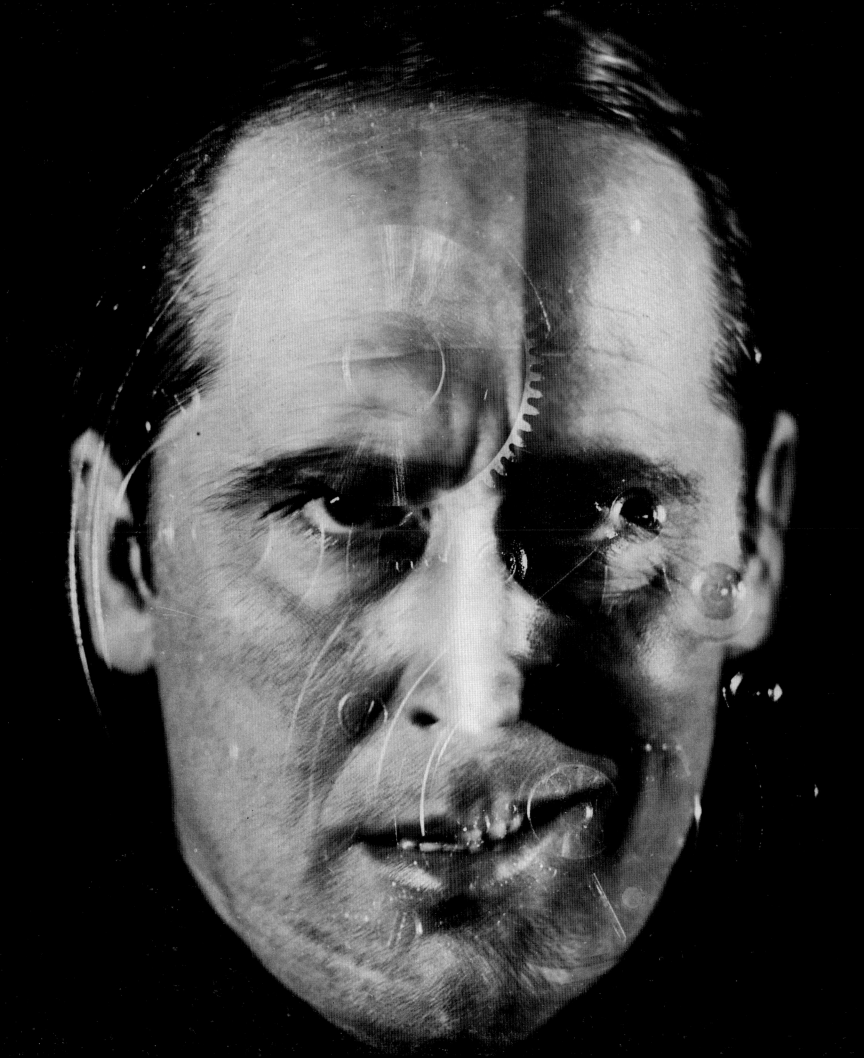

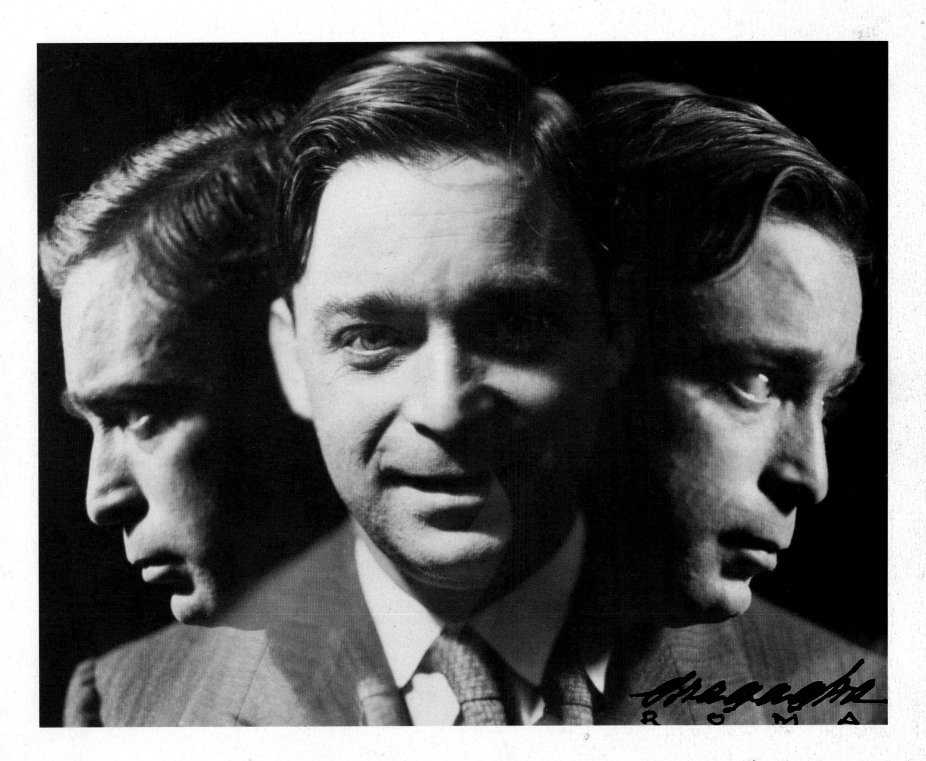

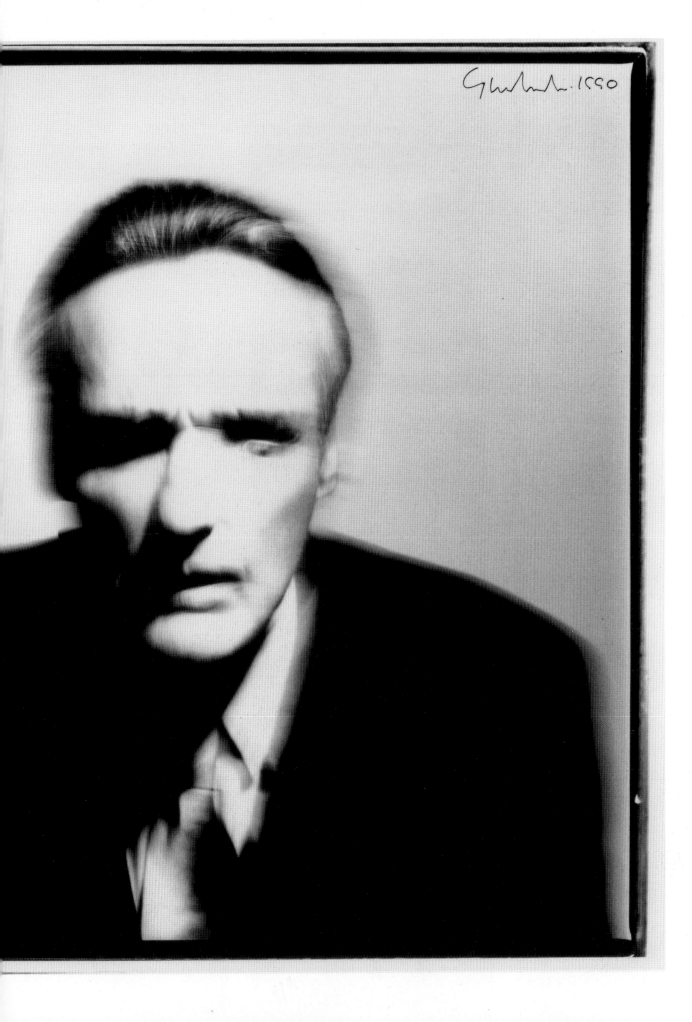

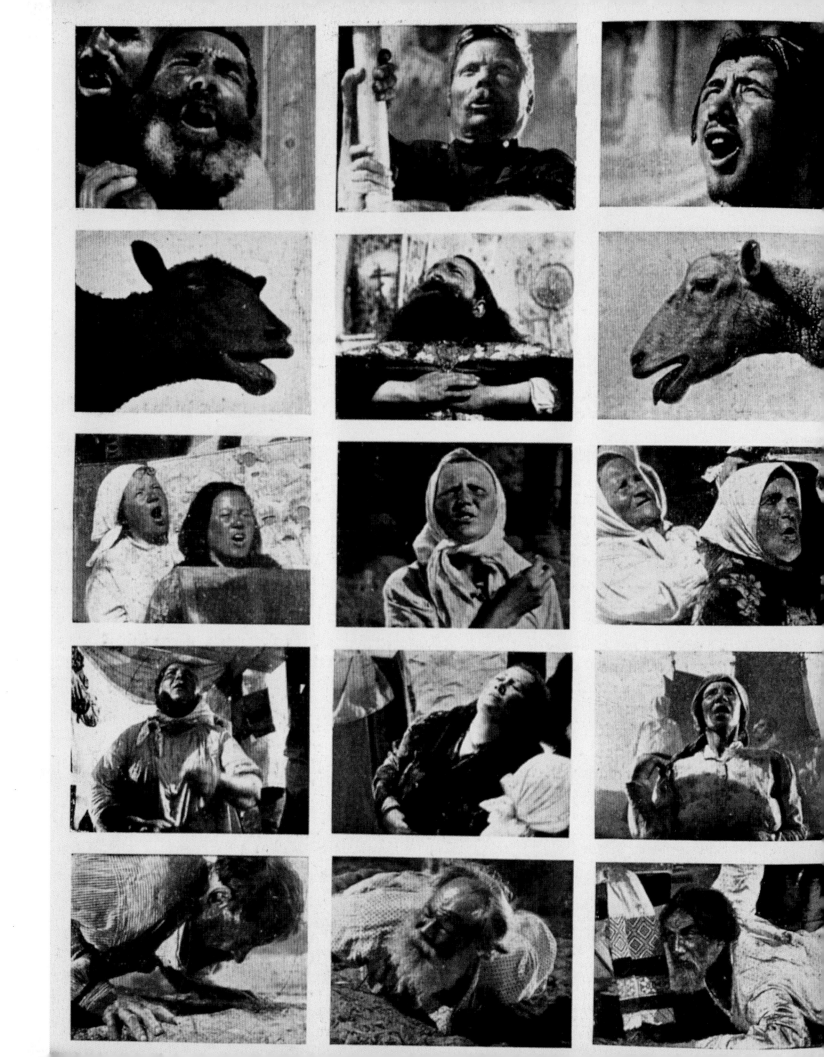

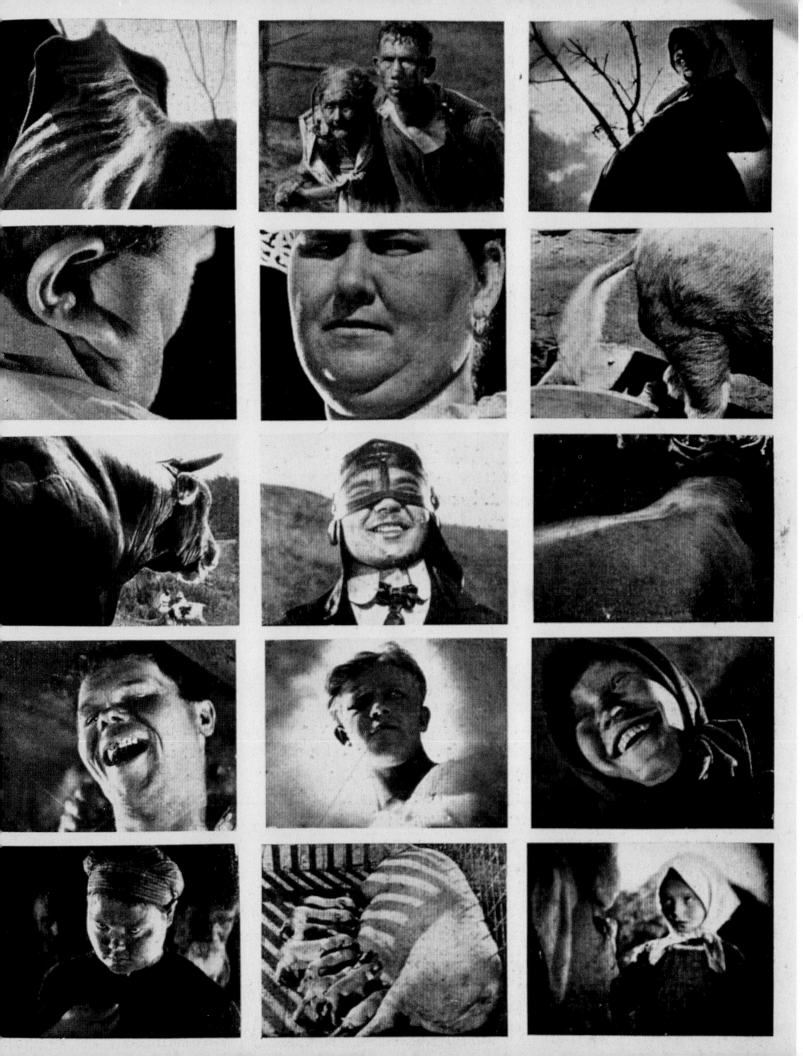

Masks and Body Sieves

For Surrealists, on the other hand, the face was the *terrain vague* of convulsive beauty and the enigmatic frissons of the nervous system. They dislodged quotidian photographs from their intended contexts and recontextualized them in periodicals such as *La Révolution surréaliste, Minotaure,* and *Documents.* In these journals, one encounters anthropological, medical, and criminological portraits, along with montaged close-ups of expressive faces of peasants taken from Sergei Eisenstein's film *The General Line* (which was banned in 1930 in Paris for its overtly Stalinist rhetoric). Images of hysterics from Charcot's *Iconographie* were included, according to art historian Christopher Phillips, to reinforce the Surrealists' contention that hysteria was "the greatest poetic discovery of the nineteenth century."[81]

Real medical issues of hysteria were not the point for the Surrealists, of course: Salvador Dalí heralded hysteria's "new signification" and even its "poetic remedy" for a world sick with reason.[82] Dalí also contended that the "moment is near when by a procedure of active paranoiac thought, it will be possible . . . to systematize confusion and contribute to the total discrediting of the world of reality."[83]

The photographic techniques at the Surrealists' disposal for accomplishing such a discrediting included solarization, negative printing, montage, and multiple exposures; their tools included disguises, masks, and mannequins. Dalí conflated ecstatic women's faces (mostly from erotic photographs), statuary, and the ears of criminals (from Bertillon's synoptic table of the 1890s) in *The Phenomenon of Ecstasy* (1933);[84] Man Ray placed glass beads on the face of an apparently grief-stricken model, Lydia, and entitled it *Tears* (c. 1930); the British photographer Madame Yevonde por-

trayed Lady Malcolm Campbell as "Niobe" (1935) and other socialites as various other "Goddesses";[85] and the Hungarian József Pécsi depicted himself holding his own head in his hand and contemplating it (1926).

For Surrealists and others, masks and mannequins were especially attractive, both as foils or alternatives to personality and for suggesting multiple selves. André Breton's novel *Nadja* (1928) begins with the question, "Who am I?" The answer, Breton suggests proverbially, "would amount to knowing whom I 'haunt'"; and the word *haunt* "means much more than it says, makes me, still alive, play a ghostly part, evidently referring to what I must have ceased to be in order to be *who* I am."[86] Later in the narrative he admits to being concerned

with facts which may belong to the order of pure observation, but which on each occasion present all the appearances of a signal, without our being able to say precisely which signal, and of what; facts which when I am alone permit me to enjoy unlikely complicities, which convince me of my error in occasionally presuming I stand at the helm alone.[87]

Breton's sense of not being alone in his mind echoes Freud's earlier notion that the ego was not master of its own house.[88] A number of contemporary critics and poets have pointed to the almost simultaneous demise of certainty in the singularity of the self and of trust in the objectivity of

[81] LOUIS ARAGON and ANDRÉ BRETON, "La Cinquantenaire de l'hysterie," *La Révolution surréaliste* 11 (15 March 1928): 20–22; quoted in Christopher Phillips, "Resurrecting Vision: The New Photography in Europe between the Wars," in Hamburg and Phillips, *The New Vision: Photography between the World Wars,* 99.

[82] SALVADOR DALÍ, "Objets surréalistes, objets oniriques" (1929), in Pontus Hulten, ed., *Salvador Dalí: Rétrospective, 1920–1980,* exh. cat. (Paris: Centre Georges Pompidou, Musée national d'art moderne, 1979), 212.

[83] DALÍ, "L'Ane pourri," *Le Surréalisme au service de la Révolution* (July 1930); extract reprinted in Hulten, *Salvador Dalí Retrospective, 1920–1980,* 276, where its source is credited as *La Femme visible* (Paris: Editions surréalistes, 1930).

[84] See above, chapter two, for a discussion of Bertillon's emphasis on the right ears of criminals. ROSALIND KRAUSS likens Dalí's images of falling women in *The Phenomenon of Ecstasy* to the Salpêtrière hysterics and suggests that Breton, in his famous comment that "beauty will be convulsive, or will not be at all," might have been thinking of Charcot's images of "passionate attitudes." *The Optical Unconscious* (Cambridge: MIT Press, 1993), 156, 152.

[85] MADAME YEVONDE, née YEVONDE CUMBER, may have made this image of "Niobe" as a reprise of the version of Man Ray's *Tears* that had appeared as the first plate of his *Photographies 1920–1934 Paris* (New York and Paris: James Thrall Soby and Cahiers d'art, 1934); see ROBIN GIBSON, "Yevonde: Gradus ad Parnassum," in Gibson and Pam Roberts, *Madame Yevonde: Colour, Fantasy and Myth,* exh. cat. (London: National Portrait Gallery, 1990), 37–38. Although Lady Campbell's portrait was meant to be a representation of Niobe's pain and suffering, some of the glycerine applied to Lady Campbell's face slipped into her eyes and, combined with her mascara, caused quite real pain. "When at last she was able to look up her eyes were bloodshot and her expression so miserable that I rushed the

focus and was able to take a face expressive of the utmost sorrow and pain." Madame Yevonde, *In Camera* (London: John Gifford, 1940), 234, quoted in Gibson, "Yevonde: Gradus ad Parnasum," 38.

[86] BRETON, *Nadja,* trans. Richard Howard (New York: Grove Press, 1960), 11.

[87] Ibid., 19–20.

[88] SIGMUND FREUD, *Introductory Lectures on Psycho-Analysis,* ed. and trans. James Strachey (New York: W. W. Norton, 1966), 353.

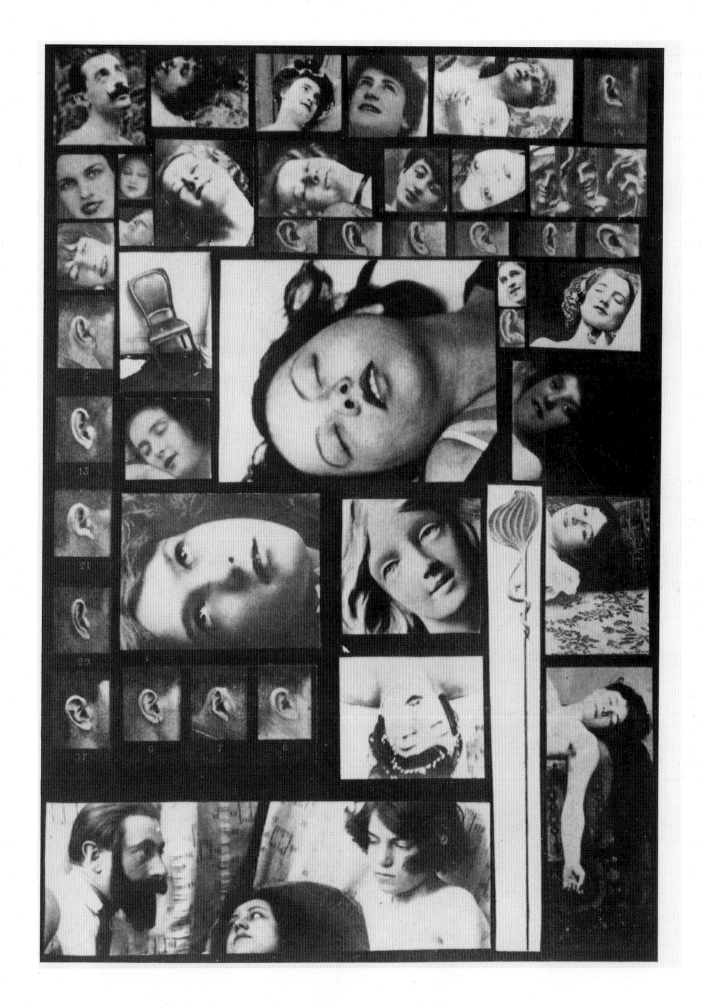

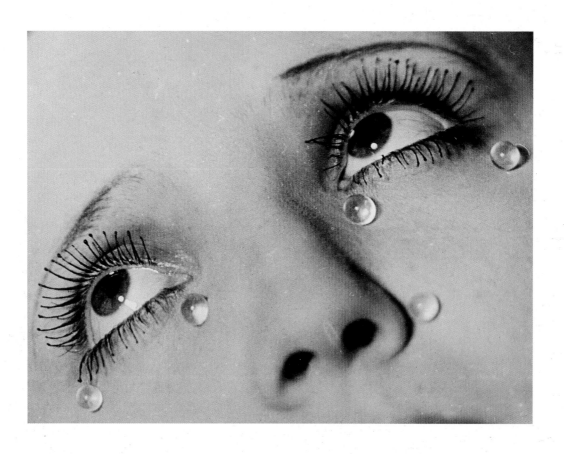

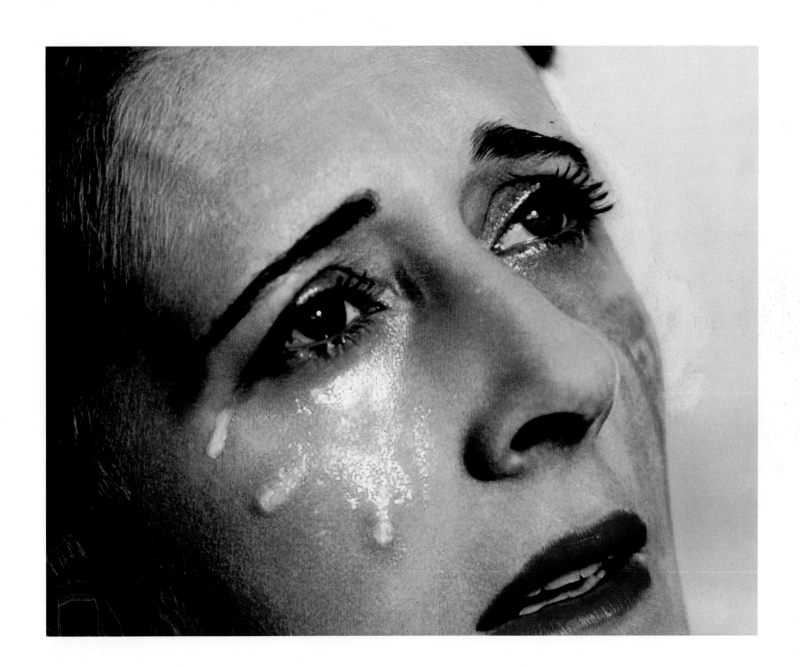

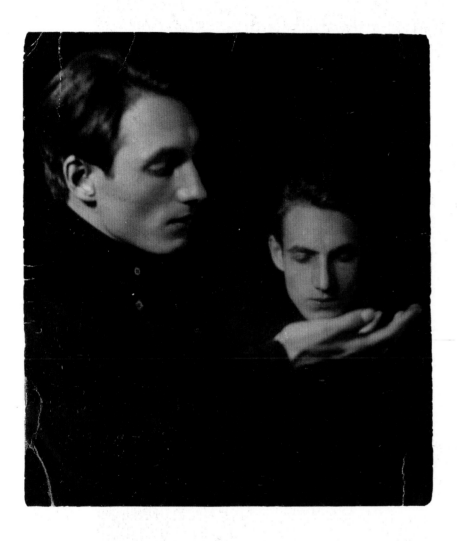

photographic representation.[89] Both deaths seem to have taken place around the late 1920s. The Soviet avant-gardist Alexander Rodchenko wrote in 1928 that "with the appearance of photographs, there can be no question of a single, immutable portrait. Moreover, a man is not just one sum total; he is many, and sometimes they are quite opposed."[90] The Italian Futurist Wanda Wulz conflated her face with a cat's in *Cat and I* (1932); the German modernist Umbo menacingly divided Paul Citroën's face in half in *Warlike Face* (1926/27); and the French Surrealist Claude Cahun (née Lucy Schwob) portrayed herself in numerous disguises in *I.O.U. (Self-Pride)* (c. 1930). This montage includes a message in Cahun's handwriting: "Under this mask, another mask. I will not finish taking off all these faces." Hidden beneath semblance, who is or how many are at the helm?

Man Ray's double portrait of the Marquise Cassati (1922) is one of the greatest Surrealist portraits. It is a fashionable yet depersonalized likeness of a frequently photographed socialite, heavily abstracted by the artist through technical manipulation. Decades after making this portrait Man Ray wrote that it "might have passed for a Surrealist version of the Medusa. She was enchanted with this one—said I had portrayed her soul, and ordered dozens of prints."[91] Saint Jerome once pronounced that "eyes without speaking confess the secrets of the heart."[92] But before this uncanny portrait of the marquise—with its shadowy double visage in both positive and negative, each with three pairs of intensely staring eyes— one is at a loss to determine what precise secrets of the heart are revealed.

[89] See, e.g., JEAN-FRANÇOIS CHEVRIER, "The Image of the Other," in James Lingwood, ed., *Staging the Self: Self-Portrait Photography 1840s–1980s,* exh. cat. (London: National Portrait Gallery, 1986), 9; and SOBIESZEK and DEBORAH IRMAS, *The Camera I: Photographic Self-Portraits from the Audrey and Sydney Irmas Collection,* exh. cat. (Los Angeles: Los Angeles County Museum of Art, 1994), 30–31.

[90] ALEXANDER RODCHENKO, "Against the Synthetic Portrait, For the Snapshot," *Novyi lef* 4 (1928), in Christopher Phillips, ed., *Photography in the Modern Era: European Documents and Critical Writings, 1913–1940* (New York: Metropolitan Museum of Art and Aperture, 1989), 241. See also BENJAMIN H. D. BUCHLOH, "Residual Resemblance: Notes on the Ends of Portraiture," in Melissa E. Feldman, *Face-Off: The Portrait in Recent Art,* exh. cat. (Philadelphia: Institute of Contemporary Art, University of Pennsylvania, 1994), 57.

[91] MAN RAY, quoted in Jane Livingston, "Man Ray and Surrealist Photography," in Krauss and Livingston, eds., *L'amour fou: Photography and Surrealism,* exh. cat. (New York: Abbeville Press, 1985), 135; Livingston points out that Man Ray was most likely a bit disingenuous about how much the Marquise liked these images. See also JEAN HUBERT MARTIN, *Man Ray Photographs* (New York: Thames and Hudson, 1982), 209.

[92] ST. JEROME, *Letters* 54.

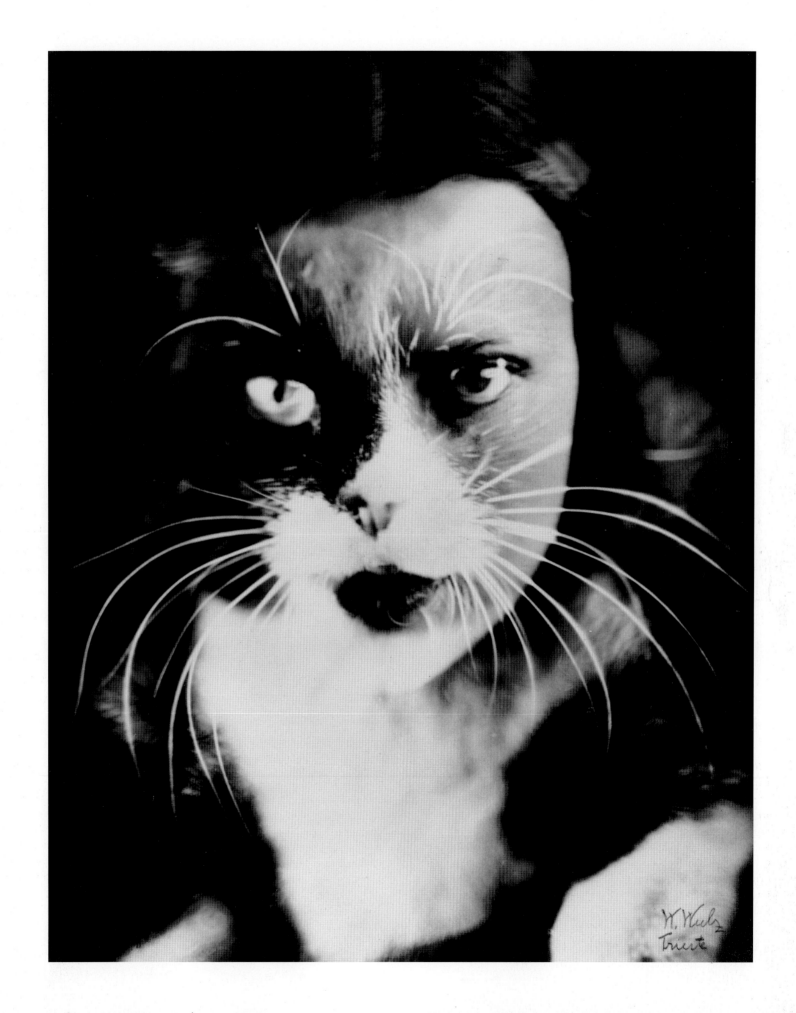

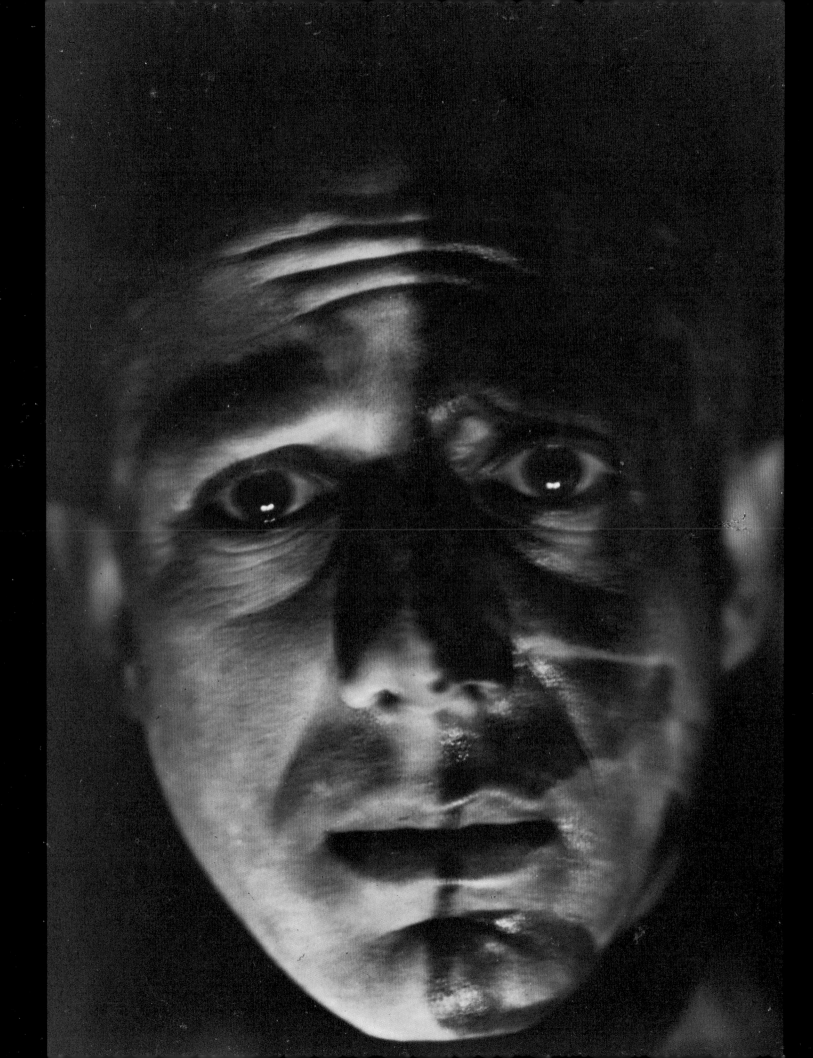

The marquise appears as a macabre, disembodied spectre. Freud's "thousand unnoticed openings" may have allowed the psychoanalyst to penetrate into the soul of the analysand, but there still needed to be a cloaking surface in which the openings could occur. In the marquise's portrait, there simply is no skin, no surface; as for her soul, take your pick: upper or lower sets of eyes, black or white, or everything all at once. Like Huysmans's "woman of the world" and "discreet salon-goer" who was also a "passionate madwoman" and a "nymphomaniac of the soul," the marquise is portrayed by Man Ray as a woman of multiple possibilities.

In the marquise's portrait, surfaces no longer hold. Sometimes there is nothing beneath them; in 1925 Antonin Artaud wrote that "it is only by a diverting of the flow of life, by a paralysis imposed on the mind, that one can fix life in its so-called real physiognomy, but reality is not under this surface."[93] Like faces, surfaces are arbitrary: the "ten thousand and one facial expressions captured in the form of masks" in Artaud's Theater of Cruelty function "independently of their particular psychological utilization."[94] Like bodies, surfaces are also permeable. Artaud again: "We use our body as a screen through which will and the release of will pass in turn."[95] Artaud viewed his own schizophrenia, according to critic Susan Sontag, as a "split *within* his mind ('My conscious aggregate is broken,' he writes) that internalizes the split between mind and body."[96] At the same time, he considered his mind a body whose disorder possessed him.[97] The philosopher Gilles Deleuze, analyzing Artaud's troubled drawings of faces, has suggested that they are the result of a clearly schizophrenic perception:

The first evidence of schizophrenia is that the surface is punctured. Bodies no longer have a surface. The schizophrenic body appears as a kind of body-sieve. . . . As a result, the entire body is nothing but depth. . . . As there is no surface, interior and exterior, container and content no longer have precise limits. . . . Body-sieve, fragmented body, and dissociated body form the first three dimensions of the schizophrenic body—they give evidence of the general breakdown of surfaces.[98]

While in an asylum in Rodez, Artaud gouged out the eyes of one of his self-portraits; a doctor who witnessed the violent act concluded, "For this, to him, was to be a visionary: by passing through the depth of his own eyes, to perceive the reality on the other side."[99]

RIGHT

Antonin Artaud, *The Blue Head*, 1946, graphite and wax crayon, Musée National d'Art Moderne—Centre de Création Industrielle, Centre Georges Pompidou, Paris, bequest of Paule Thévenin, 1993, © 1999 Artists Rights Society (ARS), New York.

93 ARTAUD, "Dinner Is Served" (1925), in *Selected Writings,* ed. Susan Sontag, trans. Helen Weaver (New York: Farrar, Straus and Giroux, 1976), 103.

94 ARTAUD, "For the Theater and Its Double" (1931–36), in *Selected Writings,* 246.

95 ARTAUD, "An Emotional Athleticism" (1938), in *Selected Writings,* 264.

96 SUSAN SONTAG, "Artaud," in *Selected Writings,* xxxvi.

97 Ibid., xxiv.

98 DELEUZE, "The Schizophrenic and Language: Surface and Depth in Lewis Carroll and Antonin Artaud," in Josue Harari, ed., *Textual Strategies: Perspectives in Post-Structuralist Criticism* (Ithaca: Cornell University Press, 1979), 286–7; quoted in Margit Rowell, "Images of Cruelty: The Drawings of Antonin Artaud," in Rowell, ed., *Antonin Artaud: Works on Paper,* exh. cat. (New York: Museum of Modern Art, 1996), 13.

99 DR. JEAN DEQUEKER, in *Antonin Artaud: Oeuvres sur papier,* exh. cat. (Marseille: Musée Cantini, 1995), 158; quoted in Rowell, "Images of Cruelty," 13.

Convulsive Travesties

Contemporary artists continue to be engaged in envisioning the reality (or surreality) on the other side of the face's surface (or nonsurface) and picturing it photographically. After nearly a century and a half of techniques, strategies, and tactics designed for probing the human soul, the tools for doing so are well inventoried and understood, and if they are not up to the task at hand, then new ones are simply fashioned. At times these new strategies have included revisiting older methods, instilling them with fresh meanings. In an extended series of troubling images entitled *Der wilde Mann* (The wild man): The Temperaments (late 1980s), William Parker has reinvested medieval and Renaissance theories of animal physiognomics and the "primordial male" with a striking urgency. Similarly, Daniel Lee seems to have coupled Giambattista della Porta's animal physiognomics with the Chinese zodiac in his morphed hybrids of human and animal faces, and Alexandre Castonguay has revisited Charles Le Brun's manual for drawing the passions to create a "new person" with computer software that merges the facial expressions of men and women. Arnulf Rainer has overdrawn new expressions ("face farces") on photographs of Messerschmidt's character heads in order to assail what he has called the contemporary "wilderness of patho-physiognomy" (1975–76).[100] Judy Dater's *Twinka Thiebaud, Actress, Model* (1970) could be an alfresco reprise of any number of the images in Charcot's *Iconographie,* and there seems to be a line connecting the images of the Salpêtrière to the high dramatics of Max Waldman's reinterpretations of various experimental theatrical presentations of the 1960s.[101] Dalí appropriated popular erotic imagery for *The Phenomenon of Ecstasy,* and Georg Jiri Dokoupil did much the same in his *Madonnas in Ecstasy* (1985/87), where mass-media images of women enacting sexual ecstasies are presented either as single images or in grids as in nineteenth-century synoptic plates. And Avedon's portrait of Oscar Levant (1972) is pure grimace.

Reprising older traditions is not the only option. Sometimes heightened dramaturgy works just as well—whether physically in theaters or on movie sets, as in Weegee's audience shots of the 1940s and Nickolas Muray's *Ezio Pinza* of 1946; or discovered on the street, as in the flâneurist shots of William Klein and Leon Levinstein in the 1950s. One senses an intense theatrical collaboration between performer and photographer in Diane Arbus's *Boy with a Straw Hat Waiting to March in a Pro-War Parade, N.Y.C.* (1967), as well as in Arnold Newman's *Alfried Krupp* (1963), Eikoh Hosoe's serial portrait of the Japanese novelist Yukio Mishima (1963), Irving Penn's *Truman Capote* (1965), Avedon's *Oscar Levant* (1972), and Annie Leibovitz's *Jessye Norman* (1988). Fashion photographer Greg Gorman directed the model Djimon to scream before the camera (1991); and in 1997, the *New York Times Magazine*'s "Fashions of the Times" commissioned various photographers to illustrate fashionably attired models affecting thirty-four "emotions" including, among others, disgust, passion, hysteria, and duplicity/self-satisfaction.[102] French artist Suzanne Lafont has had her models pose as if deafened by loud noises (*Le Bruit,* 1990), puff out their cheeks in efforts of blowing hard (*Souffleurs,* 1992), and assume the expressions of chorusing angels in the background of a Renaissance fresco (*Choeur des Grimaces,* 1992).[103] Turned upside down, the female singer in Lafont's *Grimaces 28,* not unlike figures in Georg Baselitz's paintings, suggests an utter reversal of the classical idea that human verticality signified a greater nearness to God than that of other creatures.[104] Postmodern humans simply do not know or care which end is up.

[100] ARNULF RAINER, "My Overdrawings of Franz Xaver Messerschmidt," trans. David Britt, in James Lingwood and Andrea Schlieker, eds., *Franz Xaver Messerschmidt: Character-Heads 1770–1783/Arnulf Rainer: Overdrawings Franz Xaver Messerschmidt,* exh. cat. (London: Institute of Contemporary Arts, n.d.), 35.

[101] For more on Waldman's theatrical photography, see his *Waldman on Theater* (Garden City, N.Y.: Doubleday, 1971). The documentary images made by Richard Avedon at the East Louisiana State Hospital in Jackson, Louisiana in 1963 could also be included in this list, as could as Deborah Turberville's fashion photographs of models in swimsuits and robes awkwardly posed in a tiled shower room in 1975. See AVEDON, *Evidence: 1944–1994,* ed. Mary Shanahan, exh. cat. (New York and Rochester: Random House and Eastman Kodak Company, 1994), 145. Turberville's shower-room images appeared in *Vogue* (May 1975) and are discussed in NANCY HALL-DUNCAN, *The History of Fashion Photography,* exh. cat. (New York: Alpine Book Company, 1979), 216–9.

[102] See HOLLY BRUBACH, ed., "The Height of Emotion," in "Fashions of the Times," *New York Times Magazine,* 24 August 1997, part 2. The commissioned photographers were Enrique Badulescu, Nan Goldin, Walter Iooss, Dominique Issermann, Mary Ellen Mark, Thierry Mugler, John Scarisbrick, Nina Schultz, David Seidner, Cleo Sullivan, Robert Trachtenberg, Max Vadukul, the team of Inez van Lamsweerde and Vinoodh Matadin, Ellen von Unwerth, and Michael Woolley.

[103] PIERO DELLA FRANCESCA's *Defeat of Chosroes* of c. 1460 (S. Francesco, Arezzo) has been suggested as a source for Lafont's *Souffleurs;* see JEAN-FRANÇOIS CHEVRIER, "The Ruse, the Image," trans. Brian Holmes, in Catherine David, ed., *Suzanne Lafont,* exh. cat. (Paris: Galerie nationale du Jeu de Paume, 1992), 71.

[104] For more on the theory of verticality, see above, chapter two. LAFONT inverted the central character in her *La Chute* (1991) and stated that the "fall is the catastrophe of withdrawal from God . . . [but] to fall is also to fall toward God." Excerpts from a lecture, trans. Brian Holmes, in David, *Suzanne Lafont,* 44. Regarding inversion, see the entry for "Qualities (Without)," in Yve-Alain Bois and Rosalind E. Krauss, *Formless, A User's Guide* (New York: Zone Books, 1997), 169–72.

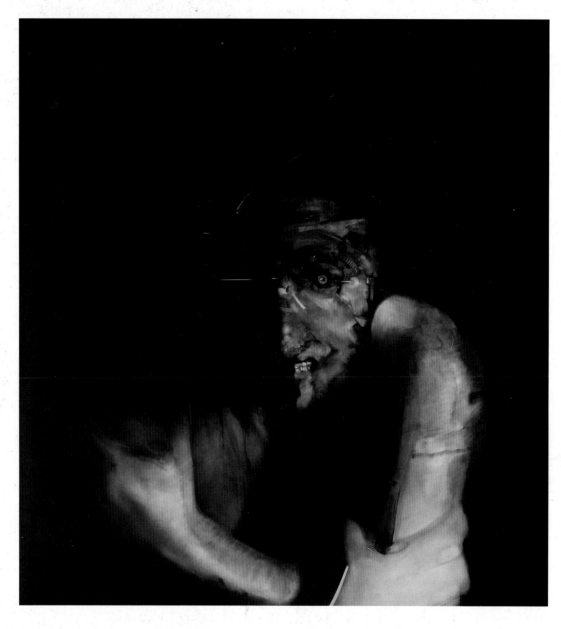

RIGHT
William Parker,
Fearful II,
1990,
cat. no. 90.

OPPOSITE
Daniel Lee,
1949—Year of the Ox,
1993,
cat. no. 65.

PAGE 224
Alexandre
Castonguay,
Admiration 0, 0, 204,
1998,
cat. no. 20.

PAGE 225
Arnulf Rainer,
Untitled
(Overdrawing
of Franz Xaver
Messerschmidt
Head), 1975—76,
cat. no. 94.

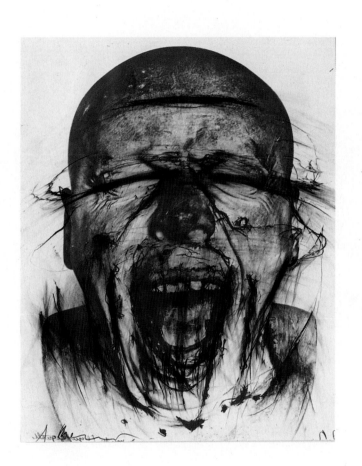

226

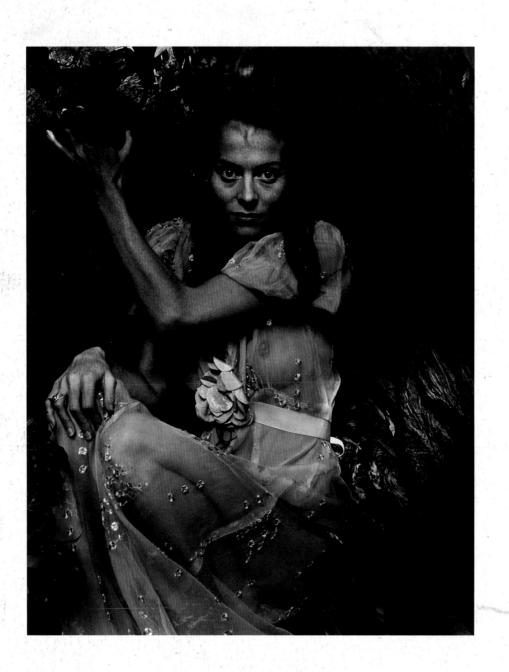

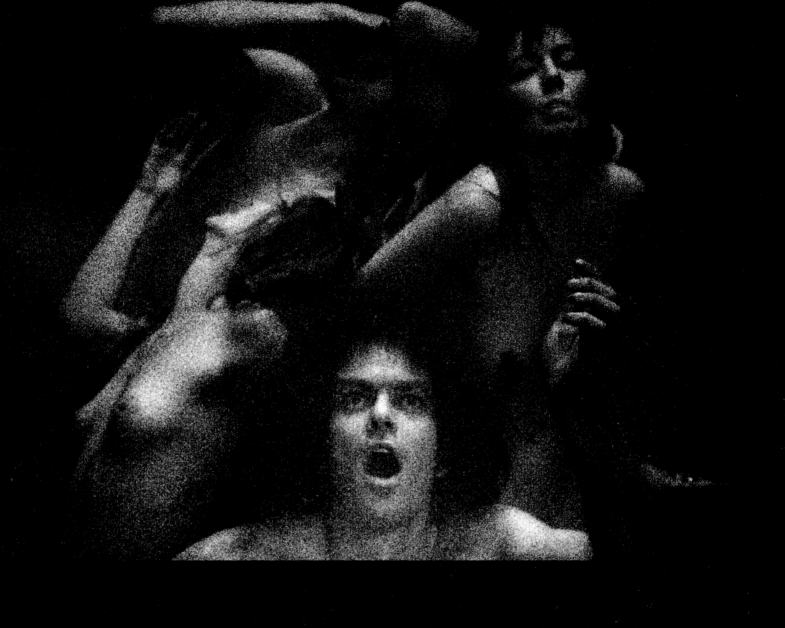

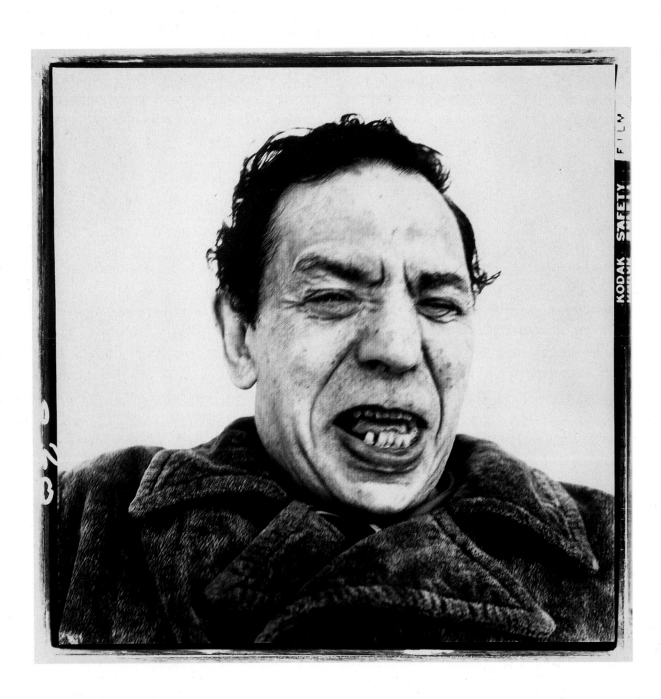

Deception and ruse are also strategies. Dalí wrote in 1930, "It must be said once and for all to art critics, artists, etc., that they must expect nothing from the new Surrealist images but deceptions, bad impressions, and repulsion. . . . the new images of Surrealism will increasingly take the shapes and colors of demoralization and confusion."[105] And the theatrics of deception are most apparent in self-portraiture, that quintessentially photographic means of doubling the self and assuming other characters, guises, and identities, much as Richard Cockle Lucas did in the 1860s and Marcel Duchamp did in the 1920s with his many self-characterizations as Rrose Sélavy. For years Pierre Molinier obsessively transformed himself before his camera into a compound travesty of fetish object, hermaphrodite, and transvestite. Lucas Samaras turned to his frequently manipulated "autopolaroids" as a "method of declassifying hush-hushed feelings" and/or as a "stylized pretension of emotion—acting."[106] Lyle Ashton Harris has traded whiteface and gender roles with equal ease, and the Japanese artist Yasumasa Morimura has photographed himself disguised as Duchamp, Manet's *Olympia,* and a bevy of movie actresses. Historian Peter Selz has compared Gottfried Helnwein's tortured, screaming, and bandaged self-portraits to Messerschmidt's sculptural self-portraits, but the artist has said, "The reason why I took up the subject of self-portraits and why I have put myself on stage was to function as a kind of representative. There is nothing autobiographical, no therapy, and it says nothing about me personally. . . . I am always available as a model."[107] And Jim Shaw's computer-generated self-images disintegrate his image into mere fractals of his former self.

No artist has made as extended or as complex a career of presenting him- or herself to the camera as has Cindy Sherman. Yet while she is the subject of most of her photographs, it is impossible to consider them self-portraits in the strictest sense. She has staged herself as unnamed actresses in undefined B movies, make-believe television figures, undifferentiated young women in ambivalent emotional states, pretend porn stars taking a break, unfashionable fashion mannequins, denizens and monsters of both newly created and traditional fairy tales, bodies with deformities, loosely referenced characters from Western painting, and any number of grotesqueries. In most of her series, she has used herself as a "model representing mock-ups of the ego, illusions of identity, masks of authenticity, and other romantic monsters and postmodern zombies."[108] Her work has been embraced by some as essentially a feminist political enterprise and by others as completely apolitical mainstream art. Racial and sexual identity have been a focus of the visual arts since the 1970s, and Sherman's photography is decidedly a part of this investigation and this culture. Her early works—the Film Stills, Rear Projections, Centerfolds, and Fashion series—were created in the midst of feminist discourses on questions of identity, the "male gaze," and media stereotyping of femininity, to which they could not be immune. To a great degree, the images of women promoted by the mass media have resulted in the "erosion of anything resembling a unified self,"[109] but most likely the same could be said of images of men. In the late nineties, gender alone may be too limiting a description of what it is to be human. In fact, Sherman's later works, such as the Fairy Tales or Sex Pictures, cannot be located specifically within a feminist critique and seem to suggest broader human and cultural issues. In 1991 critic Abigail Solomon-Godeau wrote of Sherman that "the bulk of her work until now has been constructed as a theater of femininity as it is formed and informed by mass culture. . . . [her] pictures insist on the aporia of feminine identity, indeed, of identity *tout court,* represented in her pictures as a potentially limitless range of masquerades, roles, projections."[110] Without diminishing the significance of specifically feminist critiques in Sherman's work, it can be said that the fundamental proposition that seems to connect her enterprise, to date, is the inexpressible identity (or identities) of the self, *tout court.*

[105]DALÍ, "L'Ane pourri," *Le Surréalisme au service de la Révolution* (July 1930), in Hulton, *Salvador Dalí: Rétrospective, 1920–1980,* 278; quoted in Mike Kelley, "Playing with Dead Things," *The Uncanny,* exh. cat. in conjunction with "Sonsbeek 93" (Arnhem, Netherlands: Gemeentemuseum, 1993), 15.

[106]LUCAS SAMARAS, *Samaras Album: Autointerview, Autobiography, Autopolaroid* (New York: Whitney Museum of American Art and Pace Editions, 1971), 16.

[107]GOTTFRIED HELNWEIN, in "Helnwein Quotes Helnwein," interview by Chris Mäckler, in Mäckler, ed., *Helnwein* (Cologne: Benedikt Taschen, 1992), 36. On Messerschmidt, see PETER SELZ, "Helnwein: The Artist as Provocateur," in Alexander Borovsky, ed., *Gottfried Helnwein,* exh. cat. (St. Petersburg: The State Russian Museum and the Ludwig Museum in the Russian Museum, 1997), 26.

[108]WILFRIED DICKHOFF, "Untitled #179," trans. Catherine Schelbert, *Parkett,* no. 29 (1991): 108.

[109]SUSAN J. DOUGLAS, *Where the Girls Are: Growing Up Female with the Mass Media* (New York: Times Books, 1994): 13; quoted in Amada Cruz, "Movies, Monstrosities, and Masks: Twenty Years of Cindy Sherman," in Cruz, Elizabeth A. T. Smith, and Amelia Jones, *Cindy Sherman: Retrospective,* exh. cat. (New York: Thames and Hudson, 1997), 1.

[110]ABIGAIL SOLOMON-GODEAU, "Suitable for Framing: The Critical Recasting of Cindy Sherman," *Parkett,* no. 29 (1991): 114. This article outlines the various critical receptions of Sherman's work up to the time of its writing.

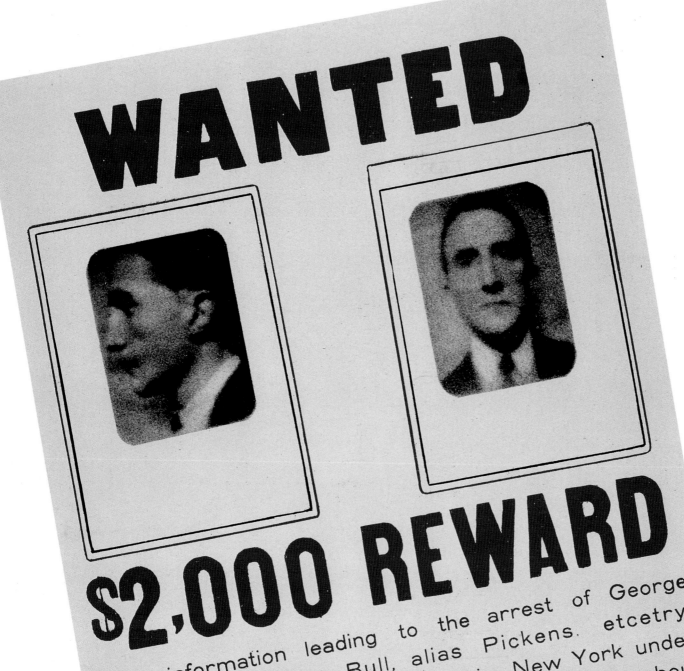

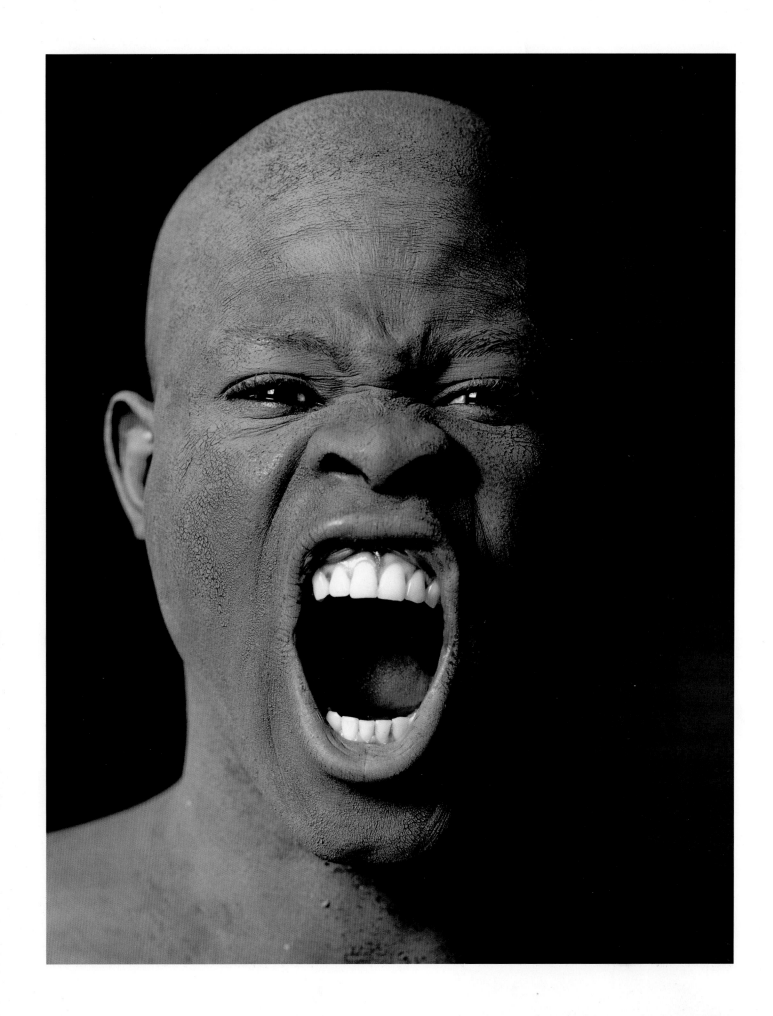

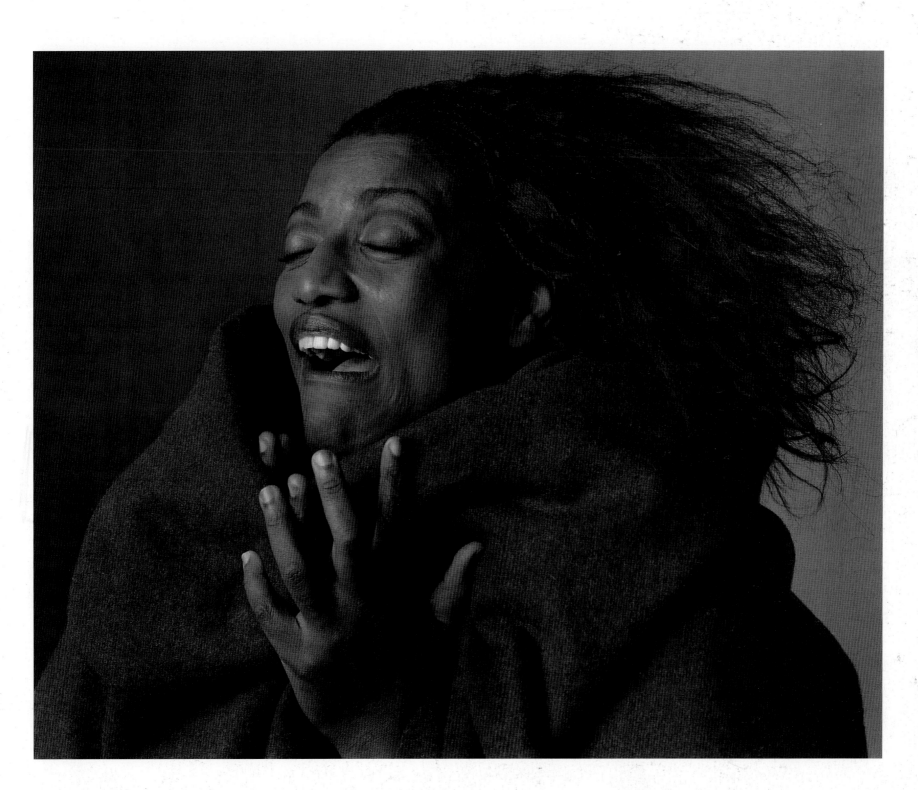

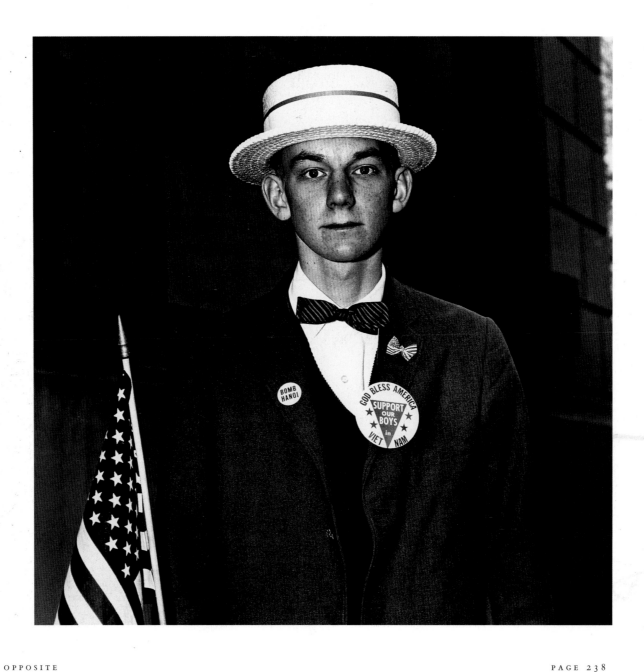

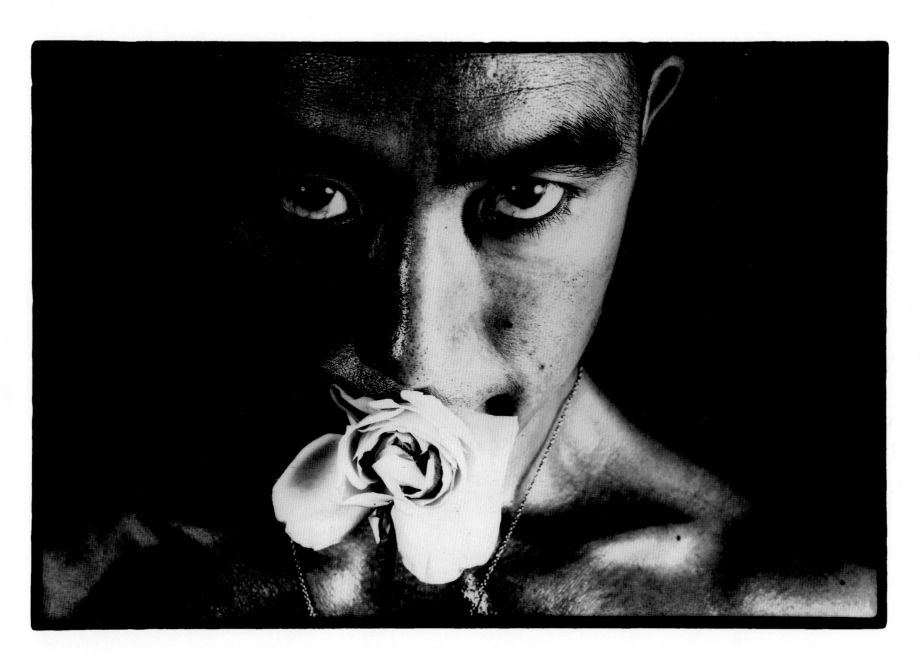

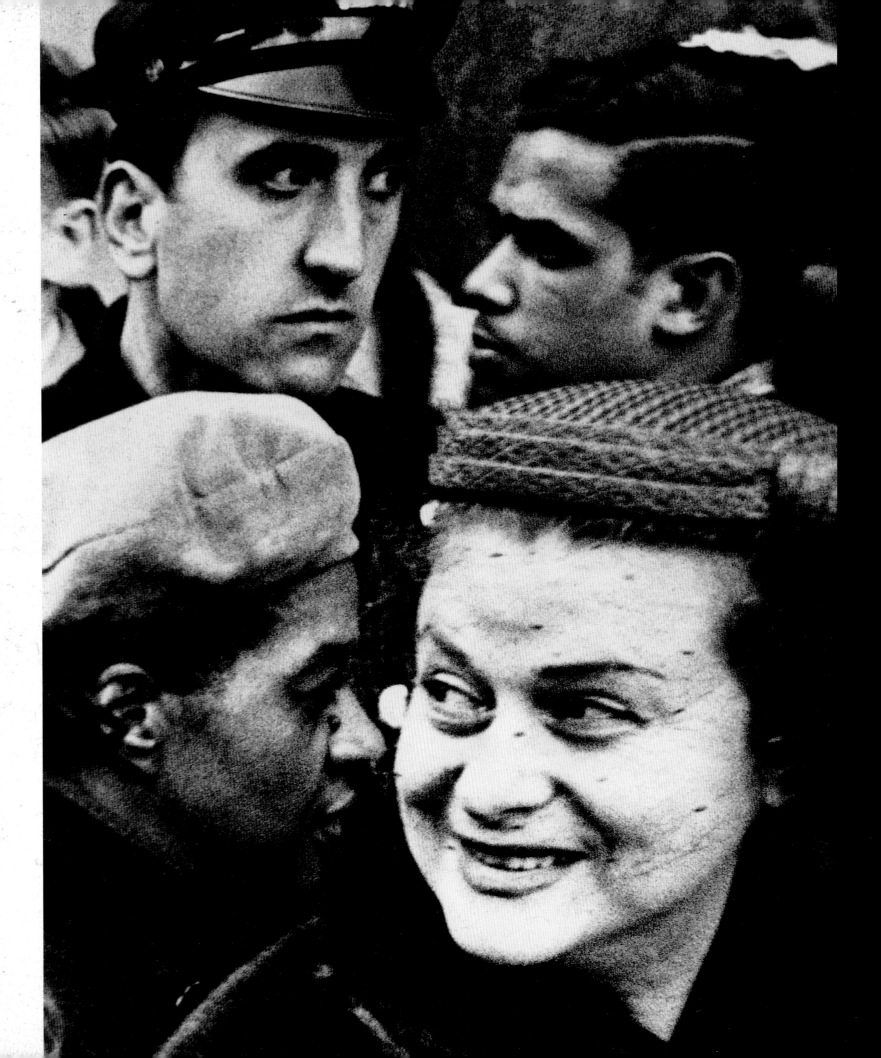

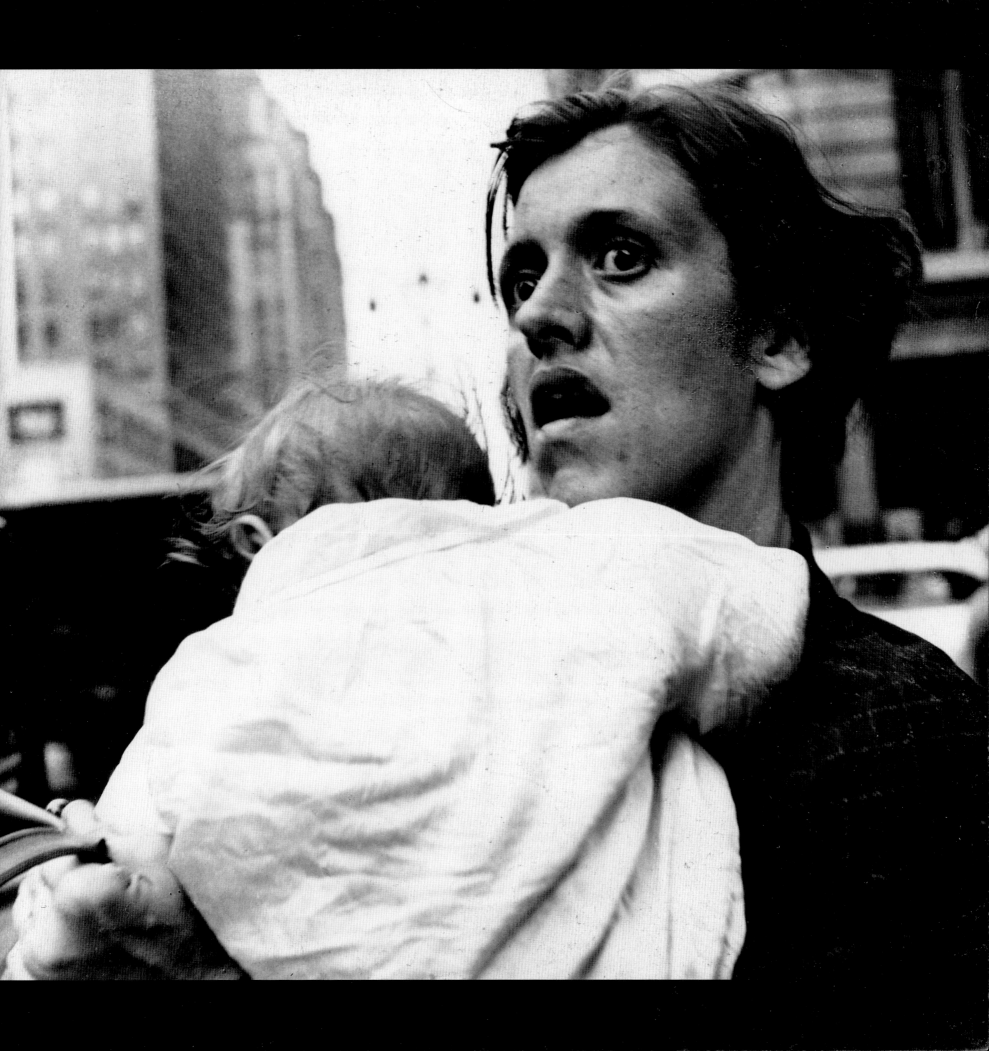

BELOW
Georg Jiri Dokoupil,
Madonna in Ecstasy,
1985–87,
cat. no. 37.

OPPOSITE
Friedrich
Seidenstücker,
Untitled (Sch),
c. 1930,
cat. no. 109.

242

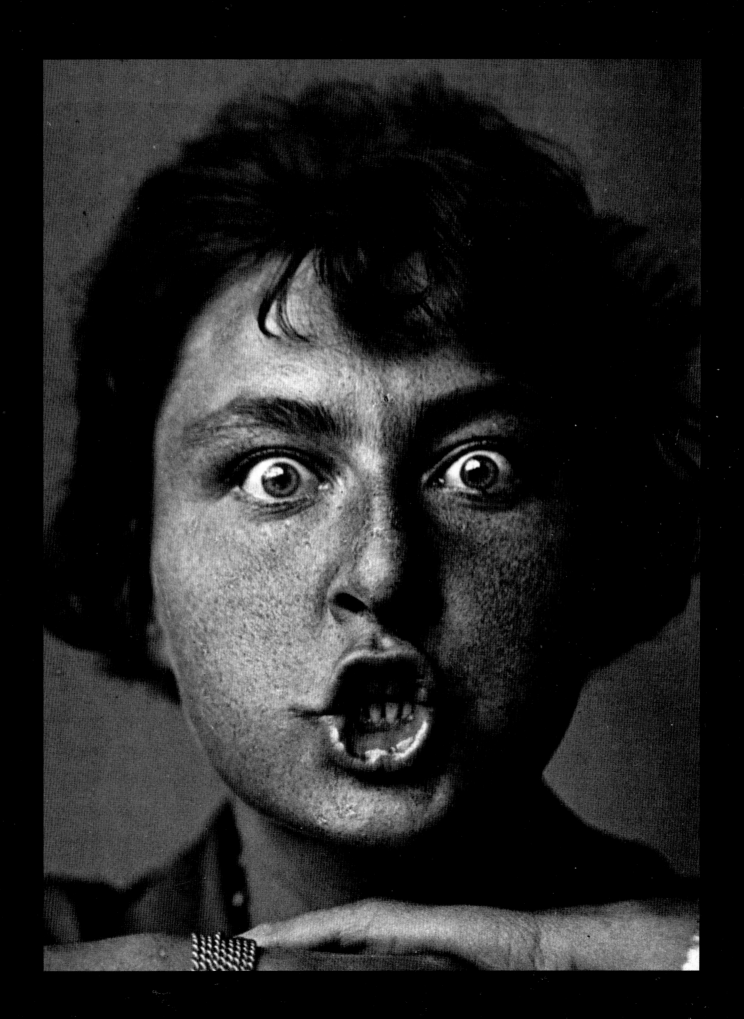

244

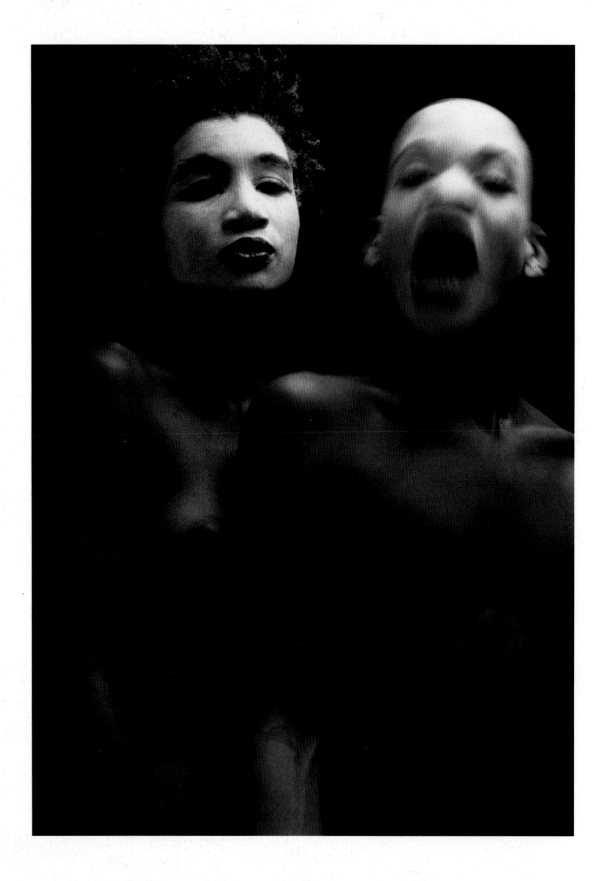

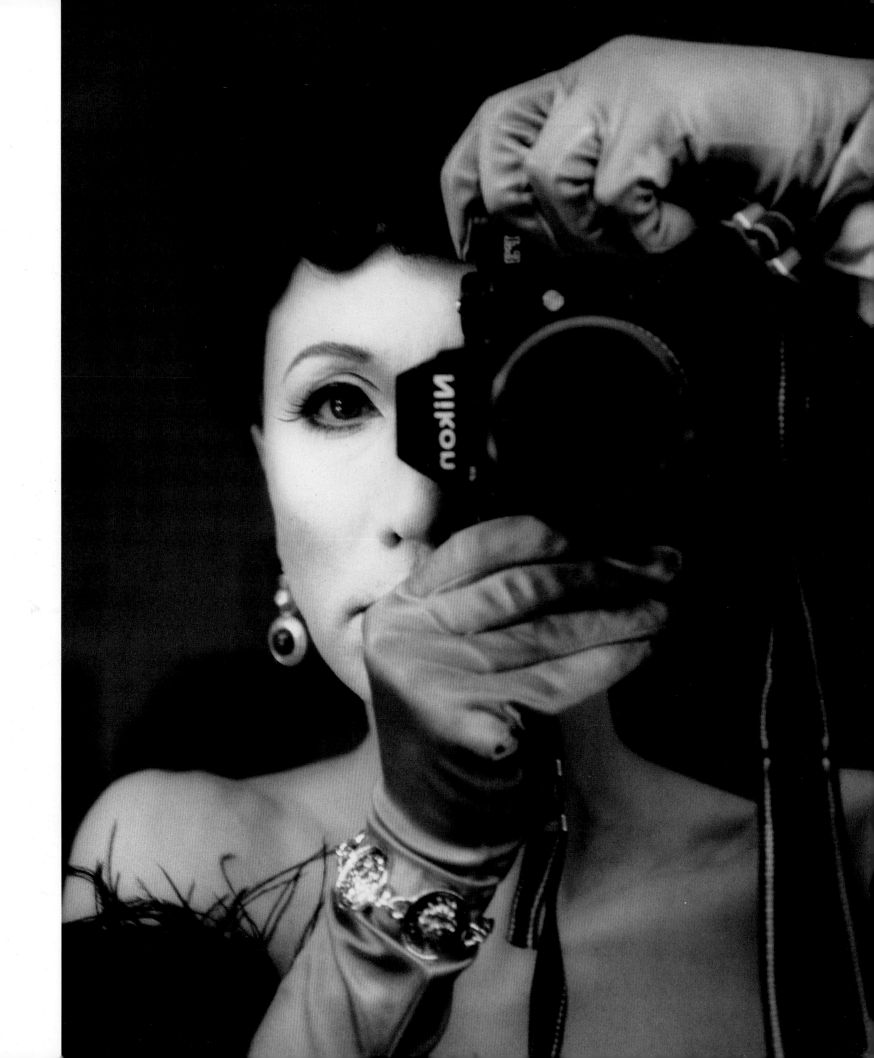

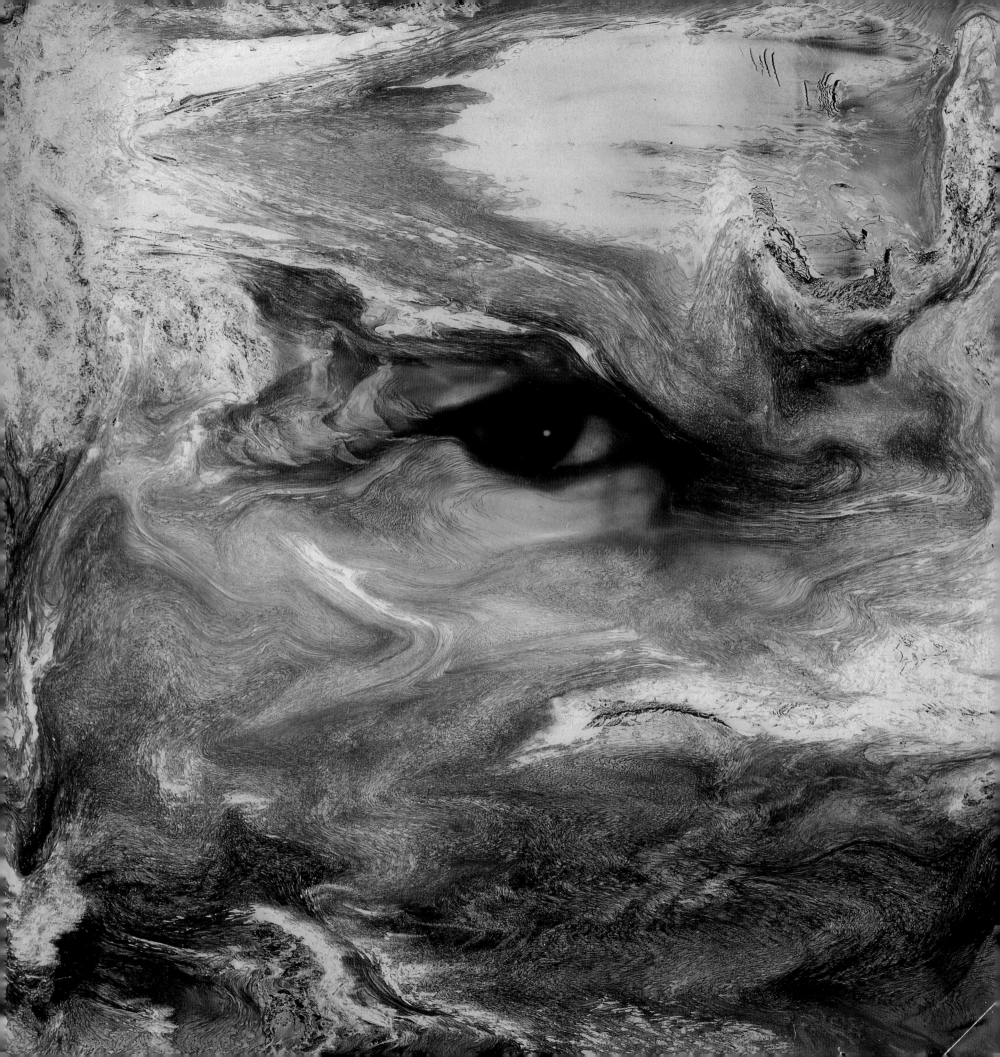

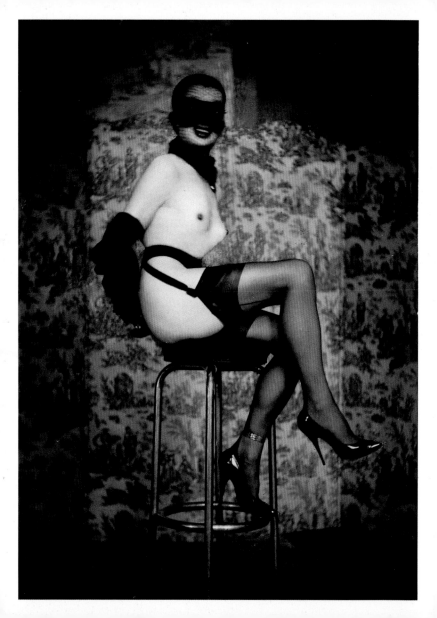

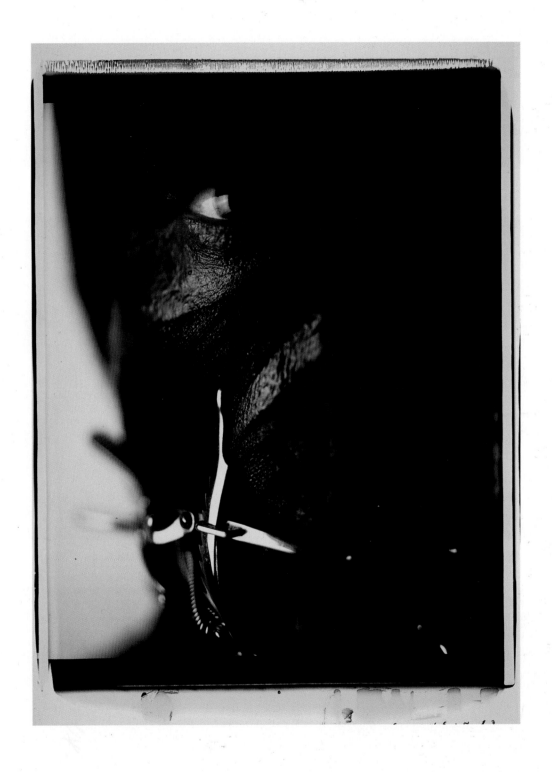

Toward the end of the twentieth century, the human body and what it represents have become "fragmented, decayed, imperfect, and artificial."[111] According to the critic Jan Avgikos,

We see a picture of the present that is over-articulated in relation to past and future. We see a picture of genetic engineering and biotechnologies and artificial intelligence and cyberspace and ironic faith, or worlds ambiguously natural and artificial, or creatures simultaneously human and animal and machine. We see a picture of post-gender. We see a picture of a post-apocalyptic ontology.[112]

In her Fashion series, including her *Untitled (Cosmo Cover Girl)* of 1990, Sherman reminds us that fashion itself allows us all to create and display a wide range of appearances as if "we each possessed a multiplicity of identities."[113] In the Fairy Tales and Monsters series, in which ghouls and goblins of childhood memories seem to return with a macabre horror likely to shock adults, she may be suggesting that we all harbor a secret, repressed self that can shift form and shape at will, not unlike Jekyll and Hyde.[114] One critic has contended that Sherman's work is about a "polymorphous antiself of terrifying multiplicity,"[115] while another has argued that her History Portraits involve an "*exchange* of subjectivities" in which "our embodied subjectivities become dissolved *in relation to each other*."[116] As in Claude Cahun's work discussed above, the various genderless guises and masks Sherman uses throughout much of her later work address a multiplicity that may be inherent to us all.

"Is she herself?" asked curator Els Barents on the occasion of Sherman's first one-person exhibition in 1982. "Are [her different personas] artificial projections of another person? . . . Something inexplicit, a game of doing and being, attracting and rejecting, making oneself beautiful and making oneself ugly, seducing and retreating into oneself."[117] In fact, in Sherman's work the notion of the self is utterly abandoned, replaced by the concept of multiplicity, dissociation, and fluidity. Her portraits do not even seem to be performances or acting out—only unstable representations in ambiguous non-narratives making brief appearances, caught in a moment of ambivalent emotional expression.[118] We may not truly understand the specific "passion" in Richard Cockle Lucas's "He tears a passion to tatters," but we are certain of the "he" who does so. In Sherman's work, there is no operative pronoun, no irreducible central character. Some recognizable figures, such as the movie star, the porn figure, and the fashion model, do appear, but they are generic stereotypes rather than true characters.

Sherman, in a conversation with Barents in 1982, told the story of the stereotypical young girl who aspires to be a movie star: "I was more interested in the types of characters that fail. Maybe I related to that. But why should I try to do it myself? I'd rather look at the reality of these kinds of fantasies, the fantasy of going away and becoming a star."[119] Even in "real life" Sherman has admitted to the protection of fractured identities: "I divide myself into many different parts. One part is my self in the country. . . . My professional self is another part, and my work self in the studio is another. Even when I do something public. . . I feel I'm using different parts of myself that I'm totally aware of. I'm not being my natural self."[120] It would indeed be futile to look for some unified self-image in Sherman's work.

[111]ELIZABETH A. T. SMITH, "The Sleep of Reason Produces Monsters," in Cruz et al., *Cindy Sherman: Retrospective*, 25.

[112]JAN AVGIKOS, "Institutional Critique, Identity Politics, and Retro-Romanticism: Finding the Face in Cindy Sherman's Photographs," in *Jurgen Klauke, Cindy Sherman*, exh. cat. (Munich: Sammlung Goetz, 1994), 51–53; quoted in Smith, "The Sleep of Reason Produces Monsters," 29.

[113]JOANNE FINKELSTEIN, *The Fashioned Self* (Philadelphia: Temple University Press, 1991), 130; quoted in Cruz, "Movies, Monstrosities, and Masks," 8.

[114]Cf. CRUZ, "Movies, Monstrosities, and Masks," 10; and SMITH, "The Sleep of Reason Produces Monsters," 23.

[115]KEN JOHNSON, "Cindy Sherman and the Anti-Self: An Interpretation of Her Imagery," *Arts Magazine* 62, no. 3 (November 1987): 52.

[116]AMELIA JONES, "Tracing the Subject with Cindy Sherman," in Cruz et al., *Cindy Sherman: Retrospective*, 42–44.

[117]ELS BARENTS, introduction to *Cindy Sherman*, exh. cat. (Amsterdam: Stedelijk Museum, 1982), 11.

[118]See CRUZ, "Movies, Monstrosities, and Masks," 6.

[119]SHERMAN, quoted in Barents, introduction to *Cindy Sherman*, 8.

[120]SHERMAN, "A Woman of Parts," interview by Noriko Fuku, *Art in America* 85, no. 6 (June 1997): 79.

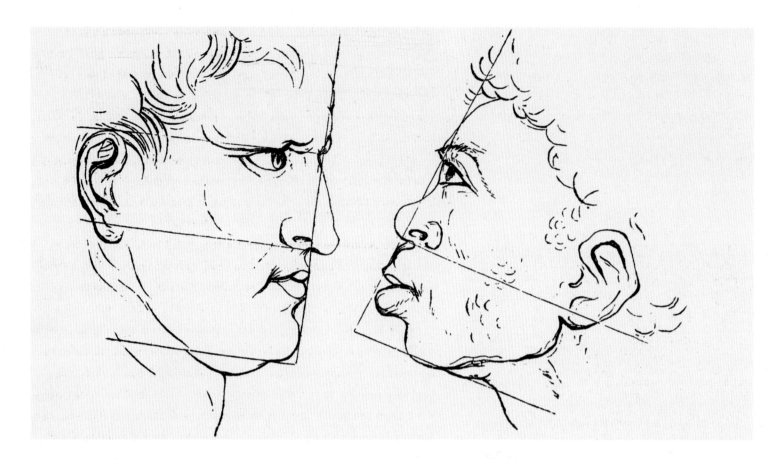

Unidentified artist, "Facial Angles," from Charles Bell, *The Anatomy of Expression* (1877), engraving, private collection, Los Angeles.

254

The Fall of the Vertical

The majority of Sherman's characterizations are arranged along a vertical axis, the norm for nearly all portraits and depictions of the human figure, from mug shots to formal portraits, and one derived from a doctrine of verticality inherent in physiognomic practice. The ideal human of this doctrine, as developed by Petrus Camper in the eighteenth century (discussed in chapter two), was the Apollo Belvedere, or at least an erect, upright white European or American male. This doctrine held that erectness equaled rectitude, a notion that still permeates our culture: Modernist Oskar Schlemmer felt compelled to literally delineate and label the vertical axis of his *Man in the Sphere of Ideas* (1928), philosopher Ludwig Feuerbach emphasized the human head atop the vertical

as the "man himself,"[121] and an actress in an Alfred Hitchcock film says to her husband: "I should never have married you, your forehead slants back too much."[122]

In an essay on Sherman, art historian Rosalind Krauss points out that modern psychology and psychiatry are insistently vertical: Freud suggested that man left the animal world when he stood up; Gestalt psychologists held up a "fronto-parallel" plane against which the "body's erect verticality" and its vision was reflected; and Jacques Lacan's writings include the metaphors "the vertical of the mirror," "the vertical of the veil," "the vertical of the phallus as instance of wholeness," "the vertical of the field of the fetish," and "the vertical of the plane of beauty."[123] Krauss contends

[121]"That which is situated highest in space is also in its quality the highest part of man, that which is closest to him, that which one can no longer separate from him—and this is his head. If I see a man's head, it is the man himself who I see; but if I only see his torso, I see no more than his torso." LUDWIG FEUERBACH, *Kleine philosophische Schriften* (Leipzig 1950), 191; quoted in Jacques Derrida, "Violence and Metaphysics: An Essay on the Thought of Emmanuel Levinas," in *Writing and Difference*,

trans. Alan Bass (Chicago: University of Chicago Press, 1978), 101.

[122]CAROLE LOMBARD to Robert Montgomery, in Alfred Hitchcock, dir., *Mr. & Mrs. Smith*, prod. Harry E. Edington (RKO Radio Pictures, 1941).

[123]KRAUSS, "Cindy Sherman: Untitled," in *Cindy Sherman: 1975–1993* (New York: Rizzoli, 1993), 93–94. See also the entries for "Horizontality" and "The Destiny of the *Informe*," in Bois and Krauss, *Formless, A User's Guide*, 93–103, 235–52.

BELOW

Yayoi Kusama.
Accumulation of Nets,
1962, gelatin-silver
print photo-collage
on paper,
Los Angeles County
Museum of Art,
Ralph M. Parsons

Discretionary Fund
and funds provided
by Blake Byrne,
Tony and Gale Ganz,
Sharleen Cooper
Cohen, Linda and
Jerry Janger, Stanley
and Elyse Grinstein.

RIGHT

Robert Smithson,
*Second Mirror
Displacement*,
from the series
Yucatan Mirror
Displacements
(1969), chromo-
genic development

transparency,
courtesy the
Estate of Robert
Smithson and the
John Weber Gallery,
New York.

that even contemporary feminist theories of the "male gaze" have for the most part steadfastly referenced the "vertical register of the image/form."[124] This doctrine of erectness was first challenged in the visual arts, Krauss argues, by the aggressive horizontality of Jackson Pollock's drip paintings, Robert Morris's scatter pieces, Warhol's Oxidation canvases, and Ed Ruscha's Liquid Word pictures, which led to a "dimension of entropy and 'base materialism.'"[125] To this list I would add Yayoi Kusama's obsessive assemblages and installations, Carl Andre's floor works, and Robert Smithson's "mirror-sites" and especially his notions concerning entropy and absorption within a landscape.[126] Smithson believed that he had to be absorbed by his subject in order to represent it, like the French philosopher Maurice Merleau-Ponty, who contended that "it is necessary that the vision . . . be doubled with a complementary vision or with another vision: myself seen from without, such as another would see me, installed in the midst of the visible, occupied in considering it from a certain spot . . . he who sees cannot possess the visible unless he is possessed by it, unless he *is of it*. . . ."[127] Amelia Jones locates Sherman's work precisely the same way: it constitutes "ourselves as embodied subjects through technologies of representation in relation to other embodied subjects."[128] No longer can the vertical hold, and only within "intersubjective identifications" or the recognition of others' subjectivities can any new subjects of vision adhere.

Krauss insightfully argues that two of Sherman's series, Centerfolds (also called Horizontals) and Disasters (also called Bulimia, Disgust), contradict the predominant doctrine of verticality with an abject horizontal-

[124]KRAUSS, "Cindy Sherman: Untitled," 97.

[125]Ibid., 96. Also see YVE-ALAIN BOIS, "Thermometers Should Last Forever," in *Edward Ruscha: Romance with Liquids* (New York: Rizzoli, 1993).

[126]For more on the concepts of entropy and absorption, see SOBIESZEK, *Robert Smithson: Photo Works*, exh. cat. (Los Angeles: Los Angeles County Museum of Art, 1993), 28–32. Smithson delighted in multiple and

contradictory views that "reveal a clash of angles and orders within a sense of simultaneity [which in turn] shatters any predictable frame of reference" and often found himself in desolate landscapes "wandering in a moving picture that I couldn't quite picture." SMITHSON, "Art Through the Camera's Eye," in Eugenie Tsai, *Robert Smithson Unearthed: Drawings, Collages, Writings,* exh. cat. (New York: Columbia University Press, 1991), 91; and "A Tour of the Monuments of Passaic, New Jersey," in *The Writings of Robert*

Smithson, ed. Nancy Holt (New York: New York University Press, 1979), 54.

[127]MAURICE MERLEAU-PONTY, "The Intertwining—The Chiasm," in *The Visible and the Invisible,* ed. Claude Lefort, trans. Alphonso Lingis (Evanston: Northwestern University Press, 1968), 134–5; quoted in Jones, "Tracing the Subject with Cindy Sherman," 48–49.

[128]JONES, "Tracing the Subject with Cindy Sherman," 48. Recent researches in neuropsychiatry have come to a similar conclusion regarding intersubjectivity. According to neurologist V. S. RAMACHANDRAN, the "sense of the self being aloof from the rest of creation—that is indeed an illusion. You can do clinical experiments to show this is true"; quoted in Robert Lee Hotz, "Seeking the Biology of Spirituality," *Los Angeles Times,* 16 April 1998, A32.

ity and slippage downward, and that in so doing they represent a radical shift in the photographic representation of the human spirit. Originally commissioned by *Artforum* in 1981 but never published by the journal, the Centerfolds variously depict Sherman dressed in ordinary young women's clothes, frequently in a prone position, and wearing a truly undefinable, uncanny facial expression. Nothing in the synoptic plates of Lavater,

Duchenne, or Ekman could prepare a viewer to state with certainty what exactly the model is feeling or thinking. Sherman explained that in one Horizontal she had imagined something as prosaic as someone going to sleep just before dawn and being suddenly awakened soon afterward by the sunrise, but a number of critics were convinced that the image portrayed a rape victim alone with her pain.[129] So intensely introspective and

internalized are her characterizations that their faces and their expressive gestures appear to have imploded into the body only to articulate the inchoate and incalculable tensions in its depths. Certain of these images, such as *Untitled #86,* in which the prone female body is almost completely enveloped in darkness, are particularly troubling. In Krauss's words, "it is as though something was working against the forces of form and of life, attacking them, dissolving them, disseminating them into the field of the horizontal."[130] With a format appropriated from CinemaScope movies and magazine gatefolds, Sherman distinctly replaces the "/vertical/" with the "/horizontal-as-lowness, -as-baseness/"[131] and, like Pollock and Smithson before her, thoroughly confounds the notion of a logical, Cartesian space.

Cindy Sherman, *Untitled #86,* 1981, cat. no. 111.

[129] See CRUZ, "Movies, Monstrosities, and Masks," 6.

[130] KRAUSS, "Cindy Sherman: Untitled," 97.

[131] Ibid., 104. The device of separating words and word combinations with bracketing slashes is a convention originating in logic and linguistics that Krauss uses in her essay.

Smithson's hallucinatory feelings of being completely engulfed and absorbed in the primal elements of the landscape led to a sense of his "slipping out of myself again, dissolving into a unicellular beginning," of having the "red heaves, while the sun vomited its corpuscular radiations."[132] For Krauss, working out from Lacan, Sherman's Horizontals suggest a profound "transgression against form": "We pass into" the picture and "feel dispersed, subject to a picture organized not by form but by formlessness."[133] Within the pictures, there is no coherent point of view. An entropic merging with the picture, as well as with the very landscape itself, is fundamental to Sherman's Bulimia or Disasters series, where the body and its parts are besieged, discarded, detached, vomited out, eviscerated, and at times no longer corporeal. In *Untitled #167*, along with a thumb and a few fingers, only an ear, the tip of a nose, lips, and what appear to be some clenched teeth remain of the face buried amidst rubble. An opened compact, however, reflects the gaze of an other staring at the scene from some unlocatable position exterior to the picture yet fully within it. Like Smithson's "mirror displacements," Sherman's compact refracts and reflects a subject within itself, disorienting the self that may yet remain in the picture, dividing the coherent self into organs without a body, as it were. The image seems to corroborate Burroughs's questions, "Whom are you talking to, when you talk to yourself? Is your self really your self? Isn't there some other self in there with your self?"[134]

In 1947 Artaud wrote, "The body is the body/it is all by itself/and has no need of organs . . ."[135] Expanding on Artaud's call to transcend the organization of the organs into an organism, Gilles Deleuze and Félix Guattari have proposed an "abstract machine of faciality" that balances the signifiers (white wall) of the human face with its subjectivity (black hole).[136] They assert that the "face has a great future, but only if it is destroyed, dismantled," and that faciality is ultimately a matter of the "body without organs, animated by various intensive movements" across a "face-landscape."[137] Most movement in Sherman's art seems to be downward, toward the horizontal, into a Surrealist landscape of masks, and what Amelia Jones has termed the "eye/hole" in which "bodies/selves" are "both dispersed and insistently embodied as well as specific."[138] Even Sherman's ostensibly vertical History Portraits, according to Krauss, disturb the notion of the "/vertical/" through their use of sagging and often grotesque prostheses that slip downward. These downward slippages of body parts somehow contradict the notion that behind a mask or a veil there is some "hidden Truth" insofar as they "elaborate the field of a desublimatory, horizontal axis that erodes the façade of the vertical, bearing witness to the fact that behind the façade there lies not the transparency of Truth, of meaning, but the opacity of the body's matter, which is to say, the formless."[139] Sherman's "theater of the cultural imaginary," as Bryson has called it, goes beyond language and discourse: In it the contemporary body "is exactly the place where something *falls out* of the signifying order—or cannot get inside it."[140] Thus the concept of the formless as derived from French Surrealist Georges Bataille's *l'informe*,[141] the total collapse of the "received wisdom that states, *one body, one subject*,"[142] the "symptomatic body," the sense that "something has gone wrong with the body," and the trajectory in Sherman's art from the "ideal to the abject."[143] Hence, also, the "/horizontal/" and Bruce Nauman's utter failure to levitate in the studio.

[132]SMITHSON, "The Spiral Jetty," in *The Writings of Robert Smithson*, 113. A similar absorption into the landscape occurs in ANDREI TARKOVSKY's film *Stalker*, prod. Mosfilm Studios (Fox Lorber Video, 1979), especially its low tracking shots of the watery terrain.

[133]KRAUSS, "Cindy Sherman: Untitled," 109.

[134]BURROUGHS, "Introduction: 'Voices in Your Head,'" in John Giorno, *You Got to Burn to Shine* (New York: High Risk Books, 1994), 4.

[135]ARTAUD, "The Body Is the Body," *84*, nos. 5–6 (1948); quoted in Deleuze and Guattari, *Anti-Oedipus: Capitalism and Schizophrenia*, 9. For a slightly different translation, cf. DELEUZE and GUATTARI, *A Thousand Plateaus: Capitalism and Schizophrenia*, 158.

[136]DELEUZE and GUATTARI, *A Thousand Plateaus*, 168.

[137]Ibid., 171–4.

[138]JONES, "Tracing the Subject with Cindy Sherman," 45.

[139]KRAUSS, "Cindy Sherman: Untitled," 174.

[140]BRYSON, "House of Wax," in Krauss, *Cindy Sherman: 1975–1993*, 221.

[141]BOIS and KRAUSS, introduction to *Formless, A User's Guide*, 13–40.

[142]BRYSON, "Façades," in Maurice Tuchman and Virginia Rutledge, eds., *Hidden in Plain Sight: Illusion in Art from Jasper Johns to Virtual Reality*, unpublished exh. cat. (Los Angeles: Los Angeles County Museum of Art, [1996]), 61, galleys.

[143]BRYSON, "House of Wax," 221, 223.

OPPOSITE
Cindy Sherman,
Untitled #167, 1986,
cat. no. 113.

Online Physiognomics

Around 1888 the French photographer Louis Ducos du Hauron created a series of optically distorted self-portraits apparently just because he could, because his own face and the camera were there for him to play with. Presumably for the same reason, Bruce Nauman also explored his own facial distortions in a drawing, *Untitled (Pulling Mouth)* (1967); a series of holograms, *Making Faces* (1968); a film, *Pulling Mouth* (1969); and a suite of photolithographs, *Studies for Holograms* (1970). Like Messerschmidt before him, Nauman pulled and pushed at his facial features, manipulating the plastic flesh into contorted absurdity and childlike humor. About the holograms, he has said, "I guess I was interested in doing a really extreme thing. It's almost as though if I'd decided to do a smile, I wouldn't have had to take a picture of it. I could just have written it down that I'd done it, or made a list of things that one could do."[144] In videos such as *Stamping in the Studio* (1968), *Pacing Upside Down* (1969), and *Revolving Upside Down* (1969), Nauman took a hint from the choreographer Merce Cunningham and inverted the camera and taped himself performing rather inane activities seen upside down.[145] His *Art Make-Up* films (1967–68) and his video *Flesh to Black to White to Flesh* (1968) show him using makeup and masks in order to, according to the critic Coosje van Bruggen, slip "back and forth between objectification and illusion."[146] "Make-up is not necessarily anonymous," Nauman said, "but it's distorted in some way, it's something to hide behind."[147]

In 1975 Nauman wrote the text to his *Consummate Mask of Rock,* a collage of typewritten lists of concepts and statements that became integral to an installation of stone rocks that he had originally entitled *The Mask to Cover the Need for Human Companionship.* The text conflates the children's ditty "This is the House Jack Built," the game "scissors cuts paper, rock

[144]BRUCE NAUMAN, interview by Willoughby Sharp, *Arts Magazine* 44, no. 5 (March 1970): 26; quoted in Coosje van Bruggen, *Bruce Nauman* (New York: Rizzoli, 1988), 234.

[145]See VAN BRUGGEN, *Bruce Nauman,* 236. In 1974 the artist Peter Campus used a video camera in an installation entitled *aen* to project live images of viewers' faces upside down at the Museum of Modern Art; see BARBARA LONDON, *Video Spaces: Eight Installations,* exh. cat. (New York: Museum of Modern Art, 1995), 15.

[146]VAN BRUGGEN, *Bruce Nauman,* 196.

[147]NAUMAN, quoted in ibid., 196.

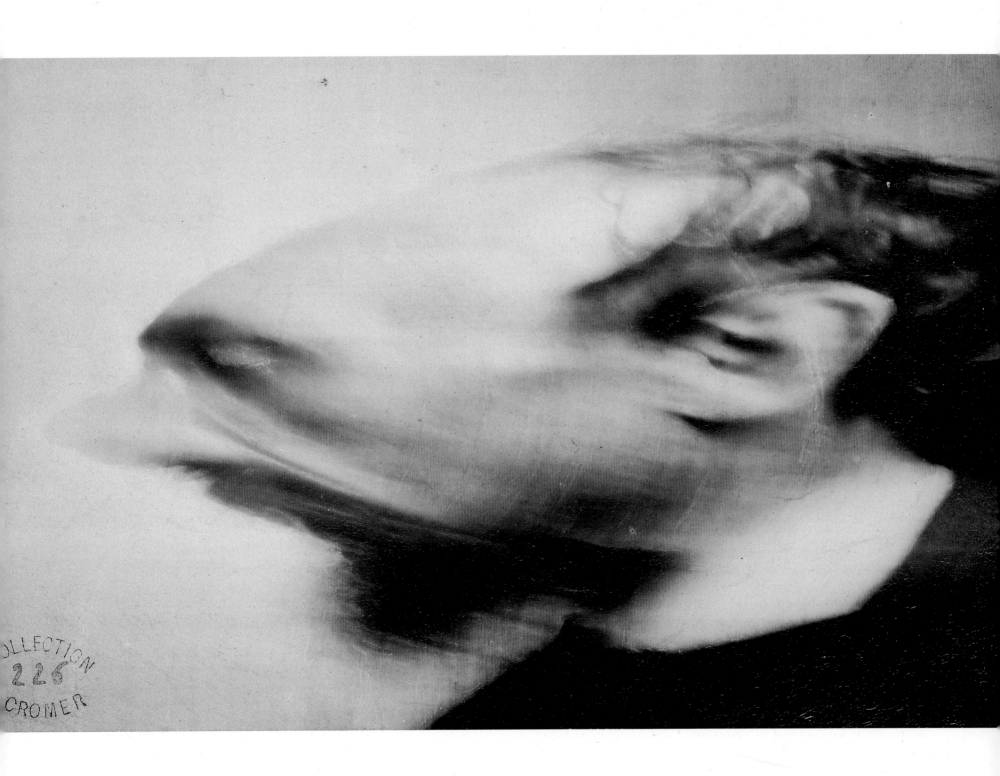
COLLECTION
225
CROMER

breaks scissors, and paper covers rock," the rhetorical construction of the classic syllogism, and a parody of Wittgenstein. One part of this work contains twenty-one or so seemingly contradictory propositions that pertain to the artist's self and his masks: The mask offers "fidelity to truth and life" and serves to "cover my infidelity to truth." The mask covers, but the cover also masks. Pain contorts the mask, which in turn signifies truth and fidelity; but painful need distorts that truth. The mask is the "cover of need for human companionship" and also the artist's "painful need distressed by truth and human companionship." Curator Robert Storr has summarized the texts: "Closing in upon the psychic import without ever fully stating it, these linked but incommensurable propositions tighten the vise that holds the reader and increases painful awareness of the breakdown of the subject's relation with itself and with other subjects."[148] Nauman's text concludes, "The consuming task of human companionship is false. The consummate mask of rock having driven the wedge of desire that distinguished truth and falsity lies covered by paper." So much for "intersubjective identifications."

In the 1990s Nauman monumentalized the inversion of the human axis in his video installations. Collaborating with Rinde Eckert, he combined inversion with playacting, plainchant vocals, and Wittgensteinian language games in two multichannel video installations, *Anthro/Socio (Rinde Facing Camera)* (1991) and *Anthro/Socio (Rinde Spinning)* (1992). In almost a travesty of traditional anthropological and ethnographic systems of faciality, giant close-ups of Rinde dominate the monitors and projections, some turned upside down and some spinning while chanting, "Help me, hurt me sociology; Feed me, eat me anthropology." Nauman's self-portrait entitled *Raw Material: Brrr . . .* (1990), a two-channel video and two-channel sound installation featuring a large projection and two monitors stacked atop one another, is particularly poignant. The artist's face is presented at ninety degrees to the vertical, shaking from side to side, and regressively stammering the primal sound "brrr," the beginning letters of his first name and perhaps a reference to his neon work *My Name as though It Were Written on the Surface of the Moon* (1968). German critic Ursula Frohne has described *Raw Material: Brrr . . .* in the following terms:

Caught in an incurable fixation of self-expression, it seems to bear witness to the overwhelming inner conflicts that are carried out in the unconscious. Its behavior is reminiscent of a catatonic's convulsions and involuntary contractions, compulsive symptoms that are the result of a psychic instability manifested as physical reactions.[149]

In Frohne's scenario, even catatonics convulse (a clinical impossibility) while conflicts rage within and the psyche is destabilized. The face, the primal voice, and the inner torments of the artist become little more than agitated "raw material" stretched across the horizontal, exteriority and interiority united in portraying the barely utterable, the unnameable.

Across the horizontal of contemporary culture, the face's features are now scattered and strewn along an entropic terrain of the mind, soul, and psyche. Nothing coheres; even the landscape has become fractured and fragmented, and Cartesian space is eradicated. Body parts are disassembled, their scales shifted; perspectives are dissolved into myriad viewpoints, and language reduced to grunts and shrieks. Artist Mike Kelley has succinctly related Nauman's experiments to the fragmentation of contemporary art:

The modernist notion of fragment as microcosm has given way in current artworks to a willingness to let fragment be fragment, to allow partiality to exist. As in the case of Nauman's uncomfortable and dysfunctional formalism, wholeness is something that can only be played with, and the image of wholeness only a pathetic comment on the lost utopianism of Modernism. It is comparable to a kind of acting out of socially expected norms, the presentation of a false "true self," long after the notion of a unified psychological mind has given way to the schizophrenic model as the normative one. Now, "sham," "falseness" and all the other terms that once were pejorative have become appropriate to our notion of what the function of art is.[150]

The "schizophrenic model" has indeed become the norm.[151] In 1983 three very different texts were written about this model. For Frederic Jameson the schizophrenic experience is one of "isolated, disconnected, discontinuous material signifiers which fail to link up into a coherent sequence."[152] Deleuze and Guattari contend that "the schizophrenic passes from one code to the other, that he deliberately *scrambles all the codes,* by quickly shifting from one to another."[153] And Jean Baudrillard claims that the schizo represents the "end of interiority and intimacy": He "can no longer produce the limits of his own being, can no longer play nor stage himself, can no longer produce himself as mirror. He is now only a pure screen, a switching center for all the networks of influence."[154]

[148]Robert Storr, "Beyond Words," in Joan Simon, ed., *Bruce Nauman,* exh. cat. (Minneapolis: Walker Art Center, 1994), 55.

[149]Ursula Frohne, "Raw Material: Brrr, 1990," trans. Bernhard Geyer, in *Mediascape,* exh. cat. (New York: Guggenheim Museum Soho, 1996), [32].

[150]Kelley, "Playing with Dead Things," 15.

[151]In 1978 the journal *Semiotext(e)* devoted an issue to this theme; see Sylvère Lotringer, ed., "Schizo-Culture," *Semiotext(e)* 3, no. 2 (1978).

[152]Frederic Jameson, "Postmodernism and Consumer Society," in Hal Foster, ed., *The Anti-Aesthetic: Essays on Postmodern Culture* (Port Townsend, Wash.: Bay Press, 1983), 119.

[153]Deleuze and Guattari, *Anti-Oedipus,* 15.

[154]Jean Baudrillard, "The Ecstasy of Communication," in Foster, *The Anti-Aesthetic,* 133.

The various pathologies discussed or alluded to throughout these essays may be of use in understanding how faciality has changed over time. According to Baudrillard's analysis, hysteria was a "pathology of expression" and an "exacerbated staging of the subject" for expressive ends; in short, physiognomics and the premodern. Paranoia was a "pathology of organization"; in other words, phrenology, control of the human face, and the modern. Now we are confronted with a "new form of schizophrenia" and a postmodern pathognomy: "No more hysteria, no more projective paranoia, properly speaking, but this state of terror proper to the schizophrenic: too great a proximity of everything, the unclean promiscuity of everything which touches, invests and penetrates without resistance, with no halo of private protection, not even his own body, to protect him anymore."[155] In this state, the body is pierced, fragmented, and dissociated. Deleuze described the "total breakdown of surfaces" that marked Artaud's schizophrenic perception, turning the body into a "body sieve."[156] Language itself is also broken down. Artaud wished to

erase verbal repetition;[157] Burroughs wanted to "rub out the word";[158] for Deleuze the "only valid language" in schizophrenia is an "inarticulate, physical language, where words are decomposed into syllables and sounds";[159] and for theorist Avital Ronell, "schizophrenia's vocabulary is . . . imbued with the ascientific dial tone of technology, no matter what number or which channel you dial."[160] Since Babel, human language has tended to fragment into many tongues; on the model of schizophrenia, language threatens to become mere glossolalia.[161]

Nauman's inverted perspectives and inability to complete his "brrr . . ." signaled a shift from an essentialist or constructionist type of human expression to one that is far more fractured and dissociated, and a number of contemporary artists have gone even further. In *Pressure (Flesh/Red)* (1996), Tony Oursler projects his own facial image onto a ceramic solid that is submerged in a tank of water, his mouth silently moving as if he is desperately trying to say something. Gary Hill's video installation *Inasmuch as It Is Always Already Taking Place* (1990) not only

[155]BAUDRILLARD, "The Ecstasy of Communication," 132.

[156]DELEUZE, "The Schizophrenic and Language: Surface and Depth in Lewis Carroll and Antonin Artaud"; cited in Rowell, "Images of Cruelty," 13.

[157]See DERRIDA, "The Theater of Cruelty and the Closure of Representation," in *Writing and Difference,* trans. Alan Bass (Chicago: University of Chicago Press, 1978), 245.

[158]BURROUGHS and BRION GYSIN, *The Third Mind* (New York: Viking Press, 1978), 85.

[159]ROWELL, "Images of Cruelty," 13.

[160]RONELL, *The Telephone Book: Technology, Schizophrenia, Electric Speech,* 119.

[161]See NEAL STEPHENSON, *Snow Crash* (New York: Bantam Books, 1993), 217–8.

ABOVE
Gary Hill, *Inasmuch as It Is Always Already Taking Place,* 1990, sixteen-channel video/sound installation, The Art Institute of Chicago, all rights reserved, gift of the Lannan Foundation, photograph courtesy Donald Young Gallery, Chicago.

PAGES 264–5
Bruce Nauman, *Raw Material: Brrr . . . ,* 1990, © 1999 Bruce Nauman/Artists Rights Society (ARS), New York, cat. no. 83.

PAGE 266
Tony Oursler, *Pressure (Flesh/Red),* 1996, cat. no. 89.

PAGE 267
Alan Rath, *Togetherness II,* 1995, cat. no. 95.

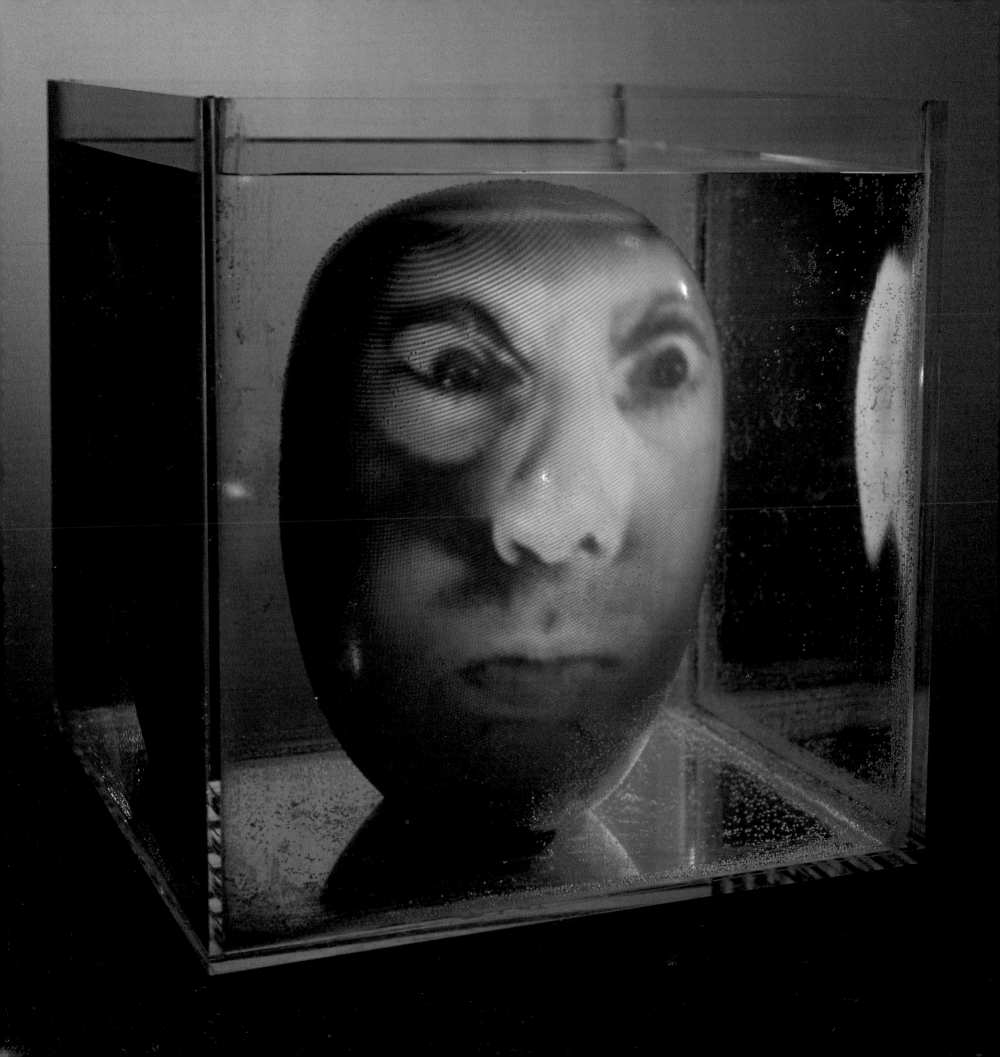

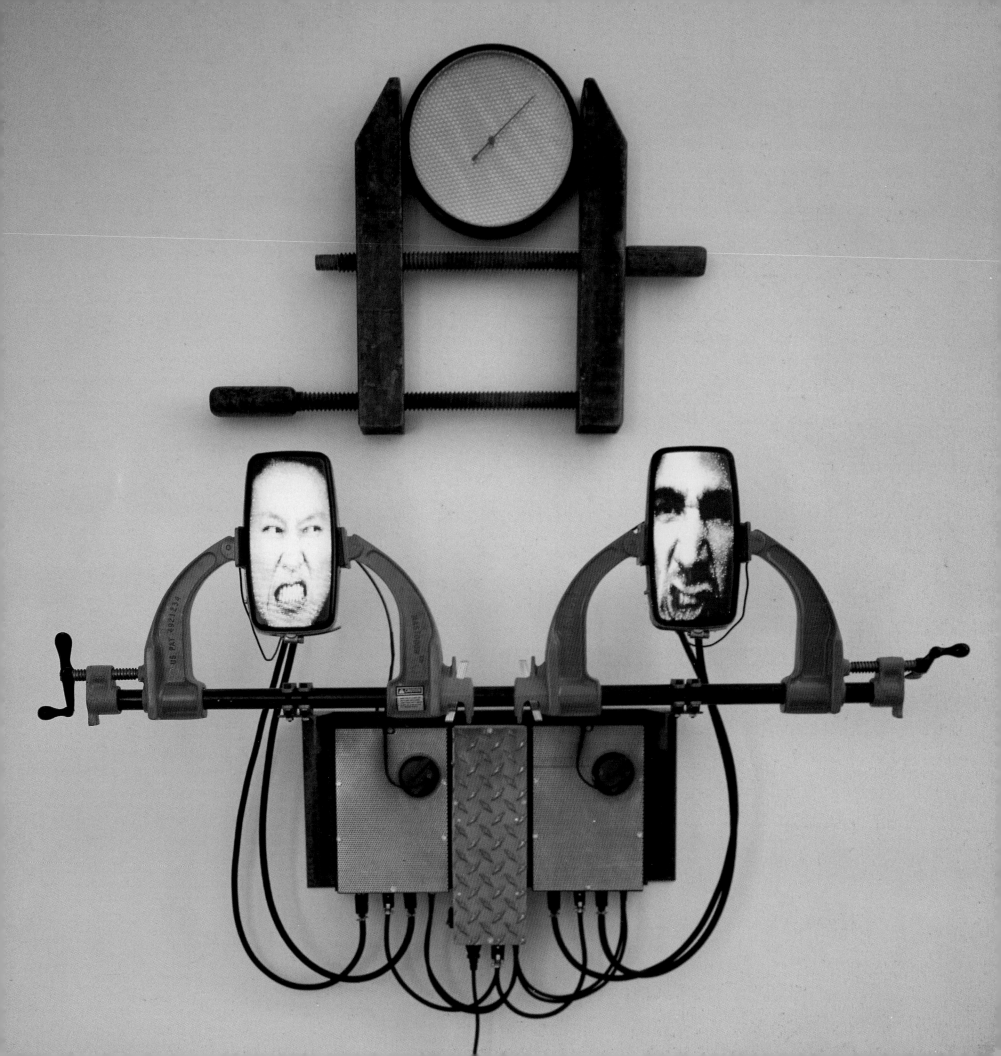

disassembles a complete body and slowly reintegrates the pieces moving slowly in counterpoint to one another on monitors of greatly differing sizes, but also eliminates all logical spatial references; these body parts exist solely on the surface of what critic Vivian Sobchack has called an "electronic space."[162] Further, a barely audible murmuring voice suggests that communication has ultimately come to what Hill calls "the debris of utterance."[163] Video artist Alan Rath's machines of faciality, such as *Togetherness II*, consist of fragments of the human head or entire faces displayed on monitors integrated within complex constructions of metal, wire, and computer parts, often accompanied by arbitrary electronic sounds. And, in what appears to be an attempt to reclaim the entire territory of the physiognomic and pathognomic, Scottish artist Douglas Gordon has produced a number of video installations, many of which have at least one component that addresses issues of human expression and the passions, the self and its double.

For example, in his *24 Hour Psycho* (1993), Gordon adapted Alfred Hitchcock's *Psycho* (1960)—perhaps the most intense film of facial expressions of the century, especially in view of the shower sequence—removed the sound track, and slowed the film down until its running time was an entire, protractedly mesmerizing day. With the installation *Hysterical* (1994), Gordon, fascinated by Charcot's "theater of the passions" and his "living museum of pathologies," took a short Italian film from 1908 that depicts male doctors laughing while wrestling a masked female hysteric into submission, and projected different scenes on a dip-

tych screen. The differing film speeds, simultaneous front and rear projection, and repeating loops tempt the viewer, in the words of critic Russell Ferguson, "by a vertiginous *mise en abîme*" where the "structure becomes labyrinthine, without a way out, without a beginning or an end, only an apparently infinite series of switchbacks."[164]

According to critic Tobia Bezzola, Gordon's *Reading Room* (1996), an installation of books, videotapes, and monitors, addresses such questions as "where do trauma and mania, euphoria and angst begin to play on the stage of our souls, and where do they begin to move our bodies?" as the viewer-participant literally browses through materials that concern multiple selves, such as the novels of Robert Louis Stevenson and James Hogg and the films *Vertigo* and *Psycho*.[165] In another installation of the same year, *Confessions of a Justified Sinner*, which is titled after the novel by Hogg, Gordon appropriated the scene of Dr. Jekyll's transformation into Hyde and back from Rouben Mamoulian's film of 1931, slowed it down, and doubled the scene by projecting a reversed and negative print of it on a second screen.[166] He also evokes these famous nineteenth-century novels of split personality in the diptych *Monster* (1997), a doubled self-portrait in which his alternative half is contorted into a grotesque by transparent tape. Gordon's projects are, in the end, a perfect summary of the synthetic theater of the postmodern "we," and they return us to where we began, to Duchenne's and Charcot's photographic experiments in human expression and in what lies beneath the human face.

BELOW
Douglas Gordon, *Hysterical*, 1994, video installation, photograph courtesy the Lisson Gallery, London.

268

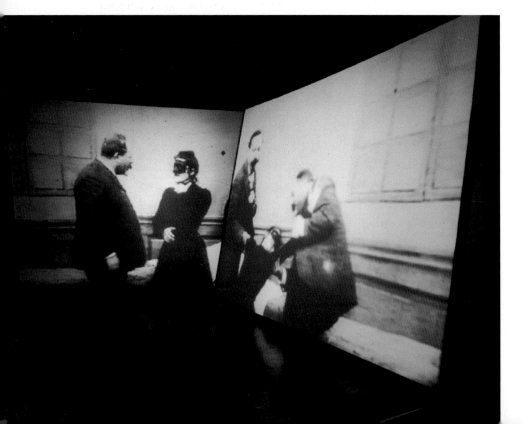

[162]Vivian Sobchack, "The Scene of the Screen: Towards a Phenomenology of Cinematic and Electronic Presence," *Post-Script* 10 (1990): 57; see also Lynne Cooke, "Postscript: Re-embodiments in Alter-Space," in Chris Bruce, ed., *Gary Hill,* exh. cat. (Seattle: Henry Art Gallery, University of Washington, 1994), 87.

[163]Gary Hill, "Inasmuch as It Is Always Already Taking Place," in otherword sandimages, exh. cat. (Copenhagen: Video Gallerie/Ny Carlberg Glyptotek, 1990), 27; quoted in Cooke, "Postscript: Re-embodiments in Alter-Space," in Bruce, *Gary Hill,* 83.

[164]Russell Ferguson, "Divided Self," *Parkett,* no. 49 (1997): 63. The Italian footage is here credited to Roberto Omegna, Turin, 1908.

[165]Tobia Bezzola, "De Spectaculis: Or Who Is Kim Novak Really Playing?" *Parkett,* no. 49 (1997): 53.

[166]Warhol anticipated Gordon's use of double screens in the mid-sixties. In *Outer and Inner Space* (1965–66), Edie Sedgwick was filmed talking to and about her videotaped self; see J. Hoberman, "A Pioneering Dialogue between Actress and Image," *New York Times,* 22 November 1998, AR34.

Synthetic Pathognomies

Charcot considered psychological trauma to be the result of an electrical shock to the mind, and in his bid to probe the inner workings of his epileptic and cataleptic patients he exposed them to flashing lights to cause their seizures and thereby make their pathologies visible. In her avant-garde choreography, Loie Fuller used flashing spotlights to portray a metaphysical fin-de-siècle expression of multiple identities and mobile subjectivities that fostered what the poet Stéphane Mallarmé called a "'transparent prolongation' of the gaze through, rather than at, the subject."[167] Flickering light was at the basis of artist Brion Gysin's "Dreamachine" of the early 1960s, a device he, Burroughs, and others used to stimulate cerebral imagery and assist in altering human consciousness.[168] More recently, researchers in the department of neurological surgery at the University of Washington showed visual stimuli to conscious patients whose skulls had been opened in order to accept minuscule CCD cameras into their cortexes. The camera recorded "minute flickers of light in neural tissue during the firing of perception sites. . . . in response to stimulation."[169] Thus a complete mapping of the emotional response locations in the human brain has begun. Still other researchers are examining the "biochemistry and neurophysiology of induced emotional states" whereby, according to nanotechnologist Charles Ostman, the "introduction of artificially generated electrical signals applied to the appropriate neural receptor sites can induce a fear reaction that is completely beyond the conscious control or awareness of the subject."[170] Forget about Duchenne's "false smile": We now can have entire ranges of false emotional expressions without even having to feign them.

We can also have entirely false faces, synthetic faces built of flesh and bone and any number of implants, protheses, additives, and technologies. "Rather than be pure," poet John Ashbery wrote in 1970, "accept your-

self as numerous."[171] The words were hauntingly convincing then. Now, rather than merely accept ourselves as numerous, we can refabricate ourselves as numerously as we wish. Norman Bryson contends that "increasingly the human subject inhabits not just the one taxable body but a mediated environment of transmissions, recordings, and relays that extend human presence prosthetically in space and time in all directions."[172] Whereas Duchenne felt compelled to "correct" the anatomical inaccuracies of certain classical busts, it is now in the realm of possibility for us to literally correct or enhance our own anatomies and faces. The Korean-Brazilian filmmaker Iara Lee has documented the considerable measures we as humans have taken to "improve" and "adjust" our lives and our very beings synthetically. In the film *Synthetic Pleasures* (1996), Lee reports on climate-controlled, artificial environments such as ski slopes within cities; the use of mind- and memory-improving chemicals; the cryogenic freezing of our bodies; our progressively expanding immersion within the Internet and virtual realities; and, of course, cosmetic plastic surgery.

ABOVE
Samuel Joshua Beckett, *Loie Fuller Dancing*, c. 1900, gelatin-silver print, the Gilman Paper Company Collection, New York.

PAGES 270–1
Douglas Gordon, *Monster*, 1997, photo courtesy Patrick Painter Editions, Hong Kong, Vancouver, cat. no. 50.

[167] See MCCARREN, "The 'Symptomatic Act' Circa 1900," 751; for the phrase "transparent prolongation," see STÉPHANE MALLARMÉ, *Crayonné au théatre*, in *Oeuvres complètes*, ed. Henri Mondor (Paris: Bibliothèque de la Pléiade, 1945), 311.

[168] See SOBIESZEK, *Ports of Entry: William S. Burroughs and the Arts*, 75–79.

[169] CHARLES OSTMAN, "Head Cheese on Wry," *Mondo 2000*, no. 15 (1996): 66.

[170] Ibid., 68.

[171] JOHN ASHBERY, "Some Words," in *The Double Dream of Spring* (Hopewell, N.J.: Ecco Press, 1970), 63. One critic, reviewing Ashbery's *The Mooring of Starting Out: The First Five Books of Poetry* (Hopewell, N.J.: Ecco Press, 1997), has suggested that in this phrase Ashbery revises Walt Whitman's "I contain multitudes" into a "more understated, psychologized key." NICHOLAS JENKINS, "A Life of Beginnings," *New York Times Book Review*, 4 January 1998, 15.

[172] BRYSON, "Façades," 61.

Todd Watts,
Methane Breather
(#0236), 1989,
cat. no. 142.

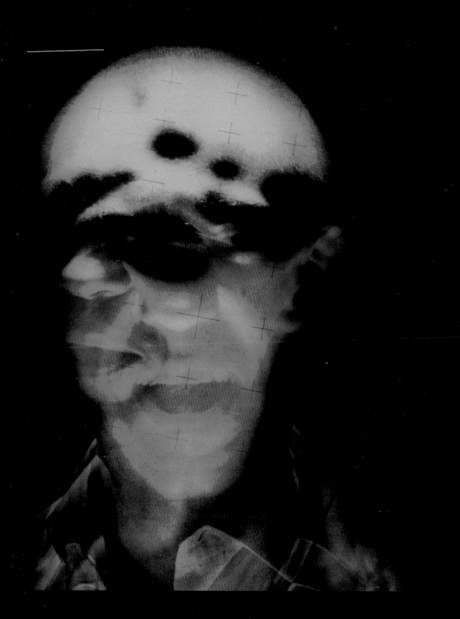

PAGES 273–83 are represented on
Orlan, the following ten
Entre-Deux, 1993, pages. The complete
cat. no. 88. installation as it
The portraits, dates, appeared at the
and composite Sandra Gering
images that make Gallery in 1993
up the forty-one is illustrated on
triptychs in this work page 283.

Plastic surgery, in the work of the French performance artist Orlan, has become a baroque, self-transgressive theater of self-idealization.[173] As discussed above, Franz Xaver Messerschmidt and Bruce Nauman played with the plasticity of their own faces in order to depict some rather disquieting countenances. Yet both of these artists reverted to their "natural" faces afterward. Between 1990 and 1993, however, Orlan participated in a series of seven surgical interventions on her own face that progressively

"ENTRE-DEUX" 21 NOVEMBRE 1993 "ENTRE-DEUX" 22 NOVEMBRE 1993 "ENTRE-DEUX" 23 NOVEMBRE 1993 "ENTRE-DEUX" 24 NOVEMBRE 1993

[173]See IARA LEE, dir., *Synthetic Pleasures,* prod. George Gund (Caipirinha Productions, 1996).

 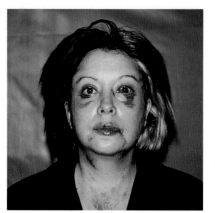 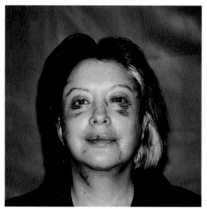

transformed her features: She acquired the chin of Botticelli's *Venus,* the nose of Gérard's *Psyche* (in the *Cupid and Psyche* that hangs in the Louvre), the lips of Gustave Moreau's *Europa,* the eyes of a School of Fontainebleau *Diana,* and the brow of Leonardo's *Mona Lisa.*[174] In nearly all of her "performance-operations," the artist remained conscious—only an epidural spinal injection for the required liposuction and a local anesthetic were administered—and was able to read from various critical texts while the operating room was decorated as a stage-set and the surgeons were outfitted in haute-couture by Issey Miyake or Paco Rabanne. In one performance, *Omniprésence* (1993), Orlan had silicon implants placed near her temples, resulting in twin horns, as it were, and the entire procedure was videotaped for CBS News, relayed directly to the Sandra Gering Gallery

"ENTRE-DEUX" 25 NOVEMBRE 1993 "ENTRE-DEUX" 26 NOVEMBRE 1993 "ENTRE-DEUX" 27 NOVEMBRE 1993 "ENTRE-DEUX" 28 NOVEMBRE 1993

[174]See SARAH WILSON, "L'Histoire d'O, Sacred and Profane," in Orlan, *This is my body . . . This is my software,* ed. Duncan McCorquodale (London: Black Dog Publishing, 1996), 13–14. Wilson mistakenly writes that Orlan quotes from Gérôme's *Psyche.* Orlan refers to Gérard's *Psyche* in "Carnal Art," trans. Tanya Augsburg and Michel A. Moos, in ibid., 89, and this painting is clearly illustrated in her *Reincarnation of Saint-Orlan*; see MARK C. TAYLOR, *Hiding* (Chicago: University of Chicago Press, 1997), 140. In an essay by BARBARA ROSE, Orlan's eyes are said to be from Gérôme's *Psyche,* the nose from the Fontainebleau *Diana,* and the mouth from a *Europa* by Boucher. "Is It Art? Orlan and the Transgressive Act," *Art in America* 81, no. 2 (February 1993): 85.

 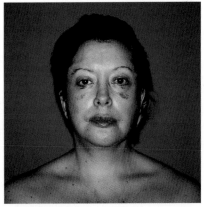 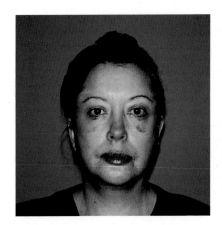 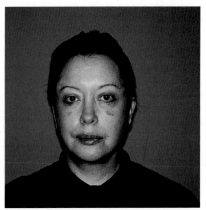

in New York, and telecast via satellite to the Centre Georges Pompidou in Paris, where intellectuals were in turn videotaped reacting to the images.[175] *Entre-Deux* is a permanent record of *Omniprésence*. Each of its forty-one vertical triptychs includes a portrait of the artist at the top (one taken just before the intervention and one on each of the following forty days), a date plaque at the center, and a composite of her face with various god-

desses' at the bottom. As of 1998 Orlan was planning at least one future operation as well as a retrospective of her work.

Orlan frequently refers to Artaud's notion of the "body without organs," Rimbaud's claim that "Je *est* un autre," and Julia Kristeva's theories of "abjection."[176] Like Sherman's photographs, Orlan's work can be viewed as grounded in feminist issues:

"ENTRE-DEUX" 29 NOVEMBRE 1993 "ENTRE-DEUX" 30 NOVEMBRE 1993 "ENTRE-DEUX" 1 DECEMBRE 1993 "ENTRE-DEUX" 2 DECEMBRE 1993

[175]Cf. WILSON, "L'Histoire d'O," 15; *Omniprésence* was also telecast by satellite to Dijon, Nice, Quebec, Antwerp, Cologne, Riga, Milan, Zurich, Geneva, Tokyo, Banff, and Toronto.

[176]ORLAN, "Carnal Art," 90–91.

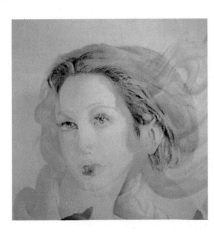

I am a multi-media, pluri-disciplinary and inter-disciplinary artist. I have always considered my woman's body, my woman-artist's body, privileged material for the construction of my work. My work has always interrogated the status of the feminine body, via social pressures, those of the present or in the past. I have indicated certain of their inscriptions in the history of art. The variety of possible images of my body has dealt with the problem of identity and variety.[177]

In the end, however, as in Sherman's oeuvre, Orlan's "theater of operation" is more broadly about identity and otherness *tout court:* "My work is not a stand against cosmetic surgery, but against the standards of beauty, against the dictates of a dominant ideology that impresses itself more and more on feminine (as well as masculine) flesh."[178] Well before Orlan,

"ENTRE-DEUX" 3 DECEMBRE 1993 "ENTRE-DEUX" 4 DECEMBRE 1993 "ENTRE-DEUX" 5 DECEMBRE 1993 "ENTRE-DEUX" 6 DECEMBRE 1993

[177]Ibid., 84.

[178]Ibid., 91.

Gysin and Burroughs said that the future was not here on earth nor in our physical bodies, but in a dimensionless and bodiless outer space, and that ultimately "we are here to go."[179] Orlan believes that the "body is obsolete. . . . We are at the junction of a world for which we are no longer mentally or physically prepared."[180] Only with synthetic prostheses, implants, and repositionings can the exterior of the person begin to be made to coincide with whatever is in the interior.[181]

Finally, postmodern faciality is about skins and surfaces, masks and costumes. Orlan begins all her surgical interventions by reading from Eugénie Lemoine-Luccioni's Lacanian essay, *La Robe* (1983):

[179]BURROUGHS, preface to Brion Gysin and Terry Wilson, *Here to Go: Planet R-101* (San Francisco: RE/Search Publications, 1982), X.

[180]ORLAN, quoted in Wilson, "L'Histoire d'O," 16.

[181]ORLAN, "Carnal Art," 85.

"ENTRE-DEUX" 7 DECEMBRE 1993 "ENTRE-DEUX" 8 DECEMBRE 1993 "ENTRE-DEUX" 9 DECEMBRE 1993 "ENTRE-DEUX" 10 DECEMBRE 1993

 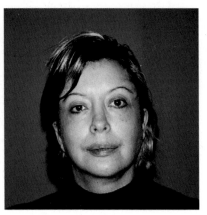 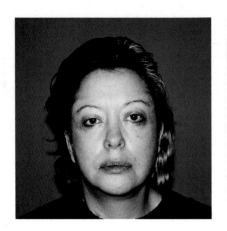 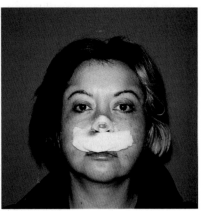

Skin is deceiving . . . in life, one only has one's skin . . . there is a bad exchange in human relations because one never is what one has . . . I have the skin of an angel, but I am a jackal . . . the skin of a crocodile, but I am a puppy, the skin of a black person, but I am white, the skin of a woman, but I am a man; I never have the skin of what I am. There is no exception to the rule because I am never what I have.[182]

Critic Michel Onfray has considered Orlan's "surgical aesthetics" and concluded that "her exclusive concern with the face means that her work addresses the nature of the Person—the Latin etymology of which reminds us of its origin with the mask worn on stage—more than that of a Subject, an Individual, a Subjectivity, if not an Identity, at least a Body."[183] The body is obsolete for Orlan; thus it can be remade, recast

"ENTRE-DEUX" 11 DECEMBRE 1993 "ENTRE-DEUX" 12 DECEMBRE 1993 "ENTRE-DEUX" 13 DECEMBRE 1993 "ENTRE-DEUX" 14 DECEMBRE 1993

278

[182]ORLAN, "Carnal Art," 88. See also EUGÉNIE LEMOINE-LUCCIONI, *La Robe: Essai psychoanalytique sur le vêtement* (Paris: Le Seuil, 1983).

[183]MICHEL ONFRAY, "Surgical Aesthetics," trans. C. Penwarden, in Orlan, *This is my body . . . This is my software,* 39.

as anything at all.[184] The artifice of faciality is rendered chillingly dramatic when Orlan reads to us as the skin of her face is pierced, punctured, cut into, and slowly separated from the subcutaneous muscles and veins that support it.[185] It is all artificial in this arena; with synthetics the possibilities are endless. After all, according to Burroughs: "It's the Plastic Age, folks. 'Tain't no sin take off your new skin and clown around in your bone-ons."[186]

For a modernist and humanist like Diane Arbus, human subjects allowed us to "wonder all over again what is veritable and inevitable and possible and what it is to become whoever we may be."[187] For Orlan, becoming whoever she may be is not a metaphor; it is a straightforward physical project: "I make myself into a new image in order to produce new images."[188] Arbus's photographs were concerned with the veritable

"ENTRE-DEUX" 15 DECEMBRE 1993 "ENTRE-DEUX" 16 DECEMBRE 1993 "ENTRE-DEUX" 17 DECEMBRE 1993 "ENTRE-DEUX" 18 DECEMBRE 1993

[184]Similarly, the Australian performance artist STELARC believes that "the body is obsolete," and his home page reads like a glossary of obsolescent and disposable bodies: "Absent Bodies," "Obsolete Body," "The Hum of the Hybrid," "The Shedding of the Skin," "Phantom Body," "Fractal Flesh," "Stimbod," "Virtual Body," and "Amplified Body," among others. *Stelarc,* online: http://www.stelarc.va.com.au/ (15 December 1998).

[185]AMELIA JONES has argued that Orlan's project emphasizes the "failure of the visual register to comprehend the meaning of the self (its 'identity' or 'identities') through the appearance of the body," and that Orlan "strips away the ideological assumptions underpinning the notion of the Cartesian subject (that this subject is pure interiority, her body simply a container that can be transcended through thought) or, alternatively, of the subject as determinable through her or his physiognomy." *Body Art: Performing the Subject* (Minneapolis: University of Minnesota Press, 1998), 226–7.

[186]BURROUGHS, *Interzone* (1953–58), ed. James Grauerholz (New York: Viking, 1984), 152. The source of this line is "Tain't No Sin (To Dance Around in Your Bones)" by songwriter Edgar Leslie in 1929.

[187]DIANE ARBUS, "The Full Circle," *Infinity* 11, no. 2 (February 1962): 9.

[188]ORLAN, "Carnal Art," 85.

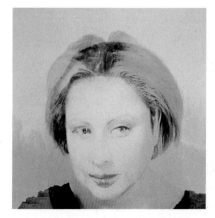

 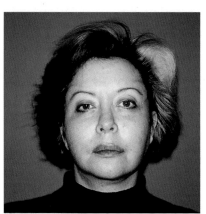

and the inevitable. Orlan's theater of operations is, on the other hand, a "fight against the innate, the inexorable, the programmed, nature, DNA (which is our direct rival as artists of representation) and God!"[189] For photographers of identity, whether criminologists or social taxonomists, the measurable features of the face and its wearer were the means to define, classify, and thereby control the subjects. "When the operations

are finished," Orlan has said, "I will solicit an advertising agency to come up with a name, a first name, and an artist's name; next, I will contract a lawyer to petition the republic to accept my new identities with my new face."[190] The videotapes, video CDs, and telecasts of Orlan's interventions clearly demonstrate that the face as the site of the human spirit is no

"ENTRE-DEUX" 19 DECEMBRE 1993 **"ENTRE-DEUX" 20 DECEMBRE 1993**

"ENTRE-DEUX" 21 DECEMBRE 1993 **"ENTRE-DEUX" 22 DECEMBRE 1993**

280

[189]ORLAN, quoted in Wilson, "L'histoire d'O," 16.

[190] ORLAN, "Carnal Art," 92.

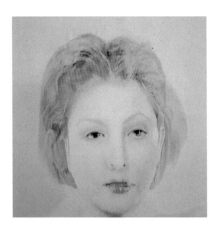 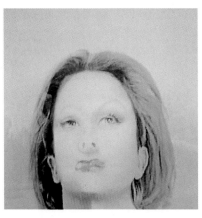 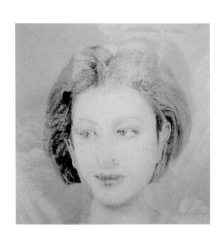

longer a fixed exteriority that acts out or reveals an essential interiority.[191] If actors can feign inner feelings and states of mentality for a moment, visual artists can now permanently mold the contours of the face in accord with whatever they imagine themselves to be or wish to be. In the end, Orlan will have a new face, a new name, and a new *carte d'identité*.

Duchenne believed he could chart the orthography of human expression and reveal what lay beneath. Warhol and others valued faces only as façades. Sherman, Nauman, Gordon, and Orlan, however, have embraced multiplicity, alterity, and fluidity as the preeminent ways of contending

"ENTRE-DEUX" 23 DECEMBRE 1993 "ENTRE-DEUX" 24 DECEMBRE 1993 "ENTRE-DEUX" 25 DECEMBRE 1993 "ENTRE-DEUX" 26 DECEMBRE 1993

[191]The uncanniness of Orlan's presentations foregrounds the detachability of the face from the body; thus, according to PARVEEN ADAMS, we "find ourselves unhinged in a space that refuses to organize an inside and an outside." "Operation Orlan," in *The Emptiness of the Image: Psychoanalysis and Sexual Difference* (London and New York: Routledge, 1996), 143; quoted in Jones, *Body Art: Performing the Subject, 227*.

with and rendering what may now reside beneath the face. Just as machines are being imbued with ever-increasing amounts of intelligence and emotional affect, humans are being permeated more and more by synthetics, prostheses, and technologies.[192] And the camera is still there to visualize human faciality and give us clues about what it is to be human. After all, phrases like "camera eye" and "cameraman" or "camerawoman" have long represented a conflation of the mechanical with the human, so what better means to address the issue? The ghosts may be essentially multiple, the shells may be infinitely changeable, and the definitions perennially slippery and awkward; yet, save in death and nullity, some sort of residency

"ENTRE-DEUX" 27 DECEMBRE 1993 "ENTRE-DEUX" 28 DECEMBRE 1993 "ENTRE-DEUX" 29 DECEMBRE 1993 "ENTRE-DEUX" 30 DECEMBRE 1993

282

[192]A parody of the fusing of human and machine/technology is found in SHINYA TSUKAMOTO's film *Tetsuo: The Ironman,* prod. Kaijyu Theatre (Original Cinema, 1991), in which scrap metal, electricity, drills, and wires completely invade and merge with the protagonist, whose last words are "Come on! Let's rust the world!" For more on this film, see BUKATMAN, *Terminal Identity,* 308

seems still to persist within us. The ghost (or ghosts) may be multiple(s), it (or they) may even change appearances or shift effortlessly from channel to channel, frequency to frequency, persona to persona, but movement and change, after all, were what initially differentiated pathognomy from its allied disciplines. Cameras have merely kept up with the movements of the human soul.

"ENTRE-DEUX" 31 DECEMBRE 1993

"Ligatures of the Human Face"

Moreover, since the I who desired and the eye who perceived had nothing to do with each other and at the same time existed in the same body—mine: I was not possible. KATHY ACKER, *Empire of the Senseless* (New York: Grove Weidenfeld, 1988), 33.

284

RIGHT

Charles Le Brun,
Desire, before 1696,
pen-and-ink
diagrammatic
drawing, Musée de
Louvre, Paris,
photograph © R.M.N.

The human countenance has been aestheticized, manipulated, and fragmented by the camera arts for the past century and a half. There have been beautiful photographs of ordinary individuals, prosaic photographs of beautiful people, and unnerving images that bear slight, if any, resemblance to faces. Perhaps the preceding chapters are best summarized by the epigraph to their Introduction.[1] In three sentences the Irish playwright Samuel Beckett reflects on the beauty of faces in photographs, the possible aesthetics of the face in death, and all the grimaces and flushes we encounter in the faces of the living. The sentiments expressed by Beckett correspond rather well to what I have tried to suggest to be the principal agendas of photographic portraiture and their characteristic facial types: expressive, blank, and fictive. But this similarity does not conflate these agendas into a comprehensive pictorial theory, nor does it, by itself, suggest what we may deduce from the ideas and images that have been presented up to this point. Something more than a discussion of these three types of portraiture still seems to be required in thinking about the photographic face in general, something we might approach by reexamining the shell of the ghost.

[1] See above, p. 16.

Descartes contended that the human soul resided in the pineal gland, Hegel concluded that the actuality and existence of humankind was in the skull bone, and Deleuze and Guattari defined the ego as a body stripped of its organs. Premodernist humanism trusted that the human essence is inscribed in the face, modernist strategies have sought to reconstruct the face and thereby control it, and postmodernist tactics are involved in distancing the face from the body and mind.[2] Despite everything we have done to cast doubt on it, however, the belief persists that something on the order of a human soul exists. Nearly all of the inductive proofs of its presence brought forward since the Enlightenment have focused on the human face, and today the face remains the dominant site of inquiry into what constitutes not only our identities but our emotions, our desires, and our character(s). Whatever we call the mysterious element that we recognize as human—spirit, subjectivity, interiority, etc.—it is for the most part inexpressible and ultimately unnameable, yet it continues to manifest itself in countless ways and through the infinite permutations of the face. Faces incarnate all manner of subjectivities; on the face, even the formless takes shape. How else might we appreciate the words of Smokey Robinson, "So take a good look at my face/You know my smile looks out of place/If you look closer its easy to trace/the tracks of my tears"?[3] For more than a century and a half, cameras have been tracking the traces of our emotions and providing the evidentiary visual documents of our "souls" simply by charting the profound surface of the face, which novelist Yukio Mishima once called "that vital borderline that endorses our separateness and our form, dividing our exterior from our interior."[4]

The face is simply a matter of skin, bones, and muscles, three anatomical organs and their attending combinatory forms that, taken together, provide the means by which our spirits are made visible. Each of the principal attempts to probe the face for its hidden texts has focused on one of its physical layers; together, these efforts can be seen as a gradual movement or trajectory from the bones toward the surface, escaping the inarticulate depths of the psyche. For Franz Joseph Gall, an essentialist, the locus of meaning was the skeletal substrate (the *osteo*) that determined the surface form of the muscles and the skin. For Duchenne, a positivist, the interior musculature of the face (the *myo*) was the interface between interior and exterior, the contents of the toolbox with which the mind communicated its inner states. Charcot, a visualist, triggered pathognomic articulations on the visible surface of the reflecting skin (the *dermo*) with his flashing light and captured them in the lens of an eye or a camera. Twentieth-century photography takes us on the same path: Andy Warhol, in his quest to reduce the face to a meaningless surface, stripped it down to the essential: the bone. Humanist artists such as Sebastião Salgado and Alfredo Jaar have recorded the face and the emotions it reveals through the

myological geometries of its expressions. Postmodernists Cindy Sherman and Orlan have changed their skins using grimaces, makeup, prostheses, and plastic surgery in their private, yet very public, theaters of the passions. And when we see the skin of Orlan's face lifted from its foundation of muscles and bones, when we see those muscles and bones reshaped to change her face and thus her self, it seems quite clear that, ultimately, appearances are essences.

We can't quite dismiss the face as skin, bones, and organs, however: it speaks to us, sometimes more profoundly than words. The Talmudic philosopher Emmanuel Levinas has written extensively about this mystery.[5] For him, the face was a metaphor, a prelinguistic primordial poem, behind which lingered the trace of God.[6] He postulated a (prelapsarian?) "face-to-face" encounter that engendered a nonverbal language of faciality as well as an ethics that he labeled a "first philosophy." He described the earliest meaning of the face as simply "the proximity of the other,"[7] a notion not unlike Darwin's concept that the looming face of the mother fills an infant's horizon and is "the first means of communication between the mother and her infant."[8] Later the ego develops self-consciousness and comes to recognize mortality in the face of the other. The ego confronts and fears the mortality of the other and of itself; this moment, one might say, is the start of intersubjectivity: "It is in the laying down by the ego of its sovereignty," Levinas writes, "that we find ethics and also probably the very spirituality of the soul, but most certainly the question of

[2] Cf. JOHN WELCHMAN, "Face(t)s: Notes on Faciality," *Artforum* 7, no. 3 (November 1988): 131.

[3] WILLIAM ROBINSON, "The Tracks of My Tears," performed by Linda Ronstadt, in *Greatest Hits* (Asylum Records, 106-2 EUR 253 055, 1976), track 12.

[4] YUKIO MISHIMA, *Sun & Steel,* trans. John Bester (New York: Grove Press, [1976]), 23.

[5] EMMANUEL LEVINAS, "Max Picard and the Face," trans. Michael B. Smith, in *Proper Names,* ed. Werner Hamacher and David E. Wellbery (Stanford: Stanford University Press, 1996), 94–98. Levinas's most complete dissertation on the face is found in his *Totality and Infinity: An Essay on Exteriority,* trans. Alphonso Lingis (Pittsburgh: Duquesne University Press, 1969).

[6] MAX PICARD wrote that "the face of man is the proof of the existence of God." See LEVINAS, "Max Picard and the Face," 95.

[7] LEVINAS, "Ethics as First Philosophy," trans. Seán Hand and Michael Temple, in *The Levinas Reader,* ed. Hand (Cambridge: Blackwell Publishers, 1989), 82–83.

[8] CHARLES DARWIN, *The Expression of the Emotions in Man and Animals,* 3rd and definitive ed. (New York and Oxford: Oxford University Press, 1998), 359.

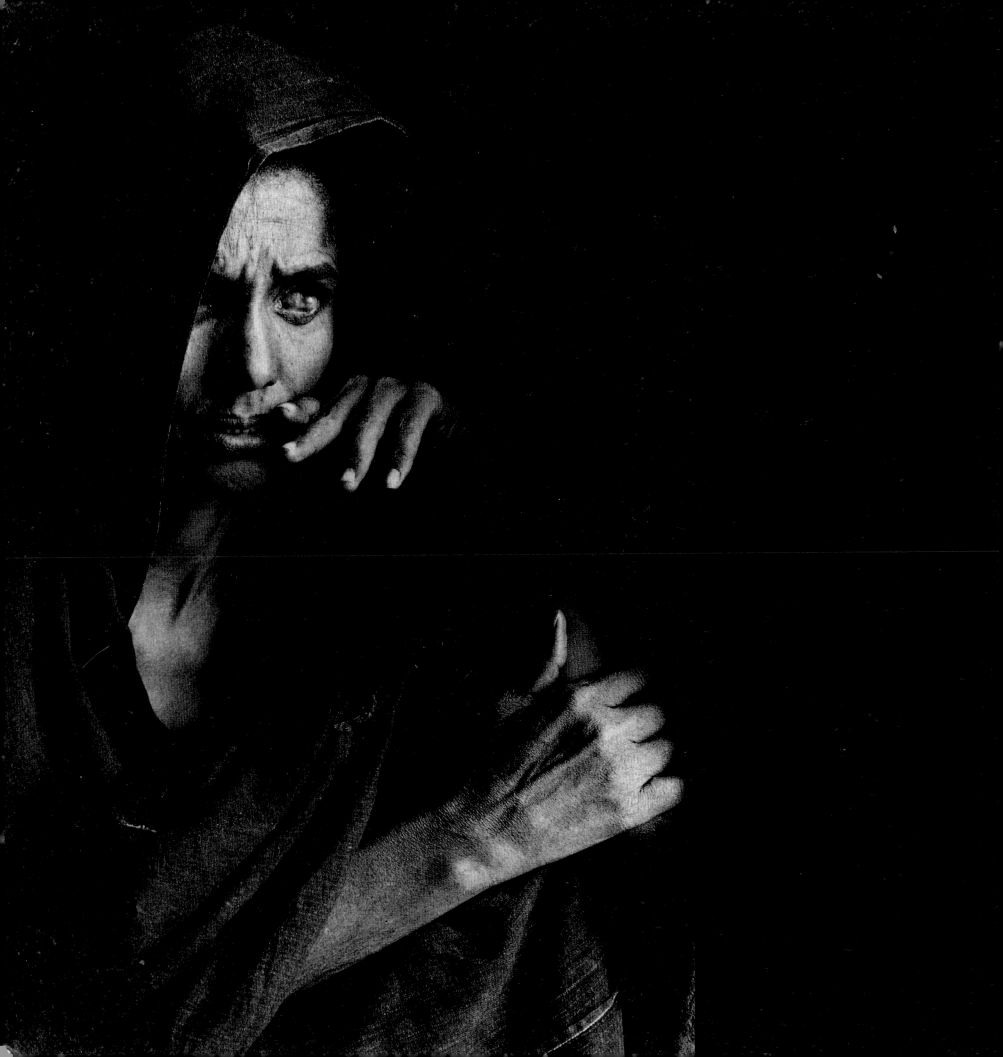

the meaning of being, that is, its appeal for justification."[9] Gazing into another's face is, in essence, an act of becoming both self and other; for Levinas, "this means that existence is pluralist. Here the plural is not a multiplicity of existents; it appears in existing itself."[10] This idea jeopardizes both the essentialist notion of an all-powerful ego and the foundations of Freudian psychoanalysis in which verbalization is the only key to understanding the ego.[11] According to the French critic Jacques Derrida, Levinas's thought "summons us to a dislocation of our identity, and perhaps identity in general."[12] Levinas is primarily a poet of metaphor, and Derrida responds to his premises poetically:

[T]he face-to-face eludes every category. For within it the face is given simultaneously as expression and as speech. Not only as glance, but as the original unity of glance and speech, eyes and mouth, that speaks, but also pronounces its hunger. . . . This unity of the face precedes, in its signification, the dispersion of senses and organs of sensibility. Its signification is therefore irreducible. Moreover, the face does not *signify*. It does not incarnate, envelop, or signal anything other than self, soul, subjectivity, etc. Thought is speech, and is therefore immediately face. In this, the thematic of the face belongs to the most modern philosophy of language and of the body itself.[13]

Faciality thus becomes philosophy, and logical discourse gives way to visual apprehension (in all senses of the word) and the concomitant visual dialogue that cannot be comprehended by any logos.[14] What lies behind the face does not matter so much as what the face lies behind: It rests behind speech and has become the philosophy of both language and body. Indeed, as Derrida states, the face incarnates subjectivity, and that is the source of both its appeal and its mystery. Neal Stephenson's cyberpunk novel *Snow Crash* suggests that the virus of rational thought was what caused languages and knowledge, after Babel, to fragment.[15] Similarly, the virus of subjectivity after positivism, after Duchenne, has resulted in the multiplicity and liquidity of facial expressions we have since encountered in both life and art.

On the face of it, faciality is about the skin, the surface, the image. Perhaps Warhol was correct after all; we need only look at the surface, and just maybe Avedon's surfaces truly are "full of clues" to be read.[16] Arguing dialectically from Hegel's phenomenological axiom that outwardness is the expression of inwardness, critic Mark C. Taylor provocatively concludes that the outer is at the same time the inner, and that "not only are appearances essential, but *essences are apparent*."[17] Language is invented to construct facts, and the line between illusion and reality is never precisely delineated; even Freud ultimately admitted that the difference between factual memory and psychic fantasy does not matter in the end. According to Taylor,

If reality is illusory, then the difference between skin and bone, appearance and essence, outer and inner, and surface and depth is a difference that makes no difference. The erasure of this difference does not, however, result in the collapse of opposites into identity but issues in the reversibility of differences, which leaves everything unstable and infinitely complex. When surface is depth and depth is surface, solutions become dissolutions in which (the) all is undecidable.[18]

When it comes to discerning what is beneath the surface that hides the human psyche, there are countless clues and no solutions: The "puzzle is not the lack of meaning but its excess."[19] François Dagognet, a philosopher and medical doctor, is convinced that the "psyche emerges from the most complex corporeal structures": the "interior overflows; mental energy always spills over. Let us learn to recover and interrogate that overflow."[20] Nothing is concealed; everything is there to see, and the possible theories are numerous. But sometimes, as in "The Purloined Letter" by Edgar Allan Poe, even careful searching will not reveal what is most obvious: the eagerly sought letter remains safe, resting atop the surface of the mantel, hidden in plain sight to all the detectives looking for it.[21]

[9] LEVINAS, "Ethics as First Philosophy," 85.

[10] LEVINAS, "Time and the Other," trans. Richard A. Cohen, in *The Levinas Reader*, 43.

[11] While LEVINAS's discourse on the face and faciality certainly suggests a visual foundation to his philosophy, he remained resolutely logocentric: "I have consistently refused the notion of vision in describing the authentic relationship with others; it is discourse and, more precisely, the response or the responsibility that is the authentic relationship." *Ethique et Infini: Dialogues avec Philippe Nemo* (Paris: Arthème Fayard and Radio-France, 1982), 82.

[12] JACQUES DERRIDA, "Violence and Metaphysics: An Essay on the Thought of Emmanuel Levinas," in *Writing and Difference*, trans. Alan Bass (Chicago: University of Chicago Press, 1978), 82.

[13] Ibid., 100.

[14] Cf. ibid., 98.

[15] NEAL STEPHENSON, *Snow Crash* (New York: Bantam Books, 1993), 218.

[16] RICHARD AVEDON, artist's statement in Carroll T. Hartwell, ed., *Avedon*, exh. cat. (Minneapolis: Minneapolis Institute of Art, 1970), unpag.

[17] MARK C. TAYLOR, *Hiding* (Chicago: University of Chicago Press, 1997), 17–18.

[18] Ibid., 30.

[19] Ibid., 38. Taylor is referring to DENNIS POTTER's novel *The Singing Detective* (Boston: Faber and Faber, 1986), a mystery with countless clues and no solutions. A televised adaptation was shown in England in 1986 and the United States in 1988. JON AMIEL, dir., *The Singing Detective*, prod. John Harris. (British Broadcasting Corp. and the Australian Broadcasting Corp., 1986.)

[20] FRANÇOIS DAGOGNET, "Toward a Biopsychiatry," trans. Donald M. Leslie, in Jonathan Crary and Sanford Kwinter, eds., *Incorporations, Zone 6* (New York: Zone Books, 1992), 531–2, 518.

[21] Both Taylor and Dagognet, arguing from rather different positions, cite this Poe tale. See TAYLOR, *Hiding*, 25; and DAGOGNET, "Toward a Biopsychiatry," 518.

It's simple: just look at the mantel (or the mantle). The look is all there is; to look is all there is to do. There is the look, the noun, like fashion designer Christian Dior's "New Look" of the late 1940s. And there is look, the verb, as in Bob Dylan's lyric about a face that is "so easy to look at, so hard to define."[22] Looking, in the sense of actively perceiving someone or of appearing to someone else, is a fundamental means of understanding, but it is also problematic. There is, to be sure, the gaze or stare that objectifies the other and may distort the act of looking into one of control or rejection, as when we transform a human being into an object of sexual desire or when we turn away from the face of someone who has been disfigured (a burn victim, someone with facial cancer, a child with progeria, for instance). But objectification is really only a matter of wanting to possess and thus "projecting [one's] lack onto the other," according to Amelia Jones.[23] And science historian Georges Canguilhem cautions us to consider that the "abnormal is not what is not normal, but what constitutes another normal."[24] Faciality, that visual dialogue that precedes language and cannot be comprehended by any logos, is much more than political control or clinical distancing, much more than Charcot's observational stare. It is the union of both looks (both noun and verb), a suturing of the inner and the outer, projection and reflection, that operates in physiognomic, phrenologic, and pathognomic expression. In vision, the I who desires and the eye that perceives come together and make the self possible. "The subject is never complete with itself," writes Jones, "but is always contingent on others, and the glue of this intersubjectivity is the desire binding us together."[25] And while *psyche* may no longer be conflated with *logos, anima* may certainly be conjoined with the profundity of *imago*. "Since when," asks Barbara Stafford rhetorically, "does working with surfaces qualify as shallowness?"[26]

The eye is the organ of this visual dialogue, and the camera's lens is not unlike this organ. The eye and the camera's lens each functions as an aperture through which the other's face enters into representation in the brain or on film. And since our lives may very well be channeled "toward some final reality in print or on film,"[27] to Darwin's "first means of communication" and to Levinas's "first philosophy" I would suggest adding film director Wim Wenders's concept of "first sight," in which "the more precision, concentration, and emotional involvement the cameraman or camerawoman brings to the 'objective image,' the more complex and many-layered and accurate the 'subjective image' will become."[28] If the face incarnates subjectivity, then so does the image. Brita Nilsson, the fictional photographer in Don Delillo's short story "Shooting Bill Gray," exercises this sort of first sight:

[She] watched him surrender his crisp gaze to a softening, a bright-eyed fear that seemed to tunnel out of childhood. It had the starkness of a last prayer. She worked to get at it. His face was drained and slack, coming into flatness, into black and white, cracked lips and flaring brows, age lines that hinge the chin, old bafflements and regrets. She moved in closer and refocused, she shot and shot, and he stood there looking into the lens, soft eyes shining.[29]

Forget about skin, bones, and muscles. Ultimately there is only the *irido,* the iris that looks out and sees the other's face, and the eye that receives and returns the glance. At this point the surface is indeed profound: at this juncture between the interior and exterior, there is a ligature of mind and body, consciousness and countenance, camera lens and human eye, the iridic surfaces of platinum prints and the carnal surfaces of human faces. Our identities may eventually be tracked in a retinal scan, in the genes of our bodies, or in the memes of our minds, but the surfaces of photographic prints, as well as those of projection screens and video monitors, still correspond rather nicely to the surfaces of human faces, just as photographic representation has decisively influenced modern

22 BOB DYLAN, "Sara," in *Desire* (Columbia Records, CK33893, 1975), track 9.

23 AMELIA JONES, "Tracing the Subject with Cindy Sherman," in Amada Cruz, Elizabeth A. T. Smith, and Jones, *Cindy Sherman: Retrospective,* exh. cat. (New York: Thames and Hudson, 1997), 48.

24 GEORGES CANGUILHEM, *The Normal and the Pathological,* trans. Carolyn R. Fawcett with Robert S. Cohen (New York: Zone Books, 1989), 203. Similarly, Friedrich Nietzsche wrote, "It is the value of all morbid states that they show us under a magnifying glass certain states that are normal—but not easily visible when normal"; quoted in ibid., 45.

25 JONES, "Tracing the Subject with Cindy Sherman," 48.

26 BARBARA MARIA STAFFORD, *Good Looking: Essays in the Virtue of Images* (Cambridge: MIT Press, 1996), 7.

27 DON DELILLO, "Shooting Bill Gray," *Esquire,* January 1991, 96. Delillo is not alone in this thought. J. G. BALLARD has also written, "Even in the privacy of our own homes we had all been recruited to play our parts in what were little more than real-life commercials." *The Kindness of Women* (New York: Farrar, Straus and Giroux, 1991), 246.

28 WIM WENDERS, "The Act of Seeing," in *The Act of Seeing: Essays and Conversations,* trans. Michael Hofmann (London and Boston: Faber & Faber, 1997), 22.

29 DELILLO, "Shooting Bill Gray," 96.

OPPOSITE
Alfredo Jaar,
Four Times Nguyen,
1995,
cat. no. 60.

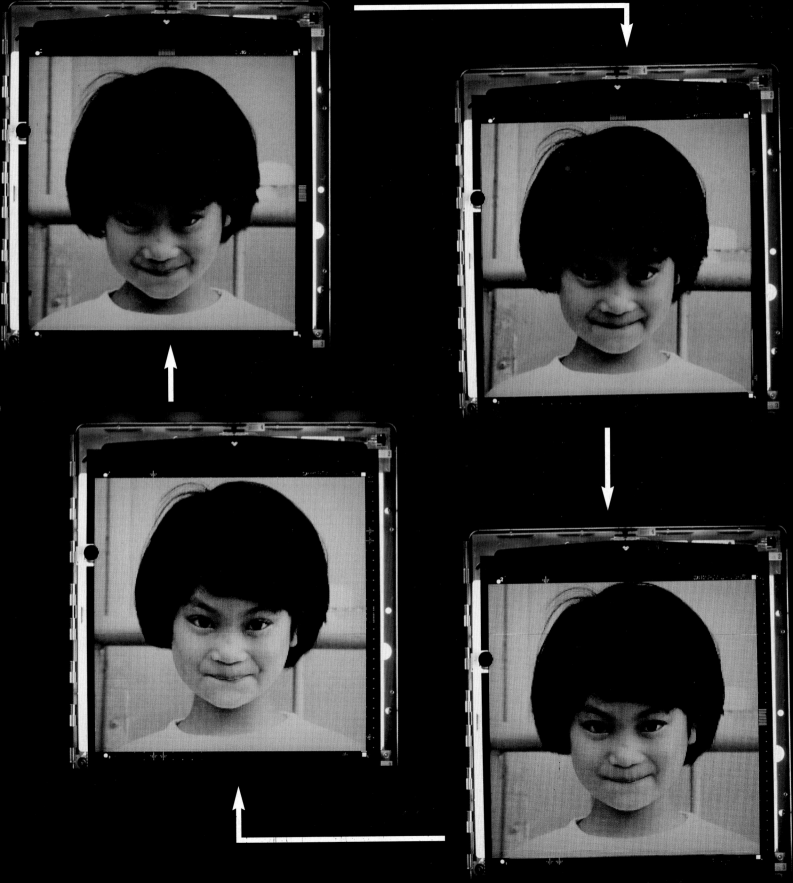

human vision itself.[30] In planar representation, therefore, there has been and continues to be a profound confrontation between face and image, and it is visual. As critic Christiane Schneider contends, "the end of the search for 'essence' is in sight."[31]

Despite its history of aniconicism, from the iconophobia of Cromwell to the prosecutional censorship of Robert Mapplethorpe's photographs by the District Attorney of Cincinnati, our culture has been appropriately characterized as "ocularcentric," and we are now confronted with the very real possibility that "everything which becomes present, everything which happens or presents itself, is apprehended [solely] within the [subjective] form of representation."[32] Descartes, although he ultimately rejected ocular vision as deceptive and favored the authority of pure reason, was avidly fascinated by optics and the metaphorics of light.[33] Hegel, who granted that vision leads us to objectify the things (and people) we see, also conceived of a "visual intuition" that was rather generous in regarding them, without the need to dominate, "as things with which we dwell and share a common space."[34] Nietzsche, while mostly dismissive of the privileging of vision, still maintained that "there is only a seeing from a perspective, only a 'knowing' from a perspective, and the *more* emotions we express over a thing, the *more* eyes, different eyes, we train on the same thing, the more complete will be our 'idea' of that thing, our 'objectivity.'"[35] Postmodernist Mieke Bal further disposes of the notion of a single "objective" vision and proposes that "differentiating modes if not kinds of vision—multiplying perspectives, proliferating points of view—may be a more useful strategy."[36]

OPPOSITE
Yasuhiro Ishimoto,
Portrait, 1968–69,
cat. no. 59.

Soon we may be compelled to invent still-unimagined ways of thinking about what makes us who or what we are or may become, contingently or otherwise. Undoubtedly both vision and the nature of representation will come under an even more precarious questioning than ever before as we progressively incorporate ourselves into the non-Cartesian coordinates of cyberspace and the virtual, where individuality is more ineffable than even Goethe could have imagined.[37] Yet the careful rendering of the human face will certainly persist and prevail. Artaud may have felt that the face was an "empty force," but he strongly defended the artistic representation of human faces "such as they are; for such as they are they have not yet found the form that they promise and designate."[38] We are heirs to a long and rich history of depicting the human countenance and striving to capture its promised form through the photographic arts. For more than a century and a half, artists with cameras have been exposing the gymnastics of the human soul, measuring the tolerances of the human face, and constructing abstract machines of faciality. More eyes and different ones, indeed. The eyes of these artists, coupled with the lenses of their cameras, have contributed in no small way to the proliferation of perspectives that we have come to regard as more appropriate and correct than any single point of view. They have borne and will continue to bear witness to the various ghosts in our individual shells.

[30] Cf. MARX W. WARTOFSKY, "Cameras Can't See: Representation, Photography, and Human Vision," *Afterimage* 7/9 (April 1980): 8. See also MARTIN JAY, *Downcast Eyes: The Denigration of Vision in Twentieth-Century French Thought* (Berkeley: University of California Press, 1994), 4–5.

[31] CHRISTIANE SCHNEIDER, "Inez van Lamsweerde: The Soulless New Machine," *Camera Austria* 51/52 (1995): 87.

[32] DAVID MICHAEL LEVIN, introduction to Levin, ed., *Modernity and the Hegemony of Vision* (Berkeley: University of California Press, 1993), 6. Words in brackets are in the original. This volume of important essays came to my attention while the present manuscript was being edited.

[33] DALIA JUDOVITZ, "Vision, Representation, and Technology in Descartes," in Levin, *Modernity and the Hegemony of Vision*, 64.

[34] HEGEL, quoted in Stephen Houlgate, "Vision, Reflection, and Openness: The 'Hegemony of Vision' from a Hegelian Point of View," in Levin, *Modernity and the Hegemony of Vision*, 114. LEVIN makes a distinction between an "assertoric" and an "aletheic" gaze in *The Opening of Vision: Nihilism and the Postmodern Situation* (New York: Routledge, 1988), 68; MARTIN JAY defines these terms as "abstracted, monocular, inflexible, unmoving, rigid, ego-logical, and exclusionary" vs. "multiple, aware of its context, inclusionary, horizonal, and caring," in *Downcast Eyes*, 275.

[35] FRIEDRICH NIETZSCHE, *The Genealogy of Morals* 3:12, trans. Horace B. Samuel, in *The Philosophy of Nietzsche* (New York: The Modern Library, 1954), 745.

[36] MIEKE BAL, "His Master's Eye," in Levin, *Modernity and the Hegemony of Vision*, 379.

[37] GOETHE's phrase *individuum est ineffable* appropriately appears in a letter written to Johann Kaspar Lavater. HEINRICH FUNCK, ed., *Goethe und Lavater: Briefe und Tagebücher* (Weimar: Goethe-Gesellschaft, 1901), 138; quoted in Christoph Siegrist, "'Letters of the Divine Alphabet'—Lavater's Concept of Physiognomy," in Ellis Shookman, ed., *The Faces of Physiognomy: Interdisciplinary Approaches to Johann Caspar Lavater* (Columbus, s.c.: Camden House, 1993), 29.

[38] ANTONIN ARTAUD, preface to exhibition of his portraits at Galerie Pierre, Paris, in Margit Rowell, ed., *Antonin Artaud: Works on Paper*, exh. cat. (New York: Museum of Modern Art, 1996), 94.

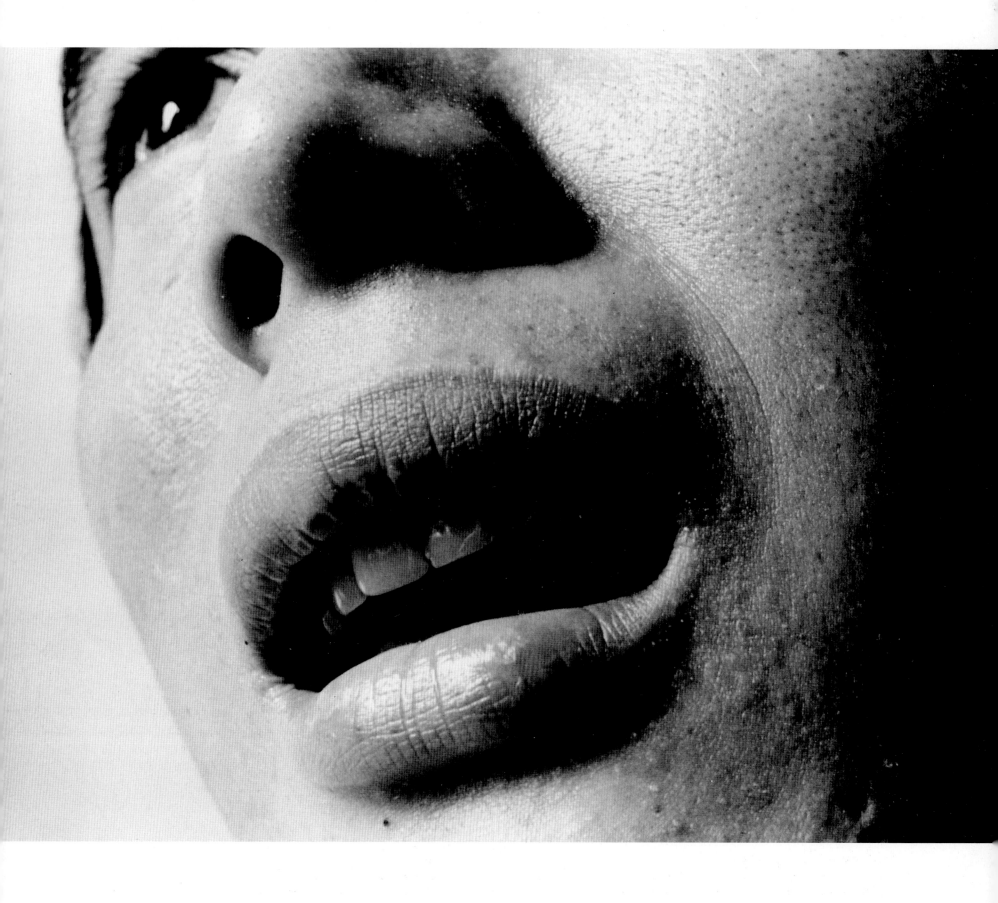

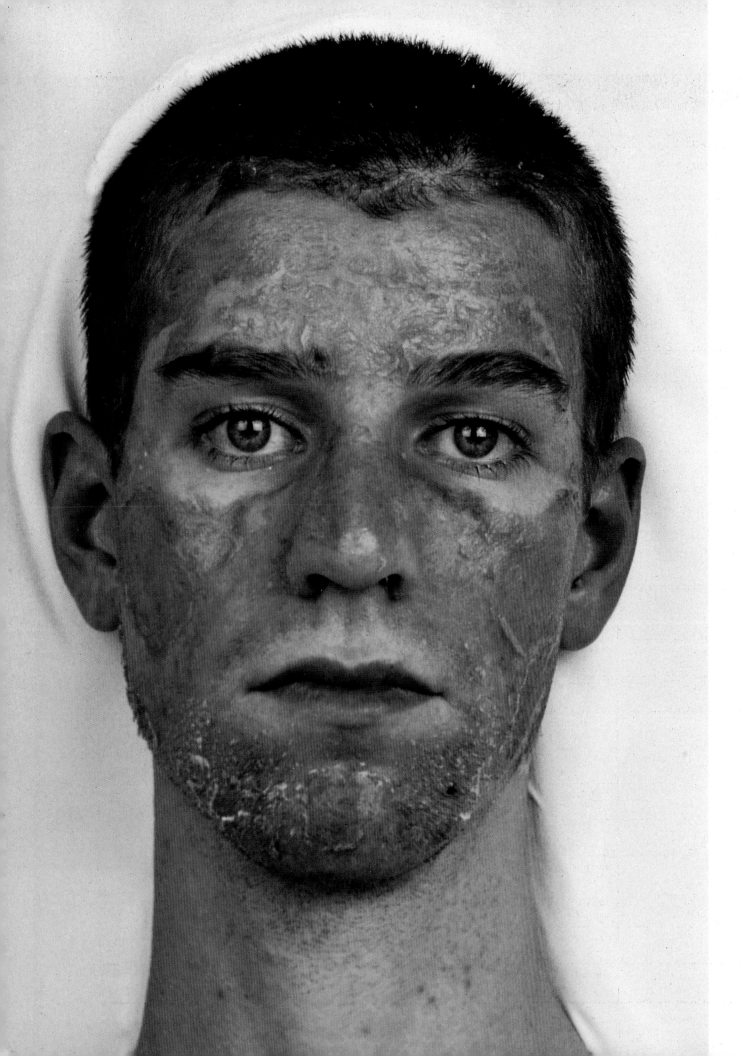

Lennaart van
Oldenborgh,
Peeling, 1994,
cat. no. 132.

CATALOGUE OF THE EXHIBITION

CAT. NO.	ARTIST, COUNTRY, AND DATES	TITLE AND DATE	DETAILS
1. (page 103)	**Antoine Samuel Adam-Salomon** France, 1811–1881	*Charles Garnier (of the Opéra)*, c. 1866	From *Galérie contemporaine, artistique, nouvelle série* (Paris, 1876–84), woodburytype print, 9½ x 7⅛ in. (24.1 x 18.1 cm), Los Angeles County Museum of Art, gift of Audrey and Sydney Irmas
2. (page 236)	**Diane Arbus** United States, 1923–1971	*Boy with a Straw Hat Waiting to March in a Pro-War Parade, N.Y.C.*, 1967/ printed later	Gelatin-silver print, printed by Neal Selkirk, 14⅜ x 16 in. (37.3 x 40.8 cm), Center for Creative Photography, The University of Arizona, Tucson
3. (page 15)		*Puerto Rican Woman with Beauty Mark, N.Y.C.*, 1965/ printed later	Gelatin-silver print, printed by Neal Selkirk, 14½ x 14⅝ in. (36.8 x 37.2 cm), Los Angeles County Museum of Art, purchased with funds provided by the Robert Mapplethorpe Foundation
4. (page 31)		*Untitled (6)*, 1970–71/printed later	Gelatin-silver print, printed by Neil Selkirk, 15⅜ x 15¼ in. (39 x 38.7 cm), Los Angeles County Museum of Art, purchased with funds provided by the Robert Mapplethorpe Foundation and the Ralph M. Parsons Fund
5. (page 228)	**Richard Avedon** United States, b. 1923	*Oscar Levant, Pianist, April 12, 1972, Beverly Hills, California*, 1972	Gelatin-silver print, 46 x 46 in. (116.8 x 116.8 cm), Center for Creative Photography, Tucson, Ariz.
6. (page 168)	**Anthony Aziz** United States, b. 1961 and **Sammy Cucher** Venezuela, active United States, b. 1958	*Maria*, 1994	From the Dystopia series, chromogenic-development print, 51¼ x 44¼ in. (130.2 x 112.4 cm), Los Angeles County Museum of Art, Ralph M. Parsons Fund
7. (page 8)	**Ernest A. Bachrach** United States, 1899–1973	*Katharine Hepburn*, 1937	Gelatin-silver print, 10 x 8½ in. (25.5 x 20.6 cm), Los Angeles County Museum of Art, gift of Graham Nash
8. (page 116)	**Alphonse Bertillon** France, 1853–1914	*Type portraits indicating the placement of the focal measure and the scale of the reduction (1/7) for judiciary photographs*, c. 1890	From *La Photographie judiciaire* (Paris, 1890), collotype print, 5½ x 3 in. (14 x 7.6 cm), George Eastman House, Rochester, N.Y.
9. (page 162)	**Dawoud Bey** United States, b. 1953	*Amishi*, 1993	4 internal-dye-diffusion-transfer (Polacolor ER) prints, 24 x 20 in. (61 x 50.8 cm) each, Rhona Hoffman Gallery, Chicago
10. (page 111)	**Prince Roland Bonaparte** France, 1858–1924	*Kolleté*, c. 1883	From *Les Habitants de Suriname, Notes recueilliés à L'Exposition coloniale d'Amsterdam en 1883* (Paris, 1884), 2 collotype prints, 9¼ x 6¾ in. (23.5 x 17.1 cm) each, University of Southern California Libraries, Special Collections
11. (page 205)	**Arturo Bragaglia** Italy, 1893–1962	*Polyphysiognomic Portrait*, 1930	Gelatin-silver print, 3³⁄₁₆ x 4³⁄₁₆ in. (8.4 x 10.6 cm), J. Paul Getty Museum, Los Angeles
12. (page 137)	**Max Burchartz** Germany, 1887–1961	*Lotte's Eye*, c. 1928	Gelatin-silver print, 12¾ x 17⅜ in. (32.5 x 44.1 cm), Museum Folkwang, Essen
13. (page 128)	**Nancy Burson** United States, b. 1948	*5 Vogue Models*, 1989/printed 1999	Gelatin-silver print, 9¼ x 8½ in. (23.5 x 21.6 cm), Los Angeles County Museum of Art, Ralph M. Parsons Fund
14. (page 166)		*Untitled (Lizard/Man)*, 1989	Internal-dye-diffusion-transfer (Polaroid ER) print, 20 x 24 in. (50.8 x 61 cm), Los Angeles County Museum of Art, Ralph M. Parsons Fund
15. (page 66)	**M. de C.** France, active 1860s	*In the Family: Sisterly Solicitude*, 1862	From the album *Essais photographiques* (1862), albumen print, 8¼ x 6½ in. (21 x 16.5 cm), George Eastman House, Rochester, N.Y.
16. (page 217)	**Claude Cahun** (Lucy Schwob) France, 1894–1954	*I.O.U. (Self-Pride)*, c. 1930	Gelatin-silver print, 6 x 4⅛ in. (15.2 x 10.5 cm), Los Angeles County Museum of Art, The Audrey and Sydney Irmas Collection
17. (page 177)	**Julia Margaret Cameron** India, active England and Ceylon, 1815–1879	*The Angel at the Tomb*, 1870	Albumen print, 13¹¹⁄₁₆ x 10⅜ in. (34.8 x 26.3 cm) (arched), George Eastman House, Rochester, N.Y.
18. (page 177)		*Mrs. Herbert Duckworth as Julia Jackson*, 1867	Albumen print, 13⅜ x 9⅝ in. (34 x 24.4 cm), George Eastman House, Rochester, N.Y., gift of Alden Scott Boyer
19. (page 50)	**Etienne Carjat** France, 1828–1906	*Charles Baudelaire*, 1863	From *Galérie contemporaine, artistique, nouvelle série* (Paris, 1876–84), woodburytype print, 9½ x 7½ in. (24.1 x 19.1 cm), Stephen Cohen Gallery, Los Angeles
20. (page 224)	**Alexandre Castonguay** Canada, b. 1968	*Admiration 0, 0, 204*, 1998	From the series *Le Dessin des passions*, chromogenic-development print, 24 x 20 in. (61 x 50.8 cm), courtesy the artist, Hull, Quebec

CATALOGUE OF THE EXHIBITION

CAT. NO.	ARTIST, COUNTRY, AND DATES	TITLE AND DATE	DETAILS
21. (page 28)	**Chuck Close** United States, b. 1940	*Alex*, 1987/printed 1996	Inkjet (Iris) print from scanned Polaroid print, 41 x 32⅛ in. (104.1 x 81.6 cm), courtesy Pace/Wildenstein/MacGill Gallery, New York and Beverly Hills
22. (page 165)		*Working Photograph for Phil*, 1969	Gelatin-silver print, ink, and masking tape, 13¾ x 10¾ in. (34.9 x 27.3 cm), George Eastman House, Rochester, N.Y., Lila Acheson Wallace Fund
23. (page 89)	**Alvin Langdon Coburn** United States, 1882–1966	*W. B. Yeats, Dublin, January 24th, 1908*, 1908	From *Men of Mark* (New York, 1913), photogravure print, 8 x 6¼ in. (20.3 x 15.9 cm), George Eastman House, Rochester, N.Y., gift of the artist
24. (page 185)	**Keith Cottingham** United States, b. 1965	*Triplets*, 1993	From the Fictitious Portraits series, chromogenic-development (Fujicolor) print, 22 x 18½ in. (55.9 x 47 cm), Los Angeles County Museum of Art, Ralph M. Parsons Fund
25. (page 112)	**Edward S. Curtis** United States, 1868–1952	*A Hopi Man*, 1921	From *The North American Indian, Being a Series of Volumes Picturing and Describing the Indians of the United States and Alaska*, vol. 12 (Norwood, Mass., 1922), photogravure print, 22 x 18⅛ in. (55.9 x 46 cm), Los Angeles County Museum of Art, Ralph M. Parsons Fund
26. (page 211)	**Salvador Dalí** Spain, 1904–1989	*The Phenomenon of Ecstasy*, 1933	From *Minotaur* (Paris, 1933) (facsimile reprint, Skira, c. 1975), photomechanical illustration, 12½ x 9½ in. (31.8 x 24.1 cm), private collection, Los Angeles
27. (page 226)	**Judy Dater** United States, b. 1941	*Twinka Thiebaud, Actress, Model*, 1970	Gelatin-silver print, 9⅜ x 7⅜ in. (23.8 x 18.7 cm), private collection, Los Angeles
28. (page 57)	**Dr. Hugh Welsh Diamond** England, 1809–1886	*Seated Woman with Birds*, c. 1855	Albumen print, 7½ x 5⁷⁄₁₆ in. (19.1 x 13.8 cm), J. Paul Getty Museum, Los Angeles
29. (page 57)		*Seated Woman with Purse*, c. 1855	Albumen print, 7¹¹⁄₁₆ x 5⁹⁄₁₆ in. (20 x 14.3 cm), J. Paul Getty Museum, Los Angeles
30. (page 19)	**André-Adolphe-Eugène Disdéri** France, 1819–1889	*Emperor Napoléon III*, c. 1859–60	Albumen print *(carte-de-visite)*, 3½ x 2³⁄₁₆ in. (8.9 x 5.6 cm), J. Paul Getty Museum, Los Angeles
31. (page 104)		*Unidentified Female*, c. 1859–60	Albumen print *(carte-de-visite)*, 3½ x 2³⁄₁₆ in. (8.9 x 5.6 cm), J. Paul Getty Museum, Los Angeles
32. (page 105)		*Unidentified Female*, c. 1859–60	Albumen print *(carte-de-visite)*, 3½ x 2³⁄₁₆ in. (8.9 x 5.6 cm), J. Paul Getty Museum, Los Angeles
33. (page 107)		*Unidentified Female*, c. 1859–60	Albumen print *(carte-de-visite)*, 3½ x 2³⁄₁₆ in. (8.9 x 5.6 cm), J. Paul Getty Museum, Los Angeles
34. (page 105)		*Unidentified Male*, c. 1859–60	Albumen print *(carte-de-visite)*, 3½ x 2³⁄₁₆ in. (8.9 x 5.6 cm), J. Paul Getty Museum, Los Angeles
35. (page 106)		*Unidentified Male*, c. 1859–60	Albumen print *(carte-de-visite)*, 3½ x 2³⁄₁₆ in. (8.9 x 5.6 cm), J. Paul Getty Museum, Los Angeles
36. (page 106)		*Unidentified Male*, c. 1859–60	Albumen print *(carte-de-visite)*, 3½ x 2³⁄₁₆ in. (8.9 x 5.6 cm), J. Paul Getty Museum, Los Angeles
37. (page 242)	**Georg Jiri Dokoupil** Czechoslovakia, b. 1954	*Madonna in Ecstasy*, 1985–87	Chromogenic-development print, 39⅜ x 39⅜ in. (100 x 100 cm), collection F. C. Gundlach, Hamburg
38. (page 145)	**Sante d'Orazio** United States, b. 1956	*Kate Moss, West Village, NYC*, 1992	Gelatin-silver print, 48 x 36 in. (121.9 x 91.4 cm), Los Angeles County Museum of Art, Ralph M. Parsons Fund
39. (page 230)	**Marcel Duchamp** France, active France and United States, 1887–1968	*Roulette de Monte Carlo/Obligation de Cinq Cents Francs (Monte Carlo Bond)*, 1924/printed later	"Rectified readymade" facsimile from *De ou par Marcel Duchamp ou Rrose Sélavy (La Boîte en valise)* (Paris and Milan, 1955–68), photolithographic print, 12⅜ x 7¾ in. (31.4 x 19.7 cm), Los Angeles County Museum of Art, gift of the Grinstein Family
40. (page 231)		*Wanted/$2,000 Reward*, 1923/printed later	"Rectified readymade" facsimile from *De ou par Marcel Duchamp ou Rrose Sélavy (La Boîte en valise)* (Paris and Milan, 1955–68), photolithographic print, 8¼ x 6⅜ in. (2.1 x 16.2 cm), Los Angeles County Museum of Art, gift of the Grinstein Family

CAT. NO.	ARTIST, COUNTRY, AND DATES	TITLE AND DATE	DETAILS
41. (page 63)	**G.-B. Duchenne de Boulogne** France, 1806–1875	"Maternal Happiness Mixed with Pain, a Psychological and Aesthetic Study of the Expression Resulting from the Conflict of Joy and Crying," c. 1862	From *Mécanisme de la physionomie humaine; ou, Analyse électro-physiologique de l'expression* (Paris, 1862), albumen print, 4⅜ x 3¼ in. (11.1 x 8.3 cm), The Getty Research Institute, Research Library
42. (page 38)		"Specimen of an Electrophysiological Experiment," c. 1854–62	From *Mécanisme de la physionomie humaine; ou, Analyse électro-physiologique de l'expression* (Paris, 1862), albumen print, 4⅜ x 3¼ in. (11.1 x 8.3 cm), University of California, San Francisco, University Research Library, Special Collections
43. (page 261)	**Louis Ducos du Hauron** France, 1837–1920	*Self-Portrait Deformation*, c. 1888	Albumen print, 3½ x 5½ in. (8.9 x 14 cm), George Eastman House, Rochester, N.Y., gift of Eastman Kodak Company, ex-collection Gabriel Cromer
44. (page 123)	**Nhem Ein** Cambodia, b. 1959	*Untitled (No. 5184)*, 1978/printed 1994	Gelatin-silver print, printed by Chris Riley and Doug Niven, 14 x 11 in. (35.6 x 27.9 cm), Los Angeles County Museum of Art, Ralph M. Parsons Fund
45. (pages 208–9)	**Sergei Eisenstein** Russia, 1898–1948	*The General Line*, 1930	From *Documents* (Paris, 1930), photomechanical illustration, 10⅜ x 8 in. (26.4 x 20.3 cm), Los Angeles County Museum of Art Research Library
46. (page 138)	**Walker Evans** United States, 1903–1975	*Alabama Cotton Tenant Farmer's Wife*, 1936	Gelatin-silver print, 8¼ x 6¹¹⁄₁₆ in. (21 x 17 cm), The Art Institute of Chicago, gift of Mrs. James Ward Thorne, 1962.158
47. (page 9)		*Young Girl*, c. 1936	Gelatin-silver print, 7¾ x 9½ in. (19.7 x 24.1 cm), Los Angeles County Museum of Art, Ralph M. Parsons Fund
48. (page 125)	**Francis Galton** England, 1822–1911	*Composite Portraits*, c. 1883	From *Inquiries into Human Faculty and Its Development* (London, 1883), albumen print, 9 x 6⅜ in. (23 x 16.1 cm), University of California, Los Angeles, Louise M. Darling Biomedical Library, History and Special Collections
49. (page 117)	**Alexander Gardner** Scotland, active United States, 1821–1882	*George B. Atzerodt*, 1865	From *Lincoln Conspiracy Album* (1865), albumen print, 6½ x 5¹⁄₁₆ in. (16.5 x 12.9 cm), George Eastman House, Rochester, N.Y.
50. (page 270–1)	**Douglas Gordon** Scotland, b. 1966	*Monster*, 1997	Transmounted chromogenic-development print, 30¼ x 46¼ in. (76.8 x 117.5 cm), collection Peter and Eileen Norton, Santa Monica
51. (page 233)	**Greg Gorman** United States, b. 1949	*Djimon Screaming*, 1991	Gelatin-silver print, 20 x 16 in. (50.8 x 40.6 cm), Fahey/Klein Gallery, Los Angeles
52. (page 244)	**Lyle Ashton Harris** United States, b. 1965	*Man and Woman #2*, 1987–88	Gelatin-silver print, 60 x 40 in. (152.4 x 101.6 cm), Thomas Erben Gallery, New York
53. (page 180)	**Robert Heinecken** United States, b. 1931	*Figure #34*, 1985/printed 1999	From *1984: A Case Study in Finding an Appropriate TV Newswoman (A CBS Docudrama in Words and Pictures)*, inkjet (Iris) print, 40 x 50 in. (101.6 x 127 cm), Los Angeles County Museum of Art, Ralph M. Parsons Fund
54. (page 249)	**Gottfried Helnwein** Austria, active Germany, b. 1948	*Self-Portrait*, 1987	Internal-dye-diffusion-transfer-process (Polaroid) print, 33 x 22 in. (83.8 x 55.9 cm), Los Angeles County Museum of Art, Ralph M. Parsons Fund
55. (page 158)	**Bill Henson** Australia, b. 1955	*Untitled*, 1985–86	Chromogenic-development print, 40 x 32 in. (101.6 x 81.3 cm), Karyn Lovegrove Gallery, Los Angeles
56. (page 90)	**Alexander Hesler** United States, 1823–1895	*Abraham Lincoln*, 1860/printed 1870–80s	Salted-paper print, 8 x 6 in. (20.3 x 15.2 cm), Los Angeles County Museum of Art, gift of the Sid and Diana Avery Trust
57. (page 101)	**David Octavius Hill** Scotland, 1802–1870 and **Robert Adamson** Scotland, 1821–1848	*Portrait of William Etty, Royal Academy*, 1844	Salted-paper print from calotype negative, 8 x 5½ in. (20.3 x 13.9 cm), Los Angeles County Museum of Art, gift of Sue and Albert Dorskind
58. (page 237)	**Eikoh Hosoe** Japan, b. 1933	*Ordeal by Roses #32*, 1962	From *Ordeal by Roses* (Tokyo, 1963), gelatin-silver print, 20 x 24 in. (50.8 x 61 cm), courtesy the artist, Tokyo
59. (page 291)	**Yasuhiro Ishimoto** United States and Japan, active Japan, b. 1921	*Portrait*, 1968–69	Gelatin-silver print, 14 x 11 in. (35.6 x 27.9 cm), Los Angeles County Museum of Art, Ralph M. Parsons Fund

CAT. NO.	ARTIST, COUNTRY, AND DATES	TITLE AND DATE	DETAILS
60. (page 289)	**Alfredo Jaar** Chile, active United States, b. 1956	*Four Times Nguyen*, 1995	Silver-dye-bleach (Cibachrome) transparency and Quadvision lightbox, 25½ x 22¾ x 3¾ in. (64.8 x 57.8 x 9.5 cm), Los Angeles County Museum of Art, Ralph M. Parsons Fund
61. (page 88)	**Gertrude Stanton Käsebier** United States, 1852–1934	*Portrait (Miss N.)*, c. 1902	From *Camera Work* (New York, 1903), photogravure print, 7⅝ x 5¾ in. (19.5 x 14.7 cm), George Eastman House, Rochester, N.Y., gift of the 3M Company
62. (page 238)	**William Klein** United States, active United States and France, b. 1928	*Four Heads, Thanksgiving Day, NY,* 1954/printed later	Gelatin-silver print, 16¾ x 13 in. (42.5 x 33 cm), Howard Greenberg Gallery, New York
63. (page 232)	**Suzanne Lafont** France, b. 1949	*Grimaces 28*, 1992	From *Choeur des Grimaces* series, silver-dye-bleach (Cibachrome) print, 55½ x 44½ in. (141 x 113 cm), Los Angeles County Museum of Art, Ralph M. Parsons Fund
64. (page 139)	**Dorothea Lange** United States, 1896–1965	*Migrant Mother, Nipomo, California,* 1936/printed later	Gelatin-silver print, 13³⁄₁₆ x 10⁷⁄₁₆ in. (34 x 26.5 cm), promised gift of Barbara and Buzz McCoy to the Los Angeles County Museum of Art
65. (page 223)	**Daniel Lee** China, active United States, b. 1945	*1949—Year of the Ox*, 1993	From the Manimal series, chromogenic-development print on foam core, 30 x 23 in. (76.2 x 58.4 cm), J. J. Brookings Gallery, San Francisco
66. (page 235)	**Annie Leibovitz** United States, b. 1949	*Jessye Norman, New York City*, 1988	Platinum print, 14½ x 18½ in. (36.8 x 47 cm), James Danziger Gallery, New York
67. (page 135)	**Helmar Lerski** (Israel Schmuklerski) France, active Switzerland and Israel, 1871–1956	*German Housekeeper*, 1928–31	Gelatin-silver print, 11¼ x 9⅛ in. (28.6 x 23.2 cm), George Eastman House, Rochester, N.Y.
68. (page 134)		*Veit Harlan, Film Director*, c. 1927	Gelatin-silver print, 9 x 6¾ in. (22.8 x 17.1 cm), Museum Folkwang, Essen, L 2399/79
69. (page 239)	**Leon Levinstein** United States, 1913–1988	*Woman with Child*, c. 1954	Gelatin-silver print, 11 x 13 in. (27.9 x 33 cm), Howard Greenberg Gallery, New York
70. (page 114)	**Cesare Lombroso** Italy, 1836–1909	*Portraits of German Criminals*, c. 1895	From *L'Homme criminel, criminel-né, fou, moral, épileptique: Etude anthropologique* *et médico-légale* (Paris, 1895), collotype print, 9¼ x 6⅝ in. (23.5 x 16.8 cm), The Getty Research Institute, Research Library
71. (page 191)	**Albert Londe** France, 1858–1917	*Hysterical Photophobia*, 1889	From *La Nouvelle Iconographie de la Salpêtrière, clinique des maladies du systeme* *nerveux, pub. sous la direction du professor Charcot* (Paris, 1889), collotype print, 6¼ x 4¼ in. (15.9 x 10.8 cm), University of California, Los Angeles, Louise M. Darling Biomedical Library, History and Special Collections Division
72. (page 197)	**Richard Cockle Lucas** England, 1800–1883	*He Studies "Divine Philosophy,"* 1865	From the album *50 Studies of Expression* (1865), albumen print, 3½ x 2¼ in. (8.9 x 5.7 cm), George Eastman House, Rochester, N.Y., gift of Alden Scott Boyer
73. (page 197)		*And "He Tears a Passion to Tatters,"* 1865	From the album *50 Studies of Expression* (1865), albumen print, 3½ x 2¼ in. (8.9 x 5.7 cm), George Eastman House, Rochester, N.Y., gift of Alden Scott Boyer
74. (page 218)	**Man Ray** (Emmanuel Rudnitsky) United States, active France and United States, 1890–1976	*Marquise Cassati (positive)*, 1922	Gelatin-silver print, 8⅝ x 6⅜ in. (21.9 x 16.2 cm), Museum Ludwig, Cologne
75. (page 143)	**Robert Mapplethorpe** United States, 1946–1989	*Ken Moody*, 1983	Gelatin-silver print, 20 x 16 in. (50.8 x 40.6 cm), The Robert Mapplethorpe Foundation, New York
76. (page 132)	**László Moholy-Nagy** Hungary, active Germany and United States, 1895–1946	*Portrait of Lucia Moholy*, c. 1926–29	Gelatin-silver print, 11½ x 8⁵⁄₁₆ in. (29.3 x 21.8 cm), collection Thomas Walther, New York
77. (page 248)	**Pierre Molinier** France, 1900–1976	*Untitled*, c. 1966	Gelatin-silver print, 6⅞ x 4⅞ in. (17.5 x 12.4 cm), Los Angeles County Museum of Art, The Audrey and Sydney Irmas Collection
78. (page 245)	**Yasumasa Morimura** Japan, b. 1951	*Self-Portrait (B&W)/* *Vivian Holding Camera*, 1996/97	Gelatin-silver print, 17½ x 14 in. (44.5 x 35.6 cm), Los Angeles County Museum of Art, Ralph M. Parsons Fund
79. (page 25)	**William Mortensen** United States, 1897–1965	*Suspicion*, c. 1935	Gelatin-silver print with patterned screen, 7¾ x 5¾ in. (19.7 x 14.6 cm), Center for Creative Photography, The University of Arizona, Tucson

CAT. NO.	ARTIST, COUNTRY, AND DATES	TITLE AND DATE	DETAILS
80. (page 240)	**Nickolas Muray** Hungary, active United States, 1892–1965	*Ezio Pinza,* 1946	Color-carbro print, 12⅜ x 17 in. (31.4 x 43.2 cm), George Eastman House, Rochester, N.Y., gift of Mrs. Nickolas Muray
81. (page 102)	**Nadar** (Gaspard Félix Tournachon) France, 1820–1910	*George Sand,* c. 1864	From *Galérie contemporaine, artistique, nouvelle série* (Paris, 1876–84), woodburytype print, 9⅛ x 6⅝ in. (23.2 x 16.8 cm), Los Angeles County Museum of Art, gift of Audrey and Sydney Irmas
82. (page 71)	**Nadar** (Gaspard Félix Tournachon) France, 1820–1910 and **Adrien Tournachon** France, 1825–1903	*Pierrot Listening,* 1854–55	Gelatin-coated salted-paper print, 11 x 8⅛ in. (27.9 x 20.6 cm), collection Thomas Walther, New York
83. (pages 264–5)	**Bruce Nauman** United States, b. 1941	*Raw Material: Brrr . . . ,* 1990	Two-channel video and two-channel audio installation, dimensions variable, exhibition copy courtesy ZKM/Center for Art and Media— Museum for Contemporary Art, Karlsruhe
84. (page 27)	**Arnold Newman** United States, b. 1918	*Alfried Krupp,* 1963/printed 1983	Dye-imbibition (Kodak Dye Transfer) print, 19 x 13⅛ in. (48.3 x 33.3 cm), George Eastman House, Rochester, N.Y., gift of the Lila Acheson Wallace Fund
85. (page 127)	**Nicholas Nixon** United States, b. 1947	*M. A. E., Boston,* 1985	Gelatin-silver print, 20 x 24 in. (50.8 x 61 cm), Fraenkel Gallery, San Francisco
86. (page 160)	**Ken Ohara** Japan, active United States, b. 1942	*Untitled,* 1970/printed 1998	From *One* (Tokyo, 1970), gelatin-silver print 24 x 20 in. (61 x 50.8 cm), courtesy the artist, Glendale, Calif.
87. (page 161)		*Untitled,* 1970/printed 1998	From *One* (Tokyo, 1970), gelatin-silver print, 24 x 20 in. (61 x 50.8 cm), courtesy the artist, Glendale, Calif.
88. (pages 273–83)	**Orlan** France, b. 1947	*Entre-Deux,* 1993	From the project *Omnipresence,* 41 triptyphs of chromogenic-development prints (2 each), and date plates on steel, 64 x 12 in. (162.6 x 30.5 cm) each, Sandra Gering Gallery, New York
89. (page 266)	**Tony Oursler** United States, b. 1957	*Pressure (Flesh/Red),* 1996	Projector, VCR, videotape, tripod, wood, Plexiglas, ceramic, and water 53 x 11 x 11 in. (134.6 x 27.9 x 27.9 cm) (not including video equipment), collection Peter and Eileen Norton, Santa Monica
90. (page 222)	**William Parker** United States, b. 1932	*Fearful II,* 1990	From the series *Der wilde Mann:* The Temperaments, gelatin-silver print, hand applied color, 43 x 40 in. (109.2 x 101.6 cm), Los Angeles County Museum of Art, Ralph M. Parsons Fund
91. (page 214)	**József Pécsi** Hungary, 1889–1956	*Self-Portrait,* 1926	Gelatin-silver print, 3¾ x 3¼ in. (9.5 x 8.3 cm), collection Thomas Walther, New York
92. (page 159)	**Irving Penn** United States, b. 1917	*Cat Woman, New Guinea,* 1970/ printed 1979	Platinum palladium print, 21 x 19¼ in. (53.3 x 48.9 cm), Fahey/Klein Gallery, Los Angeles
93. (page 234)		*Truman Capote, NY,* 1965/ printed 1986	Platinum palladium print, 26 x 22 in. (66 x 55.9 cm), courtesy the artist
94. (page 225)	**Arnulf Rainer** Austria, b. 1929	*Untitled* (Overdrawing of Franz Xaver Messerschmidt Head), 1975–76	Oilstick on gelatin-silver print, 23⅜ x 18⅞ in. (59.4 x 48 cm), Die Sammlung Essl, Klosterneuburg, Austria
95. (page 267)	**Alan Rath** United States, b. 1959	*Togetherness II,* 1995	Steel, wood, aluminum, electronics, cathode-ray tubes, 64 x 48 x 13 in. (162.6 x 121.4 x 33 cm), collection W. Scott Woods, courtesy Haines Gallery, San Francisco
96. (page 189)	**Paul Regnard** France, 1850–1927	*Catalepsy Provoked by a Sudden Light,* 1879	From *L'Iconographie photographique de la Salpêtrière* (Paris, 1879–80), collotype print, 7 3/16 x 5⅞ in. (18.3 x 10.5 cm), Yale University, Harvey Cushing/ John Hay Whitney Medical Library
97. (page 186)		*Hystero-epilepsy: Hallucinations (Anguish),* 1877	From *L'Iconographie photographique de la Salpêtrière* (Paris, 1877), albumen print, 5¾ x 4⅝ in. (14.6 x 11.8 cm), Yale University, Harvey Cushing/John Hay Whitney Medical Library

CATALOGUE OF THE EXHIBITION

CAT. NO.	ARTIST, COUNTRY, AND DATES	TITLE AND DATE	DETAILS
98. (page 200)	**Oscar G. Rejlander** Sweden, active England, 1813–1875	*Disdain and Disgust,* 1872	From Charles Darwin, *The Expressions of the Emotions in Man and Animals* (London, 1872), collotype print, 7⅜ x 4⅞ in. (18.7 x 12.4 cm), private collection, Los Angeles
99. (page 199)		*The Sisters Nower,* 1860	Albumen print, 4¾ x 5¼ in. (12.1 x 13.3 cm), George Eastman House, Rochester, N.Y.
100. (page 142)	**Herb Ritts** United States, b. 1952	*Karen,* 1989	Gelatin-silver print, 20 x 16 in. (50.8 x 40.6 cm), Fahey/Klein Gallery, Los Angeles
101. (page 176)	**Marcus A. Root** United States, 1808–1888	*Edgar Allan Poe,* c. 1847	Daguerreotype, quarter plate, 3½ x 2¾ in. (8.9 x 7 cm), George Eastman House, Rochester, N.Y., gift of Mrs. Leonard W. Tregillus
102. (page 20)		*Self-Portrait,* 1855	Daguerreotype, half plate, 4½ x 5½ in. (11.4 x 14 cm), George Eastman House, Rochester, N.Y., gift of 3M Co., ex-collection Louis Walton Sipley
103. (page 164)	**Thomas Ruff** Germany, b. 1958	*Portrait (Anna Giese),* 1989	Chromogenic-development print, 85 x 65 in. (220.4 x 165.1 cm), courtesy Janet Borden Gallery, New York
104. (page 286)	**Sebastião Salgado** Brazil, b. 1944	*Blind Woman, Mali,* 1985/ printed 1990	Gelatin-silver print, 17½ x 11 ¹¹⁄₁₆ in. (44.5 x 29.7 cm), courtesy the artist and Peter Fetterman Gallery, Santa Monica
105. (page 247)	**Lucas Samaras** Greece, active United States, b. 1936	*Photo-Transformation, 11/1/73,* 1973	Internal-dye-diffusion-transfer (Polaroid sx-70) print, 3⅛ x 3 ¹⁄₁₆ in. (8 x 7.8 cm), Los Angeles County Museum of Art, Ralph M. Parsons Fund
106. (page 133)	**August Sander** Germany, 1876–1964	*Inmate of an Asylum,* 1930	Gelatin-silver print, 11⅛ x 8¼ in. (28.3 x 21 cm), Die Photographische Sammlung—August Sander Archiv/sk Stiftung Kultur, Cologne
107. (page 26)		*Photographer,* 1925	Gelatin-silver print, 9⅛ x 6¾ in. (23.2 x 17.1 cm), Die Photographische Sammlung—August Sander Archiv/sk Stiftung Kultur, Cologne
108. (page 14)	**Akira Sato** Japan, b. 1930	*Sweetheart,* 1962	From the Cyclopean Eye series, gelatin-silver print 16 x 20 in. (40.6 x 50.8 cm) Kawasaki City Museum
109. (page 243)	**Friedrich Seidenstücker** Germany, 1883–1966	*Untitled (Sch),* c. 1930	Gelatin-silver print, 7 x 5⅛ in. (17.8 x 13 cm), Los Angeles County Museum of Art, gift of Robert T. Singer
110. (pages 250–1)	**Jim Shaw** United States, b. 1952	*Computer Degenerated Self-Portrait,* 1992	5 chromogenic-development (Fujicolor) prints, 11 x 14 in. (27.9 x 35.6 cm) each, Los Angeles County Museum of Art, Ralph M. Parsons Fund
111. (pages 256–7)	**Cindy Sherman** United States, b. 1954	*Untitled #86,* 1981	Chromogenic-development print, 24 x 48 in. (61 x 122 cm), The Eli and Edythe L. Broad Collection, Los Angeles
112. (page 252)		*Untitled #108,* 1982	Chromogenic-development print, 36 x 26 in. (91.4 x 66 cm), San Francisco Museum of Modern Art, gift of Richard Lorenz
113. (page 259)		*Untitled #167,* 1986	Chromogenic-development print, 60 x 90 in. (152.4 x 228.6 cm), The Eli Broad Family Foundation, Santa Monica
114. (page 29)		*Untitled (Cosmo Cover Girl),* 1990	Chromogenic-development print, 17 x 11 in. (43.2 x 27.9 cm), Los Angeles County Museum of Art, Ralph M. Parsons Fund
115. (page 163)	**Katharina Sieverding** Czechoslovakia, active Germany, b. 1944	*Stauffenberg-Block III/XI,* 1969–96	2 chromogenic-development prints, 79 x 49 in. (200.7 x 124.5 cm) each, L. A. Louver Gallery, Venice, Calif.
116. (pages 206–7)	**Victor Skrebneski** United States, b. 1929	*Study for Portrait of Man Watching,* 1990	Gelatin-silver print, 20 x 30 in. (50.8 x 76.2 cm), Los Angeles County Museum of Art, Ralph M. Parsons Fund
117. (page 144)		*Vanessa Redgrave, Hollywood,* 1967/ printed 1991	Platinum print, 23⅞ x 20 in. (60.6 x 50.8 cm), Los Angeles County Museum of Art, gift of the artist
118. (page 20)	**Albert Sands Southworth** United States, 1811–1894 and **Josiah Johnson Hawes** United States, 1808–1901	*Lemuel Shaw,* c. 1860	Daguerreotype, half plate, 4½ x 5½ in. (11.4 x 14 cm), The Metropolitan Museum of Art, New York

CAT. NO.	ARTIST, COUNTRY, AND DATES	TITLE AND DATE	DETAILS
119. (page 22)	**Alfred Stieglitz** United States, 1864–1946	*Georgia O'Keeffe*, c. 1919	Gelatin-silver print, 9½ x 7⅝ in. (24.1 x 19.4 cm), The Metropolitan Museum of Art, New York, gift of Georgia O'Keeffe through the generosity of The Georgia O'Keeffe Foundation and Jennifer and Joseph Duke, 1997
120. (page 136)	**Paul Strand** United States, 1890–1976	*Blind Woman, NY*, 1915/printed 1945	Gelatin-silver print, 13¾ x 10⅝ in. (34.9 x 27 cm), George Eastman House, Rochester, N.Y.
121. (page 204)	**Tato** (Guglielmo Sansoni) Italy, 1896–1974	*Mechanical Portrait of Remo Chiti*, 1930	Gelatin-silver print, 9⅜ x 7 in. (23.8 x 17.8 cm), San Francisco Museum of Modern Art, Byron Meyer Fund Purchase
122. (page 109)	**E. Thiésson** France, active 1840s	*Native of Sofala, age 30 years*, 1849	Daguerreotype, half plate, 4½ x 5½ in. (11.4 x 14 cm), George Eastman House, Rochester, N.Y., gift of Eastman Kodak Company, ex-collection Gabriel Cromer
123. (page 167)	**Patrick Tosani** France, b. 1954	*Portrait #9*, 1985	Chromogenic-development print, 51 x 39 in. (129.5 x 99.1 cm), collection Liliane and Michel Durrand-Dessert, Paris
124. (page 193)	**Anton Josef Trčka** Austria, 1893–1940	*Portrait of the Painter Egon Schiele*, 1913	Gelatin-silver print, gold-toned, 7⅛ x 4⅝ in. (18.1 x 11.7 cm), collection Thomas Walther, New York
125. (page 216)	**Umbo** (Otto Umbehr) Germany, 1902–1980	*Warlike Face (Portrait of Paul Citroën)*, 1926/27	Gelatin-silver print, 7⅞ x 5¼ in. (20 x 13.3 cm), collection Thomas Walther, New York
126. (page 120)	**Unidentified photographer** United States, active 1910s	*Alexander B. Harley*, 1913	Gelatin-silver print, 2 9/16 x 4¼ in. (6.5 x 10.8 cm), private collection, Los Angeles
127. (page 121)	**Unidentified photographer** England, active 1880s	*Portraits of Prisoners, Wormwood Scrubs, London*, c. 1880,	12 albumen prints 3⅜ x 2½ in. (8.6 x 6.4 cm) each, National Museum of Photography, Film, & Television/Science & Society Picture Library, Bradford, England
128. (page 124)	**Unidentified photographer** England, active 1870s	*William Hawkins*, 1877	Albumen print, ink on paper, 3½ x 2⅛ in. (8.9 x 5.4 cm), Stephen Cohen Gallery, Los Angeles
129. (page 24)	**Unidentified photographer** United States, active 1910s–20s	*X-Ray of Human Skull* (anterior view), c. 1920	Gelatin-silver print, 9⅜ x 7⅜ in. (23.8 x 18.7 cm), Los Angeles County Museum of Art, Ralph M. Parsons Fund
130. (page 58)	**J. Valette** France, active 1870s	*Dementia and General Paralysis*, c. 1876	From Henri Dagonet, *Nouveau Traité élémentaire et pratique des maladies mentales suivi de considérations pratiques sur l'administration des asiles d'aliénés* (Paris, 1876), albumen print, 6⅝ x 4⅛ in. (16.8 x 10.5 cm), J. Paul Getty Museum, Los Angeles
131. (page 183)	**Inez van Lamsweerde** Netherlands, b. 1963	*Final Fantasy, Ursula*, 1993	Chromogenic-development print on Perspex, dibond, 38¼ x 59 in. (97.2 x 149.9 cm), collection Peter and Eileen Norton, Santa Monica
132. (page 292)	**Lennaart van Oldenborgh** Netherlands, b. 1965	*Peeling*, 1994	Video-monitor presentation, dimensions variable, courtesy the artist, Amsterdam
133. (page 227)	**Max Waldman** United States, 1919–1981	*The Living Theater*, 1969	Gelatin-silver print, toned, 10½ x 13½ in. (26.7 x 34.3 cm), Howard Greenberg Gallery, New York
134. (page 18)	**Samuel Leon Walker** United States, 1802–1874	*Josephine Walker*, 1847–54	Daguerreotype, quarter plate, 4¼ x 3¾ in. (10.8 x 9.5 cm), George Eastman House, Rochester, N.Y.
135. (page 148)	**Andy Warhol** United States, 1928–1987	*Blue Marilyn*, 1964	Silkscreen ink on synthetic polymer paint on canvas, 19⅞ x 15⅞ in. (50.5 x 40.3 cm), The Art Museum, Princeton University, gift of Alfred H. Barr, Jr., Class of 1922, and Margaret Scolari Barr
136. (page 153)		*Farrah Fawcett*, 1979–80	Internal-dye-diffusion-transfer (Polaroid) print, 4½ x 3⅜ in. (11.4 x 8.6 cm), The Andy Warhol Foundation, New York
137. (page 146)		*Halston*, c. 1974	Internal-dye-diffusion-transfer (Polaroid) print, 4½ x 3⅜ in. (11.4 x 8.6 cm), The Andy Warhol Foundation, New York
138. (page 151)		*Martha Graham*, c. 1970	Internal-dye-diffusion-transfer (Polaroid) print, 4½ x 3⅜ in. (11.4 x 8.6 cm), The Andy Warhol Foundation, New York
139. (page 155)		*Most Wanted Men No. 1, John M.*, 1964	Silkscreen ink on synthetic polymer paint on canvas, 2 panels, 48 x 40 in. (121.9 x 101.6 cm) each, The Herbert F. Johnson Museum of Art, Cornell University, Purchase Funds from the National Endowment for the Arts and individual donors

CATALOGUE OF THE EXHIBITION

CAT. NO.	ARTIST, COUNTRY, AND DATES	TITLE AND DATE	DETAILS
140. (page 154)	**Andy Warhol** (cont.) United States, 1928–1987	*Self-Portrait*, 1964	Gelatin-silver (photobooth) print, 7¾ x 1½ in. (19.7 x 3.8 cm), Los Angeles County Museum of Art, The Audrey and Sydney Irmas Collection
141. (page 152)		*Truman Capote*, 1978	Internal-dye-diffusion-transfer (Polaroid) print, 4½ x 3⅜ in. (11.4 x 8.6 cm), The Andy Warhol Foundation, New York
142. (page 272)	**Todd Watts** United States, b. 1949	*Methane Breather (#0236)*, 1989	Gelatin-silver monoprint with dye transfer, 46 x 37 in. (116.8 x 94 cm), courtesy the artist, New York
143. (page 241)	**Weegee** (Arthur Fellig) Austria, active United States, 1899–1968	*Untitled*, 1942	Gelatin-silver print, 10½ x 13½ in. (26.7 x 34.3 cm), Los Angeles County Museum of Art, Ralph M. Parsons Fund
144. (page 129)	**William Wegman** United States, b. 1942	*Twins Lynn/Terry*, 1971	3 gelatin-silver prints, 13¹⁵⁄₁₆ x 10¹⁵⁄₁₆ in. (35.4 x 27.8 cm) each, Los Angeles County Museum of Art, Contemporary Arts Council Purchase
145. (page 21)	**Edward Weston** United States, 1886–1958	*Nahui Olin*, 1923	Gelatin-silver print, 9⅛ x 6⅞ in. (23.2 x 17.5 cm), Center for Creative Photography, The University of Arizona, Tucson
146. (page 181)	**Katherine Wetzel** (photograph) United States, b. 1950 and **Elizabeth King** (sculpture) United States, b. 1950	*Pupil: Pose 1*, 1997–99	Gelatin-silver print, 13½ x 10½ in. (34.3 x 26.7 cm), Los Angeles County Museum of Art, Ralph M. Parsons Fund
147. (page 141)	**László Willinger** Hungary, active Austria and United States, 1909–1990	*Portrait of Unidentified Young Woman*, c. 1933–37	Gelatin-silver print, 8¹⁄₁₆ x 6 in. (20.5 x 15.2 cm), Los Angeles County Museum of Art, gift of the Sid and Diana Avery Trust
148. (page 202)	**Stanislaw Ignacy Witkiewicz** Poland, 1885–1939	*Anna Oderfeld (?)*, 1912	Gelatin-silver print, 6⅝ x 4¾ in. (16.8 x 12.1 cm), collection Thomas Walther, New York
149. (page 203)		*Tadeusz Langier, Zakopane*, 1912–13	Gelatin-silver print, 4¹⁵⁄₁₆ x 6⅞ in. (12.5 x 17.5 cm), The Gilman Paper Company Collection, New York
150. (page 215)	**Wanda Wulz** Italy, 1903–1984	*Cat and I*, 1932	Gelatin-silver print, 11⁹⁄₁₆ x 9¼ in. (29.4 x 23.5 cm), The Metropolitan Museum of Art, New York, Ford Motor Company Collection
151. (page 213)	**Madame Yevonde** (Yevonde Cumber) England, 1893–1975	*Lady Malcolm Campbell as "Niobe,"* 1935	From the Goddesses series, assembly-color-process (Vivex) print, 11¾ x 14⅞ in. (29.8 x 37.8 cm), National Portrait Gallery, London
152. (page 108)	**Joseph T. Zealy** United States, 1812–1893	*Renty, Congo, Plantation of B. F. Taylor, Esq. (front)*, 1850	Daguerreotype, quarter plate, 3½ x 2½ in. (8.9 x 6.4 cm), Peabody Museum of Archaeology and Ethnology, Harvard University
153. (page 108)		*Renty, Congo, Plantation of B. F. Taylor, Esq. (profile)*, 1850	Daguerreotype, quarter plate, 3½ x 2½ in. (8.9 x 6.4 cm), Peabody Museum of Archaeology and Ethnology, Harvard University

The Andy Warhol Foundation, New York

The Art Institute of Chicago

The Eli Broad Family Foundation, Santa Monica

The Eli and Edythe L. Broad Collection, Los Angeles

J. J. Brookings Gallery, San Francisco

Alexandre Castonguay, Hull, Quebec

Center for Creative Photography, The University of Arizona, Tucson

Stephen Cohen Gallery, Los Angeles

James Danziger Gallery, New York

Liliane and Michel Durrand-Dessert, Paris

Thomas Erben Gallery, New York

Die Sammlung Essl, Klosterneuburg, Austria

Fahey/Klein Gallery, Los Angeles

Peter Fetterman Gallery, San Francisco

Fraenkel Gallery, San Francisco

George Eastman House, Rochester, N.Y.

Sandra Gering Gallery, New York

The Getty Research Institute for the History of Art and the Humanities, Research Library, Los Angeles

J. Paul Getty Museum, Los Angeles

The Gilman Paper Company Collection, New York

Howard Greenberg Gallery, New York

F. C. Gundlach, Hamburg

Haines Gallery, San Francisco

Rhona Hoffman Gallery, Chicago

Eikoh Hosoe, Tokyo

The Herbert F. Johnson Museum of Art, Cornell University

Kawasaki City Museum

L. A. Louver Gallery, Venice, Calif.

Karyn Lovegrove Gallery, Los Angeles

The Robert Mapplethorpe Foundation, New York

The Metropolitan Museum of Art, New York

Museum Folkwang, Essen

Museum Ludwig, Cologne

National Museum of Photography, Film, & Television/Science & Society Picture Library, Bradford, England

National Portrait Gallery, London

Collection of Peter and Eileen Norton, Santa Monica

Ken Ohara, Glendale, Calif.

Pace/Wildenstein/MacGill Gallery, New York and Beverly Hills

Peabody Museum of Archaeology and Ethnology, Harvard University

Irving Penn, New York

Die Photographische Sammlung—August Sander Archiv/SK Stiftung Kultur, Cologne

The Art Museum, Princeton University

San Francisco Museum of Modern Art

University of California, Los Angeles, Louise M. Darling Biomedical Library, History and Special Collections

University of California, San Francisco, University Research Library, Special Collections

University of Southern California Libraries, Special Collections

Lennaart van Oldenborgh, Amsterdam

Thomas Walther, New York

Todd Watts, New York

Yale University, The Harvey Cushing/John Hay Whitney Medical Library, New Haven.

ZKM/Center for Art and Media—Museum for Contemporary Art, Karlsruhe

A

NOTE: Sources marked with a diamond (◆) are displayed in the exhibition.

ABE, KŌBŌ. *The Face of Another.* Trans. E. Dale Saunders. Tokyo: Charles E. Tuttle, 1966.

ADHEMAR, JEAN. "Ducreux's *Le Discret:* An Attribution Established." *The Register of the Museum of Art* (The University of Kansas, Lawrence) 2, no. 6 (June 1961): 2–7.

AKERET, ROBERT U. *Photoanalysis: How to Interpret the Hidden Psychological Meaning of Personal and Public Photographs.* New York: Pocket Books, 1975.

AMANO, TARO, ed. *Morimura Yasumasa: The Sickness unto Beauty—Self-Portrait as Actress.* Exh. cat. Yokohama: Yokohama Museum of Art, 1996.

AMELUNXEN, HUBERTUS V., STÉFAN IGLHAUT, and FLORIAN RÖTZER. *Photography after Photography: Memory and Representation in the Digital Age.* Exh. cat. Amsterdam: G & B Arts, 1996.

Andy Warhol: Photobooth Pictures. Exh. cat. New York: Robert Miller Gallery, 1989.

ARBAÏZAR, PHILLIPPE, ed. *Portraits, singulier pluriel, 1980–1990: La Photographie et son modèle.* Exh. cat. Paris: Bibliothèque nationale de France, François Mitterand, 1997.

ARBUS, DIANE. "The Full Circle." *Infinity* 11, no. 2 (February 1962): 9.

ARBUS, DOON, and MARVIN ISRAEL, eds. *Diane Arbus: An Aperture Monograph.* Millerton, N.Y.: Aperture, 1972.

———. *Diane Arbus: Magazine Work, 1960–1971.* Millerton, N.Y.: Aperture, 1984.

ARBUS, DOON, and YOLANDA CUOMO, eds. *Diane Arbus: Untitled.* New York: Aperture, 1995.

ARISTOTLE [pseud.]. *Physiognomics.* Trans. T. Loveday and E. S. Forster. In *The Complete Works of Aristotle.* The revised Oxford translation. Vol. 1. Ed. Jonathan Barnes. Bollingen Series 71, no. 2. Princeton: Princeton University Press, 1984, 1237–50.

ARMSTRONG, CAROL. *Scenes in a Library: Reading the Photograph in the Book, 1843–1875.* Cambridge: MIT Press, 1998.

ARTAUD, ANTONIN. *Selected Writings.* Ed. Susan Sontag. New York: Farrar, Straus and Giroux, 1976.

AUMONT, JACQUES. "Image, Visage, Passage." In Musée national d'art moderne. *Passages de l'image.* Exh. cat. Paris: Editions du Centre Pompidou, 1990, 61–70.

AUTEXIER, HUGHES, and FRANÇOIS BRAUNSCHWEIG. "From Anguish to Ecstasy." *Cimaise,* no. 173 (November–December 1984): 29–33.

AVEDON, RICHARD. "Borrowed Dogs." In *Performance and Reality: Essays from Grand Street.* Ed. Ben Sonnenberg. New Brunswick, N.J.: Rutgers University Press, 1989, 14–26.

———. *Portraits.* New York: Farrar, Straus and Giroux, 1976.

AVRILA, JEAN-MARC. *Tony Oursler.* Exh. cat. Bordeaux: Musée d'art contemporaine de Bordeaux, 1997.

B

BAER, ULRICH. "Photography and Hysteria: Towards a Poetics of the Flash." *Yale Journal of Criticism* 7, no. 1 (spring 1994): 41–77.

BAERWALDT, WAYNE, ed. *Pierre Molinier.* Exh. cat. Winnipeg and Santa Monica: Plug In Editions and Smart Art Press, [1997].

BALDENSPERGER, FERNAND. "Les Théories de Lavater dans la littérature français." In *Etudes d'histoire littéraire.* Paris: Librarie Hachette, 1910, 51–91.

BALTRUŠAITIS, JURGIS. *Aberrations: An Essay on the Legend of Forms.* Trans. Richard Miller. Cambridge and London: MIT Press, 1989, 1–57.

BARASCH, MOSHE. *Gestures of Despair in Medieval and Early Renaissance Art.* New York: New York University Press, 1976.

BARENTS, ELS, ed. *Thomas Ruff: Portretten, Huizen, Sterren.* Exh. cat. Amsterdam: Stedelijk Museum, 1990.

BATAILLE, GEORGES. "Human Face." Trans. Annette Michelson. *October,* no. 36 (spring 1986): 17–21.

———. *Visions of Excess: Selected Writings, 1927–1939.* Ed. Allan Stoekl. Trans. Allan Stoekl, Carl R. Lovitt, and Donald M. Leslie Jr. Theory and History of Literature, vol. 14. Minneapolis: University of Minnesota Press, 1985.

BATUT, ARTHUR. *La Photographie appliqué à la production du type d'une familole, d'une tribu ou d'une race.* Paris: Gauthier-Villars, 1887.

BAUDELAIRE, CHARLES. *Intimate Journals.* Trans. Christopher Isherwood. Hollywood: Marcel Rodd, 1947.

———. *Oeuvres complètes.* Rev. and ed. Claude Pichois. Paris: Bibliothèque de la pléiade, 1961.

———. *The Painter of Modern Life and Other Essays.* Trans. and ed. Jonathan Mayne. London: Phaidon Press, 1964.

BELL, CHARLES. *The Anatomy and Philosophy of Expression as Connected with the Fine Arts.* 7th ed. London: George Bell and Sons, 1877. ◆

———. *Essays on the Anatomy of Expression in Painting*. London: Longman, Hurst, Rees, and Orme, 1806.

BENJAMIN, WALTER. *Charles Baudelaire: A Lyric Poet in the Era of High Capitalism*. Trans. Harry Zohn. London: NLB, 1973.

BERNARD, DENIS, and ANDRÉ GUNTHERT. *L'Instant rêvé: Albert Londe*. Nîmes and Laval: Jacqueline Chambon and Editions Trois, 1993.

BERTILLON, ALPHONSE. *La Photographie judiciaire*. Paris: Gauthier-Villars, 1890. ◆

BERTILLON, SUZANNE. *Vie d'Alphonse Bertillon: Inventeur de l'anthropometrie*. Paris: Gallimard, 1941.

BLESSING, JENNIFER, ET AL. *Rrose is a Rrose is a Rrose: Gender Performance in Photography*. Exh. cat. New York: Solomon R. Guggenheim Museum, 1997.

BLOORE, CAROLYN. *Hugh Welch Diamond: Doctor, Antiquarian, Photographer*. Exh. cat. Twickenham: Orleans House Gallery, 1980.

BLUM, DEBORAH. "Face It!" *Psychology Today* (September/October 1998): 32–39, 66–70.

BOIS, YVE-ALAIN, and ROSALIND KRAUSS. *Formless: A User's Guide*. New York: Zone Books, 1997.

BONAPARTE, PRINCE ROLAND. *Les Habitants de Suriname: Notes recueillies à l'exposition coloniale d'Amsterdam en 1883*. Paris: A. Quantin, 1884. ◆

BORÉE, ALBERT. *Etudes physiognomoniques: Les Expressions de la figure humaine*. Paris: Henri Laurens, [1890s].

BORÉE, ALBERT, ed. *Physiognomische studien*. Stuttgart: Hoffmann, 1899.

BOURDON, ISIDORE. *La Physiognomonie et la phrénologie; ou, Connaissance de l'homme d'après les traits du visage et les reliefs du crâne*. Paris: Librarie Charles Gosselin, 1842.

BOURNEVILLE, DÉSIRÉ-MAGLOIRE, and PAUL REGNARD. *L'Iconographie photographique de la Salpêtrière*. 3 vols. Paris: Aux Bureaux du Progrès médical/Delahaye & Lecrosnier, 1876–1880. ◆

BOWER, BRUCE. "The Face of Emotion." *Science News*, 128:1 (6 July 1985): 12–13.

BROOKS, PETER. *The Melodramatic Imagination: Balzac, Henry James, Melodrama, and the Mode of Excess*. New Haven and London: Yale University Press, 1976.

BROWNE, JANET. "Darwin and the Expression of the Emotions." In *The Darwinian Heritage*. Ed. David Kohn. Princeton: Princeton University Press, 1985, 307–26.

———. "Darwin and the Face of Madness." In *The Anatomy of Madness: Essays in the History of Psychiatry*. Vol. 2, *People and Ideas*. Ed. W. F. Bynum, et al. New York: Tavistock Publications, 1985, 151–65.

BRUBACH, HOLLY, ed. "The Height of Emotion." In "Fashions of the Times," *New York Times Magazine*, part 2 (24 August 1997). ◆

BRUNO, GIULIANA. *Streetwalking on a Ruined Map*. Princeton: Princeton University Press, 1993.

BRYSON, NORMAN. "Façades." In Maurice Tuchman and Virginia Rutledge, eds. *Hidden in Plain Sight: Illusion in Art from Jasper Johns to Virtual Reality*. Unpublished exh. cat. Los Angeles: Los Angeles County Museum of Art, [1996], 50–61. Galleys.

———. *Word and Image: French Painting of the Ancien Régime*. Cambridge, London, and New York: Cambridge University Press, 1981.

BUCKNILL, CHARLES, and DAVID H. TUKE. *A Manual of Psychological Medicine*. Philadelphia: Blanchard and Lea, 1858.

BUFFON, GEORGES LOUIS LECLERC, COMTE DE. *Histoire naturelle, générale et particulière, avec la description du cabinet du roi*. Paris: Imprimerie royale, 1750–[1804].

BUKATMAN, SCOTT. *Terminal Identity: The Virtual Subject in Postmodern Science Fiction*. Durham, N.C.: Duke University Press, 1993.

BURGIN, VICTOR. *The End of Art Theory: Criticism and Postmodernity*. Atlantic Highlands, N.J.: Humanities Press, 1986.

BURROWS, ADRIENNE, and IWAN SCHUMACHER. *Portraits of the Insane: The Case of Dr. Diamond*. London and New York: Quartet Books, 1990.

BURSON, NANCY. *Faces*. Text by Lynn M. Herbert. Exh. cat. Houston: Contemporary Arts Museum, 1992.

BURSON, NANCY, RICHARD CARLING, and DAVID KRAMLICH. *Composites: Computer Generated Portraits*. New York: William Morrow, 1986.

BUTLIN, MARTIN. *The Paintings and Drawings of William Blake*. Exh. cat. New Haven and London: Yale University Press, 1981.

BYRNES, THOMAS F. *Professional Criminals of America*. New York: Cassell & Co., c. 1886.

C

CAGNETTA, FRANCO, ed. *Nascita della fotografia psichiatrica*. Exh. cat. Venice: Marsilio Editori, 1981.

CALEFFI, FABRIZIO, and PATRICK ROEGIERS. *Aziz + Cucher: Unnatural Selection*. Exh. cat. Paris: Espace d'Art Yvonamor Palix, 1996.

CALLEN, ANTHEA. "The Body and Difference: Anatomy Training at the Ecole des Beaux-Arts in Paris in the Later Nineteenth Century." *Art History* 20, no. 1 (March 1997): 23–60.

———. *The Spectacular Body: Science, Method and Meaning in the Work of Degas*. New Haven: Yale University Press, 1995.

CAMPER, PETRUS. *Discours prononçés par feû Mr. Pierre Camper, en l'Acadêmie de dessein d'Amsterdam, sur le moyen de représenter d'une manière sûre les diverses passions qui se manifestent sur le visage; sur l'étonnante conformité qui existe entre les quadrupèdes, les oiseaux, les poissons et l'homme; et enfin sur le beau physique: Publiés par son fils Adrien Gilles Camper*. Trans. from the Dutch by Denis Bernard Quatremère d'Isjonval. Autrecht: B. Wild & J. Altheer, 1792. ◆

———. *Dissertation physique de Mr. Pierre Camper, sur les différences réelles que présentent les traits du visage chez les hommes de différents pays et de différents âges; sur le beau qui caractèrise les statues antiques et les pierres gravées. Suivie de la proposition d'une nouvelle méthode pour déssiner toutes sortes de têtes humaines avec la plus grande sûreté. Publiée après le décès de l'auteur par son fils Adrien Gilles Camper*. Trans. from the Dutch by Denis Bernard Quatremère d'Isjonval. Autrecht: B. Wild & J. Altheer, 1791. ◆

———. *The Works of the Late Professor Camper, on the Connexion between the Science of Anatomy and the Arts of Drawing, Painting, Statuary in Two Books*. Trans. Thomas Cogan. London: C. Dilly, 1794.

CANGUILHEM, GEORGES. *The Normal and the Pathological*. Trans. Carolyn R. Fawcett and Robert S. Cohen. New York: Zone Books, 1989.

CAROLI, FLAVIO. *L'Anima e il Volto: Ritratto e fisiognomica da Leonardo a Bacon*. Exh. cat. Milan: Editions Electa, 1998.

CARTER, RITA. *Mapping the Mind*. Berkeley: University of California Press, 1998.

CARTWRIGHT, LISA. *Screening the Body: Tracing Medicine's Visual Culture*. Minneapolis: University of Minnesota Press, 1995.

CENTRE NATIONAL DE LA PHOTOGRAPHIE. *Identités: De Disdéri au photomaton*. Exh. cat. Paris: Photo Copies, 1985.

CERISE, DR. "Duchenne de Boulogne: *Mécanisme de la physionomie humaine.*" *Journal des débats* (29 August 1863): 3–4.

CHAMPFLEURY [Jules Fleury]. *Les Amis de la nature*. Paris: Poulet-Malassis et de Broise, 1859.

CHARCOT, JEAN-MARTIN. *Oeuvres complètes de J. M. Charcot*. 9 vols. Paris: Bureaux du Progrès médical and A. Delhaye & E. Lecrosnier, 1888–90.

CHARCOT, J. M., and PAUL RICHER. *Les Démoniaques dans l'art*. Paris: Delahaye & Levrosnier, 1887.

———. *Les Démoniaques dans l'art suivi de "La foi qui guérit."* Ed. Pierre Fédida and Georges Didi-Huberman. Paris: Editions Macula, 1984.

CHASE, THE TROOPS FOR TRUDDI. *When Rabbit Howls*. New York: Jove Books, 1990.

CHESNEAU, ERNEST. "De la physiognomonie." Parts 1 and 2. *Le Constitutionnel* 51, no. 282 (9 October 1866): 1–2; no. 288 (16 October 1866): 1–2.

CHEVRIER, JEAN FRANÇOIS, and ANN GOLDSTEIN. *A Dialogue about Recent American and European Photography*. Exh. cat. Los Angeles: Museum of Contemporary Art, 1991.

CHEVRIER, JEAN FRANÇOIS, and JAMES LINGWOOD. *Un'altra obiettività/Another objectivity*. Exh. cat. Paris and Prato: Centre National des Arts Plastiques and Museo d'Arte Contemporanea Luigi Pecci, 1989.

CLAIR, JEAN. *Five Notes on the Work of Louise Bourgeois*. Trans. Michael Gibson. New York: Cheim & Read, 1998.

CLAIR, JEAN, ed. *L'Ame au corps: Arts et sciences, 1793–1993*. Exh. cat. Paris: Réunion des musées nationaux and Editions Gallimard, 1993.

———. *Vienne 1880–1938: L'Apocalypse joyeuse*. Exh. cat. Paris: Editions du Centre Pompidou, 1986.

CLAIR, JEAN, CATHRIN PICHLER, and WOLFGANG PIRCHER, eds. *Wunderblock: Eine Geschichte der modernen Seele*. Exh. cat. Vienna: Löcker Verlag and Wiener Festwochen, 1989.

CLAPTON, G. T. "Lavater, Gall et Baudelaire." *Revue de littérature comparée* 17 (1933): 259–456.

CLARKE, GRAHAM, ed. *The Portrait in Photography*. Critical Views. London: Reaktion Books, 1992.

CODELL, JULIE F. "Expression over Beauty: Facial Expression, Body Language, and Circumstantiality in the Paintings of the Pre-Raphaelite Brotherhood." *Victorian Studies* 29, no. 2 (winter 1986): 255–90.

COLBERT, CHARLES. *A Measure of Perfection: Phrenology and the Fine Arts in America*. Chapel Hill and London: University of North Carolina Press, 1997.

COLE, JONATHAN. *About Face*. Cambridge: MIT Press, 1997.

COMBE, GEORGE. *Elements of Phrenology*. 2nd American ed. Boston: Marsh, Capen & Lyon, 1834.

———. *A System of Phrenology*. New York: William H. Colyer, 1844. ◆

COMBE, GEORGE, ET AL. *Moral and Intellectual Science Applied to the Elevation of Society*. New York: Fowlers & Wells, 1848. ◆

CONDUCHÉ, ERNEST. "La Photographie, la médecine et la chirurgie." *La Lumiére* 5, no. 18 (5 May 1855): 69.

CONOLLY, JOHN. The Physiognomy of Insanity." *Medical Times & Gazette* 16 (2 January 1858): 2–4; (16 January 1858): 56–58; (6 February 1858): 134–6; (6 March 1858): 238–41; (27 March 1858): 314–6; (17 April 1858): 397–8; (15 May 1858): 498–500; (19 June 1858): 623–5; 17 (14 July 1858): 81–83; (28 August 1858): 210–2; (9 October 1858): 367–9; (25 December 1858), 651–3; 18 (19 February 1859), 183–6.

CONTEMPORARY ART FOUNDATION. *32 Portraits: Photography in Art*. Exh. cat. The Hague: SDU Publishers, 1989.

COOTER, ROGER. *The Cultural Meaning of Popular Science: Phrenology and the Organization of Consent in Nineteenth Century Britain*. New York: Cambridge University Press, 1984.

COPJEC, JOAN. "Flavit et Dissipati Sunt." *October,* no. 18 (fall 1981): 20–40.

COURTINE, JEAN-JACQUES, and CLAUDINE HAROCHE. *L'Histoire du visage: Exprimer et taire ses émotions (du XVIᵉ siècle au début du XIXᵉ siècle)*. Paris: Editions Rivages, 1988. Reprinted, Paris: Editions Payot & Rivages, 1994.

COUTANCIER, BENOÎT, ed. *"Peaux-Rouges": Autour de la collection anthropologique du Prince Roland Bonaparte*. Exh. cat. Thonon-les-Bains, Haute-Savoie, and Paris: Editions de l'Albaron and Photothèque du Musée de l'homme, 1992.

COWLING, MARY. *The Artist as Anthropologist: The Representation of Type and Character in Victorian Art*. Cambridge: Cambridge University Press, 1989.

CROUZET, MARCEL. *Un Méconnu du réalisme: Duranty (1833–1880)—l'homme, le critique, le romancier*. Paris: Librairie Nizet, 1864.

CROVITZ, HERBERT F. *Galton's Walk: Methods for the Analysis of Thinking, Intelligence, and Creativity*. New York: Harper & Row, 1970.

CRUZ, AMADA, ELIZABETH A. T. SMITH, and AMELIA JONES. *Cindy Sherman Retrospective*. Exh. cat. New York: Thames and Hudson, 1997.

CUMMINGS, FREDERICK. "Charles Bell and *The Anatomy of Expression.*" *Art Bulletin* 46, no. 2 (June 1964): 191–203.

D

D'AMATO, BRIAN. *Beauty: A Novel*. New York: Delacorte Press, 1992.

DAGOGNET, FRANÇOIS. *Faces, Surfaces, Interfaces*. Paris: J. Vrin, 1982.

———. "Toward a Biopsychiatry." Trans. Donald M. Leslie. In *Incorporations*. Zone 6. Ed. Jonathan Crary and Sanford Kwinter. New York: Zone Books, 1992, 516–41.

DAGONET, HENRI. *Nouveau Traité élémentaire et pratique des maladies mentales suivi de considérations pratiques sur l'administration des asiles d'aliénés*. Paris: J. B. Baillière et fils, 1876. ◆

DANTO, ARTHUR. *Mapplethorpe*. New York: Random House, 1992.

DARWIN, CHARLES. *The Expression of the Emotions in Man and Animals*. London: John Murray, 1872. ◆

———. *The Expression of the Emotions in Man and Animals*. 3rd and definitive edition. New York and Oxford: Oxford University Press, 1998.

DAVID, CATHERINE, ed. *Suzanne Lafont*. Exh. cat. Paris: Galerie nationale du Jeu de Paume, 1991.

DAWSON, MICHAEL, DIANE DILLON, and A. D. COLEMAN. *William Mortensen: A Revival. The Archive*, no. 33. Tucson: Center for Creative Photography, The University of Arizona, 1998.

DE MARNEFFE, DAPHNE. "Looking and Listening: The Construction of Clinical Knowledge in Charcot and Freud." *Signs* 17, no. 1 (autumn 1991): 71–111.

DE SALVO, DONNA. *Face Value: American Portraits*. Exh. cat. Southampton, N.Y., and Paris: Parrish Art Museum and Flammarion, 1995.

DEBORD, JEAN-FRANÇOIS. *Duchenne de Boulogne*. Exh. cat. Chalon-sur-Saône: Musée Nicéphore Niépce, 1984.

DEITCH, JEFFREY. *Post Human*. Exh. cat. New York: D.A.P., 1992.

DELAPORTE, FRANÇOIS, and PATRICE PINELL. *Histoire des myopathies*. Paris: Bibliothèque Scientifique Payot, 1998.

DELAPORTE, YVES. "Le Prince Roland Bonaparte en Laponie." *L'Ethnographie* 84, 2.104 (1988): 5–174.

DELESTRE, JEAN BAPTISTE. *De la physiognomonie*. Paris: Vᵉ J. Renouard, 1866.

———. *Etudes des passions appliqués aux beaux-arts*. Paris: N. Tresse, 1853.

———. *Traité de photographie*. Paris: Desloges, [185–].

DELEUZE, GILLES, and FÉLIX GUATTARI. *Anti-Oedipus: Capitalism and Schizophrenia*. Trans. Robert Hurley, Mark Seem, and Helen R. Lane (Minneapolis: University of Minnesota Press, 1983).

———. *A Thousand Plateaus: Capitalism and Schizophrenia*. Trans. Brian Massumi. Minneapolis: University of Minnesota Press, 1987.

DELLA PORTA, GIAMBATTISTA. *De Humana Physiognomonia*. Naples: Josephus Cacchius, 1586.

DERRIDA, JACQUES. *The Truth in Painting*. Trans. Geoff Bennington and Ian McLeod. Exh. cat. Chicago and London: University of Chicago Press, 1987.

DERRIDA, JACQUES, and PAULE THÉVENIN. *The Secret Art of Antonin Artaud*. Trans. Mary Ann Caws. Cambridge: MIT Press, 1998.

DESCARTES, RENÉ. *Les Passions de l'âme*. Amsterdam: Louys Elzevier, 1649.

DIAMOND, HUGH WELCH. "On the Application of Photography to the Physiognomic and Mental Phenomena of Insanity." Unpublished paper, 22 May 1856. In Sander L. Gilman. *The Face of Madness: Hugh W. Diamond and the Origin of Psychiatric Photography*. New York: Brunner/Mazel, 1976, 17–24.

DICK, LESLIE. "The Skull of Charlotte Corday." In *Other Than Itself: Writing Photography*. Ed. John X. Berger and Oliver Richon. Manchester: Cornerhouse Publications, 1980, unpag.

DIDI-HUBERMAN, GEORGES. *Invention de l'hystérie: Charcot et l'iconographie photographique de la Salpêtrière*. Paris: Macula, 1982.

———. *La Peinture incarnée suivi de "Le Chef-d'oeuvre inconnu" par Honoré Balzac*. Paris: Les éditions de minuit, 1985.

DISDÉRI, ANDRÉ-ADOLPHE-EUGÈNE. *L'Art de la photographie*. Paris: chez l'auteur, 1862.

———. *Renseignements photographiques indispensables à tous*. Paris: chez l'auteur, 1855.

DUCHANGE, ERNEST. "Sur deux cartes de visite de grimaciers à Paris." *Gazette des beaux-arts* 100, no. 1364 (September 1982): 79–84.

DUCHENNE DE BOULOGNE, GUILLAUME-BENJAMIN-ARMAND. *Album de photographies pathologiques complémentaire du livre intitulé De l'électrisation localisée*. Paris: J.-B. Baillière et fils, 1862.

———. *De l'électrisation localisée et de son application à la pathologie et à la thérapeutique*. Paris: J.-B. Baillière et fils, 1855.

———. *Mécanisme de la physionomie humaine; ou, Analyse électro-physiologique de l'expression des passions*. Paris: Vᵉ Jules Renouard, 1862. ◆

———. *Mécanisme de la physionomie humaine; ou, Analyse électro-physiologique de l'expression des passions*. 2nd ed. Paris: J.-B. Ballière et fils, 1876.

———. *The Mechanism of Human Facial Expression*. Ed. and trans. R. Andrew Cuthbertson. Cambridge: Cambridge University Press, 1990.

———. *Physiology of Motion: Demonstrated by Means of Electrical Stimulation and Clinical Observation and Applied to the Study of Paralysis and Deformities*. Trans. Emanuel B. Kaplan. Philadelphia: J. B. Lippincott Company, 1949.

———. *Selections from the Clinical Works of Dr. Duchenne (de Boulogne)*. Ed. and trans. G. V. Poore. London: New Sydenham Society, 1883.

DURANTY, EDOUARD. "Sur la physionomie." *La Revue libérale* 2 (25 July 1867): 499–523.

E

EDGEWORTH, M. L. "Electro-Physiognomy. A Condensed *Résumé* from the Work of M. Duchenne (de Boulogne)." *The Journal of Psychological Medicine* 4, no. 1 (January 1870): 77–87.

EDWARDS, ELIZABETH, ed. *Anthropology and Photography, 1860–1920*. New Haven and London: Yale University Press and the Royal Anthropological Institute, 1992.

EISENSTEIN, SERGEI M., and G. ALEXANDROF. "La Ligne générale." *Documents* 2, no. 4 (1930): 218–9. ◆

EKMAN, PAUL, ed. *Darwin and Facial Expression: A Century of Research in Review*. New York: Academic Press, 1973.

EKMAN, PAUL, and W. V. FRIESEN. *Manual for the Facial Action Coding System*. Palo Alto: Consulting Psychologists Press, 1977.

———. *Unmasking the Face*. Palo Alto: Consulting Psychologists Press, 1984.

EKMAN, PAUL, R. J. DAVIDSON, and W. V. FRIESEN. "The Duchenne Smile: Emotional Expression and Brain Physiology II." *Journal of Personality and Social Psychology* 58, no. 2 (1990): 342–53.

EKMAN, PAUL, WALLACE V. FRIESEN, and PHOEBE ELLSWORTH. *Emotion in the Human Face: Guide-Lines for Research and an Integration of Findings.* New York: Pergamon Press, 1972.

ELIEL, CAROL S. *Form and Content in the Genre Works of Louis-Leopold Boilly.* Ph.D. diss. New York University. Ann Arbor: University Microfilms International, 1985.

ELLENBERGER, HENRI F. *The Discovery of the Unconscious: The History and Evolution of Dynamic Psychiatry.* New York: Basic Books, 1970.

ENGLISH, DONALD E. *Political Uses of Photography in the Third French Republic: 1871–1914.* Ann Arbor, Mich.: UMI Research Press, 1984.

ESQUIROL, ETIENNE. *Des maladies mentales, considerées sous les rapports médical, hygiénique, et médico-légal.* Paris: J.-B. Ballière, 1838.

EVERDELL, WILLIAM R. *The First Moderns: Profiles in the Origins of Twentieth-Century Thought.* Chicago: University of Chicago Press, 1997.

EWING, WILLIAM A. *The Body: Photographs of the Human Form.* San Francisco: Chronicle Books, 1994.

F

FAHEY, DAVID, ed. *Sante d'Orazio: A Private View.* New York: Penguin Putnam, 1998.

FAHEY, DAVID, and LINDA RICH. *Masters of Starlight: Photographers in Hollywood.* Exh. cat. Los Angeles: Los Angeles County Museum of Art, 1987.

FAIGIN, GARY. *The Artist's Complete Guide to Facial Expression.* New York: Watson-Guptill, 1990.

FARWELL, BEATRICE. *The Charged Image: French Lithographic Caricature, 1816–1848.* Exh. cat. Santa Barbara: Santa Barbara Museum of Art, 1989.

FELDMAN, MELISSA E. *Face-Off: The Portrait in Recent Art.* Exh. cat. Philadelphia: Institute of Contemporary Art, University of Pennsylvania, 1994.

FERGUSON, RUSSELL. "Divided Self." *Parkett,* no. 49 (1997): 59–63.

FIEDLER, LESLIE. *Freaks: Myths & Images of the Secret Self.* New York: Simon & Schuster, 1978.

"The First Principle of Physiognomy." *Cornhill Magazine* 4 (1861): 570.

FISCHER, ANDREAS, and VEIT LOERS. *Im Reich der Phantome: Fotografie des Unsichtbaren.* Exh. cat. Ostfildern-Ruit: Cantz Verlag, 1997.

FOGLE, DOUGLAS. "Die Passionen des Körpers: Fotografie und männliche Hysterie." Trans. Sebastian Wohlfeil. *Fotogeschichte* 13, no. 49 (1993): 67–78.

FORD, JEFFREY. *The Physiognomy.* New York: Avon Books, 1997.

FORESTA, MERRY, ed. *Perpetual Motif: The Art of Man Ray.* Exh. cat. Washington, D.C.: National Museum of American Art, Smithsonian Institution, 1988.

FOSTER, HAL, ed. *The Anti-Aesthetic: Essays on Postmodern Culture.* Port Townsend, Wash.: Bay Press, 1983.

———. *Recodings: Art, Spectacle, Cultural Politics.* Port Townsend, Wash.: Bay Press, 1985.

FOUCAULT, MICHEL. *The Birth of the Clinic: An Archaeology of Medical Perception.* Trans. A. M. Sheridan Smith. New York: Vintage Books, 1975.

———. *The History of Sexuality.* Vol. 1, *An Introduction.* Trans. Robert Hurley. New York: Pantheon, 1978.

———. *Madness and Civilization: A History of Insanity in the Age of Reason.* Trans. Richard Howard. New York: Vintage Books, 1973.

FOWLER, O[rson] S[quire]. *Fowler's Practical Phrenology: Giving a Concise Elementary View of Phrenology . . . with References to . . . "Phrenology Proved, Illustrated, and Applied". . . .* New York: Fowlers & Wells, 1848. ◆

FRANK, ROBERT H. *Passions within Reason: The Strategic Role of the Emotions.* New York: Norton, 1988.

FREEMAN, JOAN, prod. "Faces." *Walter Cronkite's Universe* 2, no. 5 (14 July 1981). Transcript, 7–8.

FREUD, SIGMUND. *The Basic Writings of Sigmund Freud.* Ed. and trans. Dr. A. A. Brill. New York: Random House, 1938.

———. *The Psychopathology of Everyday Life.* Ed. James Strachey. Trans. Alan Tyson. New York: W. W. Norton, 1965.

———. "The Uncanny." In *Writings on Art and Literature.* Ed. Werner Hamacher and David E. Wellbery. Stanford: Stanford University Press, 1997, 193–233.

FRIDLUND, ALAN J. *Human Facial Expression: An Evolutionary View.* Orlando: Academic Press, 1994.

FRIIS-HANSEN, DANA. *Nancy Burson: "The Age Machine" and Composite Portraits.* Exh. cat. Cambridge: MIT List Visual Arts Center, 1990.

FRIZOT, MICHEL. "Corps et délits: Une Ethnophotographie des différences." In *Nouvelle Histoire de la photographie.* Ed. Michel Frizot. Paris: Bordas, 1995, 259–71.

FUCHS, RUDI, ARMIN ZWEITE, and KATHARINA SIEVERDING, eds. *Katharina Sieverding: 1967–1997.* Exh. cat. Amsterdam and Düsseldorf: Stedelijk Museum of Modern Art and Kunstsammlung Nordrhein-Westfalen, 1998.

FUNCK, HEINRICH, ed. *Goethe und Lavater: Briefe und Tagebücher.* Schriften der Goethe-Gesellschaft, no. 16. Weimar: Verlag der Goethe-Gesellschaft, 1901.

FUSELI, HENRY. "Fuseli's Collaboration in Lavater's *Physiognomy*." In *The Mind of Henry Fuseli: Selections from His Writings.* Ed. Eudo C. Mason. London: Routledge and Paul, 1951, 137–41.

G

GALASSI, PETER. *Nicholas Nixon: Pictures of People.* Exh. cat. New York: Museum of Modern Art, 1988.

GALL, FRANZ JOSEF, and JOHANN CASPAR SPURZHEIM. *Anatomie et physiologie du système nerveux en général, et du cerveau en particulier, avec des observations sur la possibilité de reconnaître plusieurs dispositions intellectuelles et morales de l'homme et des animaux par la configuration de leurs têtes.* 4 vols. and folio. Paris: F. Schoell, 1810–1819.

GALTON, FRANCIS. *Inquiries into Human Faculty and Its Development.* London: Macmillan, 1883. ◆

GARRELS, GARY, ed. *The Work of Andy Warhol.* Dia Art Foundation Discussions in Contemporary Art, no. 3. Port Townsend, Wash.: Bay Press, 1989.

GAURICUS, POMPONIUS [Pomponio Gaurico]. *De Sculpture* (1504). Ed. and trans. André Chastel and Robert Klein. Hautes Etudes Médiévales et Modernes, 5. Paris and Geneva: Centre National de la Recherche Scientifique and Librairie Droz, 1969.

GELDZAHLER, HENRY, ET AL. *Andy Warhol: Portraits of the Seventies and Eighties.* London: Anthony d'Offay Gallery, 1993.

GEORGET, ETIENNE. *De la folie; ou, Aliénation mentale.* Paris: Bechet, 1823.

GILMAN, SANDER L. "Darwin Sees the Insane." *Journal of the History of the Behavioral Sciences* 15 (1979): 253–62.

———. *Seeing the Insane.* New York: Brunner/Mazel, 1982. 2nd ed. Lincoln: University of Nebraska Press, 1996.

GILMAN, SANDER L., ed. *The Face of Madness: Hugh W. Diamond and the Origin of Psychiatric Photography.* New York: Brunner/Mazel, 1976.

GINZBURG, CARLO. "Clues: Morelli, Freud, and Sherlock Holmes." In *The Sign of Three: Dupin, Holmes, Peirce.* Ed. Umberto Eco and Thomas A. Sebeok. Bloomington and Indianapolis: Indiana University Press, 1988, 81–118.

GOFFMAN, ERVING. *Gender Advertisements.* Cambridge and London: Harvard University Press, 1979.

GOLDEN, THELMA, ed. *Black Male: Representation of Masculinity in Contemporary Art.* Exh. cat. New York: Whitney Museum of American Art, 1994.

GOLDIN, AMY. "The Post-Perceptual Portrait." *Art in America* 63, no. 1 (January/February 1975): 79–82.

GOMBRICH, E. H. "Leonardo De Vinci's Method of Analysis and Permutation: The Grotesque Heads." In *The Heritage of Apelles: Studies in the Art of the Renaissance.* Ithaca: Cornell University Press, 1976, 57–75.

———. "The Mask and the Face: The Perception of Physiognomic Likeness in Life and in Art." Originally published in *Art, Perception, and Reality.* Ed. Maurice Mandelbaum.

Baltimore and London: The Johns Hopkins University Press, 1972, 1–46. Reprinted in E. H. Gombrich. *The Image and the Eye: Further Studies in the Psychology of Pictorial Representation.* Ithaca: Cornell University Press, 1982, 105–36.

———. "On Physiognomic Perception." In *Meditations on a Hobby Horse and Other Essays on the Theory of Art.* London and New York: Phaidon, 1963, 45–55.

GOPNIK, ADAM, and JANE LIVINGSTON. *Richard Avedon: Evidence, 1944–1994.* Exh. cat. New York and Rochester: Random House and Eastman Kodak Company, 1994.

GORDON, RAE BETH. "Le Caf'conc' et l'hystérie." *Romantisme*, no. 64 (January/March 1989): 53–66.

GRAHAM, JOHN. *Lavater's Essays on Physiognomy: A Study in the History of Ideas.* Bern/Frankfurt am Main/Las Vegas: Peter Lang, European University Studies, 1979.

GRATE, PONTUS. *Deux Critiques d'art de l'Époque romantique: Gustave Planche et Théophile Thoré. Figura*, no. 12. Stockholm: Almqvist & Wiksell, 1959.

GRATIOLET, PIERRE. *De la physionomie et des mouvements d'expression. Suivi d'une notice sur sa vie et ses travaux, et de la nomenclature de ses ouvrages par Louis Grandeau.* Paris: J. Hetzel, 1865.

GRAVES, RALPH A. "Human Emotions Recorded in Photographs." *The National Geographic Magazine* 38, no. 4 (October 1920): 284–301.

GRAY, CHRIS HABLES, ed. *The Cyborg Handbook.* New York: Routledge, 1995.

GREEN, DAVID. "Veins of Resemblance: Photography and Eugenics." In *Photography/Politics: Two.* Ed. Patricia Holland, Jo Spence, and Simon Watney. London: Comedia Publishing, 1986, 9–21.

GREENSPAN, PATRICIA S. *Emotions and Reasons.* New York: Routledge, 1988.

GRIFFITHS, PAUL E. *What Emotions Really Are: The Problem of Psychological Categories.* Chicago: University of Chicago Press, 1997.

GUILLY, PAUL. *Duchenne de Boulogne.* Paris: Baillière et fils, 1936. Reprinted, Marseille: Laffitte Reprints, 1977.

GUNNING, TOM. "The Cinema of Attractions: Early Film, Its Spectator and the Avant-Garde." In *Early Cinema: Space, Frame, Narrative.* Ed. Thomas Elsaesser. London: British Film Institute, 1990, 56–62.

———. "In Your Face: Physiognomy, Photography, and the Gnostic Mission of Early Film." *Modernism/Modernity* 4, no. 1 (January 1997): 1–29.

H

HACKING, IAN. *Rewriting the Soul: Multiple Personality and the Sciences of Memory.* New York: Princeton University Press, 1995.

HAENLEIN, CARL, ed. *Anton Josef Trčka, Edward Weston, Helmut Newton.* Exh. cat. Hannover and Zurich: Kestner Gesellschaft and Scalo, 1998.

HAKE, SABINE. "Faces of Weimar Germany." In *The Image in Dispute: Art and Cinema in the Age of Photography.* Ed. Dudley Andrew. Austin: University of Texas Press, 1997, 117–47.

HALBERSTAM, JUDITH, and IRA LIVINGSTON, eds. *Posthuman Bodies.* Bloomington: Indiana University Press, 1995.

HAMBOURG, MARIA MORRIS, FRANÇOISE HEILBRUN, and PHILIPPE NÉAGU. *Nadar.* New York: Metropolitan Museum of Art, 1995.

HAMBOURG, MARIA MORRIS, and CHRISTOPHER PHILLIPS. *The New Vision: Photography between the World Wars.* Exh. cat. New York: Metropolitan Museum of Art, 1989.

HAMMOND, ARTHUR. "Character and Individuality in Portraiture." *American Annual of Photography: 1914* 28 (1913), 192–200.

HARARI, JOSUE, ed. *Textual Strategies: Perspectives in Post-Structuralist Criticism.* Ithaca: Cornell University Press, 1979.

HARAWAY, DONNA J. *Simians, Cyborgs, and Women: The Reinvention of Nature.* New York: Routledge, 1991.

HARKAVY, DONNA, ed. *Alan Rath: Plants, Animals, People, Machines.* Santa Monica: Smart Art Press, 1995.

HARKER, MARGARET F. *Henry Peach Robinson: Master of Photographic Art, 1830–1901.* Oxford: Basil Blackwell, 1988.

HARRÉ, ROM, ed. *The Social Construction of Emotions.* New York: Blackwell, 1986.

HARWOOD, JEREMY, ed. *Illustrator's Reference Manual: Hands & Faces.* Secaucus: Chartwell Books, 1989. ◆

HASGAWA YUKO. "Pleasure in Nothingness: Japanese Photography, 1980 to the Present." In *Liquid Crystal Futures.* Exh. cat. Edinburgh: Fruitmarket Gallery, 1994.

HEGEL, GEORG WILHELM FRIEDRICH. *The Phenomenology of Mind.* Trans. J. B. Baillie. New York: Harper and Row, 1967.

HEINECKEN, ROBERT. *1984: A Case Study in Finding an Appropriate TV Newswoman (A CBS Docudrama in Words and Pictures)*. Los Angeles: Robert Heinecken, 1985.

HELNWEIN, GOTTFRIED. *Gottfried Helnwein*. Exh. cat. St. Petersburg: Ludwig Museum in the Russian Museum (The State Russian Museum), 1997.

HENRY, GERRIT. "The Artist and the Face: A Modern American Sampling." *Art in America* 63, no. 1 (January/February 1975): 34–41.

HERBERT, ROBERT L. "'Parade de cirque' de Seurat et l'esthétique scientifique de Charles Henry." *Revue de l'art*, no. 50 (1980): 9–23.

HERSEY, GEORGE L. *The Evolution of Allure: Sexual Selection from the Medici Venus to the Incredible Hulk*. Cambridge: MIT Press, 1996.

HILBERRY, SUSANNE. "Two Andy Warhol Self-Portraits." *Detroit Institute of Arts Bulletin* 50 (1971): 63–65.

HOGARTH, WILLIAM. *The Analysis of Beauty Written with a View of Fixing the Fluctuating Ideas of Taste*. London: Printed by J. Reeves for the author, 1753.

HONNEF, KLAUS, ed. *Lichtbildnisse: Das Porträt in der Fotografie*. Exh. cat. Cologne: Rheinland-Verlag, 1982.

HOONE, JEFFREY, ed. *William E. Parker: Recent Work*. Exh. cat. Syracuse, N.Y.: Robert B. Menschel Photography Gallery, Syracuse University, 1988.

HUESTON, JOHN T., and R. ANDREW CUTHBERTSON. "Duchenne de Boulogne and Facial Expression." *Annals of Plastic Surgery* 1, no. 4 (July 1978): 411–20.

HULTEN, PONTUS, ed. *Futurismo & Futurismi*. Exh. cat. Milan: Gruppo Editoriale Fabbri, Bompiani, 1986.

————. *Les Réalismes: 1919–1939*. Exh. cat. Paris: Centre national d'art et de culture Georges Pompidou, 1980.

————. *Salvador Dalí: Rétrospective, 1920–1980*. Exh. cat. Paris: Centre Georges Pompidou, Musée National d'Art Moderne, 1979.

HUMBERT DE SUPERVILLE, DAVID PIERRE GIOTTINO. *Essai sur les signes inconditionnels dans l'art*. Leyden: C. C. Van der Hoek, 1827.

HÜNNEKENS, ANNETTE, ed. *Mienenspiele*. Exh. cat. Karlsruhe: ZKM Zentrum für Kunst und Medientechnologie, 1994.

HUSCHKE, EMIL. *Schadel, Hirn und Seele des Menschen und der Thiere nach Alter, Geschlecht und Race: dargestellt nach neuen Methoden und Untersuchungen*. Jena: Friedrich Mauke, 1854.

I

IMMISCH, T. O., KLAUS E. GÖLTZ, and ULRICH POHLMANN, eds. *Witkacy: Metaphysical Portraits—Photographs by Stanislaw Ignacy Witkiewicz*. Leipzig: Connewitzer Verlagbuchhandlung, 1997.

J

JAAR, ALFREDO. *A Hundred Times Nguyen*. Stockholm: Fotografiska Museet I Moderna Museet, 1994.

JAAR, ALFREDO, and RAMON PRAT, eds. *Alfredo Jaar—It Is Difficult: Ten Years* and *Alfredo Jaar—Let There Be Light: The Rwanda Project, 1994–1998*. Exh. cats. Barcelona and San Sebastian: Centre d'Art Santa Monica and Koldo Mitxelena, 1998.

JAHN, WOLF. *The Art of Gilbert & George; or, An Aesthetic of Existence*. Trans. David Britt. London: Thames and Hudson, 1989.

JAMMES, ANDRÉ. "Duchenne de Boulogne, la grimace provoquée et Nadar." *Gazette des beaux-arts* 92, no. 1319 (December 1978): 215–20.

JAMMES, ANDRÉ, and ROBERT SOBIESZEK, *French Primitive Photography*. Exh. cat. New York: Aperture, 1970.

JAY, MARTIN. *Downcast Eyes: The Denigration of Vision in Twentieth-Century Thought*. Berkeley: University of California Press, 1993.

JONES, AMELIA. *Body Art: Performing the Subject*. Minneapolis: University of Minnesota Press, 1998.

————. *Postmodernism and the En-Gendering of Marcel Duchamp*. Cambridge: Cambridge University Press, 1994.

JOUIN, HENRY. *Charles Le Brun et les arts sous Louis XIV*. Paris: Imprimerie nationale, 1889.

JUSTICE, L. A. *How to Read Faces!* Boca Raton, Fla.: Globe Communications, 1998.

K

KAPLAN, EMANUEL B. "Duchenne of Bologne and the Physiologie des Mouvements." In *Victor Robinson Memorial Volume: Essays in History of Medicine*. Ed. Solomon R. Kagan. New York: Froben, 1948, 172–92.

KASAHARA, MICHIKO. "Objects, Faces and Anti-Narratives." In *Objects, Faces and Anti-Narratives: Rethinking Modernism*. Exh. cat. Tokyo: Tokyo Metropolitan Museum of Photography, 1996, 116–7.

KATZ, D. MARK. *Witness to an Era: The Life and Photographs of Alexander Gardner—The Civil War, Lincoln, and the West*. New York: Viking, 1991.

KAUFMAN, M. H., and N. BASDEN. "Marked Phrenological Heads: Their Evolution, with Particular Reference to the Influence of George Combe and the Phrenological Society of Edinburgh." *Journal of the History of Collections* 9, no. 1 (1997): 139–59.

KILLIAN, H. *Facies Dolorosa: Das Schmerzensreiche Antlitz*. Leipzig: Georg Thieme, 1934.

KIRCHNER, THOMAS. *L'Expression des passions: Ausdruck als Darstellungsproblem in der französischen Kunst und Kunsttheorie des 17. und 18. Jahrhunderts*. Berliner Schriften zur Kunst, no. 1. Mainz: P. von Zabern, 1991.

KLOCKER, HUBERT, GRAPHISCHE SAMMLUNG ALBERTINA, and MUSEUM LUDWIG, eds. *Viennese Aktionism, Vienna 1960–1971: The Shattered Mirror*. Viennese Actionism, vol. 2. Exh. cat. Klagenfurth: Ritter Verlag, 1989.

KNAPP, PETER H., ed. *Expression of the Emotions in Man*. New York: International Universities Press, 1963.

KOCH, GERTRUDE. "Bola Bales: The Physiognomy of Things." *New German Critique* 40 (winter 1987): 167–78.

KRAUSS, ROSALIND. *Cindy Sherman: 1975–1993*. New York: Rizzoli, 1993.

————. *The Optical Unconscious*. Cambridge: MIT Press, 1993.

KRAUSS, ROSALIND, and JANE LIVINGSTON, eds. *L'Amour fou: Photography and Surrealism*. Exh. cat. New York: Abbeville Press, 1985.

KROMM, JANE. "'Marianne' and the Madhouse." *Art Journal* 46, no. 4 (winter 1987), 299–304.

KRYGIER, IRIT, ed. *The Unreal Person: Portraiture in the Digital Age*. Exh. cat. Huntington Beach, Calif.: Huntington Beach Art Center, 1998.

KUEI, CHI AN. *Face Reading: Keys to Instant Character Analysis*. Trans. Rosemary Dear. New York: M. Evans, 1998.

KUSPIT, DONALD, THOMAS MCEVILLEY, and ROBERTA SMITH. *Lucas Samaras: Objects and Subjects, 1969–1986*. Exh. cat. New York: Abbeville Press, 1988.

L

LA BRUYÈRE, JEAN DE. *Les Caractères de La Bruyère*. With 18 etchings by V. Foulquier. Tours: A. Mame, 1867.

LACAN, ERNEST. *Esquisses photographiques à propos de l'Exposition universelle et de la guerre d'orient*. Paris: Grassart, 1856.

———. "La Photographie en Angleterre." *La Lumière* 5, no. 26 (30 June 1855), 101–2.

———. "La Photographie et la physiologie." *Le Moniteur de la photographie* 13 (15 September 1862): 101–2.

———. "Portraits de folles par le Dr. Diamond." *La Lumière* 4, no. 5 (23 December 1854): 202.

LA GAVINIE. "Chronique." *La Lumière* 9, no. 9 (26 February 1859): 36.

LANDAU, TERRY. *About Faces: The Evolution of the Human Face*. New York and London: Doubleday, 1989.

LANG, GERHARD, ed. *Paläanthroppische Physiognomien*. Exh. cat. Frankfurt am Main: Senckenberg-Museum, 1993.

LARNED, W. LIVINGSTON. "Facial Expression—An Advertising Language." *The Commercial Photographer* 6, no. 9 (June 1931): 527–31.

LAVATER, JOHANN KASPAR. *L'Art de connaitre les hommes par la physionomie*. New, revised, and enlarged edition, supplemented by an exposition on the physiognomic researches and opinions of La Chambre, Porta, Camper, and Gall, an anatomical and physiological history of the face, etc., by M. Moreau (de la Sarthe). 10 vols. Paris: Libraire Depélafol, 1820.

———. *Essays on Physiognomy: Designed to Promote the Knowledge and the Love of Mankind illustrated by . . . or under the inspection of Thomas Holloway*. Trans. from the French by Henry Hunter. 5 vols. London: John Murray, 1789–1798. ◆

———. *Essays on Physiognomy: Designed to Promote the Knowledge and the Love of Mankind*. Trans. Thomas Holcroft. 9th ed. London: William Tegg, 1855. ◆

———. *Physiognomische Fragmente zur Beförderung der Menschenkenntniss und Menschenliebe*. 4 vols. Leipzig and Winterthur, 1775–1778.

LAVATER, SUE & CO. *Lavater's Looking-Glass; or, Essays on the Face of Animated Nature, from Man to Plants*. London: Richardsons et al., 1800.

LE BRUN, CHARLES. *Conférence de Monsieur Le Brun, premier peintre du roy de France, chancelier et directeur de l'Academie de Peinture et Sculpture, sur l'expression générale & particulière*. Amsterdam: J. D. de Lorme, 1698.

———. *Conférence de M. Le Brun sur l'expression générale et particulière. English. A method to learn to design the passions* (1734). Intro. Alan T. McKenzie. The Augustan Reprint Society, nos. 200–201. Los Angeles: William Andrews Clark Memorial Library, University of California, 1980.

———. *Heads, representing the various passions of the souls as they are expressed in the human countenance*. London: W. Darling, n.d. [c. 1750].

———. *Resemblances, Amazing Faces*. Text by Edward Sorel. New York: A Harlin Quist Book, 1980.

LÉGER, CLAUDE. "De l'hystérie." *Cimaise*, no. 173 (November–December 1984): 34–48.

LEIBOVITZ, ANNIE. *Photographs Annie Leibovitz 1970–1990*. Exh. cat. New York: Harper Collins, 1991.

LEPERLIER, FRANÇOIS. *Claude Cahun: L'Eclart et la metamorphose*. Paris: Jean Michel Place, 1992.

LERSKI, HELMAR. "Aphorisms on Photography and Art." Trans. E. F. R. *The American Annual of Photography* 28 (1914): 268–9.

———. *Köpfe des Altags*. Berlin: Hermann Reckendorf, 1931.

LEVIN, DAVID MICHAEL. *Modernity and the Hegemony of Vision*. Berkeley: University of California Press, 1993.

LEVINAS, EMMANUEL. *The Levinas Reader*. Ed. Seán Hand. Trans. Seán Hand and Michael Temple. Oxford: Basil Blackwell, 1989.

———. "Max Picard and the Face." Trans. Michael B. Smith. In *Proper Names*. Ed. Werner Hamacher and David E. Wellbery. Stanford: Stanford University Press, 1996, 94–98.

———. *Totality and Infinity*. Trans. Alphonso Lingis. Pittsburgh: Duquesne University Press, 1969.

LEVITINE, GEORGE. "Influence of Lavater and Girodet's 'Expression des Sentiments de l'Ame.'" *Art Bulletin* 36, no. 1 (March 1954): 33–44.

LICHTENBERG, GEORG CHRISTOPH. *Uber Physiognomik wider die Physiognomen, zu Beförderung der Menschenliebe und Menschenkenntnis* [und] *Fragmente von Schwänzen*. Steinbach bei Giessen: Anabas Verlag G. Kämpf, 1970.

LIGGETT, JOHN. *The Human Face*. New York: Stein and Day, 1974.

LINGWOOD, JAMES and ANDREA SCHLIEKER, eds. *Franz Xaver Messerschmidt: Character-Heads 1770–1783/Arnulf Rainer: Overdrawings Franz Xaver Messerschmidt*. Exh. cat. London: Institute of Contemporary Arts, n.d.

LISTA, GIOVANNI. *Futurismo e Fotografia*. Milan: Multipla edizioni, 1979.

———. *Photographie futuriste italienne, 1911–1939*. Exh. cat. Paris: Musée d'Art Modern de la Ville de Paris, 1981.

LOMBROSO, CESARE. *Crime: Its Causes and Remedies*. Boston: Little, Brown, 1918.

———. *L'Homme criminel, criminel-né, fou moral, épileptique: Etude anthropologique et médico-légale*. Trans. Régnier and Bournet. Paris: Alcan, 1887. ◆

LONDE, ALBERT. *La Photographie médicale: Application aux sciences médicales et physiologiques*. Paris: Gauthier-Villars, 1893.

LOY, MINA. "Auto-Facial Construction." In *The Last Lunar Baedeker*. Ed. Roger L. Conover. (Highlands, N.C.: The Jargon Society, 1982), 283–4.

M

MacIntyre, Alasdair, ed. *Hegel: A Collection of Critical Essays*. Notre Dame and London: University of Notre Dame Press, 1976, 219–36.

Mack, Michael. "Photo-physiognomy." In *Surface: Contemporary Photography Practice*. Ed. Simon Browning, Michael Mack, Sean Perkins. London: Booth-Clibborn Editions, 1996, 231.

Maddow, Ben. *Faces: A Narrative History of the Portrait in Photography*. Boston: New York Graphic Society, 1977.

Magli, Patrizia. "The Face and the Soul." Trans. Ughetta Lubin. In *Fragments for a History of the Human Body, Zone 4, part 2*. Ed. Michel Feher, Ramona Naddaff, and Nadia Tazi. New York: Zone Books, 1989, 86–127.

Mantegazza, Paolo. *Atlante dell'espressione del dolore: Fotografie prese dal vero e da molte opere d'arte*. Florence: Giacomo Brogi, 1876.

———. *Physiognomy and Expression*. New York: C. Scribner's Sons, 1890.

Mar, Timothy T. *Face Reading: The Chinese Art of Physiognomy*. New York: Dodd Mead, 1974.

Marable, Darwin. "Photography and Human Behaviour in the Nineteenth Century." *History of Photography* 9, no. 2 (April–June 1985): 141–7.

Marles, Hugh C. "Duchenne de Boulogne: *Mécanisme de la Physionomie Humaine*." *History of Photography* 16, no. 4 (winter 1992): 395–6.

Mathon, Catherine, ed. *Duchenne de Boulogne: La Mécanique des passions*. Exh. cat. Paris: Ecole nationale supérieure des beaux-arts, 1999.

Mazlish, Bruce. *The Fourth Discontinuity: The Co-Evolution of Humans and Machines*. New Haven: Yale University Press, 1993.

McCarren, Felicia. "The 'Symptomatic Act' Circa 1900: Hysteria, Hypnosis, Electricity, Dance." *Critical Inquiry* 21, no. 4 (summer 1995): 748–74.

McCauley, Elizabeth Anne. *A. A. E. Disdéri and the Carte de Visite Portrait Photograph*. New Haven and London: Yale University Press, 1985.

———. *Industrial Madness: Commercial Photography in Paris, 1848–1871*. New Haven and London: Yale University Press, 1994.

McCormick, Leander Hamilton. *Characterology: An Exact Science Embracing Physiognomy, Phrenology and Pathognomy, Reconstructed, Amplified and Amalgamated, and Including Views Concerning Memory and Reason and the Location of These Faculties within the Brain, Likewise Facial and Cranial Indications of Longevity*. Chicago: Rand McNally, 1920.

McDermott, Jeanne. "Face to Face, It's the Expression That Bears the Message." *Smithsonian* 16, no. 12 (March 1986): 113–23.

McNeil, Daniel. *The Face*. New York: Little Brown and Company, 1998.

McShine, Kynaston, ed. *Andy Warhol: A Retrospective*. Exh. cat. New York: Museum of Modern Art, 1989.

Mellor, David, ed. *Germany: The New Photography, 1927–33*. London: Arts Council of Great Britain, 1978.

Merrill, Patrick, and Debra R. Winters. *The Fragmented Body: Violence or Identity?* Exh. brochure. Pomona, Calif.: W. Keith and Janet Kellogg University Art Gallery, California State Polytechnic University, 1999). Online: http://www.csupomona.edu/~kellog_gallery/ (23 January 1999).

Micale, Mark S. "Charcot and the Idea of Hysteria in the Male: Gender, Mental Science and Medical Diagnosis in Late-Nineteenth Century France." *Medical History* 34 (October 1990): 363–411.

Miller, Margaret. "Géricault's Paintings of the Insane." *Journal of the Warburg and Courtauld Institutes* 4, nos. 3–4 (April–July 1941): 151–63.

MIT List Visual Arts Center. *The Ghost in the Machine*. Exh. cat. Cambridge: MIT List Visual Arts Center, 1994.

Mongeri, Luigi. "Etude de la physionomie chez les aliénés." *International Medizinische-Photographische Monatschrift* 1 (1894): 353–60.

Montague, Jennifer. *The Expressions of the Passions: The Origin and Influence of Charles LeBrun's "Conférence sur l'expression générale et particulière."* New Haven: Yale University Press, 1994.

Montaigne, Michel de. "On Physiognomy." In *Essays*. Trans. J. M. Cohen. Harmondsworth: Penguin Books, 1958, 311–43.

Moos, David. "Memories of Being: Orlan's Theater of the Self." *Art + Text* 54 (May 1996): 67–73.

Morel, Benedict Auguste. *Traité des dégénérescences physiques, intellectuelles et morales de l'espece humaine et des causes qui produisent ces variétes maladives*. Paris: J.-B. Ballière, 1857.

Morison, Alexander. *The Physiognomy of Mental Diseases*. London: Longman, 1838.

Mortensen, William. *The Model: A Book on the Problems of Posing*. San Francisco: Camera Craft Publishing, 1937.

Müller-Tamm, Pia, Hripsimé Visser, Reinhard Spieler, and Dorothee Jansen, eds. *Katharina Sieverding: 1967–1997*. Exh. cat. Cologne: Oktagon Verlag, 1997.

Museum Fridericianum, Kunstmuseum Winterthur, and Scottish National Gallery of Modern Art, eds. *From Action Painting to Actionism: Vienna 1960 1965*. Viennese Actionism, vol. 1. Exh. cat. Klagenfurt: Ritter Verlag, 1988.

N

Neve, M. "The Construing of the Face." *Times Literary Supplement*, 17 September 1982, 991.

Nummenmaa, Tapio. *The Language of the Face*. Jyväskylä: University of Jyväskylä, 1964.

O

Ohara, Ken. *One*. Tokyo: Tsukiji Shokan, 1970. Reprinted, Cologne: Benedkt Taschen, 1997. ◆

O'Neill, John, ed. *Freud and the Passions*. University Park, Pa.: Pennsylvania State University Press, 1996.

Orlan. *Ceci est mon corps…Ceci est mon logiciel/This is my body . . . This is my software*. Ed. Duncan McCorquodale. London: Black Dog Publishing, 1996.

Ottman, Klaus. "Art and Masquerade." *Art and Text* 19 (October–December 1985): 47–55.

PATTEN, ROBERT L. "Conventions of Georgian Caricature." *Art Journal* 43, no. 4 (special issue, "The Issue of Caricature," winter 1983): 331–8.

PAYNE, CAROL. *Interface: Encounters with New Technology.* Exh. brochure. Ottawa: Canadian Museum of Contemporary Photography, 1998.

PEARSON, KEITH ANSELL, *Viroid Life: Perspectives on Nietzsche and the Transhuman Condition.* London and New York: Routledge, 1997.

PEARSON, KEITH ANSELL, ed. *Deleuze and Philosophy: The Difference Engineer.* London and New York: Routledge, 1997, 180–210.

PECK, STEPHEN ROGERS. *Atlas of Facial Expression.* Oxford and New York: Oxford University Press, 1987.

PENN, IRVING. *Passage: A Work Record.* Text by Alexander Liberman. New York: Alfred A. Knopf/Callaway, 1991.

PETHERBRIDGE, DEANNA, and LUDMILLA JORDANOVA. *The Quick and the Dead: Artists and Anatomy.* Exh. cat. Berkeley: University of California Press, 1997.

PETRIOLI, ANNA MARIA, ed. *Mostra di disegni di D. P. Humbert de Superville.* Text by Giovanni Previtali. Gabinetto disegni e stampe degli Uffizi, no. 19. Exh. cat. Florence: Leo S. Olschki, 1964.

PHÉLINE, CHRISTIAN. *L'Image accusatrice. Les Cahiers de la Photographie,* no. 17 (1985).

PHILLIPS, ANITA. *The Virtues, the Vices and All the Passions.* Edinburgh: Polygon, c. 1991.

PHILLIPS, ANITA, ET AL. *Other than Itself: Writing Photography.* Ed. John X. Berger and Oliver Richon. Manchester: Cornerstone Publications and Derbyshire College of Higher Education and Camerawork, 1989.

PHILLIPS, SANDRA S., MARK HAWORTH-BOOTH, and CAROL SQUIERS. *Police Pictures: The Photograph as Evidence.* Exh. cat. San Francisco: San Francisco Museum of Modern Art, 1997.

PHILOSTRATUS THE YOUNGER. *Imagines.* In Philostratus, *Imagines*; Callistratus, *Descriptions.* Trans. Arthur Fairbanks. Cambridge: Harvard University Press, 1960, 273–365.

"Photography of the Passions." *The Photographic News* 2, no. 43 (1 July 1859): 197–8.

"Physiognomy of the Human Soul." *Littell's Living Age* 51, no. 653 (29 November 1856): 553–76.

PICK, DANIEL. *Faces of Degeneration: A European Disorder, c. 1848–c. 1918.* Ideas in Context. Cambridge: Cambridge University Press, 1989.

PIDERIT, THEDOR. *Grundsätze der Mimik und Physiognomik.* Braunschweig: Friedrich Vieweg und Sohn, 1858.

PLUTCHIK, ROBERT, and HENRY KELLERMAN, eds. *Emotion: Theory, Research, and Experience.* Vol. 1, *Theories of Emotion.* Vol. 2, *Emotions in Early Development.* New York: Academic Press, 1980 and 1983.

POHLEN, ANELIE. "Deep Surface." *Artforum* 29, no. 8 (April 1991): 114–8.

POIVERT, MICHEL. "'Le Phénomène de l'extase,' ou le portrait du surréalisme même." *Etudes photographiques,* no. 2 (May 1997): 96–114.

POMMIER, JEAN. *La Mystique de Baudelaire.* Paris: Les Belles Lettres, 1932. Reprinted, Geneva: Slatkine Reprints, 1967.

PONTALIS, J.-B. *Entre le rêve et la douleur.* Paris: Gallimard, 1977.

POPE-HENNESSY, JOHN. *The Portrait in the Renaissance.* A. W. Mellon Lectures in the Fine Arts, 1963. Bollingen Series 35, no. 12. New York: Bollingen Foundation, 1966.

POTTER, DENNIS. *The Singing Detective.* Boston: Faber and Faber, 1986.

PRODGER, PHILLIP. *Illustrations as Strategy in Charles Darwin's "Expressions of the Emotions in Man and Animals."* In *Inscribing Science: Scientific Texts and the Materiality of Communication.* Ed. Timothy Lenoir. Palo Alto: Stanford University Press, 1998.

———. *Illustrations of Human and Animal Expression from the Collection of Charles Darwin.* Lampeter: Edwin Mellen Press, 1998.

PRUSZKOWSKI, KRZYSZTOF. *Krzysztof Pruszkowski Fotosynteza 1975–1988.* Exh. cat. Lausanne: Musée de l'Elysée, 1989.

PULTZ, JOHN. *The Body and the Lens: Photography 1839 to the Present.* New York: Harry N. Abrams, 1995.

REFF, THEODORE. "Degas's 'Tableau de Genre.'" *Art Bulletin* 54, no. 3 (September 1972): 316–37.

———. *Degas: The Artist's Mind.* Exh. cat. New York: Metropolitan Museum of Art, 1976.

REISS, RODOLPHE ARCHIBALD. *Manuel du portrait parlé à l'image de la police: Methode Alphonse Bertillon.* Lausanne: Th. Sack, 1905.

REMAK, ROBERT. *Galvanotherapie der Nerven-und Muskelkrankheiten.* Berlin: August Hirschwald, 1858.

RENGADE, JULES. *La Vie normale et la santé: Traité complet de la structure du corps humain, des fonctions et du rôle des organes à tous les âges de la vie, avec l'étude raisonnée des instincts et des passions de l'homme, et l'exposition des moyens naturels de prolonger l'existence en assurant la conservation de la santé.* Paris: Librairie illustrée, c. 1881.

RHODES, HENRY T. F. *Alphonse Bertillon: Father of Scientific Detection.* New York: Abelard-Schuman, 1956.

RICHARDS, ROBERT JOHN. *Darwin and the Emergence of Evolutionary Theories of Mind and Behavior.* Chicago: University of Chicago Press, 1987.

RICHER, PAUL, GILLES DE LA TOURETTE, and ALBERT LONDE (ET AL.). *La Nouvelle Iconographie de la Salpêtrière, clinique des maladies du systeme nerveux, publiée sous la direction du Professeur Charcot (de l'Institut).* Paris: Lecrosnière and Babé (et al.), 1888–1918. ◆

RIDER, TARAH. *Dr. Guillaume Benjamin-Armand Duchenne.* History of Photography Monograph Series, no. 25. Tempe: Arizona State University, 1989.

RIVERS, CHRISTOPHER. *Face Value: Physiognomical Thought and the Legible Body in Marivaux, Lavater, Balzac, Gautier, and Zola.* Madison: University of Wisconsin Press, 1994.

ROBERTS, RUSSELL, ET AL. *In Visible Light: Photography and Classification in Art, Science and the Everyday.* Exh. cat. Oxford: Museum of Modern Art, 1997.

ROGERSON, BREWSTER. "The Art of Painting the Passions." *Journal of the History of Ideas* 14, no. 1 (January 1953): 68–94.

RONELL, AVITAL. *The Telephone Book: Technology, Schizophrenia, Electric Speech.* Lincoln: University of Nebraska Press, 1989.

ROOT, MARCUS AURELIUS. *The Camera and the Pencil.* New York: D. Appleton & Co., 1864.

ROSE, BARBARA, "Self-Portraiture: Theme with a Thousand Faces." *Art in America* 63, no. 1 (January/February 1975): 66–73.

ROTH, MICHAEL. "Hysterical Remembering." *Modernism/Modernity* 3, no. 2 (April 1996): 1–30.

ROTH, NANCY ANN. "Electrical Expressions: The Photographs of Duchenne de Boulogne." In *Multiple Views: Logan Grant Essays on Photography, 1983–89.* Ed. Daniel P. Younger. Albuquerque: University of New Mexico Press, 1991, 105–37.

ROUILLÉ, ANDRÉ. "Au-delà du principe physionomonique." *La Recherche Photographique* (October 1986): 51–55.

———. *L'Empire de la photographie: 1839–1870.* Paris: Le Sycomore, 1982.

———. "Le Portrait comme 'technologie politique du corps.'" *Les Cahiers de la Photographie* 4 (1981): 22–27.

ROUILLÉ, ANDRÉ, and BERNARD MARBOT. *Le Corps et son image: Photographies du dix-neuvième siècle.* Paris: Contrejour, 1986.

ROWELL, MARGIT, ed. *Antonin Artaud: Works on Paper.* Exh. cat. New York: Museum of Modern Art, 1996.

RUDOFSKY, BERNARD. *The Unfashionable Human Body.* Garden City: Anchor Press/Doubleday, 1974.

RYUICHI, KANEKO. *Innovation in Japanese Photography in the 1960s.* Exh. cat. Tokyo: Tokyo Metropolitan Museum of Photography, 1991.

S

SAMARAS, LUCAS. *Samaras Album: Auto-interview, Autobiography, Autopolaroid.* New York: The Whitney Museum of American Art and Pace Editions, 1971. ◆

SANDER, AUGUST. *Antlitz der Zeit.* Intro. Alfred Döblin. Munich: Kurt Wolff, 1929.

SANDER, GUNTHER, ed. *August Sander: Citizens of the Twentieth Century: Portrait Photographs, 1892–1952.* Text by Ulrich Keller. Trans. Linda Keller. Cambridge: MIT Press, 1986.

SAPPINGTON, RODNEY, and TYLER STALLINGS, eds. *Uncontrollable Bodies: Testimonies of Identity and Culture.* Port Townsend, Wash.: Bay Press, 1994.

SARTRE, JEAN PAUL. *Sketch for a Theory of the Emotions.* New York: Methuen, 1962.

SAUNDERS, FREDERICK. "The Human Face Divine." In *Mosaics by the Author of Salad for the Solitary &c.* New York: Charles Scribner, 1859, 127–68.

SCHADOW, JOHANN GOTTFRIED. *Physionomie nationales; ou, Observations sur la différence des traits du visage et sur la conformation de la tête de l'homme.* Berlin: J. G. Schadow, 1835.

SCHEON, AARON. "Caricature and the Physiognomy of the Insane." *Gazette des beaux-arts* 88, no. 1293 (October 1976): 145–50.

SCHIMMELPENNINCK, MARY ANNE. *Theory on the Classification of Beauty and Deformity, and Their Correspondence with Physiognomic Expression, Exemplified in Works of Art, and Natural Objects.* London: John and Arthur Arch, 1815.

SCHLEMMER, OSKAR. *Man: Teaching Notes from the Bauhaus.* Ed. Heimo Kuchling. Trans. Janet Seligman. Cambridge: MIT Press, 1971.

SCHNEIDER, CHRISTINE. "The Soulless New Machine." *Camera Austria* 51/52 (1995): 77–87.

SCHRÖDER, KLAUS ALBRECHT. *Egon Schiele: Eros and Passion.* Trans. David Britt. Munich and New York: Prestel, 1995.

SCHOPENHAUER, ARTHUR. *Religion: A Dialogue and Other Essays.* Ed. and trans. T. Bailey Saunders. London: George Allen & Unwin, 1915.

SCHULTZ-NAUMBERG, PAUL. *Kunst und Rasse.* Munich: J. F. Lehmann, 1932.

SEKULA, ALLAN. "The Body and the Archive." In *The Contest of Meaning: Critical Histories of Photography.* Ed. Richard Bolton. Cambridge: MIT Press, 1989, 342–88.

SENNETT, RICHARD. *The Fall of Public Man: On the Social Psychology of Capitalism.* New York: Vintage Books, 1978.

SERPA, LUÍS. *"Je est un autre" de Rimbaud.* Exh. cat. Lisbon: Galeria Cómicos/Luís Serpa, 1990.

SHAVIRO, STEVEN. *Doom Patrols: A Theoretical Fiction about Postmodernism.* New York: Serpent's Tail/High Risk Books, 1997.

SHOOKMAN, ELLIS, ed. *The Faces of Physiognomy: Interdisciplinary Approaches to Johann Caspar Lavater.* Columbia, S.C.: Camden House, 1993.

SHORTLAND, MICHAEL. "The Power of a Thousand Eyes: Johann Caspar Lavater's Science of Physiognomical Perception." *Criticism* 28, no. 4 (fall 1989): 379–408.

SICARD, MONIQUE, ROBERT PUJADE, and DANIEL WALLACH. *A Corps et à raison: Photographies médicales, 1840–1920.* Paris: Marval (Mission du patrimoine photographique), 1995.

SIEBERT, RICHARD. "Same Difference: The French *Physiologies,* 1840–1842." *Notebooks in Cultural Analysis* 1, no. 1 (1985): 179–97.

SIEGFRIED, SUSAN L. *The Art of Louis-Léopold Boilly: Modern Life in Napoleonic France.* New Haven and London: Yale University Press, 1995.

SILVERMAN, DEBORA L. *Art Nouveau in Fin-de-Siècle France: Politics, Psychology, and Style.* Berkeley: University of California Press, 1989.

SIMMEL, GEORG. "The Aesthetic Significance of the Face." *Essays on Sociology, Philosophy and Aesthetics.* Ed. Kurt H. Wolff. New York: Harper & Row, 1959, 276–81.

SIMON, JOAN, ed. *Bruce Nauman.* Exh. cat. Minneapolis: Walker Art Center, 1994.

SINGER, JANE CASEY. "Early Portrait Painting in Tibet." In *Function and Meaning in Buddhist Art.* Ed. K. R. van Kooij and H. van der Veere. Gonda Indological Series, vol. 3. Groningen: E. Forsten, 1995, 81–99.

SIZER, NELSON, and H. S. DRAYTON. *Heads and Faces, and How to Study Them, A Manual of Phrenology and Physiognomy for the People.* New York: Fowlers & Wells, 1895.

SOBIESZEK, ROBERT A. "'Gymnastics of the Soul'—The Clinical Aesthetics of Duchenne de Boulogne." In *Six Exposures: Essays in Celebration of the Opening of the Harrison D. Horblit Collection of Early Photography.* Ed. Anne Anniger and Julie Melby. Cambridge: The President and Fellows of Harvard College Press, 1999, 107–29.

Sobieszek, Robert, ed. *A Lasting Tradition: The Studio Portraiture of Phillip Stewart Charis*. San Juan Capistrano: Forster Publications, 1995.

Sobieszek, Robert, A., and Odette M. Appel. *The Spirit of Fact: The Daguerreotypes of Southworth and Hawes, 1843–1862*. Exh. cat. Boston and Rochester: David R. Godine and International Museum of Photography, 1976.

Sobieszek, Robert A., and Deborah Irmas. *The Camera I: Photographic Self-Portraits from the Audrey and Sydney Irmas Collection*. Exh. cat. Los Angeles and New York: Los Angeles County Museum of Art and Harry N. Abrams, 1994.

Sokolowski, Thomas W. *Todd Watts: New Lamps for Old*. Exh. cat. New York: Grey Art Gallery & Study Center, New York University, 1994.

Sontag, Susan. *Under the Sign of Saturn*. New York: Vintage Books, 1978.

Spencer, Stephanie. "O. G. Rejlander: Art Studies." In *British Photography in the Nineteenth Century: The Fine Art Tradition*. Ed. Mike Weaver. Cambridge: Cambridge University Press, 1989, 121–31.

Spoerri, Daniel, and François Dufrêne. *L'Optique moderne: Collection des lunettes présentée par Daniel Spoerri; avec, en regard, Dinutiles noturles par François Dufrêne*. Paris: Fluxis, 1963. ◆

Stafford, Barbara Maria. *Body Criticism: Imaging the Unseen in Enlightenment Art and Medicine*. Cambridge and London: MIT Press, 1991.

———. *Good Looking: Essays on the Virtue of Images*. Cambridge: MIT Press, 1996.

———. "'Peculiar Marks': Lavater and the Countenance of Blemished Thought." *Art Journal* 46, no. 13 (fall 1987): 185–92.

———. *Symbol and Myth: Humbert de Superville's Essay on Absolute Signs in Art*. Cranbury, N.J.: University of Delaware Press, 1979.

Starobinski, Jean. "Le Passé de la passion: Textes médicaux et commentaires." *Nouvelle revue de psychanalyse* 21 (special issue, "La Passion," 1980): 51–76.

Stern, Madeleine B. *Heads and Headlines: The Phrenological Fowlers*. Norman, Okla.: University of Oklahoma Press, 1971.

Stoddard, John T. "College Composites." *Century Illustrated Monthly Magazine*, November 1887, 121–5.

———. "Composite Photography." *Century Illustrated Monthly Magazine*, March 1887, 750–7.

Stone, Allucquère Rosanne. *The War of Desire and Technology at the Close of the Mechanical Age*. Cambridge: MIT Press, 1995.

Storr, Robert. *Chuck Close*. With texts by Kirk Varnedoe and Deborah Wye. Exh. cat. New York: Museum of Modern Art, 1998.

Sue, Jean Joseph. *Essai sur la physiognomie des corps vivants considerée depuis l'homme jusqu'à la plante*. Paris: chez l'auteur, chez DuPont, 1797.

Suleiman, Susan Rubin. *Subversive Intent: Gender, Politics, and the Avant-Garde*. Exh. cat. Cambridge and London: Harvard University Press, 1990.

Sypher, Wylie. "The Late-Baroque Image: Poussin and Racine." *Magazine of Art* 45, no. 5 (May 1952): 209–15.

Szarkowski, John. *Irving Penn*. Exh. cat. New York: Museum of Modern Art, 1984.

T

Talrich, Gabrielle, V^e E. Crépin. *Six Photographies et quelques renseignements authentiques à ajouter aux remarquables ouvrages de D^e Duchenne*. Paris, 1902.

Taylor, Mark C. *Hiding*. Chicago: University of Chicago Press, 1997.

Testelin, Henry. *Sentimens des plus habiles: Peintres sur la pratique de la Peinture et Sculpture*. Paris: V^e Mabre-Cramoisy, 1696.

Thomas, Ann, et al. *Beauty of Another Order: Photography in Science*. Exh. cat. New Haven and Ottawa: Yale University Press and National Gallery of Canada, 1998.

Thoré, Théophile. "De la phrénologie dans ses rapports avec l'art." *L'Artiste* 7 (1833): 122–5, 259–61.

———. *Dictionnaire de phrénologie et physiognomie, à l'usage des artistes, des gens du monde, des instituteurs, des pères de famille, des jurés*. Paris, 1836.

Tiberghien, Gilles A. *Patrick Tosani*. Paris: Hazan, 1997.

Tickle, Naomi R. *It's All in the Face: The Key to Finding Your Life's Purpose*. Mountain View, Calif.: Daniel's Publishing, 1997.

Trachtenberg, Alan. "Reading Lesson: The Story of a Daguerreotype." Unpublished essay, forthcoming.

Tuke, D. Hack, ed. *A Dictionary of Psychological Medicine*. 2 vols. Philadelphia: P. Blakiston, 1892.

Turgenev, Ivan, et al. *The Portrait Game*. Trans. and ed. Marion Mainwaring. New York: Horizon Press, 1973.

Turkle, Sherry. "Constructions and Reconstructions of the Self in Virtual Reality." In *Electronic Culture: Technology and Visual Representation*. Ed. Timothy Druckrey. New York: Aperture, 1996, 354–65.

———. *Life on the Screen: Identity in the Age of the Internet*. New York: Simon and Schuster, 1995.

———. *The Second Self: Computers and the Human Spirit*. New York: Simon and Schuster, 1984.

Tytler, Graeme. *Physiognomy in the European Novel: Faces and Fortunes*. Princeton: Princeton University Press, 1982.

V

VALENTINE, TIM, ed. *Cognitive and Computational Aspects of Face Recognition: Explorations in Face Space*. International Library of Psychology. New York: Routledge, 1995.

VALLHONRAT, VALENTÍN. *Cristal Oscuro*. Exh. cat. Madrid: Centro nacional de exposiciones y promoción artística y Olivares & Nusser, 1996.

VAN BRUGGEN, COOSJE. *Bruce Nauman*. Exh. cat. New York: Rizzoli, 1988.

VASSELEU, CATHRYN. *Textures of Light: Vision and Touch in Irigaray, Levinas and Merleau-Ponty*. Warwick Studies in European Philosophy. New York: Routledge, 1998.

VIEIRA, MARK A. *Hurrell's Hollywood Portraits: The Chapman Collection*. New York: Harry N. Abrams, 1997.

VON HARTMANN, EDUARD. *Philosophy of the Unconscious: Speculative Results According to the Inductive Method of Physical Science*. Trans. William Chatterton Coupland. 1931. Reprinted, London: Routledge & Kegan Paul, 1950.

W

WALDMAN, MAX. *Waldman on Theater*. Text by Clive Barnes. Garden City, N.Y.: Doubleday and Company, 1971. ◆

WALKER, ALEXANDER. *The New Lavater: or, An Improved System of Physiognomy Founded upon Strictly Scientific Principles Conformable to the Present Advanced State of Anatomical and Physiological Knowledge with a Practical Application to Nations, Professions, and Individuals to Which Are Added Remarks on Phrenology Accompanied by Accurate Engravings, Illustrative of the Theories of Dr. Spurzheim and the Modern Phrenologists*. London: S. Cornish, 1839.

WALLIS, BRIAN. "Black Bodies, White Science: Louis Agassiz' Slave Daguerreotypes." *American Art* 9, no. 2 (summer 1995): 38–61.

WARNER, MARINA. "Stealing Souls and Catching Shadows." *tate* 6/7 (1995): 41–46.

WARTOFSKY, MARX. "Cameras Can't See: Representation, Photography, and Human Vision." *Afterimage* 7, no. 9 (April 1980): 8–9.

WATTEAU, ANTOINE. *Livre de différents caractères de têtes. Inventez par M. Watteau et gravés d'après ses desseins par Filloeul*. Paris: Chereau, 1752.

WEAVER, MIKE. *Alvin Langdon Coburn: Symbolist Photographer, 1882–1966—Beyond the Craft*. Exh. cat. New York: Aperture Foundation, 1986.

———. *Julia Margaret Cameron, 1815–1879*. Exh. cat. Southampton: John Hansard Gallery and the Herbert Press, 1984.

WECHSLER, JUDITH. *A Human Comedy: Physiognomy and Caricature in 19th Century Paris*. Chicago: University of Chicago Press, 1982.

WEISBERG, GABRIEL P., ed. *The European Realist Tradition*. Bloomington: Indiana University Press, 1982.

WEISS, ALLEN S. *Shattered Forms: Art Brut, Phantasms, Modernism*. Albany: State University of New York Press, 1992.

WELCH, A. C. *Character Photography: Chapters on the Developing Process in the Better Life*. Cincinnati: Jennings & Pye, 1902.

WELCHMAN, JOHN. "Face(t)s: Notes on Faciality." *Artforum* 27, no. 3 (November 1988): 131–8.

WELLS, SAMUEL R. *New physiognomy; or, Signs of Character as Manifested through Temperament and External Forms, and Especially in "the Human Face Divine."* New York: Fowlers & Wells, 1889.

WEY, FRANCIS. "Théorie du Portrait." Parts 1 and 2. *La Lumière* 1, no. 12 (27 April 1851): 46–47; no. 13 (4 May 1851): 50–51.

———. "Theory of Portraiture." Parts 1 and 2. Trans. Ambrose Andrews. *The Photographic Art Journal* 5, no. 1 (January 1853): 33–36; no. 2 (February 1853): 104–9.

WEYERGRAF, BERND. *Dieter Appelt*. Exh. cat. Berlin: Verlag Dirk Nishen, 1989.

WHITESIDE, ROBERT L. *Face Language*. New York: Frederick Fell Publishers, 1974.

WILLIAMS, SUSAN S. *Confounding Images: Photography and Portraiture in Antebellum American Fiction*. Philadelphia: University of Pennsylvania Press, 1997.

WITTGENSTEIN, LUDWIG. *Philosophical Investigations*. Trans. G. E. M. Anscombe. 3rd ed. New York: Macmillan, 1968.

———. *Zettel*. Ed. G. E. M. Anscombe and G. H. von Wright. Trans. G. E. M. Anscombe. Berkeley: University of California Press, 1970.

WOZNIAK, ROBERT H. *Mind and Body: René Descartes to William James*. Exh. cat. Bethesda, Md., and Washington, D.C.: The National Library of Medicine and the American Psychological Association, 1992.

Y

YASSIN, ROBERT A., ed. *Art and the Excited Spirit: America in the Romantic Period*. Exh. cat. Ann Arbor: University of Michigan Museum of Art, 1972.

YOUNG, LAILAN. *The Naked Face: The Essential Guide to Reading Faces*. New York: St. Martin's, 1993.

———. *Secrets of the Face: The Chinese Art of Reading Character through Facial Structure and Features*. Boston: Little, Brown, 1984.

YOUNG, ROBERT M. *Mind, Brain and Adaptation in the Nineteenth Century: Cerebral Localization and its Biological Context from Gall to Ferrier*. History of Neuroscience, 3. Reprint with new preface. New York: Oxford University Press, 1990. Online: http://www.shef.ac.uk/uni/academic/N-Q/psysc/mba/mba1.html (13 January 1999).

YOUNGER, DANIEL, ed. *Photography with a New Face: The Advent of the Carte de Visite in American Culture*. Rochester, N.Y.: the author, 1980.

322

Ghost in the Shell

Photography and the Human Soul, 1850–2000

was set in 10.5 on 16 Bembo. The display typeface used throughout this book is Univers. This book is printed on 130 gsm, satin matte coated R-4 paper in first edition of 8,100 copies.

| EDITED BY 10.11.98 | Margaret Gray |

| DESIGNED BY 12.11.98 | Amy McFarland |

| PHOTOGRAPHY BY 10.11.98 | Barbara Lyter |

| TYPOGRAPHY BY 4.20.99 | Theresa Velázquez / Rachel Ware-Zooi |

| PRODUCTION COORDINATED BY 5.11.98 | |

| PRINTED & BOUND BY 5.21.99 | Amilcare Pizzi S.P.A. Milan, Italy |

| DIRECTOR OF PUBLICATIONS | Garrett White |
| HEAD GRAPHIC DESIGNER | Jim Drobka |

| INDEXER | Kathleen Preciado |
| PROOFER | Dianne Woo |